The New SCULPTURE

Susan Beattie

Published for the Paul Mellon Centre for Studies in British Art
by Yale University Press · New Haven and London

Designed by Faith Brabenec Hart
Filmset in Monophoto Baskerville and printed in Great Britain by
Balding + Mansell Limited, Wisbech, Cambridgeshire

Library of Congress Cataloging in Publication Data

Beattie, Susan.
 The new sculpture.

 (Studies in British art)
 Bibliography: p.
 Includes index.
 1. New sculpture (Art movement) – Great Britain.
2. Sculpture, British. 3. Sculpture, Modern – 19th
century – Great Britain. 4. Sculpture, Modern – 20th
century – Great Britain. I. Paul Mellon Centre for
Studies in British Art. II. Title. III. Series.
NB467.5.N48B42 1983 730'.942 83-42876
ISBN 0-300-02860-1
ISBN 0-300-03359-1 (pbk)

To John Beattie, with love

Acknowledgements

I OWE special thanks to Alan Bowness, who was my supervisor for the thesis in which this book originated, to the Paul Mellon Centre for Studies in British Art which accepted it for publication, and to Thomas Stainton, who gave me custody of notes and other material accumulated by his sister Lavinia Handley-Read. My debt to Lavinia will be apparent to all who knew her as a pioneering historian of nineteenth-century sculpture in Britain. Among others who have given vital support – moral or practical and sometimes both – are Mary Beal, Andrew Best, Mary Bennett of the Walker Art Gallery, Theo Cowdell, Alan Crawford, Richard Dorment, Elizabeth Einberg, Renée Free, A.S. Gray, Frank Kelsall, Brian Lewis, my brother William McMorran, Miss Parker of the Royal Academy Library, Fiona Pearson of the National Museum of Wales, Nicholas Penny, Miss Bee and Linda Vincze of PPR Printing, Ben Read, Pauline Rohatgi, Peter Rose, Ian Scott, Jenny Sherwood, Peyton Skipwith of the Fine Art Society, Hugh Stevenson of Glasgow Art Gallery and Museum, the staffs of the Witt, Conway and Courtauld Institute libraries, the libraries of the Royal Institute of British Architects and the Victoria and Albert Museum, and the Greater London and Public Record Offices. I am profoundly grateful for the expertise, encouragement and guidance of Faith Hart and John Nicoll of Yale University Press. The help of many other individuals and organisations is acknowledged in footnotes. The families and former associates of many sculptors have been exceedingly generous with their time.

PHOTOGRAPHIC ACKNOWLEDGEMENTS

Plates 158–61 are reproduced by gracious permission of Her Majesty the Queen. Grateful acknowledgement is made also to the following for the supply of photographs and for permission to reproduce them: Tate Gallery, London 7, 27, 129, 138, 140, 144, 148, 156–7, 163, 170, 179, 181, 213, 235–7; Walker Art Gallery, Liverpool 1, 68, 141, 147, 152, 185, 193, colour plate II; Glasgow Art Gallery and Museum 23–5, 72, 73; National Gallery of Scotland, Edinburgh 3; British Architectural Library, RIBA, London 38, 46, 58; National Monuments Record, London 17; Eric de Maré 83; Greater London Council 20, 100–1, 230; Royal Borough of Kensington and Chelsea 6, 8, 137; Laing Art Gallery, Tyne and Wear County Museums 56, 176; Fine Art Society Ltd 2, 143, 165, 197; John Lewis 162; Minneapolis Institute of Arts 125; Los Angeles County Museum of Art (Edward Cornacchio) 126, 168; National Museum of Wales, Cardiff 130, 133, 177–8, 186–7, 231; Aberdeen Art Gallery 146; Royal Academy of

Arts, London 155, 234, colour plate I; Musée d'Orsay, Paris 128, 164; Cliché des Musées Nationaux, Paris 136, 180; Nottingham Castle Museum 166; Harris Museum and Art Gallery, Preston 182, 194; Peter Rose 192; Graham Miller 195; Philipson Studios Ltd 214; plates 9, 26, 39, 54, 74–6, 87, 103, 123–4, 127, 132, 135, 139, 175, 208, 217–18, 222–3, 233 are by courtesy of the Courtauld Institute of Art, London; the copyright of plates 4–5, 10, 19, 21–2, 29, 30, 47–9, 52, 66, 71, 78–81, 85, 90, 106–7, 119, 120, 122, 131, 145, 153–4, 169, 172, 174, 201 and 221 is held by Penny Moore (and that of plates 149 and 151 by Cressida Pemberton-Piggott). I am also much indebted for help in assembling illustrations to Artplan Associates Ltd, Bryan Ceney, Laure de Margerie, Geoffrey Fisher, Peter Fusco, Gill Hedley, John Lewis, Melissa Moore, Penny Moore, Edward Morris, Panline Studios Ltd and Philip Ward-Jackson. I should be grateful if any individual or organisation deserving but inadvertently not accorded an acknowledgement would draw the fact to my attention so that a suitable amendment may be made in any future edition.

Dates in parentheses indicate period at which the work was conceived in its original form and are not necessarily those of the illustrated version. Unless otherwise stated locations cited are in London and refer only to the illustrated work; some information on the whereabouts of other versions is provided in the biographical notes and in notes to the text. Approximate height-sizes are given for ideal works only. LS = life-sized.

Contents

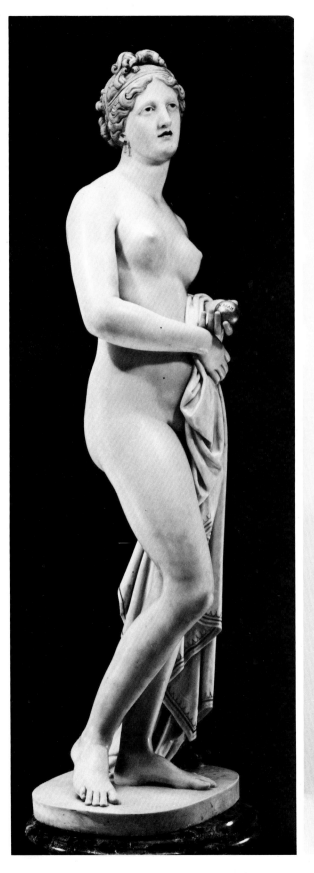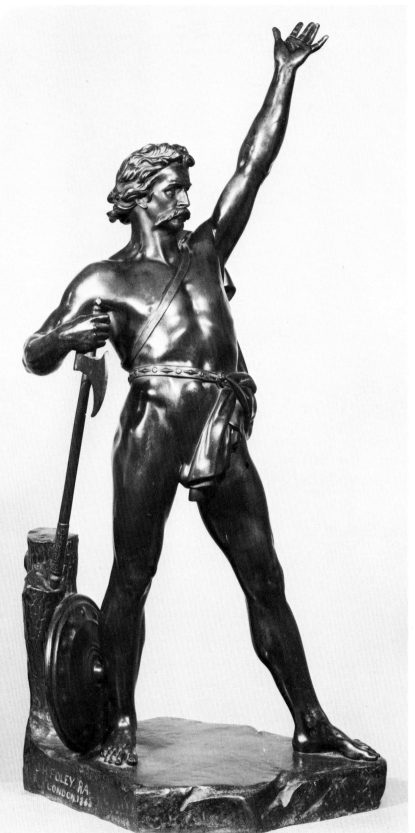

INTRODUCTION

1. The Shape of a Renaissance

In May 1875, exhausted and alone, Alfred Stevens died at his home in Hampstead. The doctor's certificate recorded angina and general debility – the results of overwork – but it was an open secret among the sculptor's close acquaintances that his death was suicide.

Stevens left a great question mark over English sculpture that still, to this day, awaits an answer. The condition of almost total artistic isolation in which he worked has been perpetuated by all his biographers, none of whom has attempted to set him in the context of his times, and, most notably of all, by his omission from Rupert Gunnis's *Dictionary of British Sculptors, 1660–1851*, the standard reference work that embraces such undistinguished practitioners of the art as Calder Marshall and E.B. Stephens who long outlived him.[1] And so, whether the object of hero-worship or expediently forgotten, he has been denied a place in the history of art, except as a freakish nineteenth-century Michelangelo, a throwback to a lost age. In such radical misunderstanding of Stevens's motives and significance lies the key to that phenomenon of modern times: the consignment to near oblivion of one of the most remarkable developments in English art, the renaissance known, since its first manifestations shortly after 1875, as the New Sculpture.

Stevens was nearly twenty-five when he returned to England in 1842 after nine years spent travelling in Italy. He returned with a vision of sculpture that was, quite simply, alien in his native land. Steeped in study of the Italian High Renaissance, he knew the potential of form and line to express electrifying energy and emotion. Apprenticed for a time in the Rome studio of the arch-neo-classicist Bertel Thorwaldsen, he took for granted that sculpture's role as an art of pure decoration was still honoured and secure. But by the mid-nineteenth century in England sculpture had shrunk to the limits imposed upon it by Francis Chantrey, John Gibson and their followers. It stood for the white marble portrait bust, the impassive Grecian goddess (plate 1) and the enervated funerary angel. It demanded the rigid suppression of all forms of self-expression, subject matter, material and technique that were deemed incompatible with an arbitrary and ever-narrowing standard of 'classical' purity, severity and dignity. The disciplines of the neo-classical tradition, confused in some mysterious way with the exigencies of Victorian morality, had hardened to a stranglehold. The faintly ridiculous air of much mid-nineteenth-century figure sculpture is the direct outcome of that collision of aesthetic with moral standards. As Edmund Gosse was to remark in 1883, J.H. Foley's *Caractacus* (plate 2), for all its pretensions as a heroic image, succeeds only in evoking some naked Englishman of good physique, 'looking as if something or another had

1. John Gibson, *Tinted Venus*, c.1850. Marble, LS. Walker Art Gallery, Liverpool.

2. J.H. Foley, *Caractacus* (1856). Bronze, 26 in. Reduction from marble figure, published by Art Union of London. Private collection.

1

3. Alfred Stevens, models for decorative details of fire-irons, and stoves, *c.*1850–62. Wax and plaster. National Gallery of Scotland, Edinburgh.

annoyed him very much'.[2] In 1846, the year that Stevens embarked upon a career in London, Baudelaire wrote a review of the Paris Salon under the cruelly contemptuous title 'Why Sculpture is Boring'. The disaffection expressed there had long been shared, if not clearly articulated, in England where the art survived in a kind of vacuum, static in form, increasingly limited in function and irrelevant to human experience.

It is difficult to imagine a challenge to that *status quo* more profound than that offered by Stevens and his work. He submitted nothing to the Royal Academy, the sanctum of high sculpture, and nothing, so far as is known, to any other exhibition gallery. He remained uninterested in portrait sculpture, except, on rare occasions, as a mark of friendship. Pouring energy in every other direction, he entered public architectural competitions (though he had never served an architectural apprenticeship), joined the staff of a small firm of interior decorators, went up to Sheffield to produce a series of decorative modellings for an industrial ironfounder. Thus his first major contributions to English sculpture were household fittings: quattrocento *putti* with garlands, conceived to frame a fire-grate; homely fire-dogs transformed into heroic figures that echo, in their freedom and power, the *ignudi* of the Sistine Chapel ceiling (plate 3). He designed silver tableware and majolica vases, iron railings and lamp standards, garden ornaments in terracotta, furniture in mahogany. He proposed composite decorative schemes of astounding grandeur for the domes of the British Museum Reading Room and St Paul's Cathedral, schemes that overrode all the long-established boundaries between painting, sculpture, architecture, decoration and design and were doomed,

from the first, to remain unrealised. Stevens's only achievements as a sculptor that, in mid-Victorian terms, could be described as of prime importance, are the great bronze figure groups of *Valour and Cowardice* and *Truth and Falsehood* which flank the monument to the Duke of Wellington in St Paul's Cathedral (plates 4, 5). Even they were conceived, not as isolated, self-sufficient works of high art, but as integral parts of a composite decorative structure.

Perhaps it is not surprising that Stevens has remained an enigma, for the enormity of his ambition, which placed so intolerable a strain upon him, is disclosed by no single work of carving or modelling but reflected only in the sum of all his activity as a designer. By embracing every opportunity for work, however grandiose or humble, that came within his grasp, he sought to demonstrate the equal validity of all creative thought, wherever it might be applied, and to make nonsense of the barriers imposed between 'high' and 'decorative' art. His investigation of form and the decorative possibilities of the heroic human figure, whether in clay or marble, paint or red chalk, whether in the context of architecture, industrial design or the commemorative monument, had one objective: to re-establish sculpture in a dynamic relationship with painting, architecture and the decorative arts, and restore to it the propensity for true expressive power.[3]

In 1876 one of the two supporting figure groups for the Wellington Monument, long accessible to view at Young's foundry in Pimlico, was exhibited posthumously at the Royal Academy. A year later there appeared in the same galleries that life-sized bronze figure which was – and has been ever since – claimed to mark the beginning of a new era in English sculpture. In Frederic Leighton's *Athlete wrestling with a Python* (plate 6) the critic Edmund Gosse saw 'something wholly new, propounded by a painter to the professional sculptors and displaying a juster and a livelier sense of what their art should be than they themselves had ever dreamed of'.[4] It is deeply significant of the prevailing attitude to sculpture in the 1870s that Leighton's dependency on and many obvious allusions to the Wellington Monument figure groups went entirely unremarked. The muscular, glossy nude athlete braced in struggle with a coiling serpent (just as Truth, with infinitely more subtle, understated power, braces her limbs in combat with Falsehood, a serpentine monster with a human torso) was immediately identifiable – as Stevens's groups were not – with the only sculpture-type wholly acceptable to Gosse and his fellow critics as 'high art': the 'Salon' work, the self-sufficient exemplar of the nude in three-dimensional form.

And so it was that the origins of modern English sculpture were identified not in the work of Stevens, but in the contemporary romantic–realist sculpture of France. 'I cannot doubt for a moment', wrote Gosse, 'that what Leighton had seen [at the Paris Salon] in the summer of 1876 had impressed him, and that the character of the Parisian sculpture determined him to attempt to work on similar lines.' The seminal essay that contains those words was published in the *Art Journal* in 1894, under the title 'The New Sculpture'.[5] It introduces the work of a group of young Englishmen who, in Gosse's opinion, had followed Leighton's lead in looking to France for inspiration and whose common, controlling objective was 'a close and reverent observation of nature'. Now without exception, from Hamo Thornycroft's lithe Grecian athletes (plate 140) and Alfred Gilbert's adolescent *Perseus Arming* (plate 129) to Onslow Ford's *Folly* (plate 144) and the Salon-inspired early work of George Frampton and Frederick Pomeroy, the milestones in the critic's history of this new movement are 'exhibition' pieces, ideal nude figures chosen precisely because they conformed to his own traditional concept of sculpture and its proper role. But the most remarkable feature of the essay is the

3

4. Alfred Stevens, *Valour and Cowardice*, 1857–75. Bronze. Wellington Monument, St Paul's Cathedral.

message of gloom that concludes it. 'In looking round the field of sculpture in this country,' Gosse declared, 'one gains the impression that the great movement begun in 1879 has now worked itself into an almost quiescent state.' Within a year he had abandoned his position as the New Sculpture's chief spokesman and promoter and wrote no more upon the subject. Gosse's ideas have shaped posterity's view of mainstream sculpture in England during the last decades of the nineteenth century.

4

5. Alfred Stevens, *Truth and Falsehood*, 1857–75. Bronze. Wellington Monument, St Paul's Cathedral.

The fundamental misinterpretation of its character, which brought about his own early disillusionment, has effectively obscured, for a hundred years, an explosion of activity and invention that was without precedent in this country and which in 1894 was fast gathering momentum.

The ideal figures and groups that began to appear at Royal Academy summer exhibitions after 1880, delighting critics with their unfamiliar freedom of modelling

5

and a freshness of vision often described in the reviews as 'imaginative realism', were not the substance but the symptoms of a revolution extending far beyond the walls of the art establishment and the scope of the Salon nude.

When Alfred Gilbert exhibited his highly acclaimed plaster group *The Enchanted Chair* at the Academy in 1886 (plate 135) he had already begun to explore and develop its complex implications in a colossal monument to Queen Victoria for the city of Winchester (plate 207). This joyful public celebration of the private themes first tentatively presented in the ideal group was to overturn the tradition of memorial sculpture in England, yet the model for it aroused scarcely a comment in the art press when it appeared at the Academy in 1888. In 1894 Gilbert exhibited another sketch model at the Academy, his first design for the Clarence Tomb at Windsor Castle (plates 158–61). No work produced at the end of the nineteenth century defies more arrogantly than this extraordinary monument Gosse's statement, in the same year, that the first concern of the new generation was 'a reverent observation of nature'. The bronze effigy of the Duke of Clarence, unearthly with its ashen face and hands of marble, lies deeply embedded in a thicket of tortured bronze ornament, peopled by tiny, vividly polychromed saints. There was little that the sculptor could have done to further remove the monument from 'nature' as the Victorians understood it. The mingling of intrinsic with extrinsic colour, the organic undulations of the paired bronze angels and stanchions forming the grille round the sarcophagus, the merciless conflicts of scale – between huge monument and tiny chapel, between life-sized reclining figure and miniature mourners – are pure fantasy, the stuff of dreams.

The Clarence Tomb points forward to the turn of the century and the appearance, almost simultaneously, of a group of sculptures that have not yet been surpassed in frightening intensity: *Mors Janua Vitae* by Harry Bates in ivory, bronze and mother-of-pearl (colour plate II), George Frampton's *Lamia* in her opal-studded armour (plate 155, colour plate I), William Reynolds-Stephens's ivory-faced fairy-figures from Arthurian legend (plate 166), Alfred Drury's spellbound *Prophetess* with crystal sphere (plate 171), the jewelled sea-goddess in marble and bronze by Frank Lynn Jenkins that rides the newel of the grand staircase at Lloyd's Registry of Shipping (plate 83). The full psychological implications of such images, sinister in their juxtaposition of sexual, religious and romantic feeling, have yet to be investigated.

Alfred Gilbert, with his apparently inexhaustible vitality as a modeller and as a generator of ideas, played a central part in overthrowing the stylistic conventions of late neo-classicism, but the movement to open out the functional boundaries of sculpture was led by his three contemporaries, Harry Bates, George Frampton and Alfred Drury. The transformation of architectural carving and modelling from anonymous, scarcely noticed craft to dynamic, seductive art was the greatest collective achievement of the New Sculptors and one of the most rational expressions of Arts and Crafts ideals in nineteenth-century history. The terracotta frieze modelled by Bates for the architect Thomas Verity (plates 20–2) was no mere pattern-book decoration but gave new meaning and purpose to the nude in sculpture, just as the exigencies of Collcutt's design for the facades of Lloyd's Registry drew from Frampton his most exquisite interpretations of the decorated figure in stone relief and free-standing bronze (plates 77–82). Similarly, in carving the colossal groups in stone for the War Office in Whitehall (plates 96–9) Drury was able to throw off those tendencies to sentimentality that flaw much of his independent ideal work. The climate created by these three men encouraged sculptors and decorative artists of widely different background and ability to enter into informal partnership with architects. The working relationships between

6. Frederic Leighton, *Athlete wrestling with a Python*, 1877. Bronze, LS. Leighton House.

6

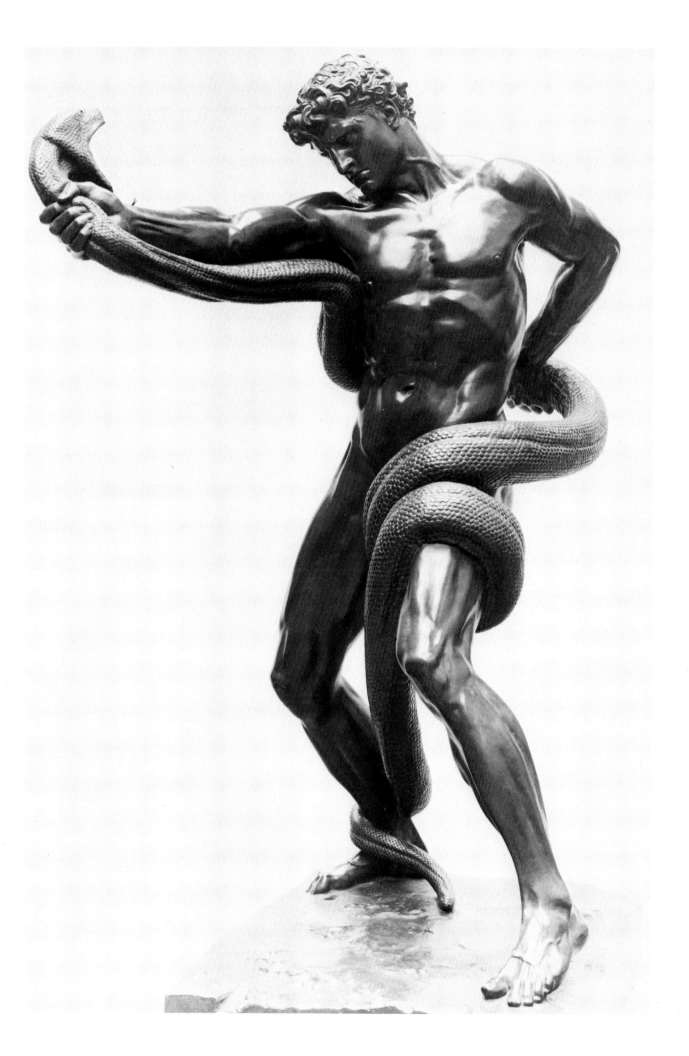

F.W. Pomeroy and the architect E.W. Mountford (plate 105), between Frederick Schenck and H.T. Hare (plate 63), between W.S. Frith and Aston Webb (plate 107), and many others, had a profound effect on late Victorian and Edwardian architectural design, and demonstrated, above all, that the practical application of sculpture to a given setting need not compromise artistic individuality as the late neo-classicists had supposed, but offered a means of richly enhancing it; did not involve some irreversible loss of 'dignity' but vastly increased sculpture's relevance in society.

The idea of contributing art to everyday life, so vigorously promoted by the revival of architectural decoration, took on an almost magical significance between 1890 and 1910. It inspired the design of street furniture and domestic fittings, of jewellery and garden ornaments. It informed the efforts of Thornycroft, Onslow Ford and others to encourage the commercial production of bronze statuettes and so bring ideal sculpture in both scale and cost within the reach of the ordinary homeowner. It gave new vitality to commemorative statuary, recognised at last as no dry, formal task but as an irresistible opportunity for sculptural theatre and the exposure of private symbolism to public view.

Behind every aspect of the New Sculpture movement, from its profound *ésprit-de-corps* to the individual achievements of its leading figures, lies the shared objective that was its true controlling force, no obedient following of nature but the most turbulent redefinition of sculpture's role ever to take place in Britain. Whether reaching out into the community as decorators in the service of architecture and industry, or challenging the old, elitist concept of high art in their enthusiasm for the mass-produced, marketable art-object, or investigating, in low relief carving and modelling and the use of colour, sculpture's affinity with painting, the New Sculptors advanced together upon ground prepared for them by Alfred Stevens. In their passion to express, through the solid, material medium of stone or clay, the intangible, secret forces of human imagination, they justified his agonised struggle for self-determination and the cause of art without boundaries.

2. *The Liberation of the Clay-Modelling Class*

SOUTH KENSINGTON

IN 1837 a new and democratic system of art education had been introduced in England, a system in which Stevens himself taught for a brief period during the 1840s and over which he later, almost by accident, came to exert a profound and enduring influence. In that year, as a result of the findings of a Government Committee on Arts and Manufactures, the first Government School of Design was opened in rooms at Somerset House. The principal function of this and the many branch schools set up in London and the provinces during the following decades was to train students, usually aged twelve and upwards, for work in industry – that is, to supply the country not with 'artists' in the commonly accepted sense, but with designers competent to meet the massive and relentlessly increasing demands of its fabric and furniture manufacturers, its stone and pottery trades, its iron and steel industries. The early history of the schools of design was fraught with controversy.[1] Committee after committee wrangled over the essentially negative premise on which the first schools were conceived: that the teaching appropriate for an industrial designer should be non-academic and should exclude all study of the human figure and the antique. Not surprisingly, this official view was challenged from the beginning by the artists employed to teach at Somerset House – men such as Stevens and C.H. Wilson who could not conceive of 'design' as wholly separate from 'art' and fervently believed life drawing to be the basis of both. In the process of evolving a compromise between these conflicting views, the schools attracted fierce criticism. The *Art Journal* angrily protested that already in 1849 'the two fundamental principles for which they were founded, viz. *the Teaching of Design and its application to manufacture* have been wholly lost sight of'.[2] It is doubtful whether the Government schools ever became precisely the kind of forcing-ground for industrial designers that had been first envisaged, but their quite remarkable success in establishing a higher status for applied design and decoration and a broader understanding of the term 'art' in the public consciousness is unquestionable. 'If they did not teach Design', wrote James Cond in the magazine of Birmingham School of Art in 1885, 'they helped to make drawing popular and brought tuition within reach of the masses.'[3]

The infancy of the scheme to provide a new system of art training ended with the creation of the Department of Practical Art in 1852. Its very title significant of a changing approach to the problem of 'design' education, the new department was among the reforms proposed by Henry Cole, whose discussions with Prince Albert

early in the same year led to the foundation of a 'Museum of Manufactures' and to the purchase of a plot of ground at South Kensington to accommodate both museum and reformed training school. The department was renamed the Department of Science and Art in 1853 and remained under Cole's administration until 1872. In 1857 the head school and new museum, both by then in cramped accommodation in Marlborough House, were moved to the South Kensington site. The National Art Training School (now the Royal College of Art) and the South Kensington (now Victoria and Albert) Museum had become a reality.

When Cole was asked in 1864 what were the leading principles of his department, he replied: 'To improve the taste and art-knowledge of all classes of the community, having especial reference to the influence of that taste and knowledge upon the manufacturers of this country.'[4] It would be difficult to exaggerate the degree of self-consciousness and sense of inferiority with which Britain set out to achieve this aim. French taste and French art were, from the first, assumed to represent an awesome standard by which our own achievements were judged, and invariably judged wanting, a hypothesis that continues to this day to hinder the proper assessment of nineteenth-century art – and particularly sculpture – in Britain. French training was firmly based on the *atelier* system. Large groups of students would prepare for admission to the École des Beaux-Arts while working in the studio of an established artist, usually himself a member of the Academy, their education organised on the assumption that 'high art' and Government commissions were its only valid and truly desirable goal. As Alphonse Legros remarked with characteristic arrogance when criticising the British system in which he held a comfortable niche for most of his life, there was no such thing as a training for designers in France. 'All men', he said, 'study to become generals, not to become corporals': designers were merely failed artists.[5] Curiously enough, it was in France that the South Kensington system was first recognised as a powerful force. A report on secondary education in Britain addressed to the French Minister of Public Instruction after the International Exhibition of 1862 stated that the Department of Science and Art 'has sown with a liberal hand the seeds of artistic instruction among the working population and has alarmed France in her possession, up to the present time, of taste and delicacy of feeling in industrial art'. The French jurors appear to have felt positively threatened by the quality of British exhibits:

> If our superiority in point of style remained undisputed, if no rivalry arose to disquiet our supremacy, we might remain such as we now are and slumber in the triumph which we might flatter ourselves we should enjoy for ever; but . . . rivals are springing up, and the pre-eminence of France in the domain of taste may ere long receive a shock, if we do not take care . . . While we are stationary others are raising themselves; the upward movement is visible, above all, among the English. The whole world has been struck with the progress which they have made since the last exhibition [1851] in designs for stuffs and in the distribution of colours, as also in carving and in sculpture.[6]

The presence of the museum as part of the training establishment at South Kensington was, they felt, particularly to be commended. Twenty years later, giving evidence before the Royal Commission on Technical Instruction, John Sparkes, Principal of the National Art Training School, boldly expressed confidence that 'the natural capacity of the English [for decorative art] is beyond that of any other country'. How, then, he was asked, 'do you account for the prevailing opinion that continental nations are much in advance of us as regards art and especially design?' 'I would say', he replied,

'that that opinion prevails only in England. French Commissioners come here to see how we do things and the Germans say to me, "Why do you come to Germany for instruction? We ought rather to go to England."'[7]

The curriculum of the National Art Training School and the branch schools that submitted their students' work each year in the National Art Competitions was designed to teach basic drawing technique, with no special emphasis on study from the human figure or from the antique casts that constantly preoccupied pupils in the Royal Academy Schools. A school's success, stated Richard Redgrave, the Department's Superintendent of Art, in 1852, must be measured by the evidence in its pupils' work of 'a careful and thorough grounding, firstly, in geometrical perspective and free-hand drawing and in the careful and well-understood study of light and shadow and good executive methods of shading and modelling; and, secondly, in the earnest and severe study of nature, as of flowers or foliage, as the source of new thoughts and graceful combinations, to which it is requisite to add a knowledge of the laws which regulate the harmonious distribution of colour'.[8] The list of classes under which students were invited to submit their work in competition conveys something of the painstaking nature of a course that was intended to take up to six years yet was frequently abandoned after two: geometrical perspective, ornament outlined from the flat, ornament outlined from the round, ornament shaded from the flat, ornament shaded from the round, figure outlined from the flat, figure outlined from the round, anatomical drawings, flowers drawn from nature, ornament painted in monochrome, from casts, ornament painted in colour, flowers and fruit painted from the flat, flowers and fruit painted from nature, the figure painted from casts, ornament modelled, the figure modelled, elementary design, applied design, executed designs in fabrics, and a final category entitled 'miscellaneous'. The chief failing of this programme as it was put into practice before 1875 was the insistence upon high finish in every drawing, however elementary. There was some truth in Legros's scathing comments to the Royal Commission on Technical Instruction in 1882, that

> In English schools . . . the students are set to work to copy an apple, or a sphere, or a cone, on which they spend a year; a second year is spent in copying a bad torso; and thus the student reaches thirty years of age and knows nothing . . . The students who have spent their time in that way . . . have no head for rapid work, spending, as they do, six weeks or a month in shading up a sphere; they get no ideas into their brains. What is wanted is to fill the mind with the appreciation of form, and this the English system does not give.[9]

But the students who moved to temporary accommodation in iron sheds at South Kensington in 1857 had two unique advantages: proximity to the museum's collection of Italian Renaissance sculptures, casts and specimens of contemporary industrial art, and the opportunity to watch and often to participate in the decoration of the buildings that were to house school and museum permanently.

That Stevens left his mark indelibly on South Kensington is due chiefly to the persistence of Henry Cole, for only once did the great sculptor-designer accept a formal role in the Government's art education system. In 1845 Stevens had taught architecture, perspective and modelling at the School of Design in Somerset House. Brief and uneasy though this appointment was, it brought him contacts which led, in 1850, to his employment as chief designer to Hoole, the ironfounder of Sheffield. There he rapidly became the idol of a group of students at the local School of Design. The stoves and grates he designed for Hoole (plate 3) brought the firm much acclaim at the

exhibitions of 1851 and 1862 and several were bought for the museum. It is apparent that Cole made a sustained effort to involve Stevens in the Department's activities. Richard Lunn, an early pupil at the National School, stated that 'after the School was moved to South Kensington Stevens was asked to be a visitor, but declined'.[10] Nor did he respond when asked, in 1862, to execute sculpture for the arcades in the Horticultural Society's Gardens, a part of the South Kensington complex. Meanwhile Cole had already turned to the best available alternative: in 1859 Godfrey Sykes, the most gifted of Stevens's Sheffield followers, was commissioned to superintend the decorations of the gardens and the new museum buildings. He remained at South Kensington until his death in 1866, extending the chain of Stevens's influence through his own upon the assistants who worked there with him and succeeded him – most notably James Gamble and Reuben Townroe, also from Sheffield, and F.W. Moody. Richard Lunn recalled how it had been part of Henry Cole's intention that National Scholars and other students at the school should help with the decorations and how all the modelling for the western staircase of the museum, designed by Moody, was 'produced under his direction in the old Modelling Room . . . by his three assistants, Albert Gibbons, Edward Wormleighton and myself'. He remembered too that Stevens took a quiet interest in the progress of the work after Sykes's death. 'He came to the studio after the Assistants had left for the day and having stayed later than usual, I have opened the door to him, on more than one occasion.'

That Stevens and his pupils remained the dominating influence in the National Art Training School for the first two decades of its existence was also partly due to the absence, at that period, of any outstanding personalities on the teaching staff. A convincing impression of the place is given by George Clausen, a National Scholar in 1871, at the end of the long headmastership of Richard Burchett. 'There was but little active direction in the School when I was there', he recalled. 'Mr Burchett was a good deal of an invalid and unfortunately we saw but little of him, for his teaching was good.' The other teachers, including F.M. Miller, the instructor in clay modelling, he described as

good, easy men, more than a little tired as teachers are apt to be with long continuance [who] let us go very much our own ways and we muddled through with such help and stimulus as we could give each other . . . The Museum was our best teacher. The Italian court with the fine sculptures and terracottas we got to know very well . . . Contemporary sculpture was non-existent as far as our knowledge and interest went, except for the work and influence of Stevens, whose tradition was being carried on in the decoration of the Museum. But I doubt whether our modelling master ever looked on Stevens as a 'proper sculptor'. His ideal was Foley, and I am told he even went so far as to point out to a student how Foley, if he had carved the 'Theseus', would have improved it by making its proportions more graceful![11]

Of all the staff, Clausen remembered most clearly F.W. Moody, then resident decorative artist and formally appointed Instructor in Decorative Art in 1874. Moody's lectures were laced with hatred for the current obsession with 'stippling' – the application of tiny dots on a drawing to produce an effect of shading – and for the pedantry that beset teaching in the life class. The drawings of Mulready, held then to be perfect examples of the life-study and copied constantly in art schools, he dismissed as 'laborious imitation of the facts' and told his students to look at those of Michelangelo where they would find the human figure, not slavishly copied, but

transformed by intellect and knowledge into 'a vigorous cypher'.[12] It was Moody who most encouraged study in the museum where, in the Italian Renaissance sculpture collection, the sources of Stevens's decorative style were to be found. 'I don't think any of us', wrote Clausen,

> drew much in the Museum except Mr Moody's students who were set to work there systematically; . . . he was an exception to the other masters in that he had a definite point of view and method of teaching. He worked in the manner of Alfred Stevens, and had reduced everything to a system, with methods of drawing heads, arms, fingers, etc.; he was an excellent teacher of his own style. I remember that once, in a lecture, he gave us a piece of advice which I think now (though I'm afraid we didn't understand it then) is one of the weightiest things to bear in mind. Talking of the beauty of plain spaces, he said, 'What you young men have got to learn, is *to keep your fingers off!*'[13]

Moody's interest in sculpture and his insistence on the need for simplicity and breadth of execution foreshadowed a new era of teaching at South Kensington.

In August 1875 Richard Redgrave resigned as Director of the Art Division and was succeeded by E.J. Poynter. The National Art Training School's new Principal was thirty-nine years old when he took up his appointment and on the point of election to full membership of the Royal Academy. Apart from – or perhaps more accurately in spite of – his growing prestige as a painter of the grand classical pictures beloved by the Victorian public, Poynter brought to South Kensington a fresh and open-minded approach to style and education that was to have far-reaching consequences for the school. Like Stevens and also Frederic Leighton whom he met in Rome at the age of seventeen, he had confronted, on the spot in Italy, the painting and sculpture of Michelangelo and found there a synthesis of realism and the ideal more passionate and complete than any achieved by the ancient Greeks. However confused attitudes to realism continued to be, it was apparent by the 1870s that the attempts of the late neo-classicists to graft 'expression' onto their impassive ideal figures were little more than derisible. Poynter's comment in 1869 on recent German and English painting seems equally pertinent to Foley's *Caractacus* of 1856 (plate 2): 'Everyone . . . knows well the scowl and the clenched fist which does duty for the tragic passions of their heroes; most of the efforts at high art which have been made in this country till within the last few years have included this scowl as the kind of stamp which marks a work of style, or what is called historical art, as distinguished from a "genre" picture.'[14] Like Moody, Poynter became convinced that the root of the problem of expression in art lay in life drawing and the method by which it was taught. He had received his own early training in the Royal Academy Schools where it was not uncommon for a student to spend several years copying casts in the Antique School before progressing to the life class. Here, again, many months might be passed in the minute elaboration of a single drawing. In 1856 he had been to Paris to work in the studio of Charles Gleyre, who prepared students for entry to the École des Beaux-Arts, and had the opportunity to observe the two major advantages of the *atelier* system: firstly the early involvement of students in drawing from the life figure, and secondly the insistence on a time limit for the completion of the drawings. 'There is', he explained, 'no division of classes.'

> The students of eight or ten years' standing work in the same room and from the same model as the newcomer; if he has never had any instruction, he is set at first to make a few drawings from casts, to give him some idea of the use of his pencil, after which he begins at once his studies from the living model. Here he works daily, the

model sitting for four hours a day for one week, so that he has no time to linger and loiter over the detailed execution of his work – his time must be employed to the best of his ability. The master attends twice a week, once on a Tuesday when the figure is sketched in, and again on the Saturday, when it is nearly finished, and that is amply sufficient for his instruction.[15]

When in 1871 the Slade School was opened as part of University College, London, and Poynter became the first Slade Professor of Fine Art, he had lost no time in putting his ideas into practice. 'In the Slade Schools', state the first calendars, 'the study of the living model is considered of the first and paramount importance, the study of the antique being put in the second place and used from time to time as a means of improving the style of the students.' On his appointment to South Kensington in 1875 Poynter was succeeded as Slade Professor by the etcher Alphonse Legros whom he had known in Paris and whom Whistler had brought to London in 1863. Poynter had been in office for barely two months when, in November 1875, he persuaded his friend to set up an etching class in the National Art Training School and to attend in person as master once a fortnight.[16] Legros's grave and austere drawing style reflected the discipline of working from memory that he had learned from Lecoq de Boisbaudran. He had an intense interest in sculpture and the work of Alfred Stevens in particular and began to produce sculpture himself in the early 1880s. With views on the teaching of drawing and the importance of the life-study that coincided with Poynter's own, he was to prove a powerful ally at the school. Giving evidence before the Royal Commission of 1882, he expressed his approval for Poynter's attempt to discourage stippling in favour of the much more rapid and spontaneous technique of stumping – shading by blending lines with a 'stump' of soft leather or indiarubber.[17]

Legros's most important contribution to South Kensington, however, was his introduction of the French sculptor Aimé-Jules Dalou to give demonstrations in clay modelling. Dalou too had been a pupil of Lecoq at the Petite École and had learnt modelling there under Carpeaux. Arriving in England as a refugee in 1871, he settled temporarily with Legros and began work on a series of small terracotta sculptures based on the genre theme of *La Brodeuse*, his Salon exhibit of that year. Dalou's subject matter in England was dominated by the theme of peasant women seated with their babies: the most fully developed version of it is the group *Charity*, near the Royal Exchange in the City, a bronze version of the original marble erected there in 1879 (plate 7). The gentle realism of his statuettes and portrait sculpture, inspired by Courbet but sweetened by a lyrical elegance of line, was, to Dalou's delight, well received in London and he became a frequent exhibitor at the Royal Academy. Maurice Dreyfous, his biographer, records that Legros, realising his friend's need for a more secure income than small commissions provided, suggested that he should give modelling demonstrations. 'If I, who have never learned English, can teach drawing at the "Sled-School", why couldn't Dalou, who can't be worse than I at English, teach sculpture in another great school . . . at South Kensington, for example?' According to Dreyfous, Dalou's first demonstrations were given at the Slade (though no evidence has yet been found to support this) and their instant success prompted Poynter to remark to Legros that if similar lessons could be given at the National Art Training School, the teaching of sculpture in England would greatly benefit.[18] Accordingly, on 11 May 1877 the Department of Science and Art 'approved the employment of Monsieur Dalou as teacher of modelling' and it was confirmed a few days later that he should receive £7 10s. for one attendance a week, or £300 a year.[19] There was some embarrassment over

7. Jules Dalou, *Charity* (1877). Marble, 36 in. Tate Gallery.

14

his status at the school: the present modelling master F.M. Miller could not be sacked and replaced by a stranger without serious cause, but Dalou was happy to forgo an official title and to act simply as Miller's supplementary teacher. His demonstration lessons, Dreyfous records, were like pantomime, with much gesturing and interjections of 'You do *so!*' No detailed description of them has come to light, but it is clear that what most excited Dalou's students was the speed and vitality of his working method. His passionate involvement in the physical process of modelling and the building-up of sculptural forms and planes from the very heart of the clay taught them more about the nature of sculpture than they had ever learned in Miller's classes, dabbing at their clay with damp cloths in the search for surface effects.[20] 'What he did for this School', wrote Edward Lanteri,

> is well-known to all artists. He gave an extraordinary impetus to sculpture during the two years he was here. By his sound method, his marvellous technique and his lucid demonstrations he completely carried his students away with him. He knew how to inspire them with the desire to work as well as the love of work, and succeeded in awaking an extraordinary enthusiasm where all before seemed dormant. It is no wonder that he gained the admiration of his students – an admiration which extended to sculptors at large, and many, as I have reason to know, are those who acknowledge their indebtedness to him.[21]

Among the 'many' was Lanteri himself, who had been Dalou's pupil in France. He came to England in 1872 and, on his master's recommendation, entered the studio of Edgar Boehm as an assistant, where he first met Alfred Gilbert. Early in 1880 he was appointed, again on Dalou's recommendation, to succeed him at South Kensington where he perpetuated Dalou's ideals and working methods and became the most renowned teacher of sculpture of his time.

THE ROLE OF J.C.L. SPARKES

Between the appointment of Legros in November 1875 and Dalou in May 1877 Poynter brought about another coup for South Kensington that was to confirm its growing reputation as a lively and progressive school. In December 1875 he recommended that the headmastership, vacant since the death that year of Richard Burchett, should be offered to the present head of Lambeth School of Art, J.C.L. Sparkes.[22] A highly articulate and capable administrator, John Charles Lewis Sparkes was himself a product of the National Art Training School where, having attended the Royal Academy Schools, he trained as an art teacher between 1855 and 1859. At that period Lambeth was used as a practice ground for pupil teachers from South Kensington and from 1857 Sparkes divided his time between the two schools, receiving his official appointment as Headmaster at Lambeth in 1859 at the age of twenty-six.

Lambeth School was established in 1854 by the Reverend Robert Gregory (later Dean of St Paul's Cathedral) as an evening class in the rooms occupied during the day by the National Schools in his parish of St Mary the Less. Gregory recalled in his autobiography how, on his arrival as incumbent in 1853, he observed in the parish and its neighbourhood, 'a considerable number of young mechanics, many of them employed in Maudsley's steam-engine factory, to whom it would prove a great advantage to be able to draw sufficiently to set out their own work'. Determined to take advantage of the Department of Science and Art's offer of aid to schools providing

tuition in drawing, he went to see Henry Cole who gave his approval and agreed to supply teachers. 'The first two masters', Gregory wrote, 'were only moderately successful; but after a time Mr Sparkes was placed in charge . . . and under him it rapidly grew and flourished.'[23] The expansion created a new problem of overcrowding. In 1859 a site was acquired in the present St Oswald's Place adjoining St Peter's Church in Kennington Lane and the architect J.L. Pearson was commissioned to prepare designs for new buildings. The extent to which Gregory harassed the Department in his impatience to realise his Ruskinian dream is revealed in an irritable letter he received from Cole in May 1860. 'One would think from your notes', it began, 'that the Lambeth School was more my affair than the 80 other schools in the United Kingdom, and if each one of them were to call upon me for the kind of private and unofficial assistance which Lambeth does, my work would soon come to a standstill.'[24] The foundation stone was laid during the following month by the Prince of Wales, the ceremony preceded by a formidable speech from Gregory on the school's role in the 'moral and intellectual elevation of the poorer classes'. A local newspaper reporter commented on the visible embarrassment of the Prince, in performing one of his first public duties, to find himself listening 'to an address which, by its length, was well adapted to give everyone an opportunity of scanning his features'.[25]

Meanwhile Sparkes had recognised that the chief potential strength of Gregory's art school lay in its proximity to Doulton's Lambeth pottery works and he determined to persuade the manufacturer 'to recommence ornamental earthenware productions, for which Lambeth had once been famous, in order to find employment for students in the school'.[26] As he told the Royal Commission on Technical Instruction in 1882, his first attempts to do so were unsuccessful:

A few months after I went to Lambeth in 1857, I had one student from the potteries and I asked him to do some trials for me; I went to his master, but he was averse to doing anything. I then asked this man to give me clay and make certain trials for me in the kiln . . . I saw that there were capabilities in the material, but it was not for some years after that I was introduced to Mr Doulton and it was only in 1869 that we [Sparkes and Doulton, who was elected onto the school committee in 1868] made some serious trials to get the clay decorated.

More trials followed and work was prepared for the International Exhibition in 1870. 'The result was that a great deal of attention was attracted by this attempt to decorate stoneware. Mr Doulton was encouraged to take up the whole question, and from that time he provided rooms, and a manager, and all that was necessary to carry on the manufacture on a trade basis.'[27] Doulton's agreement to give factory apprentices a pay rise for every exam they passed at the school is a reflection of the closely co-operative spirit that Sparkes created between the two establishments. Sparkes's early interest in pottery developed into a deep concern for the art of clay modelling in general. He came to believe that its proper teaching was of crucial importance in raising standards of industrial design and when he set about the improvement and expansion of Lambeth's classes in life drawing, modelling and design it was sculpture's interests that he had chiefly in mind. The influence of his ideas is clearly reflected in the conclusions reached by the Commissioners on Technical Instruction in 1884. 'We are of the opinion', they reported, 'that more attention than has hitherto been devoted to it should be directed to the subject of modelling in the elementary schools . . . Modelling is an exercise of great importance to the future workman and its rudiments can well be taken up . . . at the earliest age.'[28]

Nothing is known of the modelling master who worked at Lambeth before 1863 except that in April of that year Sparkes reported to his committee, 'it is essential to the interests of the modelling class that the present master be removed and that Mr Ball be appointed in his place'.[29] Percival Ball, then aged nineteen, was about to enter the Royal Academy Schools, where he won the gold medal for sculpture in 1865. Before he left for Australia in 1886, Ball was to establish a sound reputation among informed critics for work which reflects the influence of his master Henry Weekes's homely neo-classicism. He was by no means an innovator, but his introduction to Lambeth as a pupil-teacher was a significant step in Sparkes's plan to raise the status of the modelling class. It followed closely on the arrival there of the student George Tinworth, destined to become Doulton's best-known terracotta modeller.

When Sparkes took up his new post at the National Art Training School in February 1876 he would have been well aware of the prevailing low standard of modelling both there and in Britain generally, for the National Art Competitions that Henry Cole had instituted in 1857 were providing a much-publicised barometer of achievement in all branches of government-sponsored art education. Between 1868 and 1877 more than half the medals awarded in the class of modelling went to four pupils from his own Lambeth school: Edwin Roscoe Mullins, George Tinworth, William Silver Frith and Mark Rogers. Only one sculpture student from South Kensington, Henrietta Montalba, emerged with credit during that period. Of schools outside London, Edinburgh alone had been represented in the prize lists, by Frederick Schenck in 1872.[30] By 1876 the board of examiners, on which Boehm had that year replaced Henry Weekes as sculptor member, humiliatingly pronounced 'the modelling exhibited . . . so inferior that it was impossible to find any work deserving of the gold medal, and the silver (and bronze) medals were awarded rather as an encouragement than on account of the merit of the works'. They went on to deplore the lack of 'that workmanlike power over the material which is so noticeable in all French productions of this class' and warned: 'As long as this continues a large proportion of the decorative figure or ornament design in relief made for the English market will be in the hands of foreign artists.'[31]

Among Sparkes's first duties as Headmaster were exploratory visits, in the summer of 1876 and the winter term of 1877, to the art schools of Belgium and Germany. He returned to emphasise the generous and well-lit accommodation provided for students on the Continent, the imposition of a time limit on all work, whether in class or in competition, and the lively interest taken in architectural sculpture. In the school for artisans at St Josse ten Noode, Brussels, he reported, 'the modelling school was very good, and had a peculiarity, viz, that of teaching a carver to model from the latest piece of architectural carving of any excellence that has been done in the town'. Likewise in Berlin, where he remarked on the alliance, in emulation of South Kensington, of art school and Gewerbemuseum,

> the modelling section is excellent and has a large and beautiful influence on the arts of the town. Berlin, like London, is a town of brick construction, the bricks either covered with stucco or relieved with stone carving or decorated with terracotta. The excellence of the ornamental designs is remarkable all over the town and its suburbs . . . The character of fitness is found everywhere in these applications of the decorating materials, and gives evidence of sound principles in teaching. These principles are first no doubt given to the architects who design the buildings, but a considerable amount of the credit is due to the modellers and carvers who carry out the architect's design.[32]

Sparkes had one major criticism of German schools: the control exerted over students was so rigid that they tended to 'lose their individuality which is secured by our more independent system, and are more prone to fall into the lines doctrinaires may prescribe for them'.

Sparkes's return to South Kensington coincided, almost to the week, with Dalou's first appearance there. The response that the sculptor evoked in the modelling class must have confirmed Sparkes's view that the English system, however uninspired, remained receptive and adaptable to change. Dalou's impact as a teacher was vividly described by A.L. Baldry, a pupil at South Kensington in 1878–9, whose firsthand experience of those years was crucial to the understanding that he later brought to his work as a critic of contemporary English sculpture. 'What was the effect', Baldry wrote,

> of the intervention of a man of his vigorous personality and splendid powers in the rather conventional routine of English art teaching can well be imagined. He awoke in his pupils an amount of enthusiasm and a degree of keen interest in their work far beyond anything that the adherents to the older methods were capable of exciting. There was not only a stimulating novelty in his manner of presenting the dry technical facts of the sculptor's craft, but there was, as well, in his belief in the mission and purpose of sculpture, a firmness of conviction that was eminently satisfying to youthful aspirants who were seeking the right direction for the future expression of their own ideas. They found themselves, for once, in the closest association with a master mind, in contact with an individuality which was unlike any to which they had hitherto been accustomed; and they were taught to see the traditions of their art in a new light . . . Dalou's training did not produce merely a school of copyists, nor did it lead to unintelligent repetition of certain processes of execution which he prescribed. He sought rather to induce each of his pupils to think out the problems of his art with real independence, and to realise how the vital principles which underlie all memorable accomplishment could best be applied.[33]

The tradition established by Dalou at South Kensington and carried forward into the twentieth century by his pupil and successor Lanteri was to find its most faithful expression in the work of Alfred Drury. Drury had been a pupil at Oxford School of Art and was twenty-one when he entered the National Art Training School, shortly before Dalou, to study under F.W. Moody.[34] In 1878 he won a bronze medal for a figure modelled from life and in 1879, having gained a gold and a silver medal in the class of modelling, he was awarded a National Scholarship.[35] His success in the competitions continued to be spectacular. He won the gold medal again in 1880 and for the third consecutive year in 1881, when he also won a silver medal for his modelling work. By the time he left the school in the summer of 1881 Dalou had returned to France. Drury went to join him in Paris, remaining as his assistant for four years and participating in the progress of his great political sculpture *The Triumph of the Republic* (plate 87) and the *Mirabeau* relief. 'It is alike striking and curious', Drury wrote later of this period in Paris with Dalou, 'to remark the difference of style that distinguishes his work executed in France, from that produced in England.' Though reverent of his master's politically motivated rhetorical sculpture, Drury's deepest response was to the 'exquisite' statuettes of genre subjects that Dalou had produced in London, and he marvelled that the sculptor 'did not take the same pleasure in these smaller works and only considered them of secondary importance'.[36] He had been given charge of some dozen of them when Dalou left London; the influence of Alfred Stevens and Jules Dalou, those two mainsprings of sculpture teaching at South Kensington, remained crucial to Drury for the rest of his life.

Few authorities on art education in London were better placed than John Sparkes to know that South Kensington and Lambeth each had a unique advantage: the first its modelling instructor, Dalou, and the second its industrial location. It was in 1879–80 that he saw and seized the opportunity to combine those advantages in sculpture's cause. A sequence of events took place at the National Art Training School between 1879 and 1882 that cannot be described in isolation, so closely was it linked, through the activities of Sparkes, with the fortunes of the Lambeth School of Art.

In 1876 a meeting of the representatives of livery companies in the City of London had passed a resolution that 'the attention of the . . . Companies be directed to the promotion of Education, not only in the Metropolis but throughout the country, and especially to technical education, with the view of educating young artizans and others in the scientific and artistic branches of their trades'. The outcome of the meeting was the inauguration three years later of the City and Guilds of London Institute for the Advancement of Technical Education, pledged to fulfil their role by 'encouraging the establishment of local schools for artizans and workmen and by co-operating with and otherwise assisting local effort, more especially . . . within the Metropolis'.[37] Sparkes's achievement in the field of art education and in particular his proven ability to gain the co-operation of a local manufacturer made him the Institute's first object of attention when in 1879 its committee members were investigating how best to implement their proposals.

Despite his efforts and ambition Lambeth remained primarily a school for the teaching of those basic drawing skills by which it qualified for grants from the Department of Science and Art. These grants were made on a system of 'payments by results', the disadvantages of which, as Sparkes told the 1882 Commission, had been summed up in Sir Stafford Northcote's description of it as 'payment by results provided they were not too good'. Thus the relatively advanced and more expensive training in life drawing, modelling and design that Sparkes had established at Lambeth was continuing to attract a rate of subsidy no higher than the most elementary classes. 'That has made it possible', he remarked pointedly, 'that a man may work a district with enormous pecuniary success and yet produce nothing for his neighbourhood but a mass of second grade results.'[38] The precarious middle course that government-sponsored art education tried to steer between the teaching of 'Fine Art' (the province of the Royal Academy) and the teaching of trade skills (the responsibility of manufacturers) was an inheritance from the controversy that had plagued the earliest schools of design, and Sparkes knew that Lambeth could progress no further if it remained tied to the Department. Nor, in their turn, were manufacturers much interested in encouraging their apprentices to embark on the tedious stages of instruction in outline drawing, copying, shading and painting from casts that did meet the Department's requirements. As Godfrey Wedgwood commented disparagingly before the 1882 Commission: 'As a rule Schools of Design turn out slow draughtsmen.'[39]

An offer was made to Sparkes in 1879 which opened, at last, the way for development. 'Sir F. Bramwell, Sir H. Doulton and Sir Owen Roberts [Secretary of the City and Guilds of London Institute] asked me', he recalled,

if I thought a subsidy of some hundreds a year could be usefully added to the Lambeth School of Art. It seemed to me a most valuable thing, and I was glad to find an opportunity of extending the local School of Art and to get an intermediate step between the art school – which is not looked up to by the manufacturers – and the trades of the place. The ideal technical school seemed to me to be the natural

outgrowth of a school of art, and I handed over to them [the Institute] the designing, modelling and the life class, which had at that time met at the school of art at Lambeth as they were to a certain extent forming themselves on our starved classes of the Lambeth school, and they gave me the opportunity of seeing to their development. The manufacturers came without hesitation to the technical school who would not go near an art school. The head carvers of the district come to the men and lecture on their work and in fact it has been, as I hoped it would be, a proper and much wanted development of the art school.[40]

As Sparkes himself admitted, the removal of the life, design and modelling classes together with their pupils, including the two prize medallists Mark Rogers and W.S. Frith, left Lambeth School much the poorer.[41] (It survived until 1916 when it was amalgamated with the London County Council's new Westminster Technical Institute in Vincent Square.) The new establishment, in premises acquired by the Institute at 122–124 Kennington Park Road, rapidly took on a separate and thriving identity as the South London Technical Art School (still, however, commonly known as 'Lambeth' for many years to come) over which John Sparkes eagerly presided. He must have felt a certain piratical glee when, early in 1880 and almost certainly as a result of his persuasion, Jules Dalou undertook to teach the modelling class at Kennington Park Road.

In August 1881 the Governors of the City and Guilds Institute formally resolved to appoint Sparkes Superintendent of their new school.[42] In September Edward Poynter resigned as Director for Art and Principal of the National Art Training School and it was decided to rearrange the hierarchy at South Kensington. The two offices that Poynter had held were separated: Thomas Armstrong, his friend and former fellow-student at Gleyre's Paris studio, was appointed Director for Art and Sparkes was made Principal, combining within that role the duties of Headmaster. The Treasury, in confirming the changes, noted ominously that the new Principal 'will be required to give his whole time to the Department'.[43] This extraordinarily rapid accumulation of office marked the climax of Sparkes's career. His acceptance of both major posts – at South Kensington and the Technical School – while retaining some control over Lambeth School as committee treasurer, left his loyalties widely divided and the Department more than a little uneasy. It may be argued, however, that the pattern of development in English sculpture after 1880 owed much to his ubiquitous presence. Just as he had ensured the spread of Dalou's influence beyond South Kensington, so he contrived to obtain, simultaneously at both his schools, the services of a new visiting teacher of ornament and design. Hugh Stannus began work at Kennington Park Road and South Kensington in January and February respectively, 1882. His importance as a teacher lay in his single-minded devotion to Alfred Stevens and obsessive concern with the perpetuation of his memory and manner of design. At South Kensington he replaced F.W. Moody, in failing health and on the point of retirement, as a link in the long chain of Stevens's influence there. At Lambeth he was able to supplement with practical demonstration the general renewal of interest in the sculptor's work which the first biography, by Walter Armstrong, had stimulated in 1880. Stannus had already begun to collect material for his own biography, *Alfred Stevens and his Work*, which appeared in 1891.

In 1888 a committee was set up to inquire into the condition of the National Art Training School and to establish why the numbers of students had dropped off significantly since 1880. Among a mass of largely inconclusive evidence one point emerged that, in the committee's opinion, had a direct bearing on the school's decline:

John Sparkes's extra-mural commitments. 'His whole time is due to the Department', the report observed, 'and in relation to this . . . we would call attention to his evidence from which it appears that he holds the office of Superintendent of Studies at the South London School of Technical Art which must have some effect in reducing his attendance and influence in this School, which evidently suffers from his pre-occupation elsewhere.' In his evidence, Sparkes had had the grace to admit that the Technical School was now a rival to South Kensington. 'It is', he said, 'the glamour of a certain kind of teaching which attracts the students from here. In some cases the adoption of the French method had been an attraction.' His frequent absences were, the committee agreed, more deeply felt because '[as] an examination shows . . . with the exception of the Headmaster and M. Lanteri, the teacher of modelling, none of the permanent staff can be considered of the highest class'.[44] Their comment was pertinent, for the decline in the school's fortunes in general had not been reflected in the modelling class. In his first annual report as Principal, Sparkes had made his priorities plain when protesting over the uncomfortable and overcrowded buildings in which the school continued to be housed. 'This overcrowding of students', he wrote, 'is especially felt in the Modelling School, a section where the greatest amount of good to the future industries of this country may be expected and one I am particularly anxious to strengthen.'[45] He had found an ally in the new Director, Thomas Armstrong, whose paper 'The Condition of the Applied Arts in England . . .', delivered to the Society of Arts in 1887, clearly reveals a special sympathy for sculpture and who, as his biographer L.M. Lamont records, used the system of 'payment on results' to stimulate a more general acceptance of modelling in art schools. 'The enormous influence which the modelling department of the National Art Training School has had in the development of sculpture in its higher and all its subsidiary branches', wrote Lamont in 1914, 'is one of the most striking facts relating to art education in recent times and it had throughout the period of his directorship Armstrong's personal and official support and help.'[46]

The National Art Competitions continued, meanwhile, to provide yearly evidence of the success of Lanteri's teaching. The examiners reported in 1879: 'The modelling of the figure is still at a low standard in most of the schools. A gold medal was awarded for a study of the figure from the life from the National Art Training School [by Alfred Drury] and another for a head from the life, also from . . . South Kensington [by Evangeline Stirling] where the modelling was generally of a higher character.' Their opinion was confirmed in 1881 when, 'in modelling, the excellent teaching of the Instructor at South Kensington secured almost all the prizes for that school'.[47] Lanteri's most outstanding pupil of the 1880s was Albert Toft who gained a scholarship from the art school at Newcastle-under-Lyme in 1881 and won silver medals in his second and third year.[48] Perhaps the most remarkable aspect of the National School during the following decade was the number of highly accomplished women sculptors who emerged from Lanteri's classes having won medal after medal in the competitions. The names of Florence Steele, Margaret Giles, Ruby Levick, Esther Moore and Gwendolen Williams are little known today and their achievements, though widely, if begrudgingly, acknowledged during their lifetime, are now all but forgotten.[49]

By royal assent the title of the National Art Training School was changed to the Royal College of Art in 1896. The retirement of John Sparkes in July 1898 marked the end of the era at South Kensington which had begun in 1875. He was replaced as Principal by Walter Crane. The post of Director was not refilled when Thomas Armstrong left it in October of the same year.

The early records of the South London Technical Art School, like those of the National Art Training School, are far from complete. No student registration books or other manuscript material appear to have survived and its detailed history must be pieced together from printed reports, minutes and prospectuses. The lists of prizewinners in the National Art Competitions remain the only reliable guide to approximate dates and duration of students' attendances. The earliest extant documents relating directly to the school is an executive committee report to the Governors of the City and Guilds of London Institute dated 10 March 1880. It clearly expresses the spirit of optimism and reform in which the school began the first year of its existence:

> On further investigation into the conditions and requirements of the Lambeth School of Art as hitherto conducted under Mr Sparkes in its connection with the neighbouring industries of Messrs Doulton's Pottery manufactures, it became apparent that the chief necessity for extending its usefulness in the direction of making Art subservient to industrial purposes was to obtain further or independent accommodation in sufficiently close proximity to the original Art School in which classes in Applied Art might be carried on. This accommodation has been obtained by the acquisition of two houses, numbered 122 and 124 Kennington Park Road, with good gardens in the rear. These houses have been thoroughly repaired, fitted and rendered suitable by the addition of all requisite appliances under Mr Sparkes' advice and direction . . . and there have been erected on the gardens behind, spacious and excellently lighted class and work rooms, in a building measuring 70 by 22 feet, and one storey high at a cost of about £700.

The report goes on to state that one of the houses was to be devoted principally to women students, five of whom were already receiving instruction in art woodwork. 'With regard', the report continues,

> to the Technical Art Instruction carried on in no. 124 and the large rooms behind, under Monsieur Dalou and an Assistant Master, 12 men and 10 women are attending the Drawing Class from life draped and 16 men of the class working from the nude. The Modelling Class is attended by 17 men and will consist of practice in modelling with the view of development into Technical Art in all or any of the following directions:

> 1. Modelling for Pottery
> 2. Modelling for Architectural Decorations in plaster from casts and drawings
> 3. Modelling in Silversmiths' work
> 4. Carving in Wood, stone or marble
> 5. Bronze casting
> 6. Die sinking
> 7. Cameo cutting, either in shell or onyx
> 8. Fine Art Sculpture

There is no reason to doubt a successful result from this department of the Institute's actions, which must, ere long, be further extended to keep pace with the growing interest attaching to its operations. The services and cooperation of Mr Sparkes deserve the fullest recognition and consideration, the Executive and Committee have given him their unreserved confidence and ample discretion in the direction of the details as well as the general administration of the School.[50]

It is interesting to compare this direct and straightforward syllabus with that devised for South Kensington and other government-sponsored schools. The immediate involvement in life drawing was nothing less than revolutionary. Eyebrows were raised when the Royal Commissioners on Technical Instruction visited the school in 1884. 'In the life room', they reported, 'a large number of students were making drawings from the nude model; the work, as a rule, was in charcoal, and the aim seemed rather to produce rapid and effective sketches than laboriously finished drawings. The room was almost inconveniently crowded. Some of the students here seemed to have scarcely sufficient power of drawing to be working from the nude. It is a rule in most schools to require that the student, previous to attempting to study from the life, should have some considerable skill in drawing.'[51] What the Commissioners had witnessed was the effect of Jules Dalou's teaching, the 'French method' whose 'glamour' John Sparkes described as a powerful counter-attraction to the Government's system.

Dalou appears to have spent between two and three months only in his new post. The Board minutes of the Science and Art Department do not record the date of his departure from South Kensington but merely confirm, on 20 February and again on 2 March 1880, that he was to be succeeded, on his own recommendation, by Lanteri.[52] It is thus probable that he began teaching in Lambeth at the beginning of the spring term 1880. Now in 1898, summarising the early history of the technical school in his annual report, Sparkes stated that Dalou had begun the class after the building of the new studios and had left it 'at the end of two months'.[53] In 1888, however, Walter Armstrong claimed that the French sculptor returned to Paris after three months at Lambeth.[54] It is clear, at all events, that he remained long enough not only to change the course of his pupils' development, but to ensure that he left behind a disciple competent to perpetuate his ideas and working methods. The 'assistant master' cited in the 1880 report was William Silver Frith who had moved with the modelling class from Lambeth School of Art in 1879. Frith's pupilage in Lambeth was exceptionally long. Sparkes was his sponsor when he entered the Royal Academy Schools in 1872 and the prize lists of the 1880 National Art Competition still describe him as a 'Lambeth' pupil, though by then he was in his thirtieth year and already assisting Dalou in the modelling class. From the spring of 1880 when he succeeded Dalou as modelling master until 1895 when he abandoned most of his official duties owing to 'the increasing burden of private work',[55] Frith's influence as a teacher rivalled that of Lanteri. His independent success as a decorative sculptor after 1895 was well deserved, for the school in which he had taught played a central part in the elevation of architectural sculpture from a minor craft to the position of honour that it held in England at the turn of the century.

The apprentices who flocked to the evening modelling classes at the newly opened Technical Art School came, not only from Doulton's potteries, but from the firms who represented Lambeth's other major industry, architectural stone carving. Foremost among these was Farmer & Brindley of Westminster Bridge Road. The firm's workshops were a development of the monumental masons' yards which for centuries had supplied the needs of architects for decorative carving. During the 1860s and 1870s their most notable and prolific patron was George Gilbert Scott, among the first architects to campaign for higher standards in a craft he knew to have fallen steadily in inspiration since the Middle Ages. The firm went on, under the surviving partner William Brindley, to serve almost every English architect of repute until the First World War. No records survived the amalgamation with another firm in 1929 and it is impossible to distinguish which of the apprentices described as 'carvers' on their entry to the Technical School were employed by Farmer & Brindley.[56] Thomas Earp who

was much employed by the architect G.E. Street also had workshops in Lambeth. So had Thomas Nicholls, William Burges's carver. Sparkes told the 1882 Commission, 'the modelling class is filled with men who work at Farmer & Brindley's the architectural carvers, Earp, Hitch and others . . . who are . . . carvers for different trades'.[57] Of the apprentices who studied under Dalou, only one, Harry Bates, is known with certainty to have been employed in the Farmer & Brindley workshop. Bates stated in his brief entry for *Who's Who* that he was born in 1851 and 'began life as an architect's clerk'. The more detailed account of his youth, written by Walter Armstrong in 1888, gives an interesting insight into the everyday life of an apprentice stone carver. Bates's first tasks, on joining the firm of Farmer & Brindley 'while still a lad', were to carve simple roundels, rosettes and foliations. Then, between 1869 and 1879, he travelled extensively in England, for

> the great church-building movement, which may in future seem so strange a glory of our century, was in full swing by the time he could be trusted to carve an ornament of the more elaborate sort *in situ*; . . . as the rough blocks were secured in their determined places, the young carver set up his platform before them, hung it about with a protecting stretch of sackcloth, placed his model – a cast from some existing pattern or modelled design, or a drawing – at a convenient angle, and set himself, with ever growing skill to emulate the carvers of five centuries ago. Shut up thus with his work, and empowered by nature to better the examples placed before him, thoughts of freer conditions soon began to take shape in his mind.[58]

Always on the move, always copying old work or carrying out the designs of others, Bates knew that there was little room for his own development as an artist. In 1879 he returned to London, 'confined himself to such carving as could be done under his employers' roof' in Westminster Bridge Road and enrolled as an evening student at Sparkes's school.

Among his fellow pupils in 1879 was Frederick Pomeroy, five years his junior and with a background closely similar to his own. 'I started work by being articled to a firm of Architectural Sculptors', Pomeroy told A.L. Baldry in 1898,

> and supplemented my training by working in the evening at the Lambeth Art Schools [*sic*] in the drawing and modelling classes. It was not until 'Dalou' came to instruct in the new Modelling Schools, founded and endowed by the City Guilds at Kennington in 1879, that any decided progress was noticeable. But the enthusiasm and knowledge he brought to bear on the students, resulted in the founding of a really good modelling class . . . Harry Bates, George Frampton, Goscombe John . . . and many others worked together in this little out of the way quarter of London, and afterwards gained an entrance to the Royal Academy Schools where they gained all the prizes offered by that body.[59]

Frampton and William Goscombe John arrived at the school shortly after Dalou's departure, both described as 'stone carvers' on admission.[60] John was born in 1860 and worked with his father, a wood carver, for William Burges at Cardiff Castle before entering Thomas Nicholls's London workshop in 1881. Frampton's origins are more obscure. Born in the same year as John, he omitted to mention his Lambeth training in an interview he gave to the *Studio* in 1896, merely stating that before he entered the Royal Academy Schools he 'studied architecture for a while, and did much actual work in stone upon buildings, and upon marble and woodwork in them'.[61] The fifth outstanding pupil of the modelling class during the 1880s was Charles John Allen. Like Bates and Frampton, his first interest had been architecture but his family, unable to

afford an architectural apprenticeship for him, had articled him in 1879 to Farmer & Brindley.[62] He began his studies under W.S. Frith in 1882 at the age of twenty and entered the Academy Schools in 1886, continuing to work as an assistant carver in wood and stone to Farmer & Brindley until 1889.

By 1882 new studios had had to be built 'for the increased number of students who eagerly avail themselves of the system of Art teaching, as applied to industrial work, which is pursued in this school'. The Council of the City and Guilds Institute reported in March that John Sparkes had assumed the duties of Superintendent and that 'very good results are anticipated from the appointment of Mr Stannus as teacher of the Advance Class of Design and as Lecturer on Ornament'.[63] In 1883 when Sparkes himself reported on the school's progress, 157 students were enrolled there, of which the majority were in the life school and the modelling class where, he emphasised, 'the work . . . has been very considerable in amount and excellent in quality. The proficiency of the teaching is shown by the success of the students in the Royal Academy and South Kensington competitions.'[64] The prize lists in the National Art Competitions of the 1880s were studded with 'Lambeth' pupils;[65] by 1886 Sparkes felt justified in reporting to his committee that the class was now 'the best and largest in London, or so far as I know in the country'.[66] The following year he announced that the modelling section was involved, under Frith's superintendence, in a new joint venture with Henry Doulton, the design and making of a large terracotta fountain for Glasgow Green. But the finest testimony of achievement he could offer the Institute was the spectacular success of Frith's students in the Royal Academy Schools. The South London Technical Art School had, he assured the committee, opened out for large numbers of young sculptors 'the prospect of a future both lucrative and distinguished'. Among the many students who, following in the wake of Bates, Pomeroy, Frampton, and John and C.J. Allen, were to vindicate Sparkes's optimism by prospering as independent sculptors were Frank Lynn Jenkins, Henry Poole, John Wenlock Rollins, W.R. Colton and Alfred Turner. Others, such as J.E. Taylerson, William Sadler, William Fagan and Thomas Tyrell, Frith's successor as modelling master in 1895, remained primarily in the more obscure supportive role of carvers to architects and other sculptors.

Early in 1890 the future that Sparkes had predicted so confidently was threatened by a sudden and unforeseen change in the requirements for entry to the Academy Schools: admittance would be granted only to students under the age of twenty-three. While the incident properly belongs to the Academy's part in the education of sculptors, the response it evoked at Lambeth is worth recounting here, for the letters and reports that Frith and Sparkes wrote in protest clarify the unique role played by the Technical Art School in the renaissance of English sculpture. The Academy's action would, Frith argued, effectively prohibit the 'natural order of progression in sculpture' from carving to modelling. 'It is questionable', he pleaded, 'if there is a single instance of an accomplished carver who was first a proficient modeller.' On the other hand,

the only vigorous and efficient school of carving in England is that produced by the requirements of Architectural ornamentation. The carver practising in this is . . . liable to be moved from one part of England to another and is seldom long enough in a place, where proper instruction is available, to be able to get more than a rudimentary notion of modelling. The greater number are apprenticed and work in the country and have practically no opportunity for study until they have served their time and can arrange to get to London and to study modelling.[67]

26

However creditable, the training at present offered by firms of carvers was not enough to equip apprentices for entrance to the Royal Academy, 'the High School of Sculpture in England'. There still prevailed 'a considerable division between the purely decorative uses of sculpture as in carving of this nature, and sculpture in its higher development as a means of expression for the imagination'. If students who had undergone lengthy workshop apprenticeships were debarred by their age from tuition in the Royal Academy, the 'production of high-class sculpture in combination with architecture' would be seriously and indefinitely hindered. Angrily, Sparkes in turn reported to his committee in July 1890: 'Perhaps the greatest compliment and most flattering attention we have received has been the recent regulation of the Royal Academy by which a special limit of age has been fixed for the admission of students, that as far as I know, does not apply to any class of students but our own.' The perversity of the new rule was emphasised, he explained, by the fact that 'our students have made their remarkable success in the Academy in consequence of having been first educated as carvers; to this preparatory education we have added artistic theory and practice . . . I can say', he added,

> that the recipients of the Gold Medal and Travelling Studentship of the past four years would have been excluded from the school if the age limit now imposed had been in operation when they applied. Mr Brindley tells me he has never known a case of a carver who completed his education before he was 24 years of age. Modelling alone is taught in the Royal Academy, but the modeller's education is one that can be comparatively rapidly acquired . . . The sculptor has quite another education, in addition to that of the modeller, and a far more difficult one, hence we feel the hardness of the new rule, which we respectfully suggest should not apply to the student in sculpture. If this rule is enforced, we feel that a class of able students, who have for years given full proof of their ability, will be excluded from the only school of honours in the land, and thereby prevented from the opportunity of showing to the world their powers as designers, modellers or sculptors. This result would be a serious blow to the progress of the industrial arts of this land, which the City Guilds of London have done so much to foster and which they have so much at heart.[68]

Implicit in the protests of Frith and Sparkes is a radical challenge, not only to mid-nineteenth-century sculptural tradition, but to modern preconceptions about the practice of sculpture in late Victorian England. Ideal and decorative work had equal validity as a means of artistic expression, they declared. Indeed, the modeller in clay could be considered less deserving of the title 'sculptor' than the carver in stone, for carving was the very basis of the art. That argument has no meaning at all unless by 'carving' the two men meant the direct application, by the artist, of tool to material. The habitual use of the pointing machine to translate the modelled image into marble or stone, which contributed to the devaluation of sculpture as an art in the nineteenth century, is commonly assumed to have prevailed into modern times. Clearly, the concept of direct carving was, to Frith and Sparkes and their students, already a commonplace.

Of the crucial role played by the Technical Art School Sparkes had no doubt. 'Twenty years ago', he was to write in 1898, 'the emancipation of sculpture from the conventional bonds and limitations that had hampered it had hardly taken place. The men of distinction now were students then.' With unchanging devotion to the principles he had learned from Dalou, Frith had produced 'a school of young sculptors

facile, able, imaginative, free from limiting conditions, and vigorous enough to put their thoughts and ideas into fitting form in any material that seemed to them suitable'. Their subsequent remarkable success in the Royal Academy Schools 'was too systematic and continuous to have been a matter of chance'.[69]

THE ROYAL ACADEMY SCHOOLS

Powerfully influential yet resistant to change, the Royal Academy took a strangely ambivalent part in sculpture's development. Yet, as Sparkes and Frith knew well, it remained omnipotent as a source of prestige and commissions; the medals awarded in the Academy Schools far outranked those of any other educational body and almost always foreshadowed renown, if not material success, for their recipients, while the visits of Academicians and Associates and the mingling of advanced students of painting, sculpture and architecture offered an invaluable opportunity to exchange ideas and establish useful contacts for the future.

During the mid-nineteenth century the low standing of sculpture in relation to painting in England was reflected in a sluggish disregard for the particular needs of sculpture students in the Academy Schools. All candidates first entered the Antique School as probationers and were required to produce, within three months, an antique figure drawing, an anatomical drawing and a drawing of a skeleton. If admitted as full students, they would continue to work in the Antique School until they had produced sufficient competent drawings of casts to be admitted to the Life School. Privileges during the term of studentship (which was reduced from ten to seven years in December 1853) included free teaching, compulsory attendance of lectures given by the Professors, free admission to Academy exhibitions, the Zoo and the Armoury at the Tower of London, and the opportunity to compete for medals and studentships. Painters, sculptors and architects pursued the same course of study and it was only in 1851 that the Council resolved to appoint a curator to keep order in the Antique School who should, at the same time, 'be competent to teach Modelling in all its branches including modelling ornament'.[70] When in 1863 a Commission was set up to 'inquire into the present position of the Royal Academy in relation to the Fine Arts', many giving evidence before it voiced strong criticisms of the Schools and especially of their lack of facilities for sculpture students.

The most cogent evidence was given by Alexander Beresford Hope, Vice-President of the short-lived Society of Sculptors which had been set up during the previous year 'because it was considered that sculpture was not represented at the Academy as it ought to be'.[71] He suggested that the Academy might be improved in two ways. The first, he said, 'is not to let painting have that all but exclusive predominance which it has now, but to allow sculpture and architecture to have a greater amount of representation'. The second – probably the most radical change ever proposed for that elitist institution – was to 'admit various branches of art which are not strictly painting, or sculpture, or architecture, such as enamelling, the ceramic art, metal chasing, wood carving, and many things of that sort which have excited a great deal of public attention, which have been the speciality of the three great international exhibitions of the last eleven years, and which are every day more and more claiming to be recognised as art and not merely manufactures'. In short, it was time for the Academy to show more sympathy with the 'art movement' that the Government education system was doing its best to foster. 'There is a class gradually growing up,' he insisted, 'of more

importance than perhaps the Commission are aware of, which has not yet been sufficiently recognised, I mean the sculptors in stone and not in marble. They have hitherto chiefly played their part in ecclesiastical architecture, but I hope and believe they will be increasingly employed in all kinds of buildings. Every day that class is growing of more and more importance.' The Commissioners were interested. 'Did you', they inquired, 'take your idea with regard to the encouragement of handicraftsmen from any institution in the Middle Ages?' 'Not directly', Hope replied; 'the idea was floating in people's minds, I daresay.'[72] It was with the warmest recommendation that the Commissioners put forward his proposals in their report, adopting a new term, 'art-workmen', to do so. 'We recognise', they stated,

> great value in the suggestion first made . . . in the evidence of Mr. A.J. Beresford Hope that there should be a class of Art-workmen connected with the Academy. Looking to the intimate connection between the Fine Arts and those of more mechanical character, and the great importance of extending the influence of the former over the latter, we think that workmen of great excellence in metal, stone, wood and other materials, might be properly distinguished by some medal or certificate of honour conferred by the Royal Academy and in certain special cases, become members of the Academy, at least as Associates.[73]

They pronounced the existing teaching arrangements to be far from satisfactory and made the significant recommendation that students who had reached the highest grade in the National Art Training School should, if they wished, be admitted without further test into the Academy Schools. (In practice there was little interaction between the two establishments. Though South Kensington's first function was to train art teachers, a certain rivalry with the Academy Schools was inherent in the fact that many students left to become independent artists and considered their school training to have been adequate and complete.) In their observations on the Commissioners' report, published in March 1864, the members of the Royal Academy dismissed the 'art-workmen' issue in two placatory sentences and promptly forgot it. 'The importance of extending the influence of the Fine Arts over those of a more mechanical character is fully admitted', they remarked, 'and the connexion appears to us to be in a great measure represented and promoted by the establishment at South Kensington and by its affiliated schools.'[74]

When the Professorship of Sculpture, held by Richard Westmacott junior since the death of his father in 1856, fell vacant in 1868 the only new candidate for election was Henry Weekes who held the Chair until 1876, the year before his death. Weekes had been a pupil of William Behnes and had worked as a modeller to Sir Francis Chantrey. His idol was Flaxman and he stood for all those highly inhibited notions about the nature and role of sculpture which were to be questioned and rejected by the new generation. His lectures on art delivered in the Academy Schools (published posthumously in 1880) reveal both his awareness of the decline of sculpture and his enmeshment within it. The 'perfection' of Greek art must not be copied slavishly, he advised, but must be made to relate to the present age. He remained terrified, nevertheless, that sculpture might begin to emulate the kind of realism that he saw in contemporary painting: sculpture must express gravity, repose and above all a moral 'universal' beauty, and 'cannot take within her grasp, as Painting does, the familiar and domestic'. He recoiled too from the passionate, introverted realism of Michelangelo. Observe, he said, how the *David* carries truth 'to a point which becomes offensive, which destroys the elegance of the statue, and conveys the idea of rude fact

instead of abstract truth'.[75] Yet Weekes was among the few sculptor Academicians before 1875 who showed any real concern for the state of the Schools and for the ill-lit and cramped conditions in which sculpture students had to work. His lectures, he told his pupils, were not to be taken as a substitute for practice. The theory of the art was best learned 'with the modelling tool in hand and the clay to operate upon. The circumstance, too, that the Royal Academy does not think Sculpture worthy of much assistance in that way renders the task of the lecturer . . . less effective.'[76] After Weekes's resignation as Professor in 1876, Calder Marshall and Thomas Woolner, the only remaining sculptor Academicians, were asked to stand for election. Both refused but Woolner was at length persuaded to change his mind. He delivered no lectures before resigning in the summer of 1878. No other candidates being forthcoming, the General Assembly decided that, as a temporary measure only, the sculptor Associates (at that time Henry Armstead, Joseph Durham, E.B. Stephens and William Woodington) should be asked to deliver lectures during the season. The Chair was to remain vacant until 1900.

Despite the apathy that the bare facts imply, and the generally reactionary spirit of Weekes's lectures, a strong undercurrent of new thought had begun to invade the Academy Schools by 1870 and to affect the development of sculpture students there. Its origin was the cosmopolitan and charismatic figure of Frederic Leighton. Leighton had long been interested in sculpture and critical of its modern condition. He recorded in his diary in 1852 his impressions of the medieval figures at the Franciscan Church at Innsbruck: 'giants of breathing bronze', combining 'the most elaborate finish in the details, with the greatest possible breadth and grandeur of the general masses'. How different, he observed, the approach of the 'muddle-headed moderns' who could not discriminate between 'finish' in the sense of smooth idealised surface and 'the other kind of minuteness which is the beautiful fruit of a refined love of nature'.[77] After his election to full membership of the Academy in 1868 Leighton took up the Schools issue in earnest. A Special Committee of Education was formed the following year and began to force the issue of modelling instruction before a reluctant Council. In the same year, 1869, William Hamo Thornycroft, nineteen-year-old son and assistant of the sculptors Thomas and Mary, became a student in the Schools where he was captivated by the frequent presence of the painter as a Visitor. 'He was most energetic . . . and took the greatest pains to help the students', Thornycroft wrote later. 'He was, moreover, an *inspiring* master. Besides doing much for the school of sculpture, till then much neglected, he started a custom of giving a certain time to the study of drapery on the living model. His knowledge in this department and his excellent method were a new element in the training in the Schools, and soon had a salutary effect upon the work done by the students. His influence, through the Academy Schools, upon the younger generation of sculptors was very great.'[78] At first, Leighton's own activity as a sculptor was confined to the clay models that he made, in preparation for his painted compositions, 'as an exercise in the nude and . . . afterwards clad with real drapery, wetted to increase the effect of its fineness'.[79] When in 1877 his first independent work of sculpture, the life-sized bronze *Athlete wrestling with a Python* (plate 6), was exhibited in the Academy's galleries, dramatic substance seemed to have been given to his teaching in the Schools.

> Here was something far more vital and nervous than the soft following of Flaxman dreamed of; a series of surfaces, varied and appropriate, all closely studied from nature, and therefore abhorrent to the Chantreian tradition; attitudes and expressions so fresh and picturesque as to outrage the fondest principles of the

8. William Hamo Thornycroft, *Warrior bearing a Wounded Youth from Battle* (1875). Bronze, 44 in. Leighton House.

Gibsonian Canovesques. This, in short, was something wholly new, propounded by a painter to the professional sculptors, and displaying a juster and livelier sense of what their art should be than they themselves had ever dreamed of.[80]

Among the students who benefited, with Thornycroft, from Leighton's influence, and listened, with him, to Weekes's lectures, were Thomas Brock, Edwin Roscoe Mullins, W.S. Frith, Alfred Gilbert and Thomas Stirling Lee. Prize medals for figures modelled from the antique were awarded to Thornycroft in 1870, to Frith in 1873 and to Gilbert in 1874.[81] In 1875 the subject of the gold medal competition for an 'imaginary composition in the round' was to be 'a warrior bearing a wounded youth from battle' (plate 8). The struggle between Thornycroft and Gilbert for this coveted prize was made a key point in the story of the New Sculpture as told by Edmund Gosse twenty years later:

> The merit of their models, so it was then said, was so nearly equal, and so far beyond those of their fellow students, that the prize long hung poised between them. The gold medal having been finally awarded to Hamo Thornycroft, Alfred Gilbert retired disappointed, and was for some years heard of no more. The collocation of these names at the very outset is truly remarkable, since these were the two men by whom, more than by any other, the New Sculpture was later on to be piloted into fame and universal recognition . . . It is long since those juvenile works . . . have been seen . . . There was in neither yet apparent the qualities which were afterwards to shine in the work of each. Yet something in the freshness of the action and the harmony of lines in the one group prophesied of the future of Mr Thornycroft, still subdued by admiration of Flaxman; while in the equestrian composition of Boehm's pupil, with its wild Celtic or Gaulish warrior, with the youth flung across a hairy pony, the lance, and the rough accessories, something might already be guessed of Mr Gilbert's pictorial use of detail. Mr Thornycroft's model was seen in the Central Hall [of the Academy galleries at Burlington House] in 1876; Mr Gilbert's, I think, was never exhibited again.[82]

Gosse's description of the rejected model is the unique record of its character. It reveals, however briefly, that Gilbert's extraordinary originality of mind had already been brought to bear on a subject set, no doubt, by Weekes and his fellows to test the students' grasp of static neo-classical form, but transformed in his model into a highly romantic image, full of colour and vitality. The award to Gilbert in the same year of second prize for a model of the figure from life, in a class where no entry was judged worthy of first place, must also have been disappointing. The travelling studentship, likewise, was not awarded. Acting on the advice of Boehm, Gilbert left for Paris and the École des Beaux-Arts. Yet it is unlikely that, as Gosse suggested, he would have stayed longer in the Schools if he had been more successful in the competitions. The Academy's education system had already served its only purpose for an artist of his aggressive independence: diffuse and largely unstructured, it had allowed him freedom to develop at his own pace. Some schools, he told his biographer Isabel McAllister, naming two, South Kensington and the Slade, 'appear to have given too much importance to hand dexterity and little encouragement to individual art-vision. There can be no doubt that the early Academy system at the Royal Academy, when teaching was never relegated to one master, but to a number of teachers in rote, each of whom viewed his art according to his own standpoint, was the best. From that much-abused school there has been given a great number of artists working on personal and individual methods. A school is only of value as a preliminary nursery.'[83] Like

32

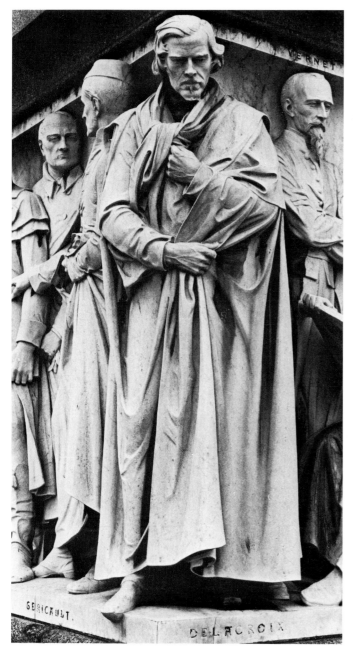

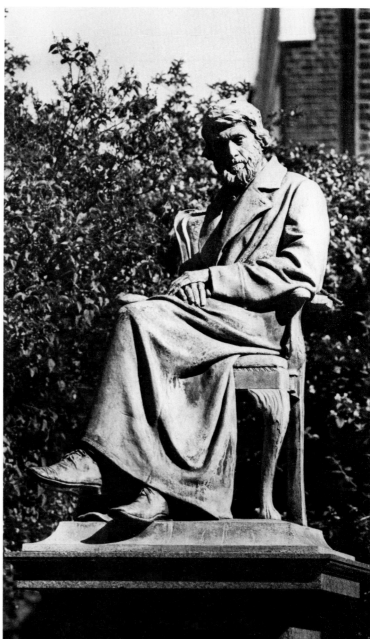

Thornycroft, Gilbert remembered Leighton as the inspiration of his student years. 'We all had an ideal', he said, 'to emulate Leighton in his aims in Art',[84] and he even declared at a meeting in the painter's studio after his death in 1896, 'I can only say that all I know, and all the little I have been able to do as a sculptor, I owe to Leighton'.[85]

The election of Henry Hugh Armstead as an Associate in January enhanced the significance of the year 1875 in the history of the Royal Academy Schools. Armstead was then forty-seven and had been an exhibitor at the Academy since 1851. His origins as a silversmith, his training at the first Government School of Design at Somerset House and his achievements as a carver of stone and wood for decorative purposes – notably the marble frieze of the Albert Memorial (plate 9) and the stone spandrels for the Colonial Office (plate 13) – had set him apart from the inflexibly academic sculptors who were his contemporaries. His acceptance as an Associate and in 1879 to full membership was a concession, however guarded, to the recommendations of the

9. Henry Hugh Armstead, detail of marble podium, c.1870. Albert Memorial.

10. J.E. Boehm, monument to Thomas Carlyle, erected 1882. Bronze. Chelsea Embankment Gardens.

1863 Commission. Armstead shared with Alfred Stevens a habit, rare among sculptors, of making numerous preparatory drawings. His harsh, rapidly executed life-studies and rough sketches, preserved in scrapbooks in the Royal Academy library, foreshadow the Masaccio-like simplicity and directness of his carved figures. He was much interested in the work of the genre painter and illustrator Fred Walker and his approach to the problem of realism in sculpture must have contrasted strangely, in the Schools where he became one of the most regular Visitors, with the timid admonitions of Henry Weekes. He appears to have been a formative influence on Thomas Stirling Lee, winner of the gold medal in 1877, and there were many students in the 1880s who would have found encouragement in his concern and special aptitude for relief sculpture in an architectural context.

By 1878, when Lee was awarded the travelling studentship and was reunited with his friend Alfred Gilbert at the École des Beaux-Arts in Paris, Armstead had been joined in the role of Visitor by a newly elected Associate, Joseph Edgar Boehm. It is easy to underestimate Boehm's role in the development of the new generation of sculptors. He was appointed Sculptor in Ordinary to Queen Victoria in 1881, and his large studio produced a colossal volume of portrait work, the very popularity of which helped to gain him the disapproval of critics who generally agreed that his work 'was always intelligent but . . . seldom rose to greatness'.[86] He had the ability, however, to recognise greatness in others and his open-minded encouragement and kindness to other sculptors, including his pupils Edward Lanteri and Alfred Gilbert, became legendary. He had a firm belief in the validity of the genre subject in sculpture, while vigorously rejecting what he called the 'wash-tubs and soap-suds in marble' that characterised modern Italian work.[87] At his best, as in the seated portrait of Carlyle at Chelsea (plate 10), Boehm represented an uncomplicated notion of sculptural realism that well complemented Armstead's influence in the Schools. A regular and conscientious Visitor, he also gave lectures on sculpture in 1878, 1879, 1882 and 1885, the last entitled 'Bronze Casting as Applied to Sculpture'.

Since Weekes's death the organisation of formal lectures to students had become a recurring problem. Sculptor members proved extremely reluctant to fill in for Woolner and, after his retirement, to take up the vacant Professorship. (As Frederick Pomeroy was to observe – and a sorry dearth of letters and personal papers relating to Victorian sculptors appears to confirm – 'The fact is that to put into writing anything pertaining to one's Art is more difficult than making a statue.')[88] After 1881, during which not one sculpture lecture had been delivered, the Academy began to depend heavily on outside help, chiefly from the staff of the British Museum. Between 1880 and 1900 members who in addition to Boehm did agree to speak were E.B. Stephens, Armstead, Thornycroft, Edward Poynter, Alfred Gilbert and the painter W.B. Richmond.

The election of Frederic Leighton to the Presidency in 1878 heralded a dramatic advance in the Academy's relationship with sculpture. In 1881 Thornycroft became an Associate, the first of the new generation to reach that status; the students from the South London Technical Art School began to take the Academy Schools by storm; and, at last, a school of modelling from the life was established, for male students only, to be open from six to eight in the evenings, under the curatorship of Horace Montford. Other changes introduced at the same time were the amalgamation of the gold medal award with the travelling studentship, now to be offered every second year instead of every fourth, and an increase in the number of prizes allocated for sculpture in the annual competitions. Perhaps most significantly of all – for the immediate future of sculpture – a separate school of modelling for architects was set up under the

supervision of the ubiquitous Hugh Stannus. It was the first open indication that the ideals of the Arts and Crafts movement had the Academy's official support.

Pomeroy and Bates were the first of Frith's pupils to enter the reorganised Schools, in December 1880 and July 1881, taking first and second place respectively in the silver medal competition for a 'model of a statue or group' in 1882. The following year Bates was awarded the gold medal and travelling studentship for his 'imaginative composition in relief', *Socrates teaching the People in the Agora*. 'I never saw anything, by a student,' wrote Walter Armstrong, 'to equal it in coherence of expression and balance of line and mass.' Bates was later commissioned by the architect Alfred Waterhouse to execute the relief in marble for Owen's College, Manchester. Enabled to spend a year in Paris on the £200 studentship, he went, on Dalou's advice, to continue his studies under Rodin. Of this period of the sculptor's life Armstrong wrote,

> he broke through the custom of joining a crowded atelier and picking up what he could from master and fellow-students. He took a studio of his own, worked from models of his own, and engaged no less a person than Rodin to be his mentor. That in so acting he was well advised, there can be I think no doubt. The artists turned out by the regular Parisian studio are, as a rule, far too much of a pattern. They are apt to say, not what Nature has put into them, but as much of it as the hard and fast system of their teacher will give them voice for. Square painting is very well in its place, but you cannot get the infinity of Leonardo with it; modelling in planes is expressive, but there are subtleties over which a sculptor may nightly linger that it will not give; and so for an artist with energy, originality, persistence, and a touch of modesty, no better plan of work than that on which Mr Bates spent his year abroad could, perhaps, be chosen.[89]

All the other prizes for sculpture in 1883 were divided among Bates, Pomeroy and Frampton, who had entered the Academy Schools in December 1881. The award of the gold medal and travelling studentship to Bates in 1883, to Pomeroy in 1885, to Frampton in 1887, and in 1889 to William Goscombe John (admitted in December 1883), was an unqualified triumph for the South London Technical Art School. 'This is the fourth time in succession', reported the executive committee in 1890, 'that this distinction, which is only awarded once in two years, has been gained by a student from the South London School, who in each instance came from the ranks of working stone carvers and received in this School his first artistic training.' All used their studentships to go to Paris. Pomeroy and Frampton both studied under the sculptor Antonin Mercié. John followed Bates into the circle of Rodin.

There were few contemporaries in the Modelling School who did not retain, for the rest of their working lives, the marks of their early association with the original group of artist-craftsmen from Lambeth, fired by a new comprehension of the sculptor's role. Among those whose terms of studentship also began during the 1880s were Henry Pegram of the West London School of Art,[90] Bertram Mackennal from Australia, who spent a few months in the Schools in 1883 before leaving for Paris, A.G. Walker, William Reynolds-Stephens, John Wenlock Rollins and C.J. Allen from Lambeth, Henry C. Fehr, Andrea Lucchesi and Paul Montford. In 1887, when Frampton and Goscombe John and all but Mackennal of the latter group were still present in the Modelling School, a new Visitor was appointed whose influence outweighed that of any other. Alfred Gilbert, who became an Associate in that year and was elected to the long-vacant Chair of Sculpture in 1900, had returned from Rome in 1884 bringing with him the basis of a new language of sculpture. Informed by the kind of troubled,

emotional realism that had terrified Henry Weekes in the art of Michelangelo, his *Icarus* shown at the Academy in 1884 (plate 133) and *The Enchanted Chair* of 1886 (plate 135) had extended the expressive range of English sculpture at the very moment when the students of Lambeth were preparing to push forward the boundaries of its function in society.

The Academy recognised what had quite evidently become one of the liveliest of its student groups by introducing two important changes in the Modelling School in 1889. It was to be open three days a week from ten o'clock to three o'clock, as well as in the evenings, and the time prescribed for study from the antique was to be substantially reduced in favour of modelling from life. On first entry students would be required to divide their week equally between the Antique School where they would draw and model from casts as usual, and the Modelling School where they would have the immediate opportunity to model 'heads or extremities' from life. As their work progressed they would be allowed to reduce the number of days spent in front of casts and increase their study from the life model, eventually spending their whole time in the Modelling School. The term of studentship was reduced to five years and a maximum age limit laid down for all entrants. The five Visitors in 1890 were Armstead, Thornycroft, C.B. Birch, Thomas Brock and Edward Onslow Ford, a newcomer to the Academy, elected Associate in 1888. It was chiefly due to their recommendations, in support of those made by Frith and Sparkes, that the Council of the Academy rescinded the new age limit in January 1894, confirming that the maximum age for admission as a student of sculpture or architecture should be raised to twenty-five years.

As the revolutionaries of the early 1880s became the Associates and Academicians of the 1890s, the Royal Academy's almost inadvertent acceptance of sculpture's new status and strength was complete. Harry Bates was elected Associate in 1891, Gilbert a full member in 1892, Frampton an Associate in 1894. The students who grew up in the Schools during the last decade of the century – Henry Poole, Frank Lynn Jenkins, Alfred Turner and W.R. Colton from Lambeth, Francis Derwent Wood from South Kensington, Gilbert Bayes from the City and Guilds School in Finsbury, Charles Pibworth from Bristol School of Art, and many others – found themselves the inheritors of an established movement with its battles won. The rigid rules and conventions laid down for young sculptors by Henry Weekes in lectures on 'Composition', 'Beauty', 'Taste' and 'Style' had given way, less than ten years after his death, to the exultant empiricism of Gilbert's philosophy of art reflected in the titles of his six addresses to students: 'Endeavour', 'To Accomplish', 'Creation', 'Revise and Use', 'Experience' and 'To a Proper End'.

3. Early Achievements

THE revival of architectural decoration owes its crucial place in the development of the New Sculpture to its close links with one of the most potent, emotive issues of the Victorian age: the relationship of art to manufacture. Like government-sponsored art education and the 'art-workman' debate, like John Sparkes's administrations at Lambeth and South Kensington and the guilds and societies of the Arts and Crafts movement, it grew out of a passionate concern to reaffirm the relevance of art in society and to bring it, whether as competitor or collaborator with industry and commerce, closer to the everyday lives of ordinary people.

The art–industry debate was still in its infancy when Alfred Stevens reached the height of his career in 1856. The *Art Journal*, describing in that year his recent commission to decorate rooms at Dorchester House, wrote perceptively: 'In any other European state he would have achieved by this time a much wider celebrity than has as yet fallen to his lot. This arises from no shortcomings on his part, but from the fact of there being no proper "status" yet for an ornamentalist in this country.'[1] Almost every commission Stevens received came to grief because of the total misunderstanding between him and his patrons about the nature of decorative art. Expecting little more than the customary commercial standard of respectable but derivative workmanship at reasonable cost in a reasonable time, they were confronted instead with the creative process at its most painstaking and refined. Robert Holford of Dorchester House innocently exposed the whole decorator–artist conflict when, still in a state of bewilderment after Stevens's death, he wrote to Hugh Stannus, 'when I first had negotiations with him I told him plainly I was not prepared to embark on a system of decoration to be charged for as fine art. He answered, very fairly, that he proposed to charge his work as decorative work and not as high art.'[2] To Stevens the distinction was meaningless and he spent most of his life in abject poverty, the victim, like the unfinished dining room of Dorchester House, of the aesthetic double standard of the age.

The idea that figure sculpture as applied decoration, devised to enhance a shared environment and divorced from any specifically commemorative role, could be considered as high art had scarcely begun to take root when Stevens died in 1875. Nevertheless, in the wake of the Great Exhibition a profound disquiet about the general state of sculpture in England had emerged and, remarkably, in the clamour of impractical and tediously lengthy suggestions for improvement, the clearest voices were those that set the problem in an architectural context. In 1861 there appeared in *Fraser's Magazine* an essay entitled 'British Sculpture: Its Condition and Prospects',

written by William Rossetti, younger brother of the painter. 'Foremost among the causes of depression of the sculptural art', he declared roundly, 'may be named the divorce which has taken place of sculpture from architecture.' If sculptors could only learn how to invest their work with expression and character and bring it out of the exhibition gallery into the city streets, Rossetti argued, public interest would be aroused again and the vicious circle of apathy and ineptitude broken.[3] It was the first clear expression of protest against the gulf that existed in the mid-nineteenth century between architectural carving and modelling and 'high art'. The Gothic Revival had provided countless opportunities for decorative work, and figure sculpture, albeit tidied away onto remote pediments and parapets, remained part of the vocabulary of the Classicists. But on both sides archaeological copyism was the accepted norm and the translation into stone of drawings for Gothic or classical ornament, supplied by the architect, was seen not as art, but as industry or, at best, as a minor craft. Even C.R. Cockerell, friend of Stevens, found it appropriate to design the sculpture for his buildings and to have it executed by anonymous carvers.

The issue was brought sharply into focus again in 1874 by the *British Architect*, a journal which made its first appearance in January of that year and remained a determined champion of sculpture's cause for the rest of the century. 'Forsaken by her Sisters and rejected by the Utilitarian World', declared a leading article published in April, the art was 'faltering and fainting in the cruel isolation of Neglect'. Its predicament was exemplified in those two great Gothic monuments of modern times, the Houses of Parliament and the Albert Memorial: architects were either refusing altogether to co-operate with 'the Sculptor proper', or, when they did so, continuing to treat his work as 'common architectural ornament'. In the Albert Memorial George Gilbert Scott had been 'undeterred by considerations of Style, by Color of material, by fitness of Composition, by the absolute essentials for Sculpture of subdued surroundings and quiet backgrounds'. The marble groups and bronze figures heaped about it 'enliven the work just as crockets and ball-flowers embellish the canopies of a sedilia'. Amidst such insensitivity, the journal concluded, 'the public ought not to be surprised that there are so few able Sculptors in England; its surprise should be that there are men of such unquenchable loyalty to their inherent gifts as to pursue their Art in the face of general apathy and studied rebukes on the part of their natural friends and old allies – the Architects'.[4]

It is a measure of the confusion attending any serious consideration of sculpture and its role at this period that the *British Architect* should have failed to observe the boldest effort yet made to achieve a new relationship between ornament and architectural design. A unique opportunity had been offered by Scott himself in his provision for sculpture on the Italianate facade of the Colonial and Home Offices in Whitehall, nearing completion in 1874 (plate 11). The spandrel figures by Henry Armstead and J.B. Philip are a remarkable early attempt to transpose the spirit of Stevens's bronze groups for the Wellington Monument into carved relief (plates 12, 13). Here, for the first time in one of London's principal thoroughfares, the decorative possibilities of the heroic human figure were exploited for the enjoyment of countless passers-by. Armstead, a more inventive designer than Philip, went further and filled the angles of his five Continent spandrels with naturalistic detail, chosen, like the amiable hippopotamus of Africa, with touching concern for their value as entertainment. There is no reason, however, to doubt the accuracy of the *Cornhill Magazine*'s melancholy assumption, some five years later, that 'few of the thousands who pass up and down Whitehall every day have ever stopped to look up at Mr Armstead's reliefs . . . or in

doing so have reflected how exceedingly rare such beautiful work is, not merely with us but in any modern country of Europe'.[5] Overlooked by the *British Architect*, the collective achievement of Scott and his sculptors had small chance of recognition by less committed observers, conditioned to accept only memorial or gallery sculpture as the real thing.

The view that architectural decoration was somehow unworthy of consideration as high art was compounded by Edmund Gosse. In his article of 1881, 'The Future of Sculpture in London', he failed to raise the subject once, while constantly poised nervously on the brink of it. 'On what theory', he asked, 'are we to account for the deplorable condition of our streets, and the radical want of power and beauty in most of our public statues? On the simplest possible – namely that by an unfortunate habit, which has grown up on both sides, the public has ceased to be on the same platform as the sculptor, and has ceased to approach him on a rational footing.' Gosse then proceeded to compare the contributions made by architects and by sculptors to the environment and to blame the imbalance on cost. 'The substances in which the sculptor works – marble and bronze – have this disadvantage over those materials in which the architect works, that they are extremely expensive; they have this advantage over those materials, that they are much more precious and beautiful in themselves as jewels are more precious than ordinary materials.'[6] Sculpture in stone or terracotta, synonymous with architectural decoration and hence with commercial carvers and modellers, lay quite outside Gosse's terms of reference. Even Ingress Bell, among the first practising architects to publish his views on sculpture as decoration in the urban

11. Home Office, Whitehall (George Gilbert Scott, completed 1875).

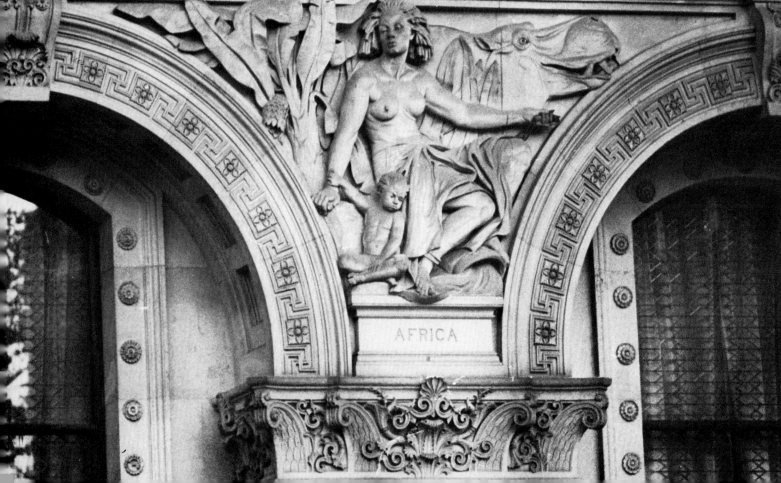

AFRICA

landscape, became thoroughly confused with side-issues such as the dangers of dirt accumulation or sculptors' inability to design the pedestals for their memorial statues. Rising to the defence of his own profession against the kind of criticism raised by the *British Architect*, he stated clearly, however, that the modern separation of 'sculptors' and 'carvers' had made it 'almost impossible to embellish our public buildings to any great extent with works of sculpture'.[7] While that separation continued, bridged only by the isolated and barely acknowledged efforts of Stevens and Armstead, there was little hope that the public would ever, in Gosse's phrase, 'approach sculpture on a rational footing'.

How much anxiety and near-hysteria the subject of decorative sculpture could generate in the early 1880s is richly illustrated by the Blackfriars Bridge competition and the affair of the St George's Hall panels. In the autumn of 1880 the Corporation of London announced an open competition for statuary to be placed on the four pedestals provided for that purpose by the engineer Joseph Cubitt at the corners of Blackfriars Bridge. No guidance as to subject was offered, 'it being the desire of the Committee that the competition shall be as wide and open as possible so that artists may not be fettered in their choice'.[8] The advertisement contained the information that Sir Frederic Leighton, President of the Royal Academy, had agreed to 'assist the Committee in the selection of the Designs', and the submission date was fixed for 21 March 1881. Forty-nine entries were received and inspected by Leighton and the Bridge House Estate committee. There then began a process of prevarication that is scarcely equalled in the history of the competition system. In July Leighton admitted that he had been unable to come to any decision alone and suggested that the selection should be referred to himself, Horace Jones the City Architect, and 'two or three other artists of standing'.[9] These, the committee resolved, should be sculptors 'who are Royal Academicians and are not competitors for the work'. Thomas Woolner, Henry Armstead and W.C. Marshall were duly approached. The first two declined at once and Marshall, when he discovered this, hastily wrote to the committee declaring that now 'the responsibility was more than he felt inclined to accept and that it would be much more satisfactory to the Competitors if the Awards were made by a larger Committee of Artists'.[10] On 15 December the report of a reluctant advisory panel, comprising Leighton, Marshall, G.F. Watts and Horace Jones, was at last laid before the Court of Common Council. There was little in its contents to satisfy any of the competitors who had waited anxiously and for so long to hear the fate of their models. Premiums ranging from £250 to £100 were awarded to those submitted by Louis Fabricci (*Triumph of the City of London*), W.S. Frith (*Queen Boadicea*), David W. Stephenson (*India visits Britain*), Louis August Malemprie (*Progress*), Edward Lanteri (*Queen Elizabeth*), E.B. Stephens and W.E. Woodington (whose models were both entitled *Emporium of the World*). The report was accompanied by an extraordinary disclaimer in the form of a letter from Leighton. The committee members had, he wrote, chosen the six models 'in which in varying degrees appropriateness and talent were best combined'. But they were not prepared, 'in view of the great importance of the work, and the high gifts required for its adequate and satisfactory performance, and in view also of the calamitous results of failure, to recommend the execution on a large scale of any of the designs submitted to them, or the employment of the competing artists in the preparation of other designs with a view to their execution'. He urged the Bridge House committee, however, to 'seek now through some other channel to achieve . . . the great object for the fulfilment of which the competition was instituted'.[11]

In January 1882 Leighton, Watts, Marshall, Jones and three committee

12. John Birnie Philip, detail of stone spandrel decoration, Home Office, Whitehall.

13. Henry Hugh Armstead, detail of stone spandrel decoration, Colonial Office, Whitehall (George Gilbert Scott, completed 1875).

41

representatives were formed into a special committee for further discussion of the problem. In July they recommended that the proposed statuary should be confined to seated symbolical figures in bronze, that another competition limited to six carefully chosen sculptors should be held, and that the winning entry should be cast full-size and erected on one of the northern pedestals before any further commitment was made.[12] By the spring of 1883, however, the main committee had decided that equestrian, not seated figures, would be more appropriate and that to prove it a plaster model of the statue of Francis I at Crystal Palace should be made and placed *in situ*. In January 1884 the special committee was re-formed to exclude Leighton, Marshall and Watts. During the following month Horace Jones addressed letters to Armstead, C.B. Birch, Boehm, Thornycroft, Woolner and Lanteri inquiring what honorarium they thought suitable for a commission to execute the Bridge statuary, how long such a commission would take to complete to plaster model stage, the cost of bronze or iron casting and what works of comparable nature they had personally executed.[13] A fee of £5,000 was verbally agreed and a tour of the studios of the six sculptors planned for March. Word of the visits spread rapidly and the committee was besieged by invitations. By the end of the month its members had been to twelve studios, including those of George Gammon Adams (a portrait sculptor of no special distinction but with City connections), Thomas Brock, Albert Bruce-Joy, Mario Raggi, Richard Belt, W.C. Marshall and G.F. Watts (whose models for the recently completed colossal equestrian group *Hugh Lupus*, for the Marquess of Westminster, would have made appropriate viewing). Many other hopeful sculptors were turned away, including W.S. Frith who was understandably aggrieved that, having been awarded one of the first premiums, he was not even permitted to be a contender for the commission.[14] Amidst a chaos of decisions and counter-decisions, misunderstandings and delays as the scheme wavered, during the next two years, between the special committee, the main committee and the Court of Common Council, sketch models, one-eighth full-size, were invited and received from Hamo Thornycroft (Edward I, a wax version of which was exhibited at the Academy in 1885 and later cast in bronze), Adams (Sir Robert Fitzwilliam), Birch (Henry V), Brock (Edward VI), Belt (Black Prince), Armstead (Edward III) and Boehm (Richard Coeur de Lion, exhibited at the Academy in 1888). A 'final' selection of the models of Thornycroft, Birch, Armstead and Boehm was presented to the Court in July 1886. The committee, it was stated, 'now confidently recommend the above subjects, representing four of England's warrior Kings, as most suitable for the purpose, and we also recommend that the work should be entrusted to each of the artists as above mentioned, and we believe that when the work is completed it will not only be a credit to the Corporation, but a great adornment to the City of London'.[15] But in October the Court suddenly 'rescinded all its resolutions on the erection of such statues'. On 10 December the Bridge House committee was authorised to place lamp standards on the four pedestals of Blackfriars Bridge at a cost of £1,500. At the same meeting it gave orders for the removal and destruction of the melancholy plaster cast, now seriously damaged, that still stood on the north-west pedestal.[16]

The failure of all concerned with the competition to reach any positive or coherent decision cannot be attributed simply to the inadequacy of the works submitted, to the expense involved, or to the notorious vagaries of committees, but seems to have stemmed from a total inability to deal with the problem of modern sculpture outside a gallery setting. Leighton displayed, throughout, a lack of confidence astonishing in the self-declared arbiter of sculptural values. The *Builder* had found the handling of the first competition deplorable and offered the pertinent comment that

the question is really an architectural one and we are disposed to think that an architect would be more likely to select the best design, and be less liable to be impressed by modelling than a sculptor, who might consider technical excellence more than architectural fitness and suitability to position. If the design should fall into the hands of the ordinary sculptor, and 'pretty groups' be placed upon the piers regardless of architectural effect, another fine opportunity will be thrown away. Verily, they do manage these things better in France, where there is a proper co-relation between the architect and the sculptor, with a resulting monumental effect, for which we here look in vain.[17]

The *British Architect* had the last sardonic word in 1886:

The pedestals of Blackfriars Bridge are not, after all, to be crowned with monumental evidences of the skill of Messrs Boehm, Thornycroft, Armstead and Birch, and these gentlemen, in submitting models and reports, have had their trouble for nothing. The Corporation, in deciding not to proceed further with a project involving the expenditure of some £30,000, acted wisely, for the one substantial reason that the subjects are not such as commend themselves to a generation which lives in the present . . . Have we no history of the present worthy of record in permanent form?[18]

It is an indication of the limbo-like area to which decorative sculpture was consigned that not one concerned comment appeared in current art periodicals. The architectural press was alone in according any significance to this potentially major opportunity for monumental decorative work. The same fate awaited the competition of equal importance being held in Liverpool at the same period.

On the advice of Sir James Picton, well-known local architect and recently knighted public servant, Liverpool City Council invited designs in 1882 for reliefs to fill the panels that Harvey Lonsdale Elmes had left empty for sculpture on the flanks of St George's Hall. The competition attracted an interesting response. Established high sculptors ignored it and of the thirty-nine entrants, which included Hugh Stannus, Stevens's pupil, most were second-rate sculptor-decorators whose designs, according to the *Liverpool Daily Post*, were 'merely stone-cutters' conceptions, of the rule and compass pattern, and free from any abstruse originality'.[19] Among them also, however, were two sculptors, T.S. Lee and W.S. Frith, for whom the competition had a special significance, and it was to them that the first and third premiums respectively were awarded. Both were fiercely impatient with the barriers separating decoration from high art. It was Frith's primary concern, as teacher of sculpture at Lambeth, that architectural work should achieve the status of 'high-class sculpture' as a means of expression for the imagination.[20] Lee told a gathering of architects in 1892, 'I was apprenticed to an architectural sculptor, so-called, in days I trust past, for I look for the time when the distinguishing epithet of "architectural" sculptor or "figure" sculptor will no longer exist and that we shall all be able to enrich architecture and be, in the most complete sense of the word, "sculptors".'[21] The two most powerful influences on Lee at the time he entered the Liverpool competition were the British Museum's holdings of Greek sculpture and the early work of his friend and recent companion in Rome, Alfred Gilbert. No doubt it was the evidence his competition designs showed of the former influence that gained him the first prize: the reliefs were, after all, to decorate the grandest Greek Revival building in England. But if, as seems likely, the City Council and people of Liverpool expected the finished panels to conform to the stereotype of mid-Victorian sub-neo-classical carving, they were soon to be

disillusioned. The first six panels on the east flank were to contain allegorical figures illustrating the Progress of Justice, introduced at the south end by *Joy follows the growth of Justice led by Conscience directed by Wisdom*. When at last this panel was completed in Istrian marble and set in place in 1885 an unfamiliar and unwelcome realism was discovered to intrude upon the solemnity of the processional figures (plate 14). A naked girl-child, awkward and vulnerable, provided the centre-point of the composition, echoing in expressive tenderness the qualities of Gilbert's bronze statuette, *Perseus Arming*, exhibited to a chorus of critical acclaim at the Grosvenor Gallery in 1882 (plate 129). With considerable reluctance the Council allowed Lee to proceed with the second panel; once completed it was found to repeat and even emphasise the qualities of the first (plate 15). The naked figure of Justice again dominated the panel, though now portrayed as an adolescent girl flanked by draped figures of Wealth and Fame. The spirit of the New Sculpture had, unnervingly, escaped the safe confines of the exhibition gallery and invaded architecture.

Just as Leighton had retreated into rhetoric to mask his confusion in the Blackfriars Bridge competition, so now, recoiling from the unfamiliar, Lee's most strident critics took refuge in sniggering scorn, arguing that the panels failed to tell a story or convey a moral. 'It is difficult', wrote Joseph Boult in a paper prepared for the first Art Congress in Liverpool (but never delivered),

> to discern whether the figure called Wisdom [in the first panel] is intended to be male or female; it carries what may be the lamp of Knowledge [but] I do not see anything about this figure which can in any way be considered typical of wisdom . . . In Justice the sculptor has been evidently very successful in portraying a gutter child, very much neglected not only by the police and the relieving officer, but also by the Society for Preventing Cruelty to Children, who might surely find a cloth of some kind to cover her nakedness.[22]

The very choice of figure type to represent Justice was ill-conceived, he continued, for 'Law is an expression of the dominant will . . . not child's play nor amusement for a girl verging on womanhood'. All the weight of entrenched opinion on the nature of decorative sculpture is contained in Boult's pronouncement that 'the artist manifestly does not understand the limits of his art and has attempted to convey in sculpture sentiments which sculpture cannot represent . . . Ideas purely abstract appear mis-suited for visual representation.'

The controversy developed steadily into uproar. A local magistrate hearing the case against a man accused of selling indecent photographs in Liverpool was informed that under his own eyes was obscene statuary on St George's Hall setting a bad example to the public.[23] One James Hay, addressing a meeting of the Liverpool Architectural Society, protested that 'if the child Justice in the first panel had been provided with a short skirt, and the naked female figure in the second clothed in the fine Classic tunic of the Greeks, veiling without concealing the beauty of the form, the idea of "purity" would have been better symbolised, the art would have been finer and public decency would not have been outraged'.[24] The finance committee broke contract with Lee for the remaining four panels of the first series. After the Edinburgh meeting in 1889 the committee of the National Association for the Advancement of Art and its Application to Industry sent a memorial to the Mayor and Corporation of Liverpool expressing the hope that Lee would be allowed to continue his work and deploring the 'stupid and ignorant abuse' of the two existing reliefs by 'people who have too little idealism to understand their meaning'. Philip Rathbone, local art benefactor and chairman of the

44

Walker Art Gallery, who was instrumental with William Conway in founding the National Association, offered to pay for the remaining panels himself if the Corporation would accept them. He quoted a letter from Alfred Gilbert stating that those already executed were 'the best thing of their kind in England'.[25] In February 1890 Lee's designs were submitted and approved and in March Rathbone had what he evidently assumed to be the last word. Acknowledging the Corporation's acceptance of his offer, he expressed his hope that 'this may be one step in restoring to British architecture that human interest which was alike the glory of Grecian and Gothic architecture including our own cathedrals'.[26] The second set of panels, to the north of the east portico – quaintly inscribed allegories of Liverpool and her Commerce – were shared between Lee, Charles Allen and Conrad Dressler and completed by the end of the century (see plate 84).

From the outset the architectural press adopted a rational view of the affair, committed to the support of Lee and insisting that the future of decorative sculpture lay in the hands of architects who must be better informed and hence more discriminating in their use of it. In February 1886 the *British Architect* was prompted by the events in Liverpool to publish a second major editorial on architectural sculpture, probably written by the then editor, T. Raffles Davison. 'We should like to see', he wrote,

> a more intelligent appreciation of the usefulness of sculpture and carving on the part of both architects and their clients than at present is apparent. We mean of course the use from a decorative point of view . . . It is in the respect of decoration to St George's Hall we should mainly regard the sculpture panel now placed therein. Does it decorate and enhance the value of the building, or does it not? . . . We may be

14. Thomas Stirling Lee, *Joy follows the growth of Justice led by Conscience directed by Wisdom*, 1882–5. Marble. St George's Hall, Liverpool.

15. Thomas Stirling Lee, *Justice in her Purity refuses to be diverted from the straight path by Wealth and Fame*, 1886. St George's Hall, Liverpool.

45

interested to know that Justice is being led satisfactorily and happily by Understanding in the way of Wisdom . . . but if [the sculptor] gives us lines of harmony and modelling of beauty, we care little how the moral lies from an architectural point of view and should not greatly grieve to learn that Gaiety was being taken in hand by Vice and led into the ways of Debauchery . . . Such matters as the Liverpool sculpture are of so great importance to the art of architecture that we cannot afford to pass them lightly over. It is by careless regard of the quality and measure of our sculptural adornments on the part of architects and public that we have come to have so much, and that the bulk of it is such wretched stuff.[27]

'We hope', the editorial concluded, 'that our students and younger men will lose no opportunity of talks with sculptors and carvers about their art, and try to form conclusions about all new sculpture and carving that they see . . . And, perchance, our school of carvers, seeing we are in earnest about our art, would become the better for more settled study of this all important matter.' It was upon similar hopes that the Art Workers Guild had been founded two years before. Two years later, in 1888, the dialogue between architects and sculptors was given fresh impetus at the Congresses of the National Association for the Advancement of Art and its Application to Industry, that 'ambitious and intriguing scheme that takes its place – if only for a brief time – within the movement to bring the world of art, particularly "practical" art, into a more integrated relation with industrial and domestic design, and so become a more viable part of British society'.[28] The St George's Hall affair had many repercussions. There is even evidence to suggest that William Conway's idea for the Art Congresses sprang from his outrage at the Liverpool Corporation's treatment of Lee.[29] But above all, it brought the sculptor–carver issue out of obscurity and strengthened the determination of the architectural press to search out and give special comment and praise to new buildings in which sculpture played a significant part.

The development of architectural decoration between 1885 and 1900 falls into two clearly defined phases. The first was a period of experiment, as architects and sculptors slowly developed confidence in the collaborative ideal. Its ending is marked and its achievement summarised in the facade of the Hall of the Institute of Chartered Accountants, completed in 1893. The years between 1893 and 1900 saw the complete acceptance of decorative figure sculpture as an art form equal in importance with independent ideal sculpture, yet more potent in its wide accessibility; purer than the portrait or commemorative monument in its freedom from all motive but that of contributing grace to everyday life. Roscoe Mullins was expressing not only his own but a widely shared opinion when he said in 1900: 'We may note the tendency of sculpture, when separated from architecture, in the popular form it takes at exhibitions, to develop into a species of bric-à-brac and *objets de vertu* . . . Too often the work, when done, is only suitable to become part of a rich man's collection of treasures, that only the few therefore can possess, rather than fitted to belong to the nation as a whole, as it could do if it were executed for public buildings.'[30] The height and the close of this phase too are marked by one building, Lloyd's Registry of Shipping, erected in Fenchurch Street in 1900 (see Chapter 4).

The issues involved in the reform of decorative sculpture were so complex that not even the most enthusiastic early reformers were able to grasp them completely. True integration between architecture and sculpture, which seemed at first to be a simple question of employing the independent artist instead of the commercial carver or modeller, was discovered by 1893 to exact profound and reciprocal adjustments in approach to design. When George Aitchison brought in Boehm – already appointed

46

The treatment of sculpture in James Hibbert's Harris Library and Museum at
Preston (plate 17) is evasive too, though it is interesting that in this strange survival
from neo-classicism, the influence of new ideas should have been felt at all. The *School of
Athens* group confined in its remote pediment is the work of Edwin Roscoe Mullins, the
first major commission he received after his early election to the Art Workers Guild in
1884 (plate 16). Mullins's responsibility for the design of the pediment, as well as for the

Sculptor in Ordinary to the Queen – to superintend the carving of caryatids for the
Royal Exchange Assurance offices in Pall Mall (demolished) he no doubt felt that he
was striking a blow for the cause, and indeed, the association of an establishment
sculptor with this relatively minor decorative work served as a useful example that the
British Architect was eager in 1885 to press home.[31] But Aitchison's provision for figure
sculpture – as one among many accessories in the decorative pattern of his design –
trivialised its status in much the same way that it was diminished, in his lectures, by a
myopic obsession with side-issues. The leasehold system, he told the Society of Arts in
1888, was largely to blame for the absence of sculpture on buildings. No one wanted to
beautify his home for the ultimate benefit of the landlord, though, 'considering the
wealth of this nation and the small remunerations excellent sculptors and painters are
ready to work for, there must be a hundred thousand people in London who could
afford a sculptured frieze on their house fronts . . . even if . . . in some cases the
indulgence might involve the sacrifice of oysters, turtle soup and champagne for a year
or two'. Another inhibiting factor was the ugliness of modern dress, which not only
reflected the nation's general insensitivity to beauty but prevented sculptors from
performing their highest function in society, 'to give us beauty of form in permanent
material, to raise noble emotions in our souls and to truthfully portray the form and
lineaments of those we love, admire and venerate'.[32]

16. Edwin Roscoe Mullins, *School of
Athens* pediment group, *c*.1886.
Harris Library and Museum,
Preston.

17. Harris Library and Museum,
Preston (James Hibbert, completed
1887).

47

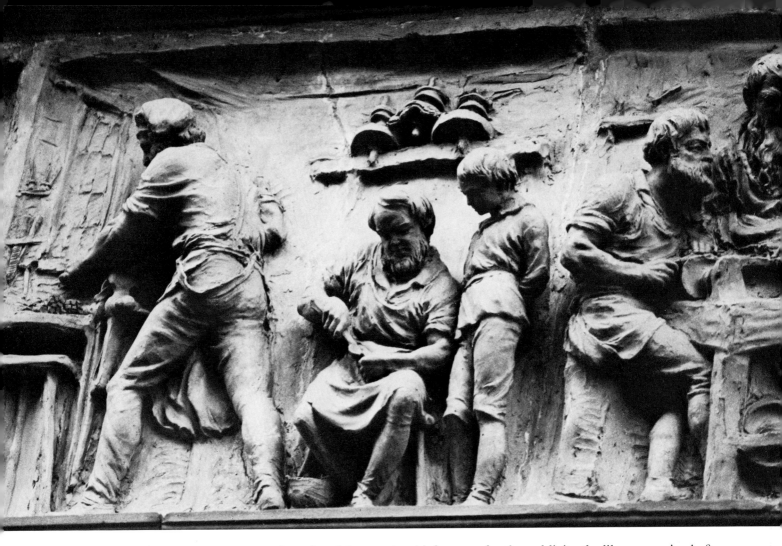

18. Benjamin Creswick, detail of terracotta frieze decoration, *c.*1886. Cutlers' Hall.

preparation of models, was the chief pretext for the publicity the library received after its completion in 1887. The *Builder*, illustrating some of the models, wrote: 'This is one of the most important works of late years in which sculpture of a high class has been employed as a decorative accessory to architecture and we hope other examples may follow.'[33] In 1888, the pediment sculpture having been finished in the spring, the journal completed its set of illustrations from the models and again applauded the achievement of the architect 'in employing a sculptor, properly so-called, and not a mere "carver"'.[34] Mullins was an appropriate choice. Though committed to the idea of unity in the arts, and with a background similar to that of Bates, Pomeroy and Frampton, he was considerably older than they – born in 1848, two years before Thornycroft – and carried many of the prejudices of the older generation into the role of decorative artist. That delicate balance between psychological realism and the ideal which became the hallmark of the new movement constantly evaded him. Like Aitchison, he was unable to separate the issue of sculpture's relevance to modern life from the problem of contemporary dress, though at Preston the architect's general specification of subject matter relieved him of the necessity to do so. 'Who can imagine', he said at the Birmingham Art Congress in 1890, 'a pediment of trousered men and petticoated women? Costume as costume is there out of place; art is paramount and what is not artistic has to be banished.'[35] Nevertheless, neither the context nor the classical uniform of Preston's Greek heroes deterred Mullins from allowing them a degree of sheer physical vitality that rudely contradicts the neo-classical solemnity of their setting.

Another outstanding attempt to relate sculpture to architecture was made before the

48

New Sculptors advanced to dominate the field. When Tayler Smith's Hall in the City of London for the Cutlers' Company was completed in 1887, once more, while the building itself was given only cursory comment, the architect was held up as an example to be followed in his care for art. Across the red brick facade in Warwick Lane, above the ground-floor windows and easily visible from the pavement, runs a terracotta frieze thirty-one feet long and nearly three feet deep, modelled by Benjamin Creswick in high relief with figures in trousers and shirt-sleeves engaged in the cutlers' trade (plates 18, 19). Again, the choice of sculptor was particularly appropriate. Creswick had been a knife-grinder in Sheffield before he met and worked under Ruskin at Coniston and was committed to the kind of workaday realism that Mullins abhorred and Ruskin saw as the salvation not only of sculpture, but of modern architecture itself. Creswick believed that the public's lack of interest in sculpture stemmed directly from its failure to express modern life. If subjects for architectural work could be taken from 'such of our industries as minister to our real wants in life . . . these could not fail to arouse elevating and honourable thoughts in the minds of our people, and would give a dignity to the life we live and invest even the humblest toil with an honourableness that is not sufficiently recognised. Sculpture when associated with architecture and giving expression to national life, wisely and sincerely, is a power that has influenced the destiny of man since the world began as no other form of expression can.'[36] The Cutlers' frieze won high praise from the *British Architect*, whose editor, Raffles Davison, was a declared admirer of Creswick's work: 'We rank him head and shoulders above most English modellers of the present day. The exquisite charm to be found in such work as that by Harry Bates and Alfred Gilbert is a credit to our time . . . and it is, in a sense, of higher range than most we have seen from Creswick's hands, but the man who can handle the current interest of our daily life and fix it for us in permanent decoration makes a stronger appeal to our sympathies than the idealist, however skilled he may be.'[37]

19. Cutlers' Hall, City of London (T. Tayler Smith, completed 1887).

Yet, for all its interest as a work of political realism and the rough vitality of its modelling, Creswick's sculpture bears no true architectonic relationship to the facade it occupies. The frieze serves a function similar to that of a fascia band advertising the purpose of the building and no attempt has been made, either by architect or sculptor, to integrate its restless spontaneity with Tayler Smith's grim and rigid design. In purely architectural terms, the mere continuation over the windows of the scroll work on the angle turret would have produced an effect more in keeping with the character of the facade.

The *British Architect* showed proper reserve in qualifying its comparison of Creswick with two of the leading sculptors of his generation. Gilbert was never to embark on a work of comparable type. Bates had only recently completed his first major contribution to architectural decoration, an inspired work of modelling that had been greeted the previous year by the same journal with unreserved acclaim. The new bakery premises of William Hill & Son in James Street (now Buckingham Gate), Westminster, were designed by Thomas Verity and completed in 1887 (plate 20). The building, mutilated long ago by a coat of grey paint over its red terracotta facade, was demolished in 1980 to make way for office development. The noble frieze panels, designed and modelled by Bates, which had been set above the ground-floor openings, were stripped of their paint during demolition and preserved, incongruously, on the exterior of the new building (plates 21–2).

Thomas Verity, father of Frank Verity the theatre architect, was born in 1837 and made his name when he won the competition for the Criterion block on Piccadilly in

49

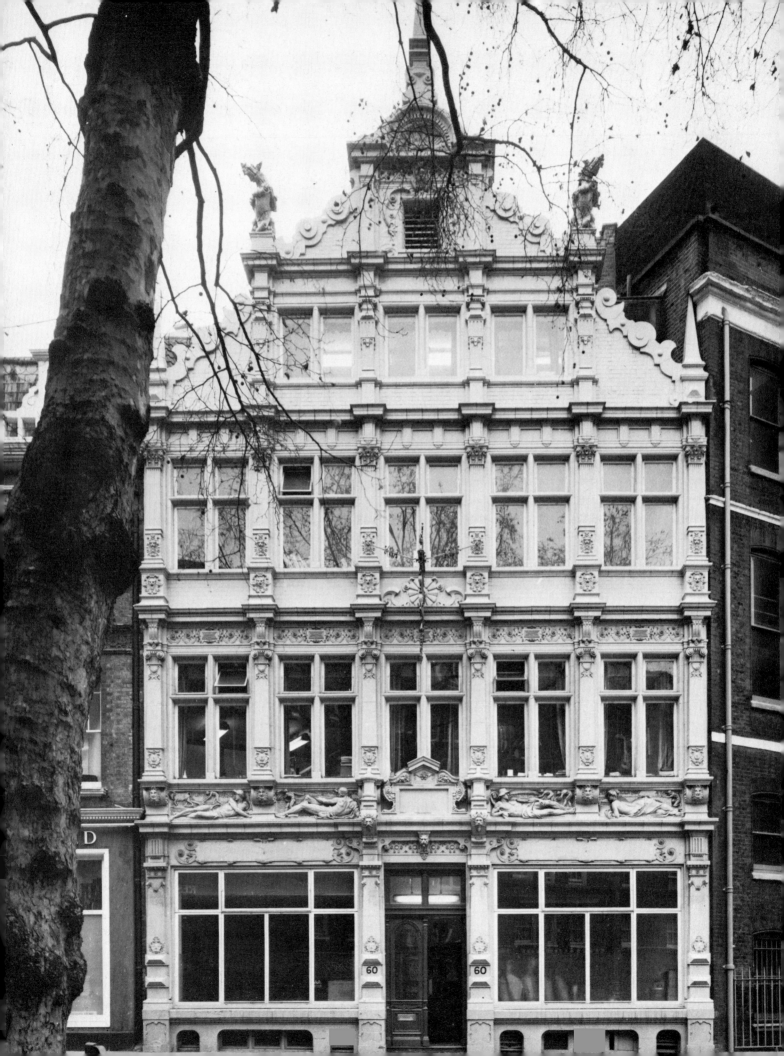

1871. By the late 1880s fashionable street architecture in London was dominated by what H.S. Goodhart-Rendel unkindly described as the 'bric-à-brac Renaissance' style,[38] a free adaptation of French, Belgian, Spanish or English Renaissance motifs developed, usually with much display of terracotta decoration, in deliberately picturesque contrast to the plain stucco terraces of the Georgian tradition. T.E. Collcutt and Ernest George were its two finest protagonists but the virtue of the style was the freedom it gave for individual interpretation, and many architects, including Verity at Hill's Bakery and in the facade of the French Hospital, Shaftesbury Avenue, had a great deal of fun with it. Verity had served part of his apprenticeship at the National Art Training School in South Kensington. Here, under Captain Fowke, he assisted in the detail work for the Albert Hall and would have become familiar with the vocabulary of Italianate ornament and architectural figure sculpture in the manner of Stevens then being applied in the new museum buildings by Godfrey Sykes and his assistants. Perhaps it was for this reason that Verity was among the first architects to seize upon the special qualities of the work exhibited by Harry Bates in the Academy during the summers of 1884 and 1885. At all events, during the course of his work on the bakery, he took an important decision. Most of the enrichments on the facade were to be moulded by J.C. Edwards, terracotta suppliers at Ruabon, from full-sized models provided by C.H. Mabey of Storey's Gate, a well-known and conveniently local firm of architectural decorators.[39] Mabey's advertisement was then frequently to be seen in the press, inviting the attention of 'architects and others to an extensive stock of new designs for buildings in all styles . . . Figure and architectural modelling and carving . . . ceiling flowers, cornice enrichment, capitals, trusses, enriched panels, chimneypieces,

21. Harry Bates, *Reaping*, c.1886–7. Terracotta relief panel. From 60 Buckingham Gate, Westminster.

20. (facing page) 60 Buckingham Gate, Westminster (Thomas Verity, completed 1887 for Hill's Bakery, demolished 1980).

22. Harry Bates, *Milling*, c.1886–7. Terracotta relief panel. From 60 Buckingham Gate, Westminster.

etc. Reredos, pulpits, fonts, tombs, monuments . . .' The range was limitless but Verity decided that the principal area of the facade should be reserved for the display of high sculpture, and Bates was commissioned to design and execute it.

'Mr Harry Bates', wrote Walter Armstrong in 1888, 'belongs to a class of artists which used to be much more numerous than it is, I mean the class which begins with some branch of aesthetic industry and climbs from servitude to creation.'[40] By the time Bates returned from Paris in 1885 he had at last, in Armstrong's forceful metaphor, 'built the bridge by which he might cross from industry to art'. But the three relief panels brought back from Paris and exhibited at the Academy that year were a proud statement that the feeling for architectural values, developed during his long training and practice as a carver with Farmer & Brindley, remained unchanged. They form a triptych in bronze and are known as the Aeneid reliefs, each inscribed with a quotation from Virgil (plates 23–5). Yet, as Armstrong pointed out, they are 'in no sense illustrations. The words of the poet afford a mere shadow of raison d'être for the attitudes of the figures and for their accessories. The problem was to produce three decorative plaques in high relief, to which unity would be given by the fitness of each for its place in the group, by the balance of parts and by the subordination of the whole to an architectonic idea, that of the pediment.' Only one complete set of Aeneid reliefs is at present known, that in the Glasgow Art Gallery.

The first and left-hand panel, *Whither does he fly?* (of which there are bronze casts also in the National Museum of Wales and the Fitzwilliam Museum, Cambridge), is a horizontal rectangle in form but its composition is triangular, designed to fill the left angle of an imaginary tympanum. Two half-draped female figures – Dido and her sister Anna – are set against the flat background of a high podium, on a narrow shelf roughly inscribed with the relevant Virgilian text. Anna, crouching to the far right, cradles the outstretched arms of Dido whose prostrate body extends to the far left lower corner of the panel. The women gaze into the distance, where, in the upper left corner beyond the podium with its glimpse of fluted column shafts, three boats are setting sail. The modelling ranges from the highest relief, in the projecting knee of Anna, to an almost imperceptible disturbance of the surface on the distant horizon. The second or central relief is square in form, appropriate for the space beneath the apex of the 'pediment'. Entitled *Then indeed Aeneas wept*, it is filled by the nude crouching figure of

23. Harry Bates, *Whither does he fly?* (1884). Bronze, 9 × 19 in. Glasgow Art Gallery.

Aeneas, turned away from the spectator to lean upon an inscribed plinth. A pair of horses, reminiscent of the Parthenon frieze, prance in the distance. In the third panel, *The form of the god . . .*, the composition of the first is reversed, with two corresponding figures of Mercury and the sleeping Aeneas arranged in the left foreground. The reliefs illustrate the developing characteristics not only of Bates's own style, but of the New Sculpture movement as a whole. They exhibit that nervous energy in the handling of form and line and that sensitivity to the nature of bronze which have their closest English precedent in the work of Stevens. They combine classical ideal and romantic realism in a manner that owes much to Dalou and Rodin. Above all, their motive is the expression in sculptural terms of a state of mind. Their true subject matter is neither classical myth nor the visible world, but yearning, grief and dream.

In common with many of his contemporaries, including the late Pre-Raphaelite painters with their similar motives, Bates felt no pressing need to be constantly inventing new images but would adapt an idea again and again to serve different decorative functions. The clearest example of this practice in his work is a later commission from Verity's client William Hill to provide two bronze plaques at the entrance to Hill's tea-shop in Kensington High Street. *Spring* and *Harvest* (plate 26) are repetitions in all but minor details of a pair of bronze reliefs representing *Peace* and *War* (plate 27), executed in 1887.[41] In the later panels the relief is much flatter, in deference, no doubt, to the shop's narrow entrance recess. The helmet and shield of the nude warrior have become the straw sun-bonnet and scythe of a farm labourer; a branch laden with fruit takes the place of a classical pilaster. Similarly, it was upon the basis of the Aeneid pediment composition that Bates developed the themes of the bakery frieze, adapting figures conceived for a deep triangular field to shallow rectangular panels grouped in responding pairs on either side of a central bay.

Critics trying with mounting excitement to define the revolutionary nature of exhibition sculpture in the 1880s had coined the term 'imaginative realism'.[42] It was this quality, briefly glimpsed in Stirling Lee's Liverpool panels, and so markedly different from the social realism of Benjamin Creswick, that entered the context of late Victorian architecture for the first time in the terracotta reliefs for Hill's Bakery. The heroic nudes are as idealised in their way as those closely related figures that decorate the border of Stevens's 1862 Exhibition certificate (plate 28), yet Bates presents this

24. Harry Bates, *Then indeed Aeneas wept* (1884). Bronze, 9½ × 9 in. Glasgow Art Gallery.

25. Harry Bates, *The form of the god . . .* (1884). Bronze, 9 × 19 in. Glasgow Art Gallery.

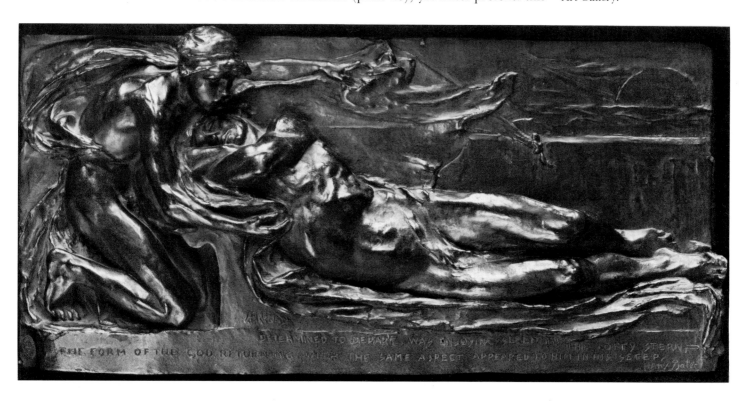

26. Harry Bates, *Harvest*, *c.*1895. One of pair of bronze panels from entrance to 29 Kensington High Street, 90 × 41 in. Private collection.

27. Harry Bates, *War*, 1887. Plaster model for bronze bas-relief, 21 × 10 in. Tate Gallery.

ideal not as an end in itself, but as a means of evoking a mood, a tentative and private dream-world. The contemplative air of the figures, the loving observation of ordinary detail like the country hats and tiny agricultural scenes in the background, even the lettering of each plaque, carelessly interrupted or pushed to one side by the encroaching sculpture, are evidence of an approach to reality that would have been unthinkable to the late neo-classicists – and, indeed, to Stevens.

The *British Architect* devoted an unusual quantity of text and illustrations to the bakery, the planning and equipment of which was intended to set a new standard of hygiene and efficiency. At only one point did the reporter diverge from a ponderous homily on function to comment on design. The introduction of 'high-class sculpture' in the 'admirable . . . plaques by Mr Harry Bates' would alone make the building worth going to see, 'and it is to be noted', he exclaimed, 'that this beautiful modelling is not thrown away by being fixed out of sight; it is, on the contrary, just at that altitude . . . where its excellence can be fully appreciated. Both the vigour and delicacy of it are alike apparent to the passer-by . . . Four sculpture panels like these are enough to give Mr Bates a reputation among architects.'[43] They were enough, certainly, to fill Roscoe Mullins with hope that 'the long prayed-for unity of the arts is on the horizon of the near future'. Over the business premises of a large confectioner in Westminster, he told the National Association in Edinburgh in 1889, 'is some most excellent terracotta work, representing the various stages and processes that corn goes through before it is made into bread'. If only this kind of 'natural and healthy demand for sculpture' could be developed, we would accumulate a store of good decoration 'interesting, not only from its subject and its execution, but from the harmony of place and surroundings'. The public would begin to care for sculpture only when it came to be seen, 'not as a mere excrescence to a building that did very well without it, but as part of the general plan of decoration, where its presence beautifies and ennobles all the rest'.[44]

28. Alfred Stevens, Certificate of Honourable Mention for the International Exhibition, 1862. Victoria and Albert Museum.

It was upon this aspect of sculpture as integrated decoration that the debate at the Art Congresses chiefly turned. The National Association for the Advancement of Art and its Application to Industry held its first congress in Liverpool in December 1888. This 'great preaching mission by the apostles of art for the benefit of the public at large', as the *British Architect* described it,[45] was led by Frederic Leighton, the Association's President. Vice-Presidents included Sir Coutts Lindsay of the Grosvenor Gallery and R.S. Holford, long-suffering patron of Stevens. The Association's object as defined at the first congress was 'to meet yearly in one of the principal manufacturing towns in Great Britain to discuss the welfare of the Arts, Fine and Applied'. The congress divided into sections for lectures and discussion and Alfred Gilbert was elected President of the sculpture section. Significantly, in his opening address, he declared that it was the duty of sculptors to *broaden their scope*, that they must respond to 'the increasing demand for their co-operation in the great architectural revival now making itself so evident in our new streets and dwellings'.[46]

In the papers that followed, at this and the subsequent congresses in Edinburgh in 1889 and Birmingham in 1890, the need for interaction between the two arts emerged as one of the strongest themes. Moreover, the most articulate arguments in favour of sculpture in and on buildings were made by architects, free at last from the restraints of mid-Victorian revivalism and eager for experiment. William Emerson, future President of the Royal Institute of British Architects, appealed to Church and Government to shoulder their responsibility in creating demand for sculpture, which 'finds its noblest and highest use in its application to architecture'. Meanwhile architects and sculptors must

work more together in the first conception . . . of designs, and must not desire to be independent of each other's views in the carrying out of works. Architects must consider more carefully the style of architecture necessary for effective embellishment by sculpture, must aim at rendering their compositions more noble and worthy vehicles for the introduction of sculpture, must study the best positions for showing it to advantage.[47]

The paper read at Liverpool by the architect John Belcher was less impassioned than Emerson's but, in retrospect at least, carries much greater weight, for Belcher was already at work upon a remarkable design embodying the principles it outlined. He was careful to establish that architecture could – and sometimes, when it had 'some plain or stern message to deliver', should – maintain its independence from the other arts. Whenever collaboration was appropriate the architect must lead, treating sculpture as 'a jewel whose beauty is to be enhanced by an appropriate setting'. He must, however, seek the sculptor's help in expressing the building's aim and character; must not use his work merely as a means of filling a void but provide plenty of plain wall surface to give decoration its 'due weight and value'. Clarity of form and outline was essential. 'A simple frieze or panel of concentrated ornament will speak more profoundly, and with a better chance of being generally understood, than all the exuberance of mere decorative verbosity.'[48] Even J.D. Sedding, who hotly refuted the more extravagant claims of Emerson that architecture without sculptural decoration was 'debased and dead', contributed many pertinent comments on the sculptor–carver issue. 'To me,' he said, 'it is little short of a scandal that the reredos of St Paul's – one of the costliest pieces of sculpture of the century – should go, as a matter of course, to Messrs Farmer & Brindley, while the successors of Flaxman and Stevens could have done the work right nobly.'[49] (The marble reredos for his own church, Holy Trinity, Sloane Street, was currently in the hands of Harry Bates.)

In terms of the original aims of the National Association as implied in its full title – '. . . for the Advancement of Art and its Application to Industry' – the success of the congresses is questionable, for no practical links were made with manufacturers. However, as an open platform for debate between architects and sculptors they had a tangible and long-term influence. Unlike the talks and discussions held at the Art Workers Guild, papers read at the three congresses reached a wide audience through publication. Many of the speakers were subsequently invited to address other organisations on closely related topics and often these papers in turn were fully reported in the press. In 1891 George Blackall Simonds, first Chairman of the Guild, read his congress paper on 'Some Aspects of Sculpture considered in relation to Architecture' at the R.I.B.A. In the same year W.S. Frith and Stirling Lee spoke on wood and stone carving at the Architectural Association, reiterating and developing themes first put forward at the congresses. Their fellow-lecturer on that occasion was F.W. Pomeroy, who in 1894 was appointed to give classes in modelling at the Association.[50] In 1892 John Belcher, Frith and Lee took part in a discussion at the R.I.B.A. on 'Sculpture and Sculptors' Methods in Relation to Architecture', Lee expressing his joy at being welcomed 'home into the family of architecture'.[51] In 1897 Gilbert was invited to address the Institute in a lecture entitled 'The Sculptor's Architecture of the Renaissance'. In 1896 Roscoe Mullins, an articulate congress speaker, was appointed teacher of modelling, with special reference to architectural decoration, at the London County Council's new Central School of Arts and Crafts,[52] and in 1900 he represented the sculptor's point of view in an R.I.B.A. symposium, 'The Collaboration of the Architect, the Painter and the Sculptor'.

Another platform from which sculptors could publicly declare their readiness and ability to adopt new roles was provided by the Arts and Crafts Exhibition Society. Significantly, it was an architect, the Venetian Gothicist George Somers Clarke, who explained in the introductory notes to the first catalogue of 1888 how the Society's aims related to sculpture. 'In these days', he wrote, 'the "sculptor" is far too often a man who would think it a condescension to execute decorative work. From his method of

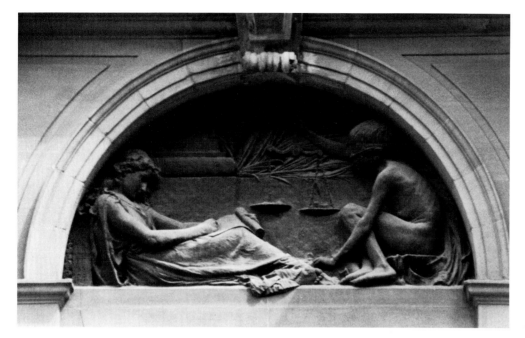

29. William Reynolds-Stephens, *Truth and Justice*, 1888–9. Bronze lunette relief panel. National Westminster Bank, High Street, Croydon (W. Campbell-Jones, completed 1889).

training he has, in fact, lost all knowledge how to produce such work. He understands nothing of design in the wider sense, and being able to model a figure with tolerable success, rests therewith content. The result is, that his work is wanting in sympathy with its surroundings; it does not fall into its place as part of a complete conception.' Figures were 'stood about' like ornaments on the mantelpiece, architects apparently as unable to prepare for them as sculptors to produce them.[53] The preponderance of modelled or carved relief work in the first exhibitions is a clear indication of the principal purpose of the Society as far as sculpture was concerned: the relief carries specifically architectural implications, for all three-dimensional decoration applied to the fabric of a building is, in a sense, relief sculpture, having a fixed background and offering a limited range of viewpoint. Most of the sculptors closely associated with the Society up to the time of its third exhibition in 1890 were engaged, during the same period, on work that played a crucial part in the early development of architectural figure sculpture and in stimulating public awareness of its new vigour. Bates was on the committee, though he did not exhibit. Creswick, who showed a plaster model for the Cutlers' Hall frieze in 1888, under the aegis of the Century Guild, was the most prolific sculptor-exhibitor in the first two years. Thornycroft showed two bas-reliefs in 1888. In the same year, in a kindly letter of advice to the young John Tweed of Glasgow, he wrote that he had recently seen some work by students at the Glasgow School of Art: 'It was in the form of decorative panels, a *very important* form of art.'[54] During the following year, when he became a member of the Arts and Crafts Exhibition Society, Thornycroft was himself embarking upon a seminal work of architectural sculpture involving monumental decorative panels in high relief. William Reynolds-Stephens, represented in the 1888 exhibition by a dance card holder and in 1889 by a copper photograph frame with figure reliefs, was simultaneously producing a bronze panel in high relief for the lunette over the entrance of a new building in Croydon (plate 29).

The London and County (now National Westminster) Bank in Croydon High Street was designed by the bank's architect W. Campbell-Jones and opened in June 1889.[55] The setting of this single precious work of high sculpture in a facade of otherwise minor

30. John Wenlock Rollins, stone pediment relief, *c*.1896. Croydon Public Library (Charles Henman, completed 1896).

interest emphasises the point that had been made at Hill's Bakery, for it symbolises the union not only of architecture and sculpture, but of commerce and art. That Reynolds-Stephens took considerable pride in the nature of the commission is suggested by his unusually explicit catalogue entry for the plaster model when it was exhibited at the Academy in 1889. The lunette is a rare example of the use of bronze for external architectural decoration, probably the first to be produced by a sculptor of the new generation. It contains many echoes of Bates's Aeneid and bakery reliefs, from the architectural detail in flat relief in the background to the crowding of the figures onto a narrow shelf in the front plane, their positions determined by the structure that contains them. On the left is seated a little girl symbolising Truth, her head bent with the curve of the arch in solemn contemplation of a scroll.[56] To the right the thin figure of a boy, naked but for a blindfold, is crouched on a low stool, holding out the scales of Justice. Spiky palm fronds, heavy with melancholy symbolism, fan out from the base of the column shaft to fill the centre background and cascade at his back. The perfect compatibility and interdependence in *Truth and Justice* of concept, technique and material is demonstrated by comparison with a neighbouring sculpture which owes much to its influence – the pediment decoration by John Wenlock Rollins on Charles Henman's Croydon Library of 1892-6 (plate 30). Here, in the hands of a lesser artist and in the medium of stone, the two boy figures set amidst conventionalised ornament are reduced to cyphers in a rigidly symmetrical composition. Children used to represent such grandiose abstractions as Truth and Justice were and remained rare in sculpture – Stirling Lee's brief venture in Liverpool was not well received – and Reynolds-Stephens's choice of them was, perhaps, more than a pretext for the poignant images he loved: a subtle flattery of the new branch bank with its unassuming character and modest scale.

Introducing an article on Reynolds-Stephens for the *Studio* in 1899, A.L. Baldry described him as belonging to that select group of artists who 'hold strongly to the creed that the true mission of the art worker is to prove himself capable of many things, to show that he has an all-round knowledge of the varieties of technical expression, and a

58

practical acquaintance with many methods of stating the ideas which are in his mind'.[57] It was the same devotion to versatility that dominated the careers of Conrad Dressler and F.W. Pomeroy, whose contributions to the first two Arts and Crafts Society exhibitions ranged from terracotta bust and ideal statuette to electrotyped copper tabernacle door in relief and light fitting design modelled in plaster. Stylistically, at least, Dressler stands, like Creswick, on the periphery of the New Sculpture, his allegiance to Ruskinian realism constantly at odds with the aesthetic values represented by the work of Bates or Gilbert. 'He likes the barbarous in fact,' wrote Frederick Miller, 'anything to get away from the school of art and so-called art designing.'[58] Dressler's characteristically heavy, somewhat coarse treatment of form is as apparent in his modelled work for the Della Robbia Pottery (initiated with Harold Rathbone in 1893–4 at Birkenhead) as in the carved reliefs with which he helped to complete the sequence of panels on St George's Hall after 1895. At the time of the first Arts and Crafts exhibitions he was concerned, amid much publicity, with the restoration of Magdalen Tower, Oxford. E.P. Warren, architect in charge of the work, thought the circumstances of Dressler's involvement there sufficiently remarkable to address a letter to the *Builder* on the subject. 'I think it is worthy of notice', he wrote,

> that Magdalen College has set a useful example . . . in acknowledging the 19th century and employing a young artist of recognised talent, in place of a firm of tradesmen, to supply their sculptural requirements [here the Editor interposed the note, 'We need hardly say that we are in entire accordance with Mr Warren in this opinion'] and I may say for myself that it has given me the greatest pleasure to be able to co-operate with a brother artist in this matter, and to illustrate my belief in the necessity of brotherly co-operation between sculptor and architect.[59]

Dressler and Warren joined the Art Workers Guild within a few months of each other, the sculptor in October 1891 and Warren in January 1892.

The importance of Guild membership as the source rather than the result of working relationships of this kind is difficult to assess. Many architects, including T.E. Collcutt, Edward Mountford, Aston Webb and Henry Hare, all of whom constantly employed sculptors, never became members, while even those connections which seem obviously to have begun there are seldom recorded as such. 'I made the friendship of J.D. Sedding in 1887', Pomeroy told A.L. Baldry, 'and executed many things for him.'[60] This was the year of his election to the Guild, of which Sedding had been a member since its year of origin. It was Sedding, a founding member of the Arts and Crafts Exhibition Society, who gave the sculptor his first opportunity to work as a decorative artist. In 1888 Pomeroy carved the capitals for the Church of the Holy Redeemer, Finsbury. He executed sculpture for the west front of the tower of St Clement's Church, Bournemouth, and the bronze choir stalls and screen for Holy Trinity, Sloane Street, the models for which were shown at the Arts and Crafts Society exhibition in 1890. Through Sedding he met Henry Wilson, the architect's pupil and successor after his death in 1891, with whom he worked on many occasions in the early 1890s. Together they executed a chimneypiece (no longer extant) for the reading room of Wilson's new Kensington Free Library in Ladbroke Grove and fittings for the chapel and library at Welbeck Abbey, part of Wilson's inheritance from Sedding's practice. Perhaps also inherited from Sedding was Wilson's strangely ambivalent approach to sculpture. On the one hand he was totally committed to the collaborative ideal. 'It is not enough', he wrote in an undated, unpublished paper, 'The Architecture of Monuments', 'to have panels to fill and friezes to flounder in; the sculptor ought to be in at the very birth of the

building and advise on the management of the mass and the distribution of light and shade.'[61] Yet at the same time he jealously guarded the concept that 'the work of the architect is sculpture in the large', for which decoration served as a desirable, but always expendable, and usually internal accessory. He used Pomeroy, to whom no reference or acknowledgement has yet been found among his papers, more as an interpreter of his own ideas for jewel-like sculptured fittings than as a collaborator on equal terms. His true aim was to become independent of practical help of this kind.

Pomeroy's own views were eloquently expressed in the paper on wood and stone carving that he addressed to the Architectural Association in January 1891.[62] The sculptors of the new school in England had, he said, already divided into at least two distinct groups. There were those who were severely limited in their art, because they had been trained primarily as modellers, and had no knowledge of the realities of their craft. The second and 'perhaps most important group' were 'the body of carver modeller's men who have received a thorough *craftsman's* training, who acknowledge the leadership of such men as Armstead, Thornycroft, Gilbert and Ford, and the vitality of their principles, as received from the great masters of the past. These are the men who recognise that sculptors' work is bound up with that of the architect, and that in the future it is in the highest degree desirable that he, the architect, should endeavour to carefully select his sculptor and give him a fairly free hand in carrying out his work'. Pomeroy went on to describe his attitude to realism in design and his belief in the natural affinity between architectural values and those of low relief carving: it is tempting to suggest that the paper may have influenced E.W. Mountford's decision, shortly afterwards, to engage him as sculptor for Sheffield Town Hall.

Mountford, who was a prominent member of the Architectural Association and its President in 1893–5, won the competition for the Town Hall in 1890 (plate 33). As the report on his designs describes, he had first intended to employ Benjamin Creswick as stone carver for the Pinstone Street front.[63] The recently completed terracotta frieze at Cutlers' Hall provided an excellent prototype for the kind of work that was required: the long shallow frieze running above the ground-floor windows was to represent 'six of the trades carried on in Sheffield'. Also, the idea of bringing in local artists appealed to Mountford. Even after his relationship with Pomeroy was established in 1891 he gave the relief carving on Battersea Town Hall to the Montfords, Paul and his father Horace (curator of the Sculpture School at the Academy), who had long been resident in the area. Mountford's design for Sheffield is strongly reminiscent of the then most renowned new public building in England, T.E. Collcutt's Imperial Institute in South Kensington. Like the Institute and that other great civic monument conceived in the 'bric-à-brac Renaissance' style, the Victoria Law Courts in Birmingham by Aston Webb and Ingress Bell, its principal elevation presents an intricate assembly of detail in which sculpture plays the same part as string course, pilaster, turret and tracery panel in fragmenting the wall surface and creating an overall decorative, picturesque effect. The lack of any true integration between sculptural decoration and architectural design is reflected in the arbitrary changes that Mountford made between the original and the final scheme: at first the decorative carving was to be confined to the frieze and

32. F.W. Pomeroy, detail of stone frieze, *c*.1892–5. Sheffield Town Hall.

31. (facing page) Sheffield Town Hall with sculptural decoration by F.W. Pomeroy.

33. Town Hall, Sheffield, competition design (E.W. Mountford). From *Builder* 28 June 1890.

61

to niches flanking the openings in the central bay, where statues of famous men connected with Sheffield were to stand. It is reflected too in the lack of co-ordination between the four principal areas of sculpture that Pomeroy was eventually required to produce: the frieze with its staccato composition of trousered craftsmen and labourers (plate 32), the symbolic figures of Steam and Electricity cut in low relief in the spandrels of the principal entrance, the massive ideal figures of Thor and Vulcan supporting the city arms over the Council Chamber window, and the panels of foliage ornament that surmount the first-floor windows in the projecting end bays (plate 31).

There is a striking contrast in quality between Pomeroy's work on the exterior and the lunettes and spandrels in the arcaded vestibule to the Great Hall (plates 34–5). Here, working in the Baroque style that he adopted for Battersea Town Hall in 1892 and in which he was most at ease, Mountford provided the sculptor with a series of six broad and boldly defined areas in which to develop a single theme. The grave seated figures emblematic of the civic virtues Faith, Fortitude, Charity, Wisdom, Work and Prudence are carved in low relief. In the framing spandrels, scrolls inscribed with related attributes are set amidst closely entwined and lovingly observed plant forms, demonstrating the ideas on the relationship between nature and design that had developed from Pomeroy's admiration of Morris and Sedding. 'Let us', he said in 1891, 'throw off the shackles of conventionalism; for now we only conventionalise on the conventional, and let us spend some of our time in studying the many beautiful trees and plants that abound in our country, bringing all our attention to bear on them . . . So that we may be real without being realistic, for realism is not design, and we shall learn more of the true nature of folial ornament in one short summer than by years of laborious copying from old casts.' The vestibule reliefs are perhaps the most complete expression in Pomeroy's work of 'imaginative realism', as defined by the sculptor himself in his Architectural Association lecture. A new approach to figure sculpture was developing, he said, from observation of the early Florentine Renaissance. By the fifteenth century the sculptor had become conscious 'of something more than the religion of beauty, [and] strove to add to his work ideas of character, of mind, of individuality of his subject . . . His mind sought to produce in his material ideas not only of beauty of appearance but of beautiful thoughts, true types of character, earnest definitions of mental qualities . . . he learned to give that true appearance of form, its charms and dignity, and likewise to preserve the thousand accidental graces of real human beings'. Seeking new subtlety of technique to match their new ideas, early Renaissance carvers turned to the medium of low relief, making discoveries they then

carried into their work in the round. No rude effects of black and white, but a delicate harmony of tones – nothing quite made out, the hollows not so deep, the projections not quite so high . . . Thus, in the statue of St John the Baptist for Sienna, by Donatello, the arms and some parts of the drapery are flattened quite in the manner of a relief; but this paleness of treatment (if I may use the term) is not allowed to be an excuse for slovenliness or want of power in drawing: there is no lack of finish, everything is wrought out with loving care, and cut to the highest perfection. Mino da Fiesole, Donatello, Verrocchio, Settignano and others, whose names call up sweet visions of grace and beauty, were all architectural sculptors in the true sense of the word.[64]

The subject of 'colour' in sculpture was both widely discussed and widely misunderstood during the late nineteenth century. In an article written for the *Universal Review* in 1888 Alfred Gilbert explained that by using the term in such a

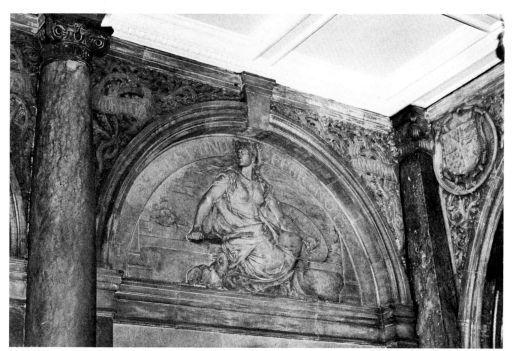

34. F.W. Pomeroy, figure representing Fortitude in lunette and spandrel decoration in Vestibule. Sheffield Town Hall.

35. F.W. Pomeroy, detail of Fortitude.

36. Town Hall, Battersea (E.W. Mountford, 1892–3).

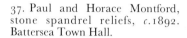

37. Paul and Horace Montford, stone spandrel reliefs, c.1892. Battersea Town Hall.

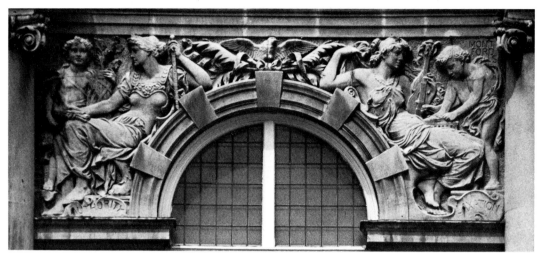

context 'we are merely expressing our sense of the presence of that just proportion of relief and due relation of one part to another which together bring about a harmony of light and shade, and gradation, and convey to us the "suggestion of reality through the means of convention".'[65] It is interesting that Pomeroy should have seen a close connection between 'colour' in this sense and architectural values. Concern for colour in its literal meaning had been one of the characteristics of the picturesque revival in architecture, as evident in Norman Shaw's 'Queen Anne' houses with their contrast of red bricks and white-painted sashes as in the increasing popularity during the 1880s of terracotta with its almost infinite range of tones from palest buff to salmon pink and deep red-brown. But by 1890 architects had begun to extend their comprehension of colour to embrace exactly that abstract sense in which Gilbert and Pomeroy understood it: Arts and Crafts architecture, and especially the Baroque style to which John Belcher, Mountford, Collcutt and many others turned, derives 'colour' not primarily from materials, but from the essentially sculptural relationships of solid to void, mass to outline and light to shade. This shift in emphasis had profound implications for sculpture. Instead of providing, like Pomeroy's frieze at Sheffield or Creswick's at Cutlers' Hall, little more than incidental pictorial interest, it could become at last part of the apparatus of architectural design.

Mountford's progress towards a new relationship with sculptural decoration, suggested in the vestibule at Sheffield, was confirmed in the elevation of the new Town Hall at Battersea (plates 36–7). The stone reliefs by Paul Montford and his father are concentrated in the spandrels of the two central openings and in the pediments over the three main bays where they enrich the facade like a coronet, echoing its serpentine rhythms and its light-hearted approach to classical form. The female figures represent the virtues and concerns of local government: Justice and Prudence, Art and Literature, Authority and Relaxation and so on. Some are accompanied by an ingenuous boy child, the growing municipality of Battersea. The Town Hall was opened in 1893. Its importance as a work of collaboration, briefly acknowledged in the press,[66] was overshadowed by the completion, early in May of the same year, of a building that set forth with startling and unprecedented clarity new terms of alliance between sculptor and architect.

In 1888 the Council of the Institute of Chartered Accountants in England and Wales invited six architects to submit designs for a new Hall and offices to be erected near Moorgate in the City of London. Following the decision of the ubiquitous competition-assessor Alfred Waterhouse, John Belcher was appointed architect and his winning design was published for the first time in January 1889 (plate 38).[67] Few architects who

64

saw it then or watched the building in progress over the following four years remained unmoved by its extraordinary qualities (plate 39). Playing with Baroque motifs almost as if they were pieces in a child's construction kit, Belcher had achieved an effect of immense grandeur and at the same time conveyed that air of sweet approachability which is the hallmark of Arts and Crafts design.

The building is faced in Portland stone. The principal part is of three storeys and thirteen bays, nine to the west-facing principal elevation in Moorgate Place with a central projecting entrance porch, one at the canted angle, articulated by an oriel window at the first floor, and three to the return onto Great Swan Alley which terminates in an octagonal turret. Here, owing to an ancient lights regulation, the height of the building drops to two storeys for the remaining bays, of which only three, containing the side entrance, are part of Belcher's original design. The extension to the east was added by his partner J.J. Joass in 1930.[68] Above the heavily rusticated piers dividing the ground-floor windows runs a broad band of masonry interrupted, over each pier capital, by a winged term that breaks through the upper string course onto the plain wall surface between the first-floor openings. The upper storey of the principal block is articulated by a plain order of bulky engaged columns carrying a massive entablature without a frieze. Between their lower shafts and immediately below the sills of the second-storey windows are deep panels carved with standing figures in high relief. This motif is carried over onto the lower return where the figures stand beneath the cornice in uninterrupted sequence, the whole forming a band of sculpture 140 feet in length. 'If', commented Reginald Blomfield in half-apologetic wonderment, 'this band of sculpture . . . is considered as a frieze, it is put in the anomalous position of starting level with the base of the columns, but this unconventional arrangement is amply justified on two grounds – first, that if put in the ordinary position it would have interfered with the lighting of the interior, and secondly, that it would have been, to all intents and purposes, invisible.'[69]

In addition to the terms and the frieze four other works of sculpture are integrated in the facade: two nude youths leaning from the scrolled pediment of the principal entrance to support the arms and shield of the Institute, the corbel beneath the angle oriel formed by two massive winged and fish-tailed atlantes, a figure of Justice surmounting the oriel, and, flanking a niche above the side entrance which was to have contained a bronze statue of Queen Victoria, two consoles formed by female half-figures terminating in foliated scrolls. No sources have yet revealed precisely how Belcher came to allocate responsibility for the sculpture. It is clear, however, that from the first he took a divisive view of the decorative carving, the figured frieze being paramount and all the rest secondary in importance, and that the role given to sculpture in the facade was the direct outcome of two closely related circumstances in his life: his friendship with Hamo Thornycroft and his strong identification with the principles of the Art Workers Guild.

Belcher, who was nine years older than the sculptor, born in 1841, had a long-established connection with the Thornycroft family. He designed the pedestal for the Poets' Memorial unveiled in Park Lane in 1875 (no longer extant), on which Hamo had worked with his father Thomas. In 1881 he sat to Hamo for the portrait bust in bronze which is now at the Royal Academy and built a house in Chiswick Mall for the sculptor's brother John, the naval architect. (Later, while the Chartered Accountants' Hall was in progress, he built a house and studio for Hamo himself, 2A Melbury Road, Kensington.) Late in 1883 the committee of the newly formed St George's Art Society led by W.R. Lethaby and E.S. Prior passed a resolution to 'invite . . . the co-operation

65

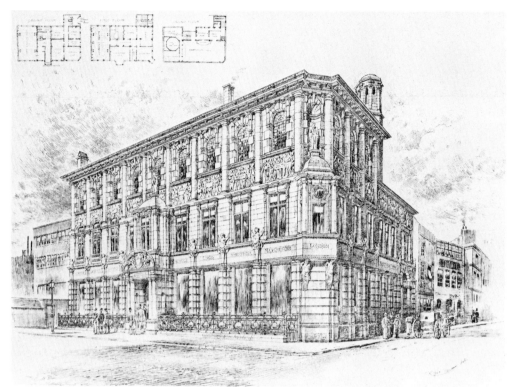

38. Hall of the Institute of
Chartered Accountants. Sketch by
Raffles Davison after John Belcher's
competition perspective. From
British Architect 4 January 1889.

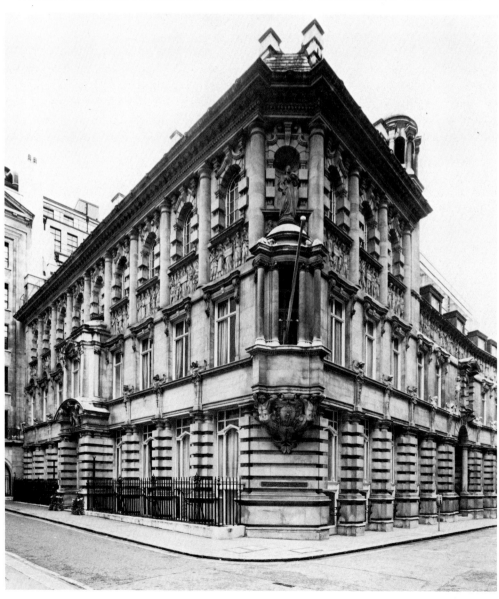

39. Institute of Chartered
Accountants, Moorgate Place, City
of London (John Belcher with A.
Beresford Pite, 1888–93).

of eminent Artists, Sculptors and Architects, in forming with this Committee a new Society for promoting more intimate relations between Painters, Sculptors, Architects, and those working in the Arts of Design'. Lethaby expressed his view that 'the drifting apart of Architecture, Painting and Sculpture is shown on the one hand in the trade decorations of our buildings, and on the other in the subject-painting and portrait sculpture of our Galleries. But any real Art-revival can only be on the lines of the Unity of all the aesthetic Arts.' When the committee set about gathering support for the scheme the first outside architect and sculptor to be approached were Belcher and Thornycroft, and Belcher took the chair when twenty-one artists met in January 1884 to consolidate their views. At the first official meeting, in May 1884, of the reorganised Society – now renamed the Art Workers Guild – the committee of six, including Belcher and Thornycroft, elected seventeen new members, among whom was Arthur Beresford Pite, chief assistant in Belcher's office and shortly to work as his partner on the Chartered Accountants' competition.[70]

At one of the earliest meetings of the Institute's building committee, on 1 February 1889, the architect announced that 'Mr Thornycroft R.A.' would undertake to design and execute the sculptured frieze for £3,000.[71] No doubt as a deliberate manoeuvre, Belcher had not included the cost of the frieze in the estimates that had accompanied his plans. The Minutes of Council do not reveal how the news of this additional expense was received but Belcher must have met with some resistance, for later in February he had to put forward the sculptor's offer again, pointing out that this area of the frontage would in any case necessitate an expenditure of at least £1,000 on ornamentation. The building committee, grasping the obliquely phrased message that decoration, if indispensable, might as well be done properly, recommended acceptance of Thornycroft's proposal.[72] To Belcher this rapid capitulation must have seemed to vindicate the argument he was to put forward at the R.I.B.A. two years later, when the experience of the Chartered Accountants' Hall was still uppermost in his mind. 'We may admit,' he said,

as an abstract proposition, that our work will gain in value and force when it is associated with sculpture. But how is this to be done? The opportunities are so rare, that when they occur we hardly know how to take advantage of them. In this grinding, mercenary age, when clients expect so much for their money, such an extravagance as sculpture seems out of the question – a luxury which the mere utilitarian aspect of a building will not allow . . . One remedy, I believe, is to associate the sculptor with ourselves early in the work; he should not be left to manipulate sundry blocks reserved for carving towards the completion of the building. His work should not be regarded only as a means of obtaining variety of texture on the surface of a front, or as a means of obtaining variety of skyline, or a counterbalance to defects in design. Such ignominious ends are not the proper use of sculpture. Whereas if the sculptor be taken early into consultation he will be able, if he rightly appreciates architectural completeness, to give expression to the purpose and object of the building, to emphasise its character, and animate it with life and beauty. When it thus becomes an integral part of the whole design, clients (whether individuals or committees) are more likely to value its significance and importance. If left to be added later on – if funds permit – and treated as an 'Applied Art' it is sure to be omitted on motives of economy and eventually forgotten.[73]

Amid some frivolous speculation as to the subjects that would be represented in the frieze – one subscriber to the accountants' professional journal suggesting that it should

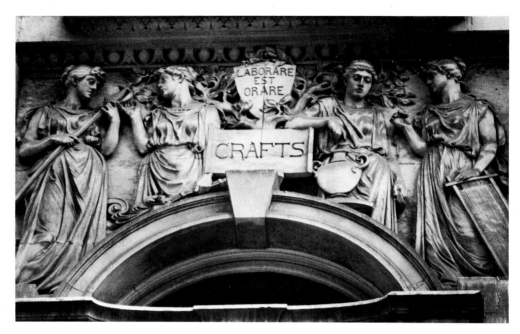

40. William Hamo Thornycroft, *Crafts*, 1890–1. Stone frieze panel. Institute of Chartered Accountants.

consist of 'a row of figures balancing themselves'[74] – Thornycroft exhibited at the Academy in 1891 a model for one of the panels over the Council Chamber to the left of the principal entrance. Here he introduced the visual theme that is continued throughout the frieze, a row of standing figures filling the whole height and width of each compartment and reading from below as a serried rank, both echoing and providing horizontal contrast with the brisk vertical rhythm of engaged columns and rusticated architraves in the upper storey. The frieze, stated the Batsford monograph volume published to coincide with the opening in 1893, 'represents those varied interests which look to the Chartered Accountants for financial guidance and order'. Within that loosely defined programme Thornycroft was able to combine realism and the ideal in a way that subtly underlines the spirit of Belcher's design. The first three panels, devoted to the Arts, Science and Crafts, are occupied by ideal female figures in classical drapery (plate 40). In the succeeding eight panels on the principal block, representing Education, Commerce, Manufactures, Agriculture, Mining, Railways, Shipping and the Colonies, only the central figures are symbolic, the rest portraying people in modern dress (plate 41). Over the two-storeyed wing in Great Swan Alley the link with reality is closer still: a single allegory of Building presides over a phalanx of representatives from the trades and professions associated with the erection of the Hall – surveyor, architect, stonemason, sculptor, carver, carpenter, plumber, plasterer, furnisher and so on.

Magnificent in general effect as an element in the architectural design, the frieze nevertheless reflects Thornycroft's unease in the role of architectural sculptor. He was concerned here with that characteristically Victorian theme, the heroism of labour. He had already given a remarkable new interpretation to the theme in the *Mower* of 1884 and *Sower* of 1886 (plates 141–2; see Chapter 6) and was now confronted by the opportunity to develop it on a massive scale. However, as Linda Nochlin has shown in her discussion of the work of Dalou and Meunier, Victorian sculpture seems to have had curious limitations as a medium for the expression of heroic realism. The frieze bears the same disappointing relationship to the *Mower* as Constantin Meunier's *Monument to Labour* bears to his earlier individual figures and groups. The French work,

68

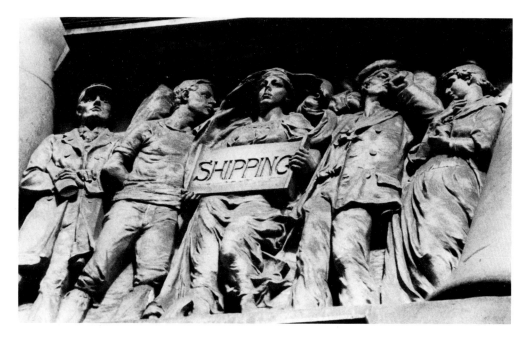

41. William Hamo Thornycroft, *Shipping*, 1890–1. Stone frieze panel. Institute of Chartered Accountants.

Nochlin wrote, 'reduces the individual elements to platitude rather than raising them, as the artist intended, to a higher level of symbolic grandeur . . . Once more, the dilemma of supporting an abstract or general theme with elements of realist specificity and concreteness becomes apparent, and the difficulty is obviously greatest where the demands of the programme are the most grandiose, as in monumental sculpture.'[75]

The second weakness apparent in the frieze has to do with technique. Thornycroft, for all his passionate admiration of the Parthenon sculptures, had little instinctive feeling for carving. He was essentially a modeller, interested in the process of building up three-dimensional form in the malleable, fluid substances of clay and bronze to create an effect of movement and spontaneity. His difficulty in reconciling the preliminary work of modelling with its ultimate expression in stone has led, in some passages of the frieze, to an unusual clumsiness of treatment. That this was evident even at model stage and cannot therefore be attributed to those who assisted with the carving – C.J. Allen, J.E. Taylerson and John Tweed, all from the South London Technical Art School[76] – is implied by the poor reception given to the *Science* panel when it was exhibited at the Academy. Claude Phillips commented: 'The work does not lack the dignity which he always has at command, but it is heavy and not very effective, while the draperies of the symbolic figures are decidedly inferior and wanting in style.'[77] Phillips put the fault down to a general unease in treating relief but no such unease is evident in Thornycroft's reliefs conceived for bronze or terracotta. Perhaps, too, the sculptor was unduly influenced by the work that provided the precedent closest, in both type and location, to his own. The soft, agitated drapery of his figures is reminiscent of Creswick's treatment of detail in the modelled terracotta frieze at Cutlers' Hall. It was their ability to respond to the nature of their materials that gave Harry Bates and his successors at Lambeth – Pomeroy's 'body of carver modellers men' – their special significance in the development of architectural sculpture. Pomeroy, when designing the Sheffield frieze, took constant care to work in terms of its final material, stone. Even the preliminary modelling, he explained, was worked from the front or surface plane, 'this being the true plane of all glyptic art, the opposite to the building up, or back plane of plastic decoration'.[78]

44. (facing page top) Harry Bates, group above principal entrance. Institute of Chartered Accountants.

45. (facing page bottom) Harry Bates, detail of corbel group. Institute of Chartered Accountants.

42. Harry Bates, detail of stone console, *c.*1892. Institute of Chartered Accountants.

43. Harry Bates, winged term. Institute of Chartered Accountants.

Thornycroft's contract began and ended with the frieze, but in June 1892 he offered to execute, without charge, a figure of Justice to be placed over the angle oriel. It was resolved that 'a vote of thanks be given to Mr Hamo Thornycroft for his handsome offer which the Committee had great pleasure in accepting'.[79]

Among the many remarkable aspects of the Hall is the opportunity it offers to compare his handling of carved decoration with that of the sculptor responsible for all the other figure decoration on the facade, Harry Bates. How he came to be employed here is not known but two possibilities present themselves: that he established a personal contact with Belcher and Pite during the brief period of his membership of the Art Workers Guild in 1886 or that he was recommended by the firm which carried out all the subsidiary carving for the Hall, Farmer & Brindley.[80] Neither annual reports nor committee minutes contain any reference to him, an indication that his work was classed under the general heading of 'Decorations', the estimate for which was £1,500.[81] There is, however, one clue to the kind of sum Bates received for his individual contributions. The only ornamental figures that are not suggested on Belcher's drawings are the consoles that flank the niche above the side entrance (plate 42). In July 1892 Belcher was authorised to 'spend a sum not exceeding £250 on additional sculpture',[82] and in October of the same year the *Accountant* reported that 'Mr Harry Bates has completed a second large design for the decoration of the new Hall'.[83] It seems likely that the two events were related and that the 'second large design' was for the consoles, added by Belcher as an afterthought and perhaps as a

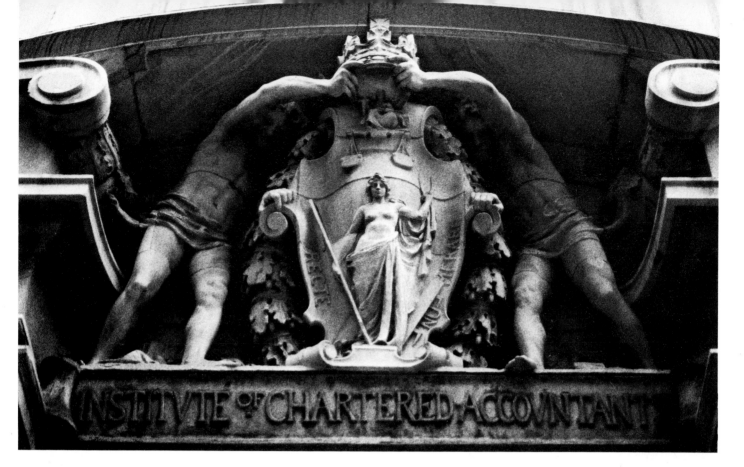

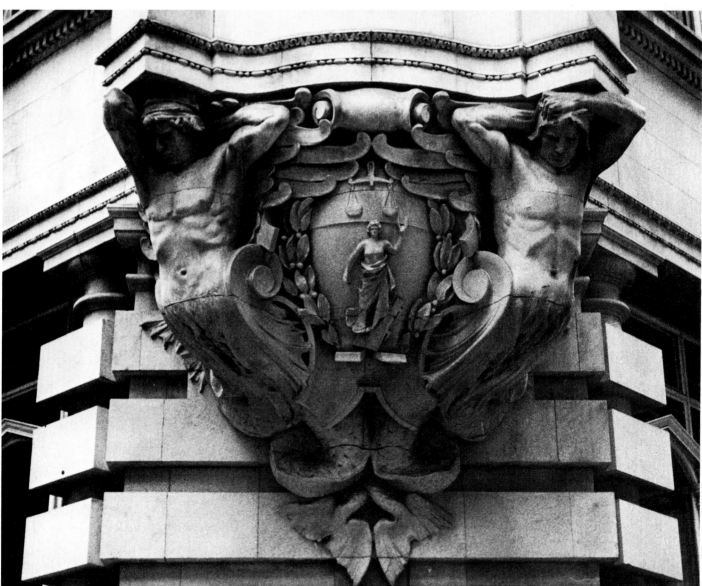

46. Palazzo Podesta. From *Palast-Architektur von ober-Italien und Toscana . . . Genua*, ed. Robert Reinhardt, Berlin 1886.

cheaper alternative to the bronze seated figure of Queen Victoria that he had first intended the niche to hold.

The consoles, terms and groups above the principal entrance and beneath the oriel all display Bates's astonishing virtuosity as a stone carver (plates 42–5). Constantly expressive, in their masses and planes, of the blocks from which they are cut, sparing yet precise in detail, heroic and yet full of humour and variety, they are so exquisitely matched to Belcher's building as to become an indispensable part of its meaning and character. As Raffles Davison's sketch of the competition perspective shows (plate 38), there are considerable differences of proportion and general design between these features as first conceived by Belcher and as finally executed, differences that must be credited to the sculptor and that demonstrate his extraordinary sensitivity to architectural as well as sculptural values. Belcher's provision for the decoration carved by Bates was in direct emulation of Genoese Baroque architecture. It has been suggested that a book on palaces in Genoa, published in Berlin in 1886, 'made Belcher see the possibilities of achieving integration by using the Baroque style'.[84] Some of its illustrations show detailing which is very close to that on the Hall and stress how completely Bates's sculpture enters into the spirit of the architect's audacious parody. A view of the front elevation of the Palazzo Podesta (plate 46) emphasises the ground floor where the openings alternate with winged half-figures on diminishing pilasters, the close counterparts of Bates's terms. A view of the garden shows the central pillars of the grotto to be terminated by two muscular fish-tailed caryatids supporting the forward thrust of a balustrade, just as the great corbel group carries Belcher's angle oriel.[85] Belcher himself gave more than a hint of his sources when he told the R.I.B.A. in 1892:

> Our buildings would gain in dignity and beauty if, instead of being covered from top to bottom with meretricious ornament or meaningless enrichments, the interest were concentrated on a few square feet of real sculptor's work, after the manner of certain old Spanish buildings and Genoese palaces, where the carving is centred in the entrance-doorways, which itself is placed in a broad field of plain wall surface . . . Pure and simple outline is desirable in work of this character, for, just as melody in music, this is able to reach and touch the heart.[86]

Just as the Chartered Accountants' Hall realised all Belcher's ambitions for architectural decoration – the terms set like jewels on their plain background, the broad field provided for Thornycroft to work in, the figures of the frieze 'considered and treated as a continuous band encircling the building' – so it set sculpture in a relationship with the Baroque style in architecture that was to last for nearly twenty years. It is a conscious celebration of the collaborative ideal. By what may have been only a happy accident, it celebrates too, through the participation of both Thornycroft and Bates, sculpture's new unity of purpose in the 1890s. The two men were exactly the same age – thirty-eight when Belcher's design was conceived – though Thornycroft, training for high art in the studio of his father and mother, had reached the Royal Academy Schools in 1869, much earlier than Bates who was then beginning a commercial apprenticeship. Thornycroft's acceptance of responsibility for the frieze (in the same year that he and Belcher joined Bates as members of the Arts and Crafts Exhibition Society) did as much as Bates's inspired carving to enhance the prestige of architectural sculpture and to end the prejudice that had dismissed it as a supportive craft without relevance to the glamorous world of ideal art.

4. The Triumph of the Collaborative Ideal

LIKE all artists in the age that invented psychoanalysis and began to probe self-consciously beyond the surface of human behaviour, architects and sculptors were united during the last decades of the nineteenth century by their longing to express a personal and unique identity. Among architects this need was commonly rationalised as a determination to develop a specifically 'modern' style, to broaden and sharpen observation of past tradition and to make it seem relevant to the present day. But their true motivation, as far as the external appearance of their buildings was concerned, is betrayed by the extraordinary diversity of design between 1875 and 1910, for which no better collective term has yet been found than the 'Free Style'. Sculptors too began to see the historical development of their art in a new light and found, in the quattrocento, justification for their own search beyond received notions of classical beauty for the expression of 'self'. Alfred Gilbert explained how his bronze statuette *Perseus Arming* (plate 129) had been directly inspired by his encounter, on the spot in Florence, with the works of Donatello. 'I was struck', he said, 'by the absolute independence and freedom of thought and truthful representation of the ideas they possessed. Without being merely photographic they were yet so true to nature that they revealed to me what I then understood as "style" but which I have since learnt to regard as the expression of an artist's individuality.'[1] The same statement in architectural terms was made by Lethaby in 1889: 'It is . . . the power to embody the old principle to the ever-new conditions, distinguishing and setting aside that which does not form part of the living thought of the time, which is the true objective of the true architect.'[2] The interest that architects took in the collaborative ideal sprang from their recognition of sculpture's power to contribute to the unique identity of buildings, to be a weapon in their own fight for 'freedom of thought'.

Signs of a new approach to sculptural decoration appeared quite spontaneously in the first major development of architecture away from the 'Battle of the Styles' – the 'Queen Anne' revival of the 1870s described by J.J. Stevenson as 'the outcome of our common modern wants picturesquely expressed'.[3] In their rediscovery of the brick buildings of the English Renaissance and eighteenth-century vernacular architecture the advocates of the new style had found the pretext they needed for a freer, more relaxed interpretation of classical forms. The flower panels in stone, cut brick or terracotta that decorate, with such deceptive casualness, the gables and walls of London Board Schools and the houses of Stevenson and Norman Shaw not only contribute to a carefully contrived pattern of picturesque asymmetry but, capable of infinite variation, help to establish the separate personality of each building on which

47. Cut-brick flower panel. Lowther Lodge, Kensington (R. Norman Shaw, 1874).

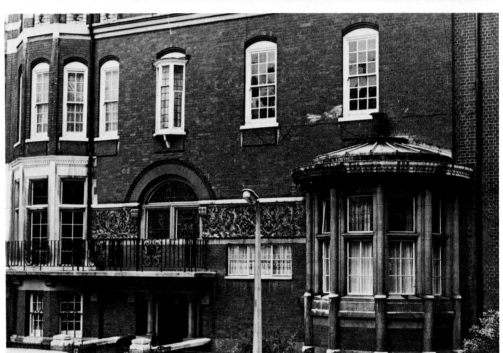

48. 10–12 Palace Gate, Bayswater (James Maclaren, 1889; stone frieze by George Jack).

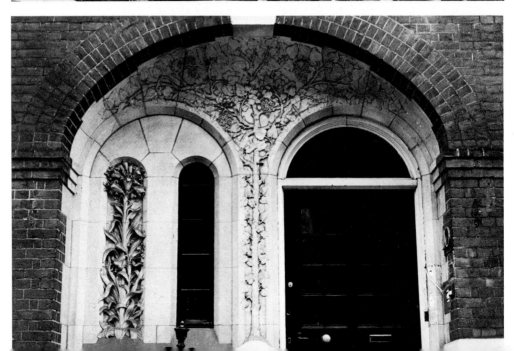

49. Entrance recess with vine and lily relief decoration. 10 Green Street, Mayfair (Balfour and Turner, 1895).

they appear (plate 47). Carved or modelled foliage ornament applied to facades became a kind of signature for the Arts and Crafts movement in architecture, especially on houses and small commercial buildings where figure sculpture was inappropriate or simply too costly for the client.

The Development of Foliage Decoration

Precisely the same general characteristic is evident here as in architectural figure sculpture: foliage decoration evolved from the isolated, self-contained sunflower panels of 'Queen Anne' to become an integrated part of facade design. George Jack's frieze for James Maclaren's pair of houses in Palace Gate of 1889 is given an important role in the asymmetrical arrangement of horizontals and verticals, providing a foil for the complex system of floor levels in the two lower storeys (plate 48). A different but none the less integrated use of flower and foliage decoration is illustrated by 10 Green Street, Mayfair, designed by Balfour and Turner (plate 49). Within a coved recess containing entrance and hall window a vine springs from the base of the central architrave to spread over the two arched openings and fill the cove. A narrow hall window is paired, within the left arch, by a niche of identical proportions containing a lily plant in high relief. Compared with Maclaren's frieze which is treated as an abstract element in the composition Balfour and Turner's vine and lily have the characteristics of *trompe l'oeil* ornament.

The form of architectural foliage decoration which came to prominence by the turn of the century was a synthesis of these two contrasting ideas. It seems to have been the joint creation of two of the most individualist designers of the period, Charles Harrison Townsend and George Frampton. In common with most informal relationships of this kind little is known of their collaboration beyond what may be inferred from isolated facts and finished works. Frampton joined the Art Workers Guild in 1887 and Townsend in 1888, possibly the starting-point for their friendship. In 1894 and 1895 their respective terms on the Guild's committee overlapped. But they are not known to have worked together until, in 1896, they were joint exhibitors at the Arts and Crafts Exhibition Society with a huge fireplace in American walnut for a house recently built to Townsend's designs in Düsseldorf (plate 50). Among the most conspicuous features of the fireplace were the capitals of the two columns supporting the mantelshelf: these comprised four tree branches issuing at right angles from the shaft and turning upward to form a solid four-cornered block of foliage. The chamfered angles of the shelf were carved with small trees set in shallow niches, the foliage of each flattened out to fit exactly the niche's round-arched head (plate 51). The massive simplicity of the fireplace and the carving that both echoed its severe geometry and provided a fascinating contrast of intricate and delicate detail, was a revelation to the critics who saw it in 1896. 'It is a work that owes little to precedent', wrote the *Studio*,

> and is yet infused with the best traditions of the past. Indeed, without eulogising it beyond its legitimate merit, one might claim that it supplies suggestions for a new architectural style. You cannot father it upon Gothic or Renaissance ancestors. It owes no more to Norman Shaw than to Welby Pugin. Even Queen Anne could not enfold it within the ample cloak of her charity, that covers a multitude of architectural virtues and sins . . . Mr Townsend's design is worthy of the very beautiful carving that Mr Frampton has wrought so cunningly.[4]

50. Fireplace for Linden Haus, Düsseldorf, shown by C. Harrison Townsend and George Frampton at Arts and Crafts Society exhibition, 1896. From *Studio* October 1896, vol. 9, p. 51.

51. George Frampton, detail of carved relief decoration on Düsseldorf fireplace, 1895–6. From *Studio* October 1896, vol. 9, p. 53.

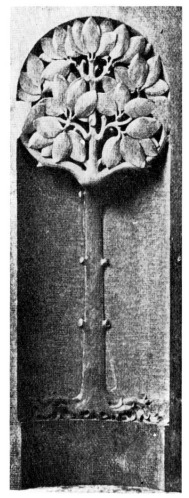

How much of the inspiration for this new type of foliage decoration, devised with exquisite care for an architectural setting, can be credited to the architect who designed the fireplace and how much to the sculptor who carved it? The evidence is confusing and the possibility cannot be discounted that behind the ideas of both men lay a common source: Burne-Jones's design for the Tree of Life mosaic in the American Church in Rome, first shown under the aegis of the Arts and Crafts Exhibition Society in 1888.[5] In 1892 Townsend designed his first large building, the Bishopsgate Institute in the City of London. The street frontage is divided horizontally by two foliated frieze bands whose spreading trees with flattened stylised leaves display a geometrical control that is clearly related to the foliage of the Düsseldorf fireplace (plate 52). Yet Frampton consistently claimed to have been the first to use trees in this way as architectural ornament. While still at work on the fireplace he told a *Studio* reporter that its carving 'follows no accepted style, but is an attempt to carry out a decoration suited to wood in a personal manner . . . My architectural training is useful for a work of this sort.'[6] It was not until the Institute was in course of erection, however, that the motif began to appear in his work in a clearly defined form. In 1894 Frampton moved with his new wife Christabel to 32 Queen's Road (now Grove), St John's Wood, which was to be their home until 1909. For the drawing room he designed a coloured plaster frieze in low relief in which cherubs' heads alternate with trees forming a semi-architectural arcade.[7] 'The idea of breaking a horizontal band perpendicularly into compartments by means of growing tree trunks', wrote the *Studio* in 1899, 'is now so widely adopted that it seems hard to realise that there was, not very long since, a time when the motif was regarded as an innovation on the hackneyed form of the acanthus scroll or of the ugly and artificial swag-ornament. Mr Frampton has, moreover, done signal service to architecture by inventing a new kind of capital, in which tree-stems, springing up out of the column, grow upward and unite in a solid cap of foliage at the top.'[8] The clear implication that Frampton had been responsible not only for carving but for designing the decoration of Townsend's fireplace was made explicit in W.T. Whitley's article on the history of the Arts and Crafts Exhibition Society written in 1910. One of the most outstanding exhibits in 1896, he wrote, had been a mantelpiece 'in the modelled detail of which appeared the typical "Frampton tree" that afterwards in numberless instances influenced the work of our young designers'.[9]

Examples of the widespread influence of the Frampton tree motif in architectural decoration include William Reynolds-Stephens's metal chancel screen for Harrison Townsend's Church of St Mary the Virgin at Great Warley of 1902–4, and the decorative detail on Manor House, Marylebone Road, a stone-built block of flats designed by the firm of Gordon & Gunton in 1903 (plate 53). Here the frieze running above the first-floor windows on the front and side elevations, and the bands at fifth-floor level on the angle turrets and projecting bays are occupied solely by stylised trees carved in low relief. Many designs produced by W.J. Neatby for Doulton at the turn of the century include exaggerated forms of the motif, such as the buff terracotta panels above the entrances of Orchard House, Westminster (plate 54); much commercial ironwork produced at the turn of the century, like the railings at 8 Bolton Street, Piccadilly, is indebted to the same source.[10]

Frampton's own use of tree capital and arcade may be seen combined in the Charles Mitchell Memorial at St George's Church, Jesmond, Newcastle-upon-Tyne, which he designed and modelled for execution in bronze, copper and enamel in 1897 (plate 56). 'The monument . . . occupies a space between two half-columns supporting a Gothic arch in one of the aisles,' observed Frederick Miller,

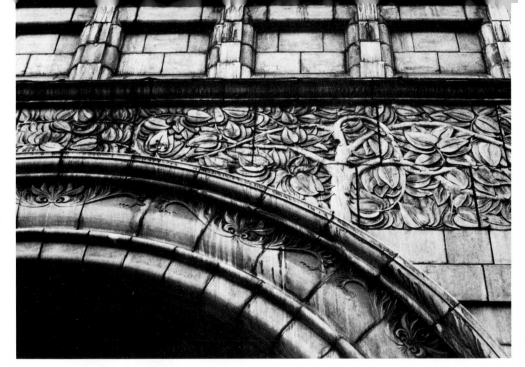

52. Detail of terracotta frieze decoration. Bishopsgate Institute (C. Harrison Townsend, 1892–4).

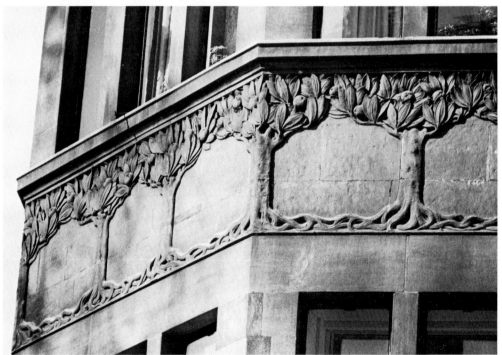

53. Detail of carved frieze, Manor House, Marylebone Road (Gordon and Gunton, 1903).

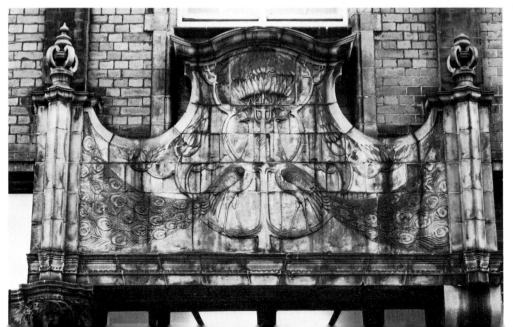

54. W.J. Neatby, terracotta panel, c.1900. Orchard House, Westminster.

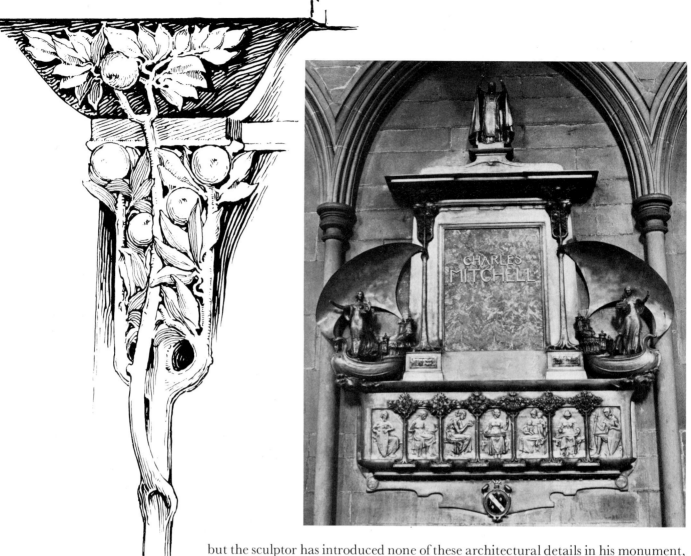

but the sculptor has introduced none of these architectural details in his monument, though most men would have divided up the panels below by columns for the very insignificant reason that columns have been so employed for some centuries, and therefore instead of thinking out a new way, something of one's own, precedent is followed. Mr Frampton goes back to nature, and models a tree trunk . . . to divide the panels, and in lieu of capitals or arches, introduces the foliage . . . Thought is displayed not only in the arranging of the foliage to fit it for the space it occupies, but in the ideas the herbs selected may symbolize . . . As he said to me, everything should have a meaning, a purpose – should be the outcome of thought, and not custom or laziness; and 'I can be just as much an artist in the way I use an ivy leaf as in the way I use the human form'; and he would repudiate such classifications as 'fine' art, 'decorative' and the like, for the simple reason that in art we have a republic and all and everything finding a place in that republic are of equal importance. There is no 'highest order art', for the smallest effort in art is the work of the imagination, and can alone be so judged.[11]

The principal panel of the memorial is framed by trees taking the place of pilasters, their fruiting branches forming 'capitals' to carry the surmounting cornice (plate 55). Frampton himself told of the disquiet caused by this break with tradition:

Many a grey head has been shaken in pained disapproval of the conventionalised, if somewhat naturalistic, capitals which I have worked into a mural tablet recently

designed by me. 'These are all wrong, you know!' they say, 'I never saw a capital without an abacus or with so great a space above the fillet. It looks very well, perhaps – it looks very well indeed, but I do not think any of the old men would have ventured to do that'. The fact being that if any one of the 'old men' for whom they have so reverential an esteem, had thought of doing it, and had wished to do it, he surely would have done it, and then it would have become a precedent for them to slavishly follow.[12]

Frampton's approach to style, as summarised by Miller, was strikingly-similar to that of Gilbert and Pomeroy. 'What you expect from every artist', he said, 'is that he shall give you a new point of view, bring his own perception to bear upon nature, which shall find forcible expression in his art; and the greater the power of the artist, the more stamped with his individuality (ego) will his work be. His character will show itself in his creations, and this very individuality becomes in time crystallized into what those who come after call "style".' It is this philosophy which underlies all radical movements in Western art and architecture at the turn of the century and which led so many artists to reject with dismayed incomprehension every attempt to classify their work as 'Art Nouveau' or by any other collective title. 'Absolute nonsense', declared Gilbert at the symposium on Art Nouveau organised by Marion Spielmann in 1904, 'I am incapable . . . of understanding what such a movement can mean.' Frampton, on the same occasion, wholeheartedly agreed.[13]

THE INFLUENCE OF THE CHARTERED ACCOUNTANTS' HALL

Frampton's participation with Townsend in the invention of a new kind of foliage ornament for architecture took place at the very time when the relationship of figure decoration to architecture was also undergoing profound re-examination. Among the first executed designs to make explicit reference to the Chartered Accountants' Hall were the Royal Insurance Offices in Dale Street, Liverpool, a commission won by Francis Doyle in competition in 1896. The panels forming a frieze beneath the second-floor windows and carried onto the first bay of the return are framed, as Belcher's are, by the lower shafts of bulky attached columns (plate 57). Their stone decoration is the work of Thornycroft's chief assistant on the Accountants' frieze, Charles Allen. He has faithfully imitated many aspects of his master's idea, each panel being filled with standing figures grouped round a central personage to whom they defer, but he has carefully avoided the difficult confrontation between realism and the ideal. Though they hold attributes of contemporary life, the attendant figures are clad in classical drapery. Like many eclectic artists, however, Allen seems to have been inhibited rather than inspired by the images he borrowed. The stolid formal group of *Fame* with two attendant infant boys set over the entrance on the return facade pays homage to Bates's group above the Institute's doorway yet only serves to emphasise how extraordinarily expressive and energetic the earlier work is.

The influence of Belcher's Baroque palace went much deeper than this kind of obvious borrowing. Even those architects working outside the Baroque style began to experiment with the idea of using concentrated masses of sculpture, not simply to give decorative interest, but to provide a nucleus for the grid-like geometry of their designs, or to underline the sculptural values upon which their organisation of masses and planes was based. The frieze of standing figures became one of the hallmarks of progressive design between 1895 and 1900. Projects by Percy Newton for a library,

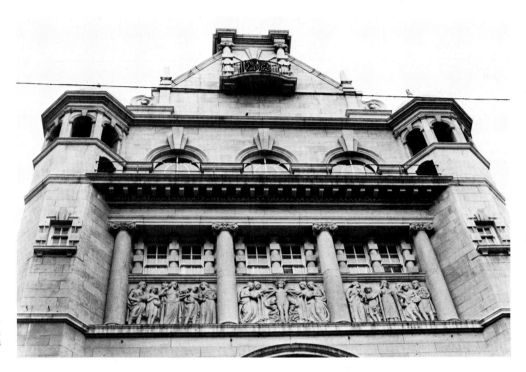

57. C.J. Allen, stone frieze panels, *c.*1900. Royal Insurance Offices, Dale Street, Liverpool (Francis Doyle, 1896–1903).

58. Design for market hall with sculptured frieze decoration (Charles Holden, R.I.B.A. Soane medallion competition, 1896). From *Architectural Review* 1896–7, vol. 1, p. 205.

Gerald Horsley for a University Settlements competition and C.H.B. Quennell for a picture and sculpture gallery, all published in 1895, gave this feature a vital function in the articulation of the facade.[14] So too, in 1896, did Quennell's design for an Institute of Architects, John Honeyman and Keppie's project for Paisley Technical Schools and Smith and Brewer's original scheme for the Mary Ward Settlement.[15] Friezes appear in G.C. Carter's Architectural Association student design of 1897 for a provincial bank,[16] and the Soane Medallion competition schemes of Charles Holden for a market hall (plate 58) and Alfred Houston for a concert hall (1899).[17] Outstanding among built schemes that continued the tradition into the twentieth century are Leonard Stokes's All Saints' Convent, St Albans (plate 116), and J.S. Gibson's Middlesex Guildhall completed in 1913 (plate 120).

Two remarkable examples of the integration of sculptural and architectural form are the work of Arthur Beresford Pite, Belcher's assistant when the design for the Chartered Accountants' Hall was conceived. The great caryatids that support the pediment to the second-floor window of 82 Mortimer Street contribute as much to the wit and mannerist fantasy of the facade as the architectural details themselves (plates 59, 60). Carved by Thomas Tyrell, Frith's successor as modelling master at the South London Technical Art School, they are the direct descendants of the caryatids designed by Stevens for the dining-room chimneypiece at Dorchester House. Pite's perspective drawing in the R.I.B.A. collection shows that Tyrell kept close to the architect's original conception but drew out, in the finished work, the Michelangelesque undertones of the east- and west-facing figures with their contrasting alert and slumbrous attitudes.

No drawings have survived to indicate how much freedom Pite allowed his sculptor at 37 Harley Street, a scheme completed some three years later, in 1899 (plate 61). For this he chose an artist with a highly individual style and a specialist in relief decoration, Frederick Schenck. Schenck is an obscure figure. He came from a Staffordshire family. After two years as National Scholar at South Kensington in 1873–5 he was appointed

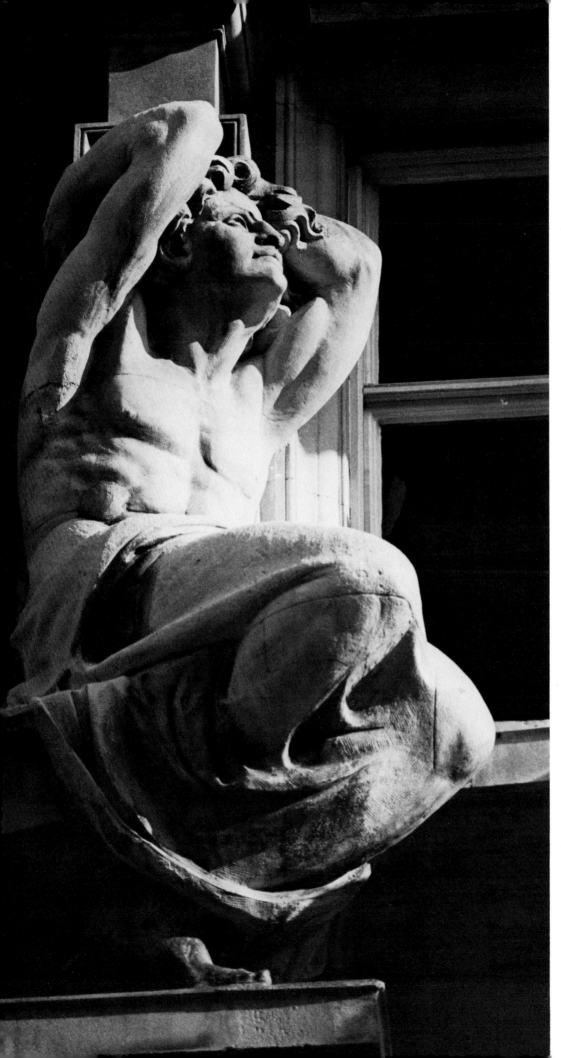

59. Thomas Tyrell, stone caryatid, 1896–7. 82 Mortimer Street.

60. 82 Mortimer Street, Westminster (A. Beresford Pite, 1896).

61. 37 Harley Street, Westminster (A. Beresford Pite, 1898–9).

62. Frederick Schenck, details of stone relief panels representing Poetry and Grammar, 1899. 37 Harley Street.

modelling master at Hanley School of Art. He worked as a designer for several potteries and exhibited at the Academy for the first time in 1886 from an address in Basford, Stoke-on-Trent. By 1889 he had moved to London. Here he began to use the Arts and Crafts Society exhibitions as a means of advertising his ambitions as an architectural sculptor. 'Mr Schenck', wrote Spielmann, 'is essentially an architect's sculptor, who has devoted himself to adapting his art to the decoration of the numerous great buildings which for some years past have been springing up all over the country. That is to say, Mr Schenck has sailed gaily on the top of the art wave that has been flowing of late, thanks mainly to the efforts of the present generation of architects.'[18] The critic was less than fair in implying that he had merely profited by an already well-established demand: Schenck's involvement with the Arts and Crafts Exhibition Society suggests that he had had a considerable part to play in creating it. His numerous exhibits in 1889 and 1890, including 'Panels in plaster for terracotta, Music and the Drama', 'Art and Science', 'model in plaster for ceiling or wall', 'panel carved in brick', leave no doubt as to the kind of patron they were designed to attract. Shortly afterwards Schenck was engaged on his first major works of architectural decoration, for the Council Chamber of J.M. Brydon's Municipal Buildings in Bath, and Henry Hare's Staffordshire County Hall, the latter initiating a long association with one of the most prolific civic architects of the Edwardian period. There are few public buildings designed by Hare which do not include Schenck's peculiarly abstracted and attenuated classical figures. The facade of Hammersmith Central Library, Shepherd's Bush Road, of 1904, shows them to particular advantage (plate 63).

Pite's attitude to collaboration between architects and sculptors was ambivalent.

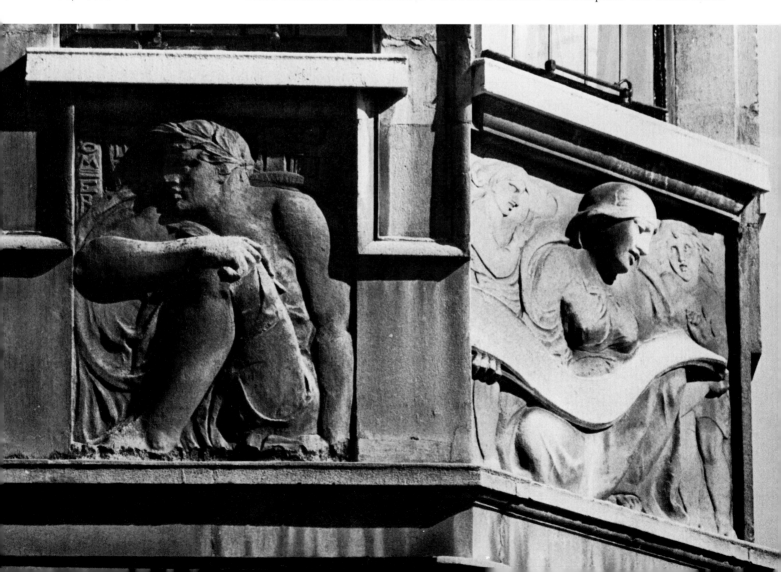

Like Henry Wilson, he was deeply conscious of the affinity between the two arts, yet jealous of the architect's right to total control over a building's aesthetic character. To him, as to Stevens, the true meaning of unity in art was not collaboration between separate individuals but the combination in one artist of many abilities. 'It seems to me', he said at the R.I.B.A. in 1897, 'that the time has arrived when perhaps the introduction of a little architectural vaccine in the arms of the sculptor, and the infusion of a little sculptor's blood into the veins of the architect, might produce a mongrel sculptor-architect or architect-sculptor of a distinctly strong breed.'[19] This was, however, an idea easier to propound than to put into practice and Pite's compromise seems to have been to avoid identification with any one sculptor and to engage only those, like the relatively obscure Tyrell at Mortimer Street or the Farmer & Brindley firm at 32 Old Bond Street, who were essentially technicians and ready to do little more than follow closely his own designs. It is not surprising, therefore, that the reliefs for 37 Harley Street are the only known work executed for Pite by Frederick Schenck. More surprising is the architect's choice, on this one occasion, of a sculptor with a highly individual style and his lavish provision on the facade of precisely the kind of decorative field for which that style had been developed: the shallow rectangular frieze panel. Pite's comment quoted above was made on the occasion in February 1897 when the great apostle of individualism in sculpture, Alfred Gilbert – recently elected Honorary Associate of the Institute – delivered an address entitled 'The Sculptor's Architecture of the Renaissance'. Characteristically nebulous and emotional though the sculptor's brief speech was, two points were made with forceful clarity. The first was that harmony between architecture and its sculptural decoration had been achieved in Renaissance Italy because sculptors had refused to be bound by convention, saw ornament as a means of expressing their own ideas and were free to respond as individuals to whatever tasks they were given. The second was a plea that unless sculptors today were accorded the same freedoms, no true alliance of the arts could ever take place. Casting fascinating light on his own inactivity as an architectural sculptor, Gilbert added irritably: 'It is a plea I would set up to architects – though it may be I cannot follow it – it is a plea not for myself, for I could not work under those conditions; . . . what I had in my mind was that the architect of to-day does not work, and does not seek to work, with the sculptor, and consequently the sculptor says "Buona notte".'[20] Perhaps it was more than a coincidence that Pite's association with a sculptor of pronounced individuality at 37 Harley Street – the most closely related of all his designs to the architecture of the quattrocento – should have followed so closely upon hearing Gilbert's address.

The *British Architect* declared the new building to be 'nothing short of a revolution' in Harley Street architecture.[21] The asymmetry which is a striking aspect of the design is strongly supported by the sculpture, concentrated in panels on the angle oriel and the three-storeyed bay window to the left of the entrance porch in Queen Anne Street. Each panel, filled almost to overflowing by figures carved in low relief on the front plane, is treated differently but within each group there is a tightly controlled equilibrium. Thus, in the angle oriel the figures in the upper order of panels echo in reverse the poses of those in the lower order. The deceptive spontaneity of the design is reinforced by the occasional substitution of dense foliage for figures in the panels and by the single, winged figure in high relief that appears to have alighted, like a great bird, on the oriel's upper stage. Schenck's iconography is not easy to decipher. The *Builder* described the reliefs as 'relating to the arts and labours of life'.[22] Many do seem to be referring to arts and attributes particularly relevant to life in the city: Poetry,

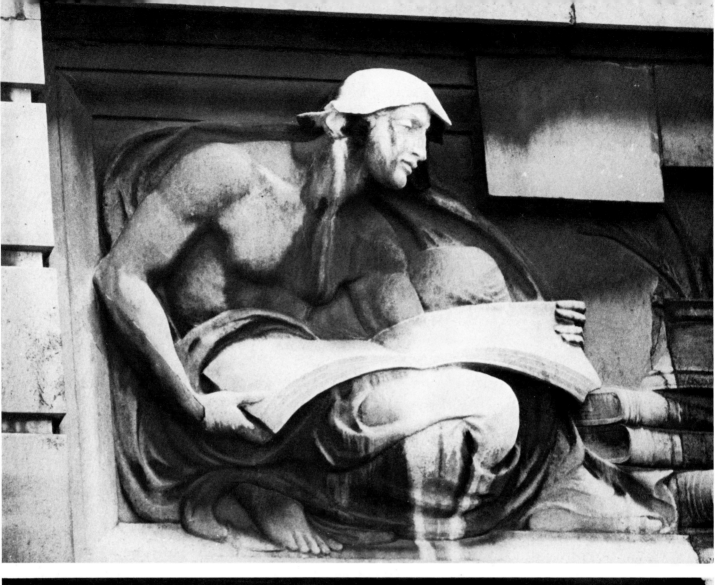

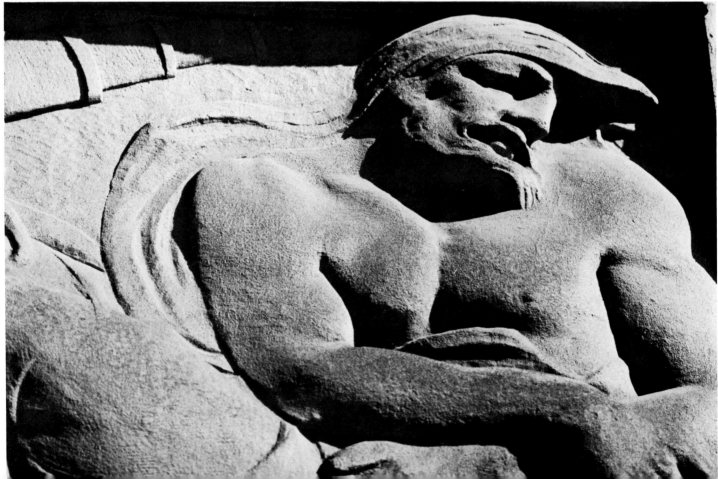

represented by Homer, is adjacent to Grammar (plate 62). Astronomy (plate 64), Justice and Philosophy may also be identified; and Fame, in the winged figure of the oriel. Schenck's free, unexplicit and intensely subjective interpretation of classical subjects and symbolism is part of a development that had begun in Harry Bates's *Aeneid* triptych. The Harley Street panels reflect that passionate interest in fifteenth-century Italian bas-relief which had become a crucial, unifying influence on decorative sculpture by the turn of the century. Unmistakably evident, in some of the distortions of pose, the set of a head between hunched shoulders, the cling of drapery against the flattened forms beneath, is Schenck's experience as a National Scholar of such works as Donatello's *Ascension* relief, acquired by the South Kensington Museum in 1861.

THE INVESTIGATION OF LOW RELIEF

Schenck was not the first to recognise in the conventions of Florentine bas-relief the source of a new and exciting direction for architectural figure sculpture. The seeds of this discovery are present in Bates's reliefs of the late 1880s and implicit in the work and opinions of Pomeroy and Gilbert; it was, however, George Frampton who grasped them with almost missionary fervour, developed them consistently in his work and was chiefly responsible for their dissemination. Of the stone-carver pupils who attended Sparkes's new school in Lambeth Frampton remained the most dedicated to the principles it upheld. 'I worked at regular commissions for architectural carving', he told the *Studio* in 1896, 'even while I was a student at the Royal Academy Schools – some of the students thought it *infra dig.*; but it seems to me that all ornament applied to a building should be as finely wrought as you can accomplish.'[23] His many commissions from architects up to the time he left the Academy Schools for Paris in 1887 included sgraffito work on the front of Tower Bungalows, Birchington, Kent (1882); a reredos for Manchester Cathedral and ornamental details for the Fawcett Memorial, Thames Embankment, both for Basil Champneys; a plaster frieze of dancing putti for a music gallery at 2 Kensington Court for T.G. Jackson (1885); terracotta reliefs of putti and garlands for columns on the Constitutional Club, Northumberland Avenue, for Colonel Edis (*c.*1886); and two panels with allegorical female figures, Concord and Industry, for J. Hurst Seagar's Municipal Buildings in Christ Church, New Zealand (*c.*1887).[24] The early work that survives or can be assessed from contemporary illustrations indicates that even at this date Frampton was fascinated by that shadowy area in which the principles of sculpture overlap those of painting and two-dimensional design. A large part of his working life was to be spent in investigating the peculiar properties of the decorative relief and the disciplines imposed by its background plane. In his first published article on sculpture, 'On Colouring Sculpture', which appeared in the *Studio* in 1894 Frampton wrote:

> A tendency has been noticed among architects to prefer bold ornament on their buildings – so bold, in fact, as to make the figures or foliage employed in the decoration nearly in the round . . . I have seen this fault indulged in to an alarming extent, especially in modern coloured reredoses, with Biblical scenes appearing to all the world like the performances of marionettes [a comment irresistably bringing to mind the reliefs of George Tinworth, as, for example, his tinted terracotta reredos for G.E. Street at York Minster]. I always think that the charm of low relief is its delicate lights and shades, and the losing and finding of the design.[25]

63. Frederick Schenck, stone relief panel, 1905. Hammersmith Central Library, Shepherd's Bush Road (Henry Hare, completed 1905).

64. Frederick Schenck, detail of stone relief panel representing Astronomy. 37 Harley Street.

65. Sketch of fourteenth-century carved wood coffer. From *Studio* December 1897, vol. 12, p. 161.

66. Robert Anning Bell, *Harvest*, 1890. Coloured plaster bas-relief, 22 × 12½ in. Private collection.

It is difficult to assess whether Frampton's observation of early Italian Renaissance carving was the cause or the effect of his conviction that relief sculpture must constantly echo and respond to the flatness of the decorated surface. His delight in a carved coffer at South Kensington emphasises, however, the key role played by the Museum of Manufacture in his development (plate 65). This *cassone*, he wrote in 1897,

I have for long regarded as one of those rare instances of artistic completeness which in their simple perfection produce the same sensuous effect of pure satisfaction as does the strain of some melody beloved in childhood . . . The whole of the flat surface of the front is enriched by the cunning of the carver until it fairly palpitates with beauty . . . Firstly to be observed is the absolute flatness of the entire work, a flatness which does not depend entirely upon the obviousness of the technical method by which the design is incised rather than carved . . . but is emphasised by the actual lines of the design itself. Even if a slight degree of modelling had been employed, the effect as a whole would still have been flat and reposeful. Secondly, note may be taken of the happy disposition of the lines of the design in relation to the space it occupies . . . Again, the requisite amount of mystery is attained by the simplest of means. At a slight distance the general effect is pleasurable in the extreme, though the details of the various subjects may evade observation. There is a subtle movement, as it were, of the surface, a palpitation, as I have observed above, which appeals to the senses one knows not why or wherefore, and which would be altogether lost were definition sharp and insistent. On nearer acquaintance, the game of hide-and-seek, which the main lines of the design seem to have been playing with one's artistic sense, gives place to a realisation of their cunning intricacy and abiding interest. The figure subjects are conventionalised, one notices, to exactly the requisite point, while the borders are marvellous in their almost riotous opulence of decorative motive.[26]

In low relief as in no other medium, Frampton believed, lay the possibility of reconciling intricacy and understatement, sculpture's illusion of reality and painting's colour and line, and of securing that mysterious, elusive harmony of the sensual and the austere to which all late nineteenth-century art to some degree aspires.

In 1887, when he won the Royal Academy gold medal and travelling studentship and departed for Paris, Frampton's activity as an architectural decorator abruptly ceased. No major work of collaboration is recorded until 1897. The low relief panel remained, however, his chief preoccupation during the intervening years and the influence of his experiments was widely reflected, before 1897, in the architectural work of his contemporaries, notably Schenck and Frank Lynn Jenkins. The critic who wrote a description in 1897 of the coloured plaster reliefs by Jenkins and his painter friend Gerald Moira in the new Trocadero Restaurant had no doubt of the origin of this new decorative form. 'When Mr Bates and particularly Mr Frampton', he explained, 'seized and adapted the conventions of the 15th century bas-reliefs of Italy, a wide field of possibilities was opened up for the decorative artist'. Moira and Jenkins had, however, yet to master that perfect correlation between projection, perspective and background found in the reliefs of Donatello, Settignano, Pollaiuolo and Rossellino and 'made of late years familiar to us in the work of Mr Frampton'.[27]

During the 1880s Frampton had formed a friendship that, like his relationship with Harrison Townsend, was to act as a catalyst in his development. It is not known precisely when he first met Robert Anning Bell. A portrait of the painter-sculptor was among Frampton's earliest exhibited works, shown at the Society of British Artists in

86

the winter of 1884–5. By 1887 the two men were sharing a house and studio at 98A Warner Road, Camberwell Green, and beginning the exchange of ideas that was to result in such coloured plaster reliefs as Bell's *Harvest* of 1890 (plate 66). In this small panel, line and scarcely perceptible three-dimensional forms interact to produce an image of curious subtlety, its very tentativeness suggestive of meaning and mood beyond appearances. Frampton publicly declared his admiration for it in his *Studio* article of 1894: in the delicate swellings and recessions and incisions of its surface he would have recognised the element of mystery and understatement, the game of aesthetic 'hide-and-seek' that he had seen in the quattrocento carvings at South Kensington. In 1888 he produced the first of a series of plaster bas-relief panels that are a direct outcome of his association with Anning Bell.

Mary, dedicated to the painter William Margetson, Frampton's fellow student in the Royal Academy Schools, was dated 1888 and must have been produced in Paris (plate 67). It is closely related in subject, medium and the disposition of certain details to the coloured terracotta relief of the *Virgin and Child* by Donatello in the Louvre. As in the Renaissance panel the head of the Virgin is presented in left profile and framed by a halo that overlaps the upper edge of the frame. Significantly, however, Frampton has depended for the proportions and general composition on a different source: the crisp, flat images of quattrocento portrait painting. The *St Christina* bas-relief of the following year, first exhibited as a coloured gesso panel and afterwards cast in bronze, shows the same duality of intent (plate 68).[28] It might be argued that in their handling of relief Frampton and Bell were recreating the conditions of the early fifteenth century when the '*rilievo stiacciato* was a no man's land between painting and sculpture in which the sculptor could glean the fruits of pictorial research'.[29] The climax of the working relationship between them was marked in 1890 by their joint entry in the Arts and Crafts Society exhibition of altar panels in gilt and coloured plaster, variations on those designed for the reredos in Leonard Stokes's then recently completed Church of St Clare, Sefton Park, Liverpool (plate 69).[30] They are not known to have worked so closely together again. Frampton was ready now to build upon the foundation of his early relief modelling and to develop alone the 'mystic quality' that the *Magazine of Art* had already noted in *St Christina*[31] towards a more occult and profane imagery.

Shortly before he was in France in 1888 the manifesto of a new art movement, symbolism, had been published in the *Figaro*. The essential principle of art, it had declared, was 'to clothe the idea in sensuous form'. It may well be that his knowledge of

67. George Frampton, *Mary*, 1888. Coloured plaster bas-relief. From *Studio* January 1896, vol. 6, p. 209. Present location unknown.

68. George Frampton, *St Christina* (1889). Bronze bas-relief, 17 × 9½ in. Walker Art Gallery, Liverpool.

69. Robert Anning Bell and George Frampton, coloured plaster bas-relief panel from altarpiece of St Clare, Liverpool, *c*.1890. From *Studio* May 1893, vol. 1, p. 55.

70. George Frampton, *Music*, c.1895–6. Silver bas-relief panel for cabinet door. From *Studio* January 1896, vol. 6, p. 211. Present location unknown.

71. George Frampton, *Guinevere*, 1895–6. Plaster model for silver-gilt door panel, for Astor House, Temple Place. From *Royal Academy Pictures*, 1896, p. 91. (Completed door panels still *in situ*.)

this movement, fast gathering force in the early 1890s, helped Frampton to crystallise his own highly literary and individualist ideas. In 1892 he produced an ideal bust in polychromed plaster, *Mysteriarch*, that seems to have the status of a personal symbolist manifesto in his *oeuvre* (plate 152). The figure, cut off, as the *Studio* remarked, 'Florentine fashion, just below the shoulders',[32] is set upon a shaped base and backed by a rectangular screen with residual cornice and pilasters, in the centre of which, immediately behind the head, is a gilded disc modelled with an abstract motif of swirling, whip-lash curves. Thus, though the bust is modelled wholly in the round, something of the quality of a relief is imposed upon it and the 'exquisite serenity of this noble head is assured of its environment wherever it may be placed'. No harsh contrasts of hollow and projection disturb its taut and enigmatic mood. Simplicity of form and outline is offset by detail of the utmost precision and delicacy, as, for example, in the pleated fabric, winged headdress and great cabalistic brooch. The discoveries that early Renaissance sculptors had made in low relief, said Pomeroy, they had then carried into their work in the round. *Mysteriarch* shows Frampton in the very act of making the same adjustment and it has a direct bearing, ideologically as well as technically, on his later activity as an architectural sculptor.

In his early work Frampton kept close to the iconography of his first masters, the painters and sculptors of the Florentine Renaissance, content to further the 'mystic'

quality he sought with overtly Christian images of the Virgin or an obscure martyr-saint. *Mysteriarch*, too, has the solemnity of a quattrocento madonna, an impression reinforced by the halo-like disc behind her. Yet the mysteries over which, according to her title, she presides, have little to do with Christian lore. Part sorceress, part medieval princess, part classical goddess, she has attributes that include the bat, symbol of Night, and a Medusa-like head with entwined snakes, symbols of evil and also of the goddess Minerva to whom the helmet too seems to refer. The disc portrays, perhaps, the vortex of time from which she has emerged to confront the beholder. Melancholy, still, self-absorbed, and with a pathos heightened rather than diminished by the sinister undertones, *Mysteriarch* is in dramatic contrast to the agitated *femmes fatales* of contemporary French sculpture. When the bust was exhibited at the Academy in 1893, close to Gérôme's screaming *Bellona* in bronze and ivory, its peculiarly abstract, inexplicit, decorative qualities must have been startlingly apparent.

The beginning of Frampton's long preoccupation with the type portrayed in *Mysteriarch* coincided with his deepening relationship with Christabel Cockerell. Their marriage in 1893 heralded the fullest and most varied seven years of the sculptor's life. It was during the first flush of their home-making in St John's Wood that he set his mind to the design of household decorations. He made jewellery in enamel and precious metals for his wife because nothing in the shops was 'artistically effective' enough for her.[33] Together they made the frieze for their drawing room. In 1894 he was on the committees of the Art Workers Guild and the Arts and Crafts Exhibition Society, teaching sculpture at the Slade School under Fred Brown, elected Associate of the Royal Academy and appointed Art Advisor to the London County Council's new Technical Education Board. He became interested in the design of medals and had produced two notable examples by 1895, for Winchester College and for Glasgow University. He undertook commissions for decorative fittings, including two silver cabinet-door panels for James Mann (plate 70) and a folding screen, of what must have been delectable prettiness, for Alice Radcliffe, a wealthy art-lover who lived in Berkeley Square.[34] With painted figures of SS Elizabeth and Dorothy flanked by panels decorated with apple and rose trees, the screen was made of stained leather, lacquered gesso, enamel, silver, mother-of-pearl, aluminium, ivory and gold. He designed nine silver-gilt panels for the door of the Great Hall at Astor House, Temple Place, Westminster, depicting nine heroines from *Morte d'Arthur* (plate 71).[35] These exercises in low relief figure decoration for a narrowly defined architectural setting provided Frampton with a treasury of forms and ideas to which he and many other sculptors returned again and again in succeeding years. The models for seven of the Astor House door panels were exhibited at the Academy in 1896, the same year in which he made his most profound impact as an exhibitor with the Arts and Crafts Society. His showing then, which included the Townsend mantelpiece, the folding screen, and plaster models for the cabinet-door panels, was for long afterwards regarded as a standard by which future exhibitions were judged. 'Nothing', wrote E.F. Strange three years later, 'stands out as did . . . the . . . splendid series of modelled work by . . . Frampton [in 1896]'.[36] It was during the following year that the sculptor made a public statement which, only a decade earlier, would have been incomprehensible in the context of 'high art'. He told a reporter from the *Art Journal* that he preferred 'to be known as an art-worker and not by the more restricted title of sculptor'.[37] He was then on the point of accepting two of his most important commissions for architectural decoration, commissions that were to establish his place among the most renowned and sought-after sculptors in England.

In 1897 J.W. Simpson, the winner, five years earlier, of the competition for new art galleries at Kelvingrove, Glasgow, asked Frampton to supervise the external sculptural decoration of the building, now nearing completion (plate 72). No earlier connection between the two men is known, except their common membership of the Art Workers Guild to which the architect was elected in 1889. Simpson, whose best-known work apart from the galleries is Roedean School at Brighton of 1898, was no revolutionary designer. (He later became President of the R.I.B.A. and was knighted in 1924 for his services to the profession.) He was, however, an ardent enthusiast for collaboration and seems to have had a talent for attracting publicity to any scheme in which he was associated with a sculptor. He was responsible, in 1901–2, for the Queen Victoria Memorial at Bradford, in which Alfred Drury's noble bronze figure is hedged about by balustrades and other heavy and trite architectural accessories. It received, nevertheless, extravagant acclaim as an exemplary effort of 'practical collaboration in the Arts'.[38] Even a modest memorial to Mary, wife of Ernest Waterlow, on which he collaborated with Frampton in 1900, was accorded illustration and comment in the *British Architect*.[39] Perhaps the nationwide attention given to the Glasgow sculptures was as much the result of Simpson's promotional flair as a spontaneous recognition of his ability to advance upon the achievement of the Chartered Accountants' Hall.

Like Belcher, Simpson seems to have delayed confronting his clients openly with the question of decorative sculpture and its expense until the last possible moment, and then to have presented them boldly with what amounted to a *fait accompli*. As the *British Architect* remarked: 'In this country, to the architect of any structure of magnitude, there is no period of greater anxiety than when the time comes for him to present to the authorities under whom he works his scheme and estimate for the sculpture and decorative carving best fitted to give the crowning touch to his conception. He generally finds his committee embued with the cast-iron notion that this matter is an artizan's affair, to be priced per labour-time at trade-union rates.'[40]

On 23 July 1897 the Art Galleries sub-committee approved the architect's choice of Frampton as supervising sculptor and requested that sketches and a report be prepared for the Corporation's consideration.[41] This report, submitted in October, was published in full in the *British Architect*, on the grounds that it constituted 'a masterpiece of what such a document should be' and 'a precedent for use on future occasions'.[42] The first part of the report, written by Simpson and Frampton, describes in detail the disposition and subjects of the proposed decoration and ends with a special plea that the committee note 'the essential *structural* nature of the sculpture and carved work on this building. It is no mere filling of panels with ornament which may be left blank or unfinished without interfering with its form or design, but is in every case an integral part of the design.' The report then proceeds to explain how responsibility for the work was to be allocated. Frampton was to undertake the preparation of clay and plaster models for all parts of the work and supervise their execution in stone. He was also to take entire responsibility for the three most prominent areas of monumental figure sculpture on the facade: a free-standing bronze group of St Mungo and two attendant figures of Art and Music to be set beneath the central arch of the main north porch; the spandrels of this and the two companion arches on the returns of the porch, 'to be filled with groups of figures in low relief representing instrumental and vocal music'; and eight seated figures in the round symbolic of Music, Architecture, Painting, Sculpture, Science, Literature, Religion and Commerce, to crown the angle pavilions. Subsidiary

72. Glasgow Art Gallery and Museum, Kelvingrove (J.W. Simpson, completed 1897).

90

or less prominent decoration was to be shared among six carvers personally selected by Frampton from the Glasgow and Edinburgh districts, all of whom were eager to participate in this 'great municipal undertaking' and from whom competitive tenders had already been obtained. The sum allocated for sculpture in the original contract was a mere £5,000. Sweeping this aside, Simpson and Frampton began their list of estimates for each item of decoration as follows: 'Master-Sculptor – clay and plaster models, drawings and general supervision, £1,600; eight figure compositions on pavilions at £450 each, £3,600; group under central arch, £2,000; six low relief spandrels, at £300 each, £1,800.' The contract sum having already been exceeded by £4,000, the Corporation was informed that the estimated cost of subsidiary decoration was £4,894 6s. To this should be added a provisional sum of £250 for scaffolding and sculptors' sheds and another £500 for 'contingencies'. The paragraph ends on a note of almost impudent assurance: the Corporation's original commitment of £5,000 is presented not as a threat to the scheme but as a welcome little subsidy 'towards the expenditure proposed' of £15,644 6s. Of course, it was added, if the committee were unable to sanction the scheme, there were two courses open:

> First, to have the work executed by inferior craftsmen; second, to carry out a portion only, and leave the building unfinished. The first alternative will not, we believe, recommend itself to the committee. The building will be visited and criticized by the artists and *cognoscenti* of all nations, and the work must be such as we can show them, without fearing its comparison with their own productions. The second raises a purely financial question, which we are not competent to discuss. We can, however, affirm that full value will be obtained for the money spent, and that the work proposed is required for the completion of the buildings. In any case it is necessary that a commencement should be made without delay, so that the Galleries may be completed by the appointed time.[43]

Predictably enough, the report drew a panicked response from the Corporation and it was decided that Alfred Waterhouse, assessor of the galleries competition, should be asked to give his opinion on the proposals. His reply was poised seductively between hard practicalities and high idealism, as if calculated to appeal to the twin preoccupations of the Victorian patron. 'What struck me first', he wrote,

> was the great discrepancy between the sum originally included in the estimates for this decoration and the amount of expenditure now suggested. Reflection, however, induced me to believe that the difference is easily to be accounted for by the fact that there is in reality no comparison between what was originally contemplated and what is now proposed. This difference – a little more than £10,000 – is, of course, a very material addition to the cost of the building, but I can conceive of no means more likely to add to its artistic value and general attraction than securing for its embellishment the most beautiful sculpture obtainable. Such a result is, I believe, likely to be realised by the employment of Mr Frampton as master sculptor . . . I consider that the great merits of [the] scheme are, first, that harmony in the work will be secured by all the sculpture being under the control of a master of acknowledged originality and independent thought; and, second, that it gives the opportunity for large employment, under his direction, of local talent. In the highest periods of art the best sculpture was undoubtedly associated with the best architecture. Sculpture never has justice done it unless it remain in the place, the light and the distance from the eye for which the artist designed it. Though in France this association of the two arts and the prominent place given to sculpture are still the

73. Francis Derwent Wood, stone figure of Music above north porch, c.1898. Glasgow Art Gallery.

fashion, unhappily in this country it is very unusual to employ sculptors of the first class on architectural work, and our buildings suffer lamentably from this cause. Glasgow has now an opportunity of reviving the practice and I believe if she does so, she will never repent it.[44]

Somewhat mollified, the Corporation next asked Simpson for comparative drawings in charcoal of the work valued at £15,000, of the work originally estimated at £5,000 and 'since there are misgivings about price', of such work as might be obtained for £10,000.[45] By February 1898 the sub-committee had agreed that a further sum not exceeding £5,000 was necessary 'to complete the building in a satisfactory manner' and that a separate sub-committee should be set up to reconsider the whole sculpture question. In April this body conceded, after much prevarication, that carved ornament was an essential part of the building. It was proposed that savings be made, not in the amount of sculpture, but in the way it was allocated. The master sculptor's role should

93

74. George Frampton, stone spandrel decoration, 1897–1900. North porch, Glasgow Art Gallery.

be modified and individual carvers left to work more independently, effecting a saving of some £600 on Frampton's fee for models and general superintendence. Frampton should personally execute only the St Mungo group in bronze and the stone spandrels of the north porch. Other reputable but less eminent sculptors should be commissioned for the eight stone figures on the pavilions, thus cutting their cost by £100 per figure to £2,000.[46] To this net saving of a mere £1,400 on the revised estimate of £15,644 the sub-committee finally agreed. The Corporation accepted its recommendations in May 1898, instructing that an open competition be held for the pavilion sculptures.[47]

'We cannot help feeling very pleased indeed', commented the *British Architect*, 'that the architects and Mr Frampton have secured so golden an opportunity for showing what can be done when liberal ideas concerning art are allowed to prevail. And we feel confident they will be equal to the occasion, and that the new Art Galleries of Glasgow will be a typical example of unfettered modern effort to produce good architecture adequately adorned with good sculpture.'[48] The report on the competition, presented to the committee by Frampton and Simpson on 2 December 1898, invites comparison with that submitted by Leighton, seventeen years earlier, on the Blackfriars Bridge sculpture competition. 'We have to congratulate the Corporation', they wrote, 'on the successful result of their experiment.' One hundred and fifty designs had been sent in, representing the work of forty-seven sculptors; 'Some of the designs are of exceptional merit, and the standard of work submitted is, generally speaking, of considerable excellence . . . For Music, Architecture, Painting and Sculpture we had no difficulty in selecting the models. Those submitted by the author marked A [Francis Derwent Wood] are characterised by great beauty of line and knowledge of form, and are thoroughly suitable in their decorative treatment, to the architecture of the buildings' (plate 73). They went on confidently to describe the individual merits of the remaining four winning designs, even troubling to list seven models that had shown 'admirable points of one kind or another'.[49]

The decorative stonework for the galleries was completed by the summer of 1900 when the sculptors' sheds at Kelvingrove were sold off and Frampton's model for *St Mungo as Patron of the Arts* was finished and ready for casting. The buildings were first used for the International Exhibition hosted by Glasgow in 1901 and began to function as the Corporation Galleries in the following year.[50]

Though Simpson's treatment of individual detail was often coarse and uninspired, he could achieve, as the Kelvingrove galleries and Roedean School show, an overall effect of startling and almost sinister romanticism. The crowded Baroque and Jacobean

75. George Frampton, detail of *St Mungo as Patron of the Arts*. Bronze. Glasgow Art Gallery.

forms in the galleries' facades, their skylines bristling with towers, turrets, pediments and pinnacles, contrive to suggest both shrine and fairy-tale castle and it was this quality that Frampton, with unerring sense of the appropriate, set out to echo in the sculpture of the north portal. His part in determining the final iconography of the bronze group and spandrel reliefs remains obscure: whatever the prescribed programme may have been, in the course of interpreting it he made it entirely his own.

Kentigern, nicknamed Mungo, was a sixth-century Celtic bishop-saint closely connected in legend with the city of Glasgow, whose church he is said to have founded and on whose heraldic arms his symbols are displayed. He sits beneath the arch in full robes of office, an unequivocally ecclesiastical figure, and yet the group as a whole has the same strange ambivalence evident in *Mysteriarch* (plate 75, cf. plate 152). The two beautiful female figures that sit like human buttresses at right angles to the saint represent the Liberal Arts whose two chief attributes, a book and a portative organ, they hold on their laps. But Frampton had little interest in such grandiose abstractions. He seized instead the opportunity to bring to life once again his beloved vision of the Tennysonian heroine, explored in *Mysteriarch* and in the door panel reliefs for Astor House. The story of St Mungo coincides approximately in date with the legend of King Arthur and the saint is said to have been driven by persecution from Cumbria into Wales. The idea that his monument might unite the two legends – one sacred, one secular, and both shrouded in mysticism – must have been irresistible to the sculptor. The composition of the group, too, is developed from *Mysteriarch*. Symmetrical and bounded by the lines of an equilateral triangle, it demands, like a relief, a fixed and frontal viewpoint, and so defers elegantly to the facade that provides its setting. Nor from any other position can Frampton's masterly contrast of simple form and outline with richly treated surface be properly appreciated. The bound hair of the Liberal Arts, the vestments, crown and crozier of St Mungo are observed as if under a microscope, their detail a sensual foil to the asceticism of the subject and a vivid illustration of the philosophy that is expressed in Frampton's writings. Every student, he explained, must study carefully and reverentially the work of the great masters of the past from whom first the alphabet and then the words of art must be learned. Later, however, he must also learn

to combine those words into sentences of his own – sentences which convey an original idea and which bespeak his own individuality – rather than to slavishly repeat phrase after phrase in the dead languages of olden-time design. Such language is meaningless to our ears and conveys no message to our generation; yet there are not wanting those . . . who insist that we cannot do better than keep on repeating the lessons we have learned by rote. Hanging up in my studio is a model of the head of a pastoral staff which I placed in the hand of a statue of St Mungo which I was commissioned to execute for a building in the city of Glasgow. Not long ago a distinguished antiquary happened to visit me and this object caught his eye. Now in place of the conventional crocket I had broken the curves of the head of the staff by some little clusters of conventionally treated leaves which it seemed to me might be supposed to have sprung from the simple sapling from which the earliest shepherd's crook was most probably fashioned . . . 'But where are the crockets?' said he, to which I had to reply that there were none, but that I thought that my little clusters of leaves fulfilled the artistic purpose of the crocket, and yet added a touch of originality and individuality to my work. 'Dear! dear! dear!' was the only comment, '. . . I never saw a pastoral staff of the best period of the thirteenth century without crockets, and I cannot think how you can have let yourself design one without any'. I

found it a hopeless task to persuade my distinguished friend that a nineteenth century designer might be allowed to think for himself as well as the craftsmen of the thirteenth century, and we parted in mutual esteem.

Frampton was similarly amused to recall that another friend 'seemed to feel personally aggrieved when he noticed that there had been introduced into the head of the same staff the somewhat heterogeneous arms of Glasgow, a salmon, a tree and a bell, in place of the figure of the Virgin or of a Saint, which alone would have satisfied his antiquarian soul'.[51] No doubt his friends' sense of propriety would have been similarly outraged had they noticed the decoration on the bronze St Mungo's cope. The motif of an avenue of trees hung with bells and interspersed with fishes so pleased Frampton that he repeated it in 1902 as the background to his relief portrait in Glasgow School of Art of Sir James Fleming, Chairman of the Governors.

The Glasgow group and spandrels posed a certain risk for the sculptor. The delicate fantasy of his small and essentially private sculptures was here exposed for the first time on a colossal scale. There is evidence that some critics found the experiment disturbing. In an essay of 1911 on Frampton's monumental sculpture, which omits any reference to Glasgow, W.K. West went to undue lengths to explain that the subtlety and delicacy of his work did not detract from its 'virility' and 'masculine vigour'.[52] Because of the sheer physical effort it involves, sculpture has always suffered more than painting from identification as a male preserve. The conditions of the late nineteenth century, with strong undercurrents of sexual curiosity and aggression and the increasing participation of women in the production of art, engendered much hysterical defense of 'masculinity' as a measure of artistic excellence. Even Walter Shaw Sparrow (whose architectural criticism shows peculiar sympathy for the more 'feminine' aspects of the Arts and Crafts movement) felt compelled to justify those elements in Frampton's sculpture which he perceived as 'female' and he dealt with them at length in an article on the Glasgow work published in the *Studio* in 1901. Its most welcome attribute, he wrote, is 'a manliness that is not at all obtrusive, not at all ostentatious. To put the truth plainly, Mr Frampton has here achieved that fine harmony of masculine and feminine qualities which ought always to be present in the work done by an artist of genius, for the reason that genius itself is neither masculine nor feminine, but each and both – is, indeed, a single creative agent with a double sex. As Coleridge says, "a great mind must be androgynous".' Continuing in this vein for another three half-columns, he concluded, bewilderingly, with the hope that *St Mungo* would prove 'an invaluable lesson to all students, more especially to those who are unduly fascinated by the neuter style of Beardsley'.[53] What can Frampton himself have made of this contorted argument? The lesson he had hoped to impart was that fresh vision and individuality could be brought even to public sculpture, weighed down as it had been by precedent, outworn idealism and the need to convey some bureaucratic message.

As in the bronze group, the sweet reserve of the figures in low relief standing over eight feet tall within the red sandstone spandrels gently contradicts the swaggering tone of the given subjects. The horn- and cymbal-playing girls in medieval dress above the main arch represent the 'British Colonies saluting the Arms of Glasgow' (plate 74). Each group is turned towards the apex of the arch where the city arms, surmounted by a tiny half-figure of St Mungo, is carved on the keystone. Their extended instruments thus fill conveniently each spandrel's inner angle. The two groups of horn-playing figures are adaptations on a monumental scale of the motif invented by Frampton for the cabinet-door panel *Music* (plate 70), itself inspired, perhaps, by the trumpeter in Luca Della Robbia's singing gallery for Florence Cathedral. At Glasgow, in deference

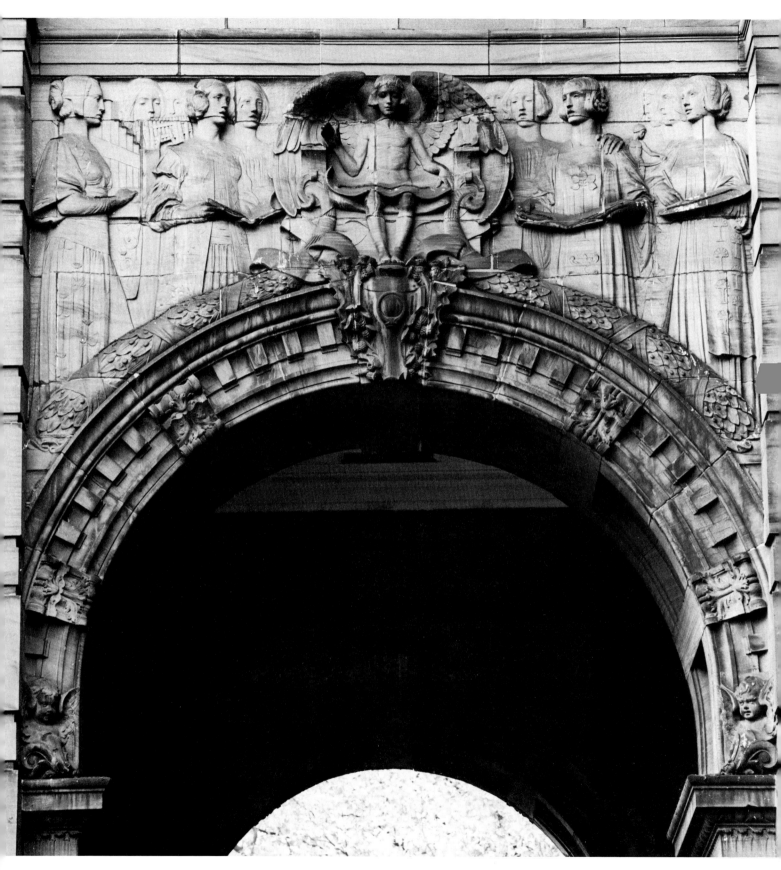

to his subject, he decorated the horns with hanging banners bearing animals symbolic of the Colonies – a kangaroo, an elephant and a striding lion are among those clearly visible. The less attenuated spandrels above the portal's two return arches describe 'Love teaching Harmony to the Arts' (plate 76) and 'The Industries of Glasgow at the Court of Mercury'.[54] Here Frampton was able to treat each pair more as a continuous band than as separate triangular fields, the arches having a much smaller span and leaving plenty of space between apex and cornice. The central areas he filled with figures of Love and Mercury, seated nude boys with a curious icon-like rigidity, removed from the 'reality' of the rest of the spandrel by the enclosing circle of their wings. Outside this magic circle girls of a type identical to those of the main spandrels process in frieze formation across the width of the arch, bearing appropriate attributes.

The effect of Frampton's design in these subsidiary spandrels is marred by conventional swags and cornucopia carved, by another hand, on the extrados of each arch. Concurrently with his work on the Glasgow spandrels, however, Frampton was able to develop his ideas for architectural frieze decoration in much greater freedom elsewhere. Shortly after receiving Simpson's commission he had been approached by the architect T.E. Collcutt who needed a sculptor to decorate the facades of Lloyd's Registry of Shipping, the final designs for which were approved in June 1898.

LLOYD'S REGISTRY

The general committee of Lloyd's had appointed a sub-committee in November 1897 to superintend the erection of new premises in Fenchurch Street in the City of London.[55] Its first duty was the selection of an architect and an informal list of likely candidates was drawn up, headed by John Belcher and including many somewhat obscure self-nominations. Among several pencilled additions to the list made in December is the name of Collcutt and beside it the work which is the key to his final appointment as architect to Lloyd's, the new offices of the Peninsular and Orient Line in Leadenhall Street, designed by him in 1893 (and demolished in 1964). The sub-committee having reviewed examples of the work of ten short-listed architects, Collcutt was selected by ballot on 6 January 1898. By October the working drawings were completed and Collcutt had estimated for a final cost of about £65,000. In December Mowlem's tender for £71,460, the lowest submitted, was accepted. In the specification for carving appear the following items: 'Ordinary carving – Provide the sum of £1,183 net p.c. for carving enrichments, caps to columns, brackets, shields, griffins, panels, etc, in Portland stone and Hopton Wood stone to be paid in full to Mr J.E. Taylerson or such other Artist as the Architect may appoint . . . Sculptured carving – Provide the sum of £7,000 net p.c. for carving sculptured panels and figures etc in Portland stone and Hopton Wood stone to be paid in full to G. Frampton Esq ARA or such other Artist as the Architect may appoint.' After many delays caused by a general shortage of fine quality Portland stone, the Registry was completed in December 1901 (plate 77).

Most splendid of all the legacies of John Belcher's Chartered Accountants' Hall, it represents a remarkable *volte face* on the part of Collcutt, leading protagonist, during the 1880s, of 'bric-à-brac Renaissance'. Abandoning the lacy detail, polychromy and linear preoccupations of his terracotta facades, he adopted here, in direct emulation of Belcher, the robust, richly sculptural forms of the Baroque style. His building is a perfect expression of the idea of architecture as casket and decorative sculpture as jewel. It literally does contain, in the upper vestibule and principal rooms, decorations

76. George Frampton, *Love teaching Harmony to the Arts*. Subsidiary spandrels on north porch, Glasgow Art Gallery.

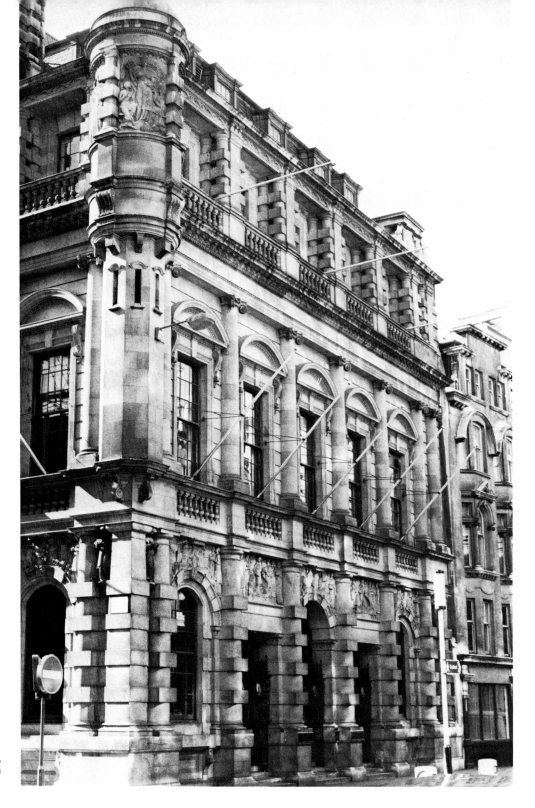

77. Lloyd's Registry of Shipping, Fenchurch Street, City of London (T.E. Collcutt, 1898–1901).

of jewel-like brilliance, but the idea is first presented in a subtle and provocative manner on the two Portland stone facades. Running like a filigree bracelet above the ground-floor openings and round the angle turrets is a frieze of full-length standing female figures carved in low relief and representing Trades, Commerce and Shipping (plates 78–9). The bulky columns dividing the ground-floor bays are heavily rusticated up to the springing of the window arches and then rise as plain shafts through the whole height of the frieze. At the ends of the front to Fenchurch Street and the principal three-

100

78. George Frampton, stone frieze panel, *c*.1899–1901. Lloyd's Registry.

79. George Frampton, stone frieze panel. Lloyd's Registry.

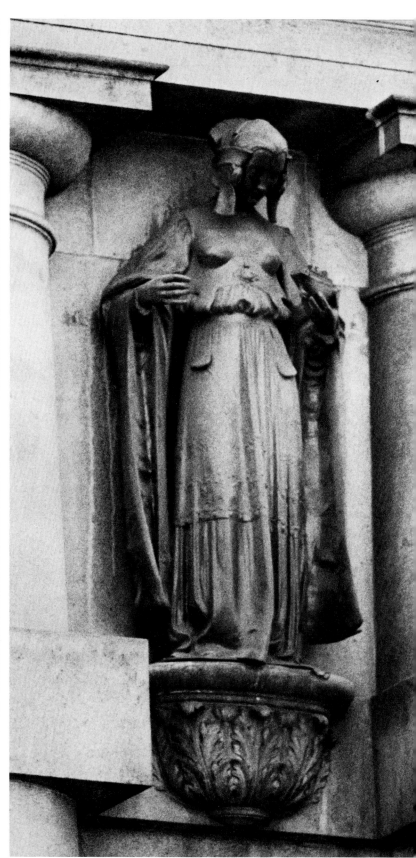

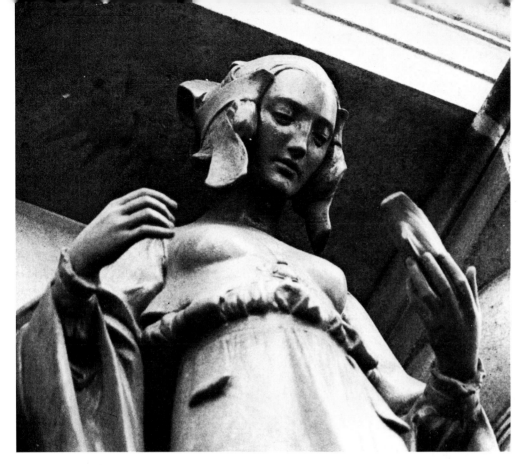

bay return onto Lloyd's Avenue the columns are paired and at each of these four points a bronze statuette set upon a bronze corbel nestles between the upper shafts, of the same height and at the same level as the frieze (plates 80–2). So tightly and secretively are these figures enclosed in their pod-like setting that they take the spectator constantly by surprise, seemingly to emerge and retreat, under different conditions of light and from different view-points, like the refractions of a precious stone.

There is no mention in the specification of sculpture in bronze. In Collcutt's final breakdown of expenses, however, Frampton's contribution is accurately described as 'sculptured carving in stone and bronze figures' (for the same cost of £7,000), so that the decision to introduce it may have been taken after Frampton had received the commission and possibly at his own suggestion. The introduction of bronze seems now to be indispensable to the building's character, a foretaste of the glowing richness of the vestibule with its inlaid metal frieze and bronze and marble group, *The Spirit of Maritime Commerce*, at the head of the stairs, both the work of Frampton's follower, Frank Lynn Jenkins (plate 83). How little the relationship between architecture and sculpture was understood by laymen, even when art-consciousness was at its height at the turn of the century, is shown in the concern expressed by Collcutt's clients for the safety of the bronzes. 'It has occurred to some members of the Committee', the architect was informed in December 1901, 'that they would prefer to see the bronze statuettes intended to decorate the outside of the building placed somewhere in the interior . . . It is thought that they are too good to be exposed to London atmosphere and weather, and cannot be seen to the same advantage outside as inside.' At the same time, these sentiments reflect the high degree of interest and pride taken in the sculptural decoration of the Registry. The surviving records of the general and sub-committees reveal not one objection to its cost or character. Only the painting of the Board Room ceiling by Gerald Moira in 1903 aroused some controversy on financial grounds.

Collcutt's choice of Frampton to design and execute the frieze and statuettes was

80. (facing page left) George Frampton, bronze statuette, 1899–1901. Lloyd's Registry.

81. (facing page right) George Frampton, bronze statuette. Lloyd's Registry.

itself a significant departure from his usual practice. Frampton told the *Studio* reporter in 1896 that his early architectural work had included 'some fireplaces and other work at the Imperial Institute', but no other commissions from Collcutt are recorded. The modeller habitually employed on Collcutt's terracotta facades of the late 1880s and early 1890s was Walter Smith, well known as an art-instructor and designer but without pretensions as a 'high' sculptor. That the architect should have turned to Frampton in 1898, now at the peak of his career, is further evidence that he regarded his scheme for Lloyd's quite self-consciously as a development of what Belcher had begun in the nearby Chartered Accountants' Hall.

If he and the committee hoped that their achievement would be recognised as such, they were not disappointed. The building, and the clients' enlightened patronage of art, were to receive clamorous and prolonged acclaim. Reviewing the new offices on 16 December, their day of opening, the *Shipping Gazette* wrote:

> It may, at the outset, be claimed that externally and internally the edifice . . . is one of the handsomest in the City of London. Indeed . . . in point of decoration and adornment it has only one equal among the thousands of structures which are in the metropolis devoted to trade and industry, namely, the new Hall of the Institute of Chartered Accountants, near Moorgate Street [*sic*] . . . As a rule, even when money is available for the purpose, architects and builders are not allowed time to carry out

83. Frank Lynn Jenkins, *The Spirit of Maritime Commerce*, *c.*1900. Bronze and marble group and polychromed metal frieze. Vestibule of Lloyd's Registry.

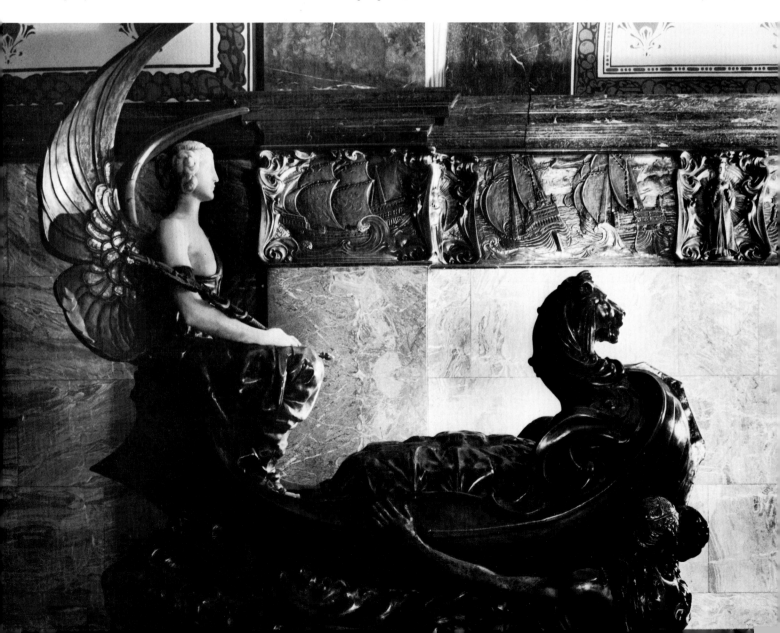

genuine artistic treatment in connection with such properties, the prevailing desire being to get all such people out of the way as soon as possible . . . But the Committee of Lloyd's Register have had a somewhat higher aim, and . . . they resolved that [their] new habitation should in every sense be worthy of the vast interest they have done so much to create. The result is that they have a structure which is undoubtedly one of the artistic treasures and sights of the modern capital . . . The sculptured frieze of Mr George Frampton ARA is one of the first artistic features which attract attention in the main facade. It has already been acknowledged by the many artists who have been to see the new premises that this frieze is one of Mr Frampton's finest pieces of work; and so much is thought of the sculptor's original plaster design that its various sections are to be carefully set up in the well-lighted museum provided in the sub-basement for specimens of machinery and other exhibits that may be too heavy for display in the museum for models at the top of the building. Another pleasing effect . . . has been secured by introducing between the rusticated columns on the ground floor four figures in bronze, each 4 feet 6 inches high, which mark quite a new departure in external decoration. The figures . . . are in duplicate, two being intended to represent one of the early types of sail tonnage and the others the modern steamship . . . Mr J.E. Taylorson [sic] executed the ordinary architectural carving, as well as the figures and corbels carrying the over-hanging parts of the structure on the Lloyd's Avenue side.[56]

In 1903 the *Magazine of Art* published two major assessments, one of the exterior and one of the interior, entitled 'Lloyd's Registry: A Modern Palace of Art'.[57] 'Mr Collcutt', declared the first, 'is chiefly to be congratulated on having obtained from his clients a sufficient sum of money to decorate the building in a liberal manner . . . in the outcome, the Committee of Lloyd's are, in their turn, to be congratulated on the result'. The strongest quality of the scheme, in the magazine's opinion, was the individuality apparent in every detail, testifying to Collcutt's abilities as 'a true collaborator, sympathetic and unbiased, giving and taking, ever allowing full play to the ideas and execution of those associated with him, yet strong and firm in his own conception of the requirements at issue'. The journal marvelled over Frampton's handling of the friezes and statuettes, 'how, in the former, he has arranged the composition of the sails and similar details, making them carry the feeling and suggestion of lines which harmonize with the architecture; while in the latter the bronze figures have been made satisfactorily to fill the wide niches . . . by a skilful treatment of the drapery'. The artist's individuality was 'indelibly stamped on the whole of the sculpture entrusted to him'.

Perhaps the most stirring tribute Frampton ever received was that written by H.C. Marillier for *Dekorative Kunst*, published in Munich in 1904. Declaring his work as architectural decorator to be the best testimony to his stature as an artist, Marillier named the Registry frieze as Frampton's supreme achievement:

The long frieze of figures with model ships and other attributes of commerce that decorates the facade of Lloyd's Registry deserves special attention for the magnificence of its general effect and for the enchanting grace of its detail. When this marvellous work is compared with the conventional, stereotyped sculpture that defaces rather than decorates so many large public buildings today, the difference strikes one as astonishing and leads one to think with longing of the days of the great church-builders when every craftsman was an artist in his own right and put his whole soul into his work and knew nothing of terracotta moulds and stock architectural ornament.[58]

84. C.J. Allen, *Liverpool a Municipality employs Labour and encourages Art*, c.1897. Marble panel. St George's Hall, Liverpool.

85a. Jacob Epstein, stone figure, c.1907. Rhodesia House, Strand.

Frampton seems to have perfected and synthesised at Lloyd's all the ideas that had been central in his mind for the previous fifteen years. How far he had progressed away from those conventional standards of architectural figure decoration still evident even in the work of contemporaries may be demonstrated by comparing one of the frieze panels with C.J. Allen's *Liverpool a Municipality employs Labour and encourages Art*, for St George's Hall, Liverpool (plate 84). Frampton's modern girls in their richly embroidered medieval gowns stand, with their model boats, as motionless as Allen's classical goddesses and yet in their remote and melancholy gaze there is implied a psychological activity which is entirely absent from the Liverpool panel. Frampton's treatment of relief is related with infinitely more care to the wall plane beyond. However rich the drapery folds or complex their surface patterns, they are governed by a geometrical simplicity of mass and outline. The heads in bas-relief in the background echo, like cast shadows, those of the foreground figures, emphasising the system of parallel planes upon which the composition is based. The strong element of 'parallelism' in the Lloyd's frieze, foreshadowed in the Glasgow spandrels, is one of several stylistic attributes that Frampton's work shared at this period with European symbolism. It has not yet been possible to determine how much he knew of events in Vienna before 1898, but in March of that year he entered four works in the first Secession Exhibition – sufficient evidence, though he did not exhibit there again, that he recognised in the work of Gustav Klimt and others interests that mirrored his own.[59] 'I like a picture to have clarity', wrote Ferdinand Hodler in 1905, 'and therefore I like parallelism. In many of my pictures I have chosen four or five figures in order to express one and the same feeling, because I know that repetition of one and the same thing deepens the effect produced. I have a particular preference for five, since an uneven number heightens the regularity of the picture and creates a natural centre-point.'[60] Frampton's frieze shows uncanny sympathy with such ideas.

Hodler loved Dürer, the Italian primitives and the frescoes of Klimt, 'where everything is fluent and still'. Frampton's taut, almost graphic handling of form is particularly evident in the bronze statuettes and it is in these enigmatic figures, embodying in the round so many of the qualities admired by the Swiss painter, that the symbolist implications of the Registry sculptures are made most explicit.[61] While at work on them he produced *Lamia* (plate 155, colour plate I), an ideal bust in which the snake-witch heroine of Keats's poem is the pretext for an investigation of that most symbolist of themes: woman as hypnotic icon, remote and potentially malign, transfixed within a perverse and wordly carapace of ornament. Less threatening an image, perhaps, than Klimt's *Pallas Athene*, shown at the second Secession Exhibition of 1898, *Lamia* is nevertheless its closest English counterpart. Even the scaly armature of Klimt's painted goddess has a parallel in the snakeskin markings upon the bust's bronze neck-brace. In projecting the mood of *Lamia* onto the full-length figures of the Registry facade Frampton made a remarkable further attempt to relate symbolist values to three-dimensional form and so demonstrate their relevance to the abstract discipline of architecture (plates 80–2). Perhaps the only sculptor who truly understood his achievement was Jacob Epstein. For all their radical simplifications, the stone figures of Rhodesia House in the Strand owe more to the Registry bronzes than even he may have cared to acknowledge (plate 85a–b).

5. Consolidation and Decline

THERE was a simple message in Lloyd's Registry which few failed to grasp: that decorative figure sculpture could, in the hands of an independent artist with a highly individual style, become a source of immense prestige for both building as architecture and client as patron. An outstanding instance of the assimilation of this message, even at the most anonymous, bureaucratic level, was the selection in 1904 of Alfred Drury to decorate the War Office in Whitehall.

In 1898 the erection of new offices, delayed since 1887 for lack of funds, was once again put in hand and the designs of William Young were selected in a limited competition. True to his declared allegiance to the collaborative ideal, Young provided for sculpture in his elevations but true also to his fundamentally neo-classical concept of architectural decoration, his drawings show groups of three rigid figures ranged at intervals along the parapet, detached, both physically and stylistically, from the massive Baroque facades below.[1] Young died in 1900 and his son was appointed to carry on the scheme in association with Sir John Taylor of the Office of Works. At some time between 1901 and the completion of the architectural stonework in 1903 the idea for symmetrical parapet sculpture was abandoned. Lightly sketched amendments to a drawing dated 1901 show, instead, colossal figure groups lowered to the pediments of the projecting end bays on each facade, where, at the most dramatic points of the design, the angles of the trapezoidal site are turned on four great domed circular turrets.[2] The setting and opportunity having now been provided for a true interaction between sculpture and architecture, there remained the choice of sculptor and this was handled by Taylor and Clyde Young with revealing diplomacy. Evidently their decision in favour of Alfred Drury was already made when, late in 1903, they approached him and two other sculptors for estimates and made their report. In March 1904 Taylor addressed a memo to the Secretary of State:

> The Advisory Committee having approved a general design for the sculptured figure subjects to be introduced over the segmental pediments of the . . . angle features I have in conjunction with Mr Clyde Young had under consideration the course to be adopted for the execution of the said subjects and we have invited estimates from three sculptors which I now submit.
>
> No. 1 This estimate amounting to £5,000 is from Mr Alfred Drury ARA (a rising man in his profession) highly spoken of by Mr Webb and Mr Belcher and considered by them a competent and suitable artist to undertake this work, in which opinion I concur. The estimate has been considerably reduced in amount from what it was originally in consequence of an interview I had with Mr Drury at which I offered to

85b. Jacob Epstein, stone figure, c.1907. Rhodesia House, Strand.

provide facilities for modelling the subjects on the building instead of his having to hire expensive premises for the purpose, owing to the great size of the models which are to be four in number.

No. 2 is an estimate from Mr Mabey [C.H. Mabey of Storey's Gate, who had already tendered successfully for the carving of capitals, columns and pilasters on the facades] amounting to £3,480 for execution of the same work as contained in No. 1 and under corresponding conditions as to the preparation of models, time of execution etc. Mr Mabey, although an excellent carver of ordinary architectural subjects, can hardly be considered to be an artist of the same class as Mr Drury for figure sculpture.

No. 3 is an estimate from Mr [George] Lawson of a very perfunctory character amounting to 'about' £2,000. Although Mr Lawson has on more than one occasion been employed on figure sculpture on buildings of importance his work is not considered of the highest order and having regard to the absurdly low sum named by him, a sum at which the work could not possibly be done in the best manner, I am disposed to consider that his tender be set aside.

There is of course a considerable difficulty in getting artists of standing and repute to give tenders in competition, but in this instance I believe Mr Drury has endeavoured to quote a fair price for the execution of the work in an artistic manner.

It would no doubt be possible to reduce the total cost of the subjects by modifying those at the north-eastern and south-eastern angles of the building but this could only be done at a loss of effect at those points which although not of equal importance to the two angles next to Whitehall are nevertheless very prominent positions. I therefore do not recommend such modifications.[3]

There was, in effect, no contest: the commission went to the artist submitting the highest tender. As Taylor and Young had accurately predicted, considerations of cost were swept aside when it became clear that the choice lay between 'high sculpture' and decoration of merely average competence. Their recommendations were accepted without demur.

Just as the decoration of Lloyd's Registry represents the climax of Frampton's development, not simply as decorative artist but as a sculptor in the widest sense, so the War Office commission proved to be the high-point of Alfred Drury's career. The analogy is fitting, for no sculptor outside the immediate circle of Bates, Pomeroy and Frampton had identified more closely with their ideals than Drury during the five years preceding his appointment as War Office sculptor.

There is no reason to suppose that when Drury left Dalou's Paris studio in 1885 for the studio of Boehm in London he expected to adopt any less conventional role than that of ideal and portrait sculptor. Though his training at South Kensington and his veneration of Alfred Stevens are likely to have encouraged in him a wider view of the function of art, he had no background as a stone carver, no particular interest in relief sculpture and remained entirely aloof from the Arts and Crafts Exhibition Society. The family likeness between some of his work and that of Bates and Pomeroy – a certain ripeness of form and gesture conspicuously absent from the early sculptures of Thornycroft, for example, or Alfred Gilbert, Onslow Ford and Frampton – may be ascribed less to direct borrowing than to the firsthand experience of Dalou's teaching shared by the three men. Behind Bates's figure of Dido (plate 23), Pomeroy's statuette *Pensée* (plate 173) and Drury's *Circe* of 1893 (plate 86) lies the same concept of sculptural form that is to be found in Dalou's monument to the Third Republic (plate 87).

Very little is known of the background to Drury's emergence as a decorative sculptor

108

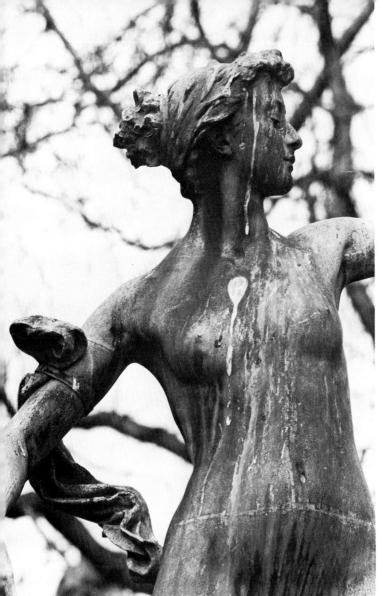
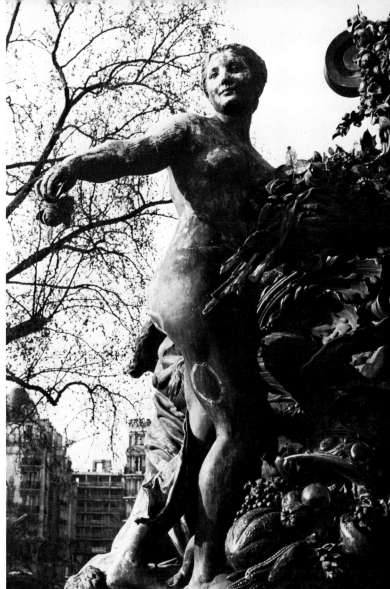

but there is evidence to suggest that a turning point in his development occurred about 1896 and that the impetus for it was the work of George Frampton. By 1894 Drury's ideal work, previously dominated by Dalou and French sculpture, had begun to reflect the influence of his English contemporaries (see Chapter 6). The first clear sign of his identification with Frampton's aims was the bust of *St Agnes* (plate 169) exhibited at the Academy in that year, and by 1896 he had produced *Griselda* (plate 170), a bronze bust whose gentle melancholy mood and arcane undertones owe much to *Mysteriarch*. Its exhibition at the Academy coincided with the appearance there of one of Frampton's most important early works of decorative relief sculpture, the series of door panels for Astor House. It is possible that his encounter with them prompted Drury's sudden and intense involvement, the following year, with sculpture as applied decoration and with the development of his own repertoire of decorative female figures. According to A.L. Baldry, it was because he was so busy with architectural schemes that in 1897 he had time to enter only one work in the Academy, the bronze *Age of Innocence*, a portrait of Gracie, young daughter of his friends the Doncasters, but conceived as a variation on the *Griselda* bust.

If Baldry's statement that '[Drury] has been chiefly occupied with terracotta modelling for various buildings in London and the country'[4] is taken at face value, it must be assumed that much more remains to be discovered about his activities in 1897.

86. Alfred Drury, detail of *Circe* (see plate 167), 1893–4. Bronze, LS. Leeds City Art Gallery.

87. Jules Dalou, detail of *The Triumph of the Third Republic*, begun 1879. Place de la Nation, Paris.

88. 233 Hammersmith Road, Hammersmith (*c*.1896, demolished 1980).

89. Alfred Drury, terracotta spandrel reliefs (overpainted) representing Art and Design, *c*.1897. 233 Hammersmith Road.

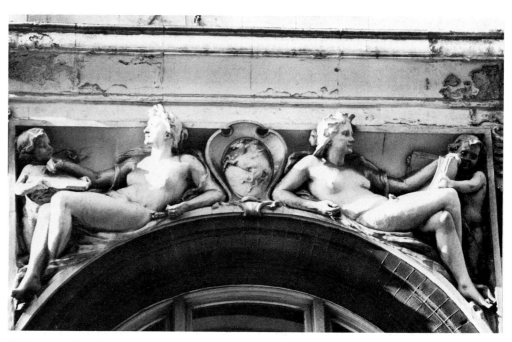

Only one London work in terracotta is recorded – the spandrel figures for 233 Hammersmith Road (plates 88–9). Baldry, who illustrated one of the three spandrel groups, without comment, in the *Magazine of Art* in 1900,[5] later referred to Drury's 'first notable effort in architectural sculpture, a set of terra-cotta spandrils with figures in high relief for the front of a coach-builder's establishment in the Hammersmith Road'.[6] Until the architect of the building is identified it is impossible to speculate how Drury obtained this commission. A substantial increase in the rateable value of a coach-builder's premises on this site in 1896 confirms that they were rebuilt in that year and suggests, in accordance with Baldry's evidence, that the sculptor was at work on the facade decorations in 1897.[7]

The upper storey of the red brick and terracotta structure survived, until the demolition of the building in 1980, unspoiled except by over-painting. Its five bays were filled by broad round-arched openings. The smaller openings at the centre and in the two outer bays left space for decoration between the apex of their arch and the coved cornice moulding above and here were set escutcheons flanked by reclining nude figures modelled almost in the round, their feet filling and overhanging the lower angle of each spandrel space. The pair of female figures with attendant children above the central arch were intended to represent Art and Design, though the easel and brush of Art, visible in Baldry's illustration, had disappeared (plate 89). The escutcheon they supported bore a winged horse. The pairs of male figures over the outer windows, differing from each other only in minor details, carried attributes relating to the horsedrawn carriage and its manufacture. It is remarkable that a small carriage-building firm of no special repute should have adopted such an ambitious and self-consciously artistic programme of decoration.[8] Ideologically the building followed closely the precedent of Hill's Bakery in Westminster where the alliance of art and commerce had been celebrated ten years earlier. Drury's treatment of the languorous nudes, the flow and breadth of the terracotta modelling, indicate that he had Bates's pioneering work firmly in mind while engaged on the spandrels (cf. plate 22).

Drury's first known public work of decorative sculpture in bronze – the plaques to commemorate the opening of the Blackwall Tunnel in 1897 – adheres closely, too, in

style and handling to Bates's early reliefs in the same medium.[9] The two identical plaques still survive, one in its original position in the lodge at the tunnel's southern approach, and one on the wall of the modern approach road where it was resited after the demolition of the original north lodge in 1959 (plate 90). The inscribed tablet is surmounted by the heavily bearded mask of a river god modelled in high relief. Supporting the tablet on either side crouch half-draped female figures in low relief, demanding comparison, in their poses and the treatment and arrangement of drapery, with Bates's Aeneid reliefs of 1887 (plates 23–5). A shallow dado panel beneath the main decorative field is treated as a section through the tunnel and shows, in miniature, the construction work in progress. A similar confrontation of realism and the ideal took place in the frieze panels of Hill's Bakery.

While Drury kept close to Bates's example in the earliest decorative commissions he received, the third and fourth schemes known to date from this period show the development, under Frampton's influence, of a mood and an expressive power much more precisely his own. The decoration of the garden at Barrow Court near Bristol appears to be the only instance of his collaboration with the architect F. Inigo Thomas. How their relationship originated is not known, but Thomas was a fellow exhibitor at the Academy from 1893 to 1895 and his observation then of the much-admired *St Agnes* and *Circe* may well have aroused his interest in the sculptor's work. The Jacobean mansion at Barrow Gurney was bought by Henry Martin Gibbs and substantially restored and rebuilt for him under Thomas's direction during the 1880s. The lengthy process of renewal included the laying-out of formal gardens, and on an open area giving views of exceptional beauty across the surrounding hills Thomas devised what was to be the *pièce de résistance* of his scheme: a broad terrace terminated at one end by a huge semicircular enclosure of low walls, piers and railings (plate 91). The balustrade is interrupted at its centre by a monumental gateway, surmounted by urns and flanked by attached piers carrying winged lions. Each of the twelve free-standing piers that punctuate the railings at regular intervals round the semicircle carries a bust terminated at either side by a volute (plate 92). These busts, all of women and girls, and the lions on the gateway, are the work of Drury. In February 1906 Baldry wrote: 'It is

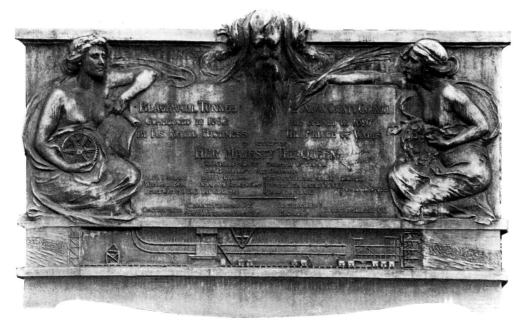

90. Alfred Drury, bronze plaque, c.1897. Northern approach, Blackwall Tunnel.

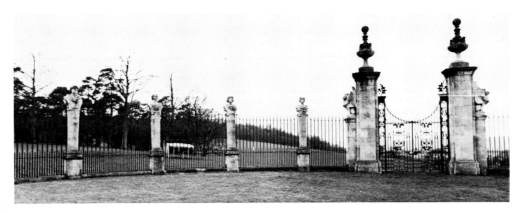

91. View of terrace at Barrow Court, near Bristol (F. Inigo Thomas, *c*.1897–8).

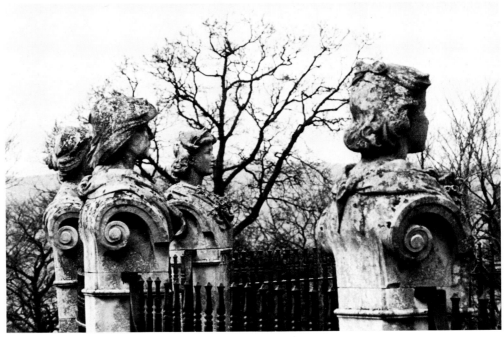

92. Alfred Drury, busts representing February, March, April and May, *c*.1897–8. Barrow Court.

some eight years since he executed the much-praised series of allegorical terminal figures . . . for the terrace of a garden in the West of England.'[10] Baldry himself had been the first to draw attention to the scheme in an article of 1898, illustrating all Drury's models and sculptures *in situ*. It is likely, therefore, that most of the work belongs to 1897.

Baldry explained that the material was terracotta (a puzzling statement, for the sculptures have the appearance and the weathering of stone) and went on to describe, with evident delight, the iconography of the busts. There being twelve piers, the obvious course was to represent the twelve months of the year, but instead of adopting a series of stereotypes Drury had had the happy idea of portraying the life-cycle of one person from infancy to old age. Thus January is represented by a baby, February as a small girl and so on. The meaning of each bust is underlined by appropriate small detail, such as the wind-swept hair of March and the heavy shawl wrapped about the care-worn face of December. Drury was to be congratulated, wrote Baldry, on having shown how truly excellent sculpture could be when 'used in obedience to modern needs as an adjunct to architecture'.[11]

In his highly personal interpretation of a conventional problem of decoration, Drury

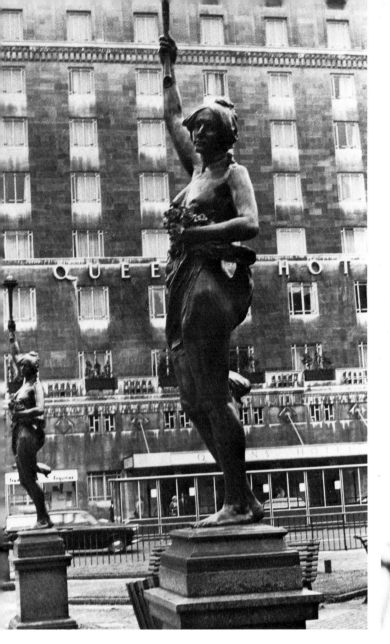

93. Alfred Drury, bronze figures with torches, representing Morning, c.1898. City Square, Leeds.

94. Alfred Drury, detail of bronze figure with a torch, representing Evening. City Square, Leeds.

both matched and enhanced the quality of the garden and its architecture. Their changing physiognomy a constant commentary on the real evolution of the surrounding landscape, the twelve busts echo, too, the timeless, dream-like atmosphere of the great terrace, gazing silently beyond it as if, like *Mysteriarch* and *Griselda*, in rapt contemplation of some distant memory.

The idea of establishing a psychological link between decorative sculpture and its environment was again used by Drury when he was commissioned to provide eight standards for electric lights in Leeds City Square. After the exhibition of *Circe* and *St Agnes* at the Academy in 1894 both works were bought from the artist by Leeds City Art Gallery and, followingly closely upon their acquisition, he was called upon to take a leading part in the scheme initiated by the Mayor of Leeds, Colonel T. Walter Harding, to make the Square an enclave of modern sculpture.[12] The lay-out of City Square, like its perimeter, has undergone savage alteration, though the sculpture remains intact. Thomas Brock's colossal monument to the Black Prince was originally the central point of a circular lay-out, defined by a balustrade of marble on which were set Drury's eight over-life-sized female nudes in bronze.[13] Cast from only two moulds, four of the torch-bearing figures represent Morning and four Evening (plates 93–4).

113

Dismounted from their balustrade, of which no trace remains, they are now set among the litter bins in two banal straight lines down one side of the square. The model for *Evening* was exhibited at the Academy in 1898. 'It would not be easy', commented the *Studio*, 'to find a better instance of the applicability of art to common things.'[14] The two figures, their faces based on Clarrie Doncaster, sister of Gracie the model for *Innocence*,[15] succeed in combining sensuality and aestheticism in a way that proved irresistible to the Edwardians and still exerts a peculiar magic. Cast by J.W. Singer of Frome and set in place in 1903, *Evening* rapidly established itself as the most popular image created by Drury. In 1905 he exhibited a cast of the head at the Academy under a new title, *Spirit of the Night*; in 1911 it appeared there again, reworked in marble. 'We can only say', observed the *Architectural Review*, 'that . . . Mr Drury has produced one of the most beautiful modern heads we have ever seen.'[16]

By 1904 when Drury began work on the War Office groups he was firmly established among the leading decorative sculptors in England. John Belcher, who, with Aston Webb, was asked by the Office of Works to vouch for his ability, had already brought him in to contribute to the first of those great collaborative machines of the new century, Electra House, Moorgate, opened in 1902. The rectangular panels at first-floor level with arms and seals supported by putti carved in high relief are Drury's work as also were the bronze doors, now removed and lost. For Belcher's Royal London Friendly Society premises in Finsbury Square of 1903 he had provided stone figures for the corner tower and other decorative carving, including female half-figures, their faces framed by heavy looped braids, flanking the small windows beneath the principal cornice and strongly reminiscent of those by Bates on the side elevation of the Chartered Accountants' Hall. On the keystone above the main entrance is set the jewel of Drury's decorative scheme, the helmeted head of a woman in bronze, her hair braided and looped, framed by ivy and branches of oak (plate 95). The model was exhibited at the Academy in 1904, a measure of the sculptor's special pride in this piece of work. Coloured though it is, like all his work, by familiarity with Stevens's grave classical masks, the immediate derivation of the head is Frampton's *Lamia* (plate 155).

Aston Webb, too, asked Drury to co-operate with him in the decoration of his own buildings. The offices of the Grand Trunk Railway Company in Cockspur Street of 1908 once displayed a beguiling relief panel of children at play with a model engine and boat, now replaced by a modern fascia.[17] At the same period the sculptor was at work on relief panels and niche figures that hold positions of honour in Webb's decorative scheme for the Cromwell Road front of the Victoria and Albert Museum.

'Thank you', wrote Drury to Sir John Taylor and Clyde Young on 23 January 1904,

for the tracing safely to hand . . . In reply to your accompanying letter I have much pleasure in quoting the prices of the groups (which I have very carefully considered). I should supply as desired *4 small sketch models* – different designs, illustrating the subject and design. From these models the requisite projection of the stone may be obtained. I should also supply *4 working models* (one third full size) and *4 full-size plaster models* from which the pointing and carving may be done.

The work would be carried out and completed within 15 months from the date the order is given.

It would be executed to your entire satisfaction in my very best manner.

I should spare no trouble to make it a unique and imposing work.

All my other work would have to be put aside for the time being.

Should you favour me with the commission I should be glad to know in good time as I should have to secure specially large studios for the work as the 4 full size groups

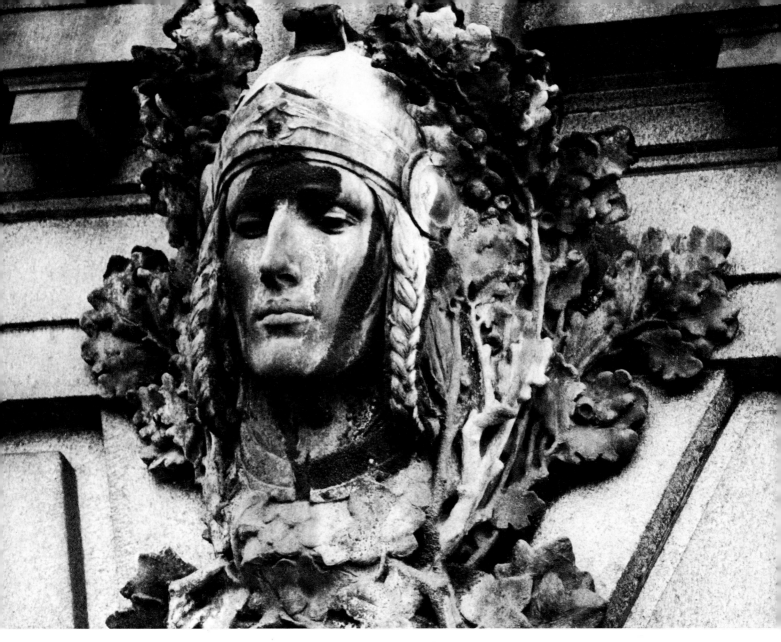

must be carried on at the same time – in order that there shall be harmony and that the pointing and carving can be started immediately on the 4 groups.

My estimate for the 4 *front* groups would be £850 each, for the 4 *back* £800 each making a total of £6,600.[18]

Drury met Taylor in March for further discussion. It was decided that, in order to bring down the fast-escalating costs, studio accommodation for the four huge models would be provided by the Government free of charge. In the event, the work cost a great deal more than even the highest estimate, a fact that the supervising architect took pains to conceal until it was too late for any economies to be made. The groups were already in place when the Office of Works revealed, in January 1906, that 'about £9,300 (not entirely an extra) has been occasioned by the eight sculptured subjects designed by Mr Drury ARA which would not have been authorized without further consideration if it had been realized that there would not be a sufficient margin of savings to meet it'.[19]

Carved almost in the round, each of the eight War Office groups consists of two seated and heavily draped female figures. Those that surmount the two end pediments on the Whitehall front represent, on the north, Peace (plates 96–7; the Sorrow of Peace

95. Alfred Drury, bronze keystone mask, 1904. Royal London Friendly Society, Finsbury Square (Belcher and Joass, completed 1905).

115

and the Winged Messenger of Peace) and on the south War (plate 98; the Horrors of War and the Dignity of War). Above the pediment on the return into Whitehall Place are set Truth and Justice (plate 99), balanced, on the return into Horse Guards Avenue, by Victory and Fame. These groups have their exact counterparts above the corner pediments at the eastern end of the block. Critics and public alike seem to have been united in their acclaim for Drury's handling of 'an opportunity that would have been hailed with enthusiasm by one of the great medieval sculptors'.[20] One of the first full accounts of the scheme was published in the *Daily Mail* on 7 September 1905. Headed 'Sculpture in London at Last: Sightseers and the New War Office', it demonstrates a consciousness of public sculpture and an aesthetic sensibility in vivid contrast to the indifference which had greeted Armstead's Colonial Office spandrels thirty years before. 'No-one passing down Whitehall', began the report,

> can fail to notice the recently completed groups of sculpture which adorn the western corners of the new War Office . . . There is so little decorative sculpture worthy of the name in London that Mr Drury's achievement is remarkable. He has awakened an enthusiasm for sculpture in the usually unresponsive mind of the man in the street, and actually provided the Whitehall omnibus-drivers with a new topic of conversation. Everyone riding past the new War Office turns to LOOK AT THE WORK. 'War' is shown in two aspects – first as a thing of strength and dignity, typified by the goddess Minerva with her Gorgon-headed shield and sword, and then in its horrible aspect, as a woman seated gazing with terror and disgust at a skull. It is probable that the woman with the skull is more talked about than any other figure in the whole scheme of decoration . . .
>
> 'Peace' is the most charming of the four groups, the workmanship being full of the softness and feeling of the subject . . .
>
> The 'Victory' and 'Fame' group is noticeable for the wonderful little bronze-gilt 'Victory' which the seated figure on the left holds in her hand. This dainty little winged figure gives distinction to the whole group, and is so charmingly modelled that many people, seeing it in Mr Drury's studio, have begged the sculptor not to 'sky' it seventy feet above the pavement of Whitehall . . .
>
> Mr Drury's fourth group is emblematic of Truth and Justice; the one with her mirror and the other with her book, sword and the equilateral triangle on her forehead signifying absolute fairness to all.
>
> All Mr Drury's figures are modelled on an heroic scale, being more than twice life size, and the aggregate weight of the Portland stone in which they are carved exceeds 700 tons.

The War Office groups illustrate the complete assimilation into their sculptor's personal style of the influences most crucial to his development: Alfred Stevens and the *terribilità* of the Wellington Monument figure groups, the lyrical realism of Dalou, the symbolist images of Frampton (most obviously, in the tree motif on the book held by Justice and the Mysteriarch-like head of Truth), the energy in handling three-dimensional form that Drury had recognised in the work of Bates. It is a measure of his achievement that, in allowing the architectural setting to dictate the general character of his sculptures, Drury has enhanced rather than subdued their expressive power. Each figure is related to its pair and each group to its seven counterparts by a wholly Baroque balance of mass, gesture and light and shade, maintaining a tragic grandeur that the dark streaking of the pale stonework now serves only to accentuate.[21] 'Indeed', wrote Baldry,

96. Alfred Drury, stone group representing Peace, 1904–5. North-west angle of War Office, Whitehall (now Ministry of Defence, designed 1898 by William Young and completed 1905 by his son).

97. Alfred Drury, detail of Peace. War Office.

117

this is, perhaps, the greatest merit of Mr Drury's achievement here: that in producing magnificent sculpture he has not forgotten that the object of his effort was to be the completing and enhancing of a piece of well-proportioned and impressive architecture. He has sacrificed none of his own individuality, none of his personal sentiment about his art, and certainly none of his admirable vigour of technical practice . . . The large and certain modelling of the heads and limbs; the breadth and firmness of the draperies, magnificent in their quality of light and shade, and yet properly elegant and easy in their flow of lines; the rhythmical adjustment of form and masses – all are imposing in their masculine power, and yet all are restrained and kept in proper subjection by a sense of refinement and a love of beauty which deserve no ordinary degree of commendation.[22]

The first five years of the twentieth century were a period of intense activity for decorative sculptors, when partnerships with architects were consolidated and monumental figure carving was an accepted feature in the design of grandiose commercial premises and public offices; a time during which, in a last surge of self-confidence before the years of doubt to follow, architects went to extraordinary and sometimes misguided lengths to affirm their faith in the collaborative ideal.

To what extent attitudes to architectural sculpture had changed in two decades may be appreciated by comparing the Blackfriars Bridge affair with its modern counterpart, the scheme to provide decoration for Vauxhall Bridge. The London County Council's conduct of the latter in 1904 was exemplary in its confidence, clear-headedness and flexibility. In February 1904 the Bridges Committee was informed by W.E. Riley, Architect to the Council, that 'as arrangements for constructive work to this bridge are now well in hand, it becomes necessary that a decision be arrived at with respect to the sculptured panels over the piers and abutments, so that the sculptors whom the Committee may select may have an opportunity of preparing designs and sketch models for approval, and ultimately preparing and casting the work'. A sum of £8,000 had been provisionally set aside for sculpture, which was originally intended to take the form of low relief panels in cast-iron over the piers and abutments on the upstream and downstream sides. 'I have', continued the Architect, 'given the question careful consideration and am of the opinion that Mr Alfred Drury ARA who has great skill and experience in the Decorative side of the Sculptor's art, is a most suitable man to control the whole scheme and be responsible to the Committee, and would suggest that if he works in conjunction with Mr George Frampton RA and Mr F.W. Pomeroy on the panels . . . I have every confidence that a fine and worthy result would be obtained and that the whole composition would be greatly beautified thereby.'[23] In July Riley reported that he had now been informed by Drury of Frampton's inability to take part in the scheme 'through pressure of work by public commission'. He proposed therefore that the work should be divided between Drury and Pomeroy, Drury being responsible to the Bridges committee. During the intervening period the sculptor had suggested that the panels be cast in bronze instead of iron and had presented the following estimate for the work: 'To prepare sketches, sketch models to scale, model the panels, cast in bronze ready for fixing on the work, for the inclusive cost of £1,200 each.' The additional cost of bronze casting could, the architect added, be easily afforded with certain savings on constructional work and by omitting the subsidiary decoration proposed for the abutments.[24] By early November when Drury submitted models for the committee's consideration, the sculptor had initiated yet another alteration to the scheme. Instead of relief panels he proposed to set above each pier a single monumental figure modelled in the round. 'The treatment indicated by the Sculptors in the panels

98. Alfred Drury, stone group representing War. South-west angle of the War Office.

99. Alfred Drury, stone group representing Truth and Justice. North-west angle of the War Office, side elevation.

118

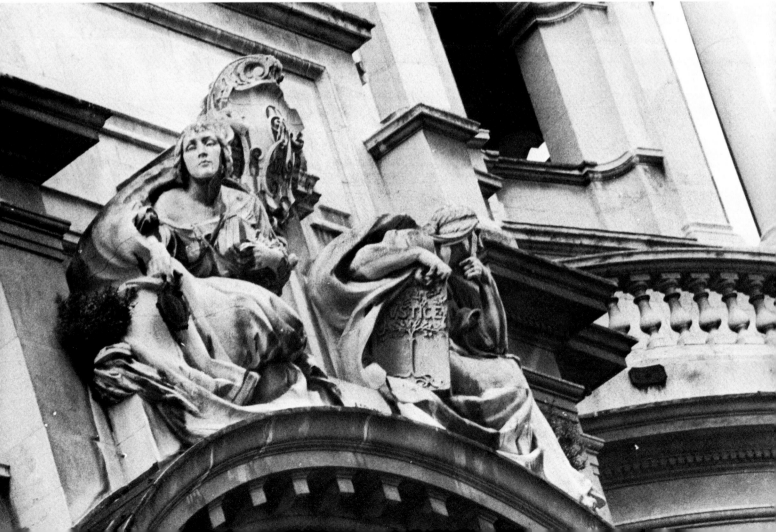

submitted', pleaded Riley, 'is so vastly superior to the Bas Relief Treatment previously considered that I am confident the Committee will feel justified in authorising that the work should be put in hand on the basis of bronze figures in accordance with the sculptor's estimate.'[25] On 8 November the committee informed the Council: 'Sketch models have been submitted to us and from them we have had an opportunity of judging the effect of different panels in entire and low relief. The effect of the former method of treatment in this instance appears to us to be so greatly superior to the latter that we have unanimously decided to adopt the proposals. Though it will involve an increase of expenditure on this item of £1,600 . . . a saving of a much larger sum has been effected on other parts of the decoration of the bridge.'[26]

In Drury's suggestion that colossal figures in the round would be more suitable than flat relief panels for the giant, steel-plated pier-niches lies the same sensitivity to architectural values that informs the War Office sculptures. His four allegorical female figures, standing nearly fourteen feet high, on the eastern side – *Fine Arts* (with palette and statuette), *Science* (with globe), *Local Government* (with book), and *Education* (with children) – express, as no relief panel could, the bulk and strength of the great supports. The tubular formation of their draperies and steady, static poses, particularly evident in *Science* (plate 100), suggest that Drury wanted to achieve an effect similar to that of Frampton's statuettes for Lloyd's Registry which are intimately related, as abstract forms, to the column shafts that enclose them. The more agitated Baroque figures by Pomeroy that stand on the bridge's upstream side – *Architecture* (plate 101), *Engineering*,

100. Alfred Drury, *Science*, bronze figure, *c*.1905. Vauxhall Bridge (downstream side).

101. F.W. Pomeroy, *Architecture*, bronze figure, *c*.1905. Vauxhall Bridge (upstream side).

Agriculture and *Ceramic Art* – sacrifice something of the architectural significance of Drury's group, though, paradoxically, they are closer in style than any other of Pomeroy's works to the heroic figures of the War Office with which he would have become familiar while engaged on the bridge commission.

Pomeroy had played an early and leading part in the movement to extend the boundaries of sculpture and to give equal status to decorative and high art. Despite his prolific activity as a collaborator, however, he seems to have been less at ease than his peers in the role of architectural sculptor. His style as a whole lacks the definition of that of Frampton or Drury and nowhere are his deficiencies as an original thinker more evident than in the monumental figure sculpture he produced for architecture. It was C.R. Ashbee who unintentionally identified the dilemma that hampered Pomeroy's development. In his account of the sculptor's Mastership of the Art Workers Guild in 1908, the architect commented on the 'chronic indecision' that had afflicted sculptors at the turn of the century:

> Can the art get free of the building – should it? The sculptor hesitates; and so he has towards the architect an air now of deference, now of defiance, at times he has been architect himself. Pomeroy, less medieval and more renaissance in sentiment, was on the side of freedom – individualism in stone. Both are right. When we are undecided as to the fitting marriage between sculpture and architecture it is well to ponder over the lovely mouldings of the Lorenzo tomb of Michelangelo, or the Wellington tomb

102. F.W. Pomeroy, stone pediment figures, *c.*1902. Technical College, Liverpool (E.W. Mountford, completed 1902).

103. F.W. Pomeroy, detail of dome spandrel, 1906–7. Central Criminal Court, Old Bailey (E.W. Mountford, completed 1907).

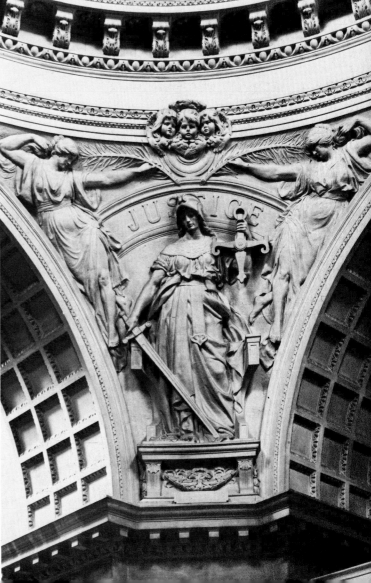

104. F.W. Pomeroy, bronze lamp standard, *c*.1902. Technical College, Liverpool (see plate 102).

105. F.W. Pomeroy, stone frieze panel, *c*.1902. Booth's Distillery, City of London (E.W. Mountford, 1901).

of Alfred Stevens. Whether the sculptor or the architect takes the lead matters little, as long as the relationship is right; and that, like every true marriage is a matter of feeling – and from heaven.[27]

If Pomeroy was on the side of freedom he failed to show it consistently, however, in the working 'marriage' with E.W. Mountford that dominated his activity during the first decade of the new century. The popular success of Sheffield Town Hall was followed by Liverpool's Museum and Technical College, completed in 1902, Mountford's chilliest exercise in Edwardian classicism, to which Pomeroy's anonymous classical figures politely respond (plate 102). The same almost lazy pragmatism informs the monumental sculpture he executed for the facade and interior of the Central Criminal Court, Old Bailey, in 1907. The fleshy, loose-limbed figures above the doorway and in the dome spandrels (plate 103) with their stylised, conventional poses bring to mind Ashbee's description of Pomeroy himself in his role in the Art Workers Guild Masque of 1899: 'He fancied himself in the part, all the more so as the girls – for his easy-going and indolent grace of movement, if a trifle heavy – nic-named him "the beautiful Pom".'[28] And yet in the decorative sculpture he produced with Henry Wilson and in every scheme where he was required to work on a more intimate scale there is a poignant individualism which vindicates Ashbee's theory. The bronze lamp standards surmounted by statuettes of young scholars that flank the entrance to Liverpool Technical College are full of invention and humour (plate 104). Their details – the fishes that form their bases, the sea-horse capitals and dreaming children – reflect Pomeroy's personal philosophy as an artist as freshly and vividly as the vestibule reliefs at Sheffield Town Hall. So also do the panels in low relief, illustrating the labours of gin-making, which decorate the facade of Booth's Distillery, Mountford's little masterpiece of Arts and Crafts free-classical design (plate 105).[29]

An architect–sculptor partnership which closely parallels that of Mountford and Pomeroy developed during the same period between Aston Webb and W.S. Frith. Their association began many years before Frith gave up most of his teaching duties at the South London Technical Art School in 1895. He had been one of a number of collaborating artists – including Harry Bates, William Aumonier and Walter Crane – introduced by Webb to decorate the Victoria Law Courts, Birmingham, won in the

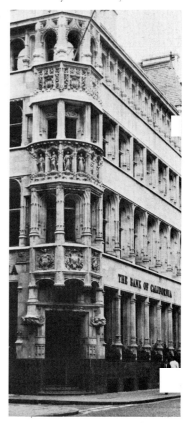

competition of 1886. His most prominent London work of the early 1890s was the carving of niche figures, corbel-stops and heraldic panels for the angle oriel of 13 Moorgate, offices of the Metropolitan Life Assurance Society, completed in 1892 (plates 106–7). Aston Webb's approach to ornament and design was very different from that of his contemporary John Belcher. He would merge figurative and architectural detail together in a complex and tightly knit pattern, giving his collaborating artist little freedom to develop a theme of his own. But it was precisely this close interweaving of naturalistic and abstract form that fascinated Frith in the art of carving for architecture and he must have seen the Moorgate commission as an opportunity to put into practice the ideas he was propounding at that time in lectures at the Architectural Association and the R.I.B.A. 'It is interesting', he said, 'to note between masonry and the simpler forms of carving, and . . . the most elaborate and highest sculpture, the series of links graduating from severe restraint to complete freedom . . . In performing its functions, masonry begins the scheme of light and shade, but with forms severely restrained and more or less geometrical in character, not imitative of living nature; until the point is reached where figure sculpture may carry the work beyond the merely decorative, and may jewel it with the highest imaginative production of which art is capable.'[30] Carving was the very basis of the art of sculpture, for it allowed 'the appearance of the thought and its expression [to be] presented together, . . . the drift of the tool presenting a charm as showing actual cuts expressive of active thought guiding their production'.[31] There is a sense of immediacy in the Moorgate carving, especially evident in the relief panels with angels supporting shields, that gives new life to the dry commercial symbolism imposed by the building's function.

Other work for Webb included garden statuary and fountain figures in Doulton terracotta at Claire Lawn, East Sheen, of 1893,[32] decorative carving in stone at Birmingham University and the fountain in the quadrangle at Christ's Hospital

School, Horsham, of 1902. But Frith's place in the New Sculpture movement is defined chiefly by two late schemes which did not originate in this relationship: the bronze lamp standards on the entrance steps of Astor House (exhibited at the Academy in 1908), and the spandrels for the bridge across King Charles Street in Whitehall, designed by J.M. Brydon and completed in 1908 by Henry Tanner. Preoccupied with the idea of sculpture appearing to 'grow' out of its architectural base and little interested in 'gallery' works as he disparagingly described them,[33] Frith rarely seems to have allowed himself that free expression of the imagination which, as a teacher, he advocated so strongly. But these late decorative works – one wholly detached from the building to which it relates and one part of a structure conceived primarily as a receptacle for sculpture – fall into a different category and may fairly be taken to represent his style at its most intimate and individual.

The superficial theme depicted in the lamp standards is modern technology: on their bases pairs of naked baby girls are engrossed in play with a telephone and an electric lighting set (plate 108). Taking place within this quaint genre setting, however, is a radical investigation of the nature of sculpture and of Frith's favourite theme, the relationship between sculptural and architectural form. The delectable mouldings of the bases with their interlocking curves and planes say as much in architectural terms about sculptural values as the figures themselves. The pressure of the artist's fingers on the surface of the clay is constantly evident in the free and sensuous modelling of the heads and limbs and it is clear that Frith was concerned here to suggest in bronze that synchronisation of thought and action which delighted him in the carving process.

The Whitehall bridge spandrels reassemble – arguably for the last time in an architectural setting – the principles and stylistic resources of the New Sculptors (plate 109). Products of a movement that Frith had quietly and persistently promoted from its beginnings, the limpid female figures reclining above the three arches bear comparison, not only with the heroic architectural carving and modelling of Bates and

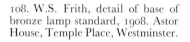

108. W.S. Frith, detail of base of bronze lamp standard, 1908. Astor House, Temple Place, Westminster.

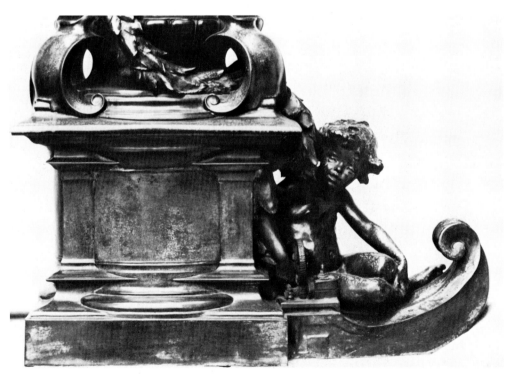

109. (facing page) W.S. Frith, stone spandrel relief, c.1908. King Charles Street Bridge, Whitehall (J.M. Brydon, completed 1908 by Henry Tanner).

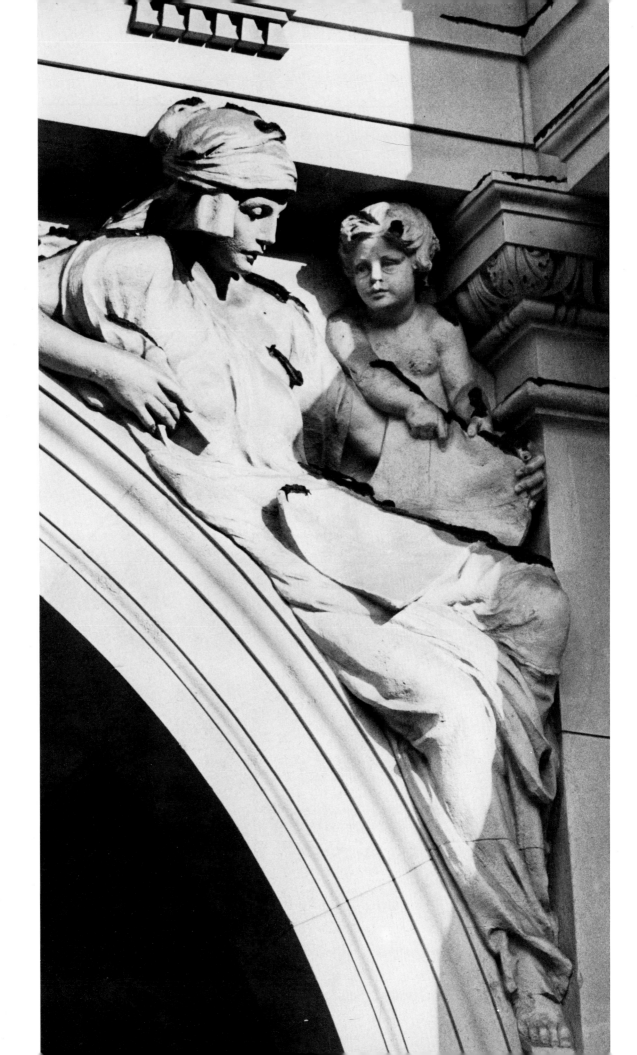

Drury and the terse, abstracted reliefs of Frampton and Schenck, but with the pulsating images created by Alfred Gilbert in his early small-scale sculptures in bronze.

By 1900 English sculptors had developed interests which were increasingly difficult to reconcile with the demands of external architectural decoration. Their passion for colour and rich materials, for example, exquisitely indulged in *Lamia* and the ivory and bronze ideal sculpture of Bates, Reynolds-Stephens and Frank Lynn Jenkins, had no place there, nor closely observed detail in bold, generalised groups that would tell at some distance from the passer-by. Above all, the visionary, poetic themes they loved were seldom compatible with the boastful political or social messages that architectural figure decoration was now frequently required to transmit from the fronts of public buildings and business premises. It may be argued that Frampton's work at Lloyd's set the limits of expression in sculpture as external architectural decoration, and that never again in quite the same way did either he or his contemporaries achieve so serene a balance between individualism and deference to setting. Soon after 1900, moreover, the fragile foundations upon which the collaborative ideal had been built began to show signs of strain. Paradoxically, not even those monuments to collaborative effort, Electra House, Ingram House, Thames House and the Cromwell Road front to the Victoria and Albert Museum, may be regarded as whole-hearted reassertions of the ideal. They depend for their effect not so much upon the delicate interaction of two

110. George Frampton, stone spandrel figure representing Telecommunication, *c.*1901–2. Electra House, Moorgate, City of London (now City of London Polytechnic, Belcher and Joass, completed 1902).

111. George Frampton, stone spandrel, pair to plate 110. Electra House.

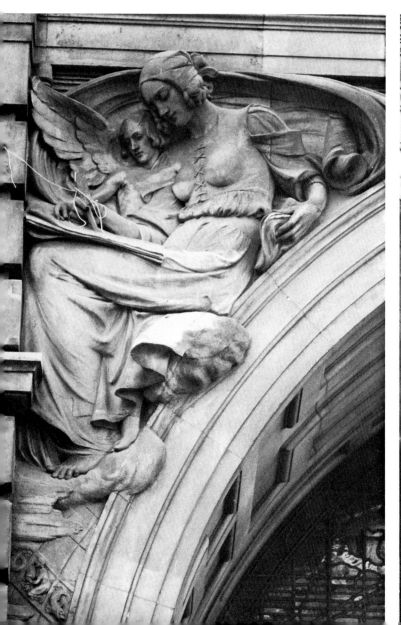

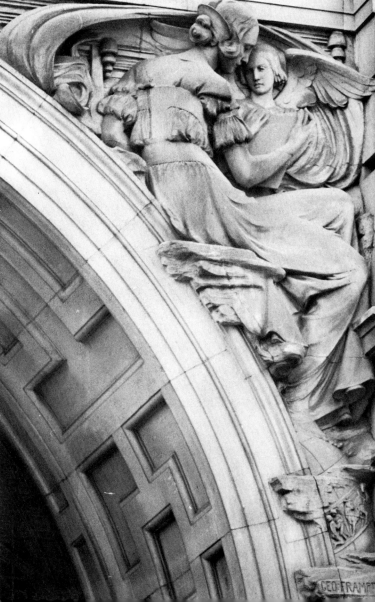

aesthetic disciplines as upon sheer quantity of sculpture and of collaborating sculptors.

The facade of John Belcher's Electra House, Moorgate, completed for the Eastern and Associated Telegraph Companies in 1902, carries at its centre isolated patches of relief sculpture in stone that bear little relation either to each other or to the lumpish architectural forms that surround them. Belcher employed three leading sculptors, in addition to Drury, to provide decoration: Goscombe John (who executed the four allegorical figures of India, China, Japan and Egypt in low relief between the third-floor windows), Pomeroy (responsible for the relief panels in the entrance recess and the group of atlases surmounting the dome) and Frampton, whose lovely spandrel figures transmit and receive telegraph messages across the entrance arch (plates 110–11).[34] At Ingram House in the Strand, the now demolished offices of the United Kingdom Provident Institution, Henry Hare chose, at the same date, to divide the sculpture for the facade between Schenck and Henry Poole and to give the interior work to a third sculptor, Frank Lynn Jenkins. The successor to Collcutt's practice, Stanley Hamp, heaped sculpture upon his design for the Southwark Bridge elevation of Thames House, offices of the Liebig Extract of Meat Company, and distributed responsibility for its execution between Jenkins, Richard Garbe and J.E. Taylerson. The oddly assorted figures and groups that tumble above the entrances and in the pediments (plates 112–13) lend a certain energy to an otherwise enervated Baroque pastiche but the facade as a whole, completed in 1912, is a denial of that concept of homogeneous design which the Arts and Crafts movement had striven to promote.

As an example of the misapplication of the collaborative ideal the Victoria and Albert Museum is the more grave because it was intended to represent the apotheosis of unity between architecture and sculpture. Uncertain in his handling of the scale of the huge and wilfully elaborate facade, Aston Webb has reduced the sculpture to anecdote, figures and panels once more deposited in available spaces 'like ornaments on the mantelpiece'.[35] He had set about the selection of sculptors, late in 1904, with confidence and pride. 'I propose', he wrote to the Office of Works, 'with the sanction of the Board to obtain estimates from sculptors of eminence for the Sculpture on and around the principal entrance and to invite promising young sculptors with a feeling for Decorative Sculpture to undertake the figures in the range of niches.'[36] The spandrels of the principal entrance arch, he later explained, would contain figures representing Truth and Beauty and constitute the most important areas of ornament on the building. Second in importance would be the bosses on the archivolt, the niches at the springing of the arch and those immediately above its apex which would contain figures of Queen Victoria, St Michael and St George. By March 1905 the whole of this secondary group and a portrait figure of Prince Albert to stand above the doorway had been commissioned from Alfred Drury, whose estimate for the work was £4,200. The portraits of English painters, sculptors, architects and craftsmen to fill the long range of subsidiary niches would be allocated to John Wenlock Rollins, James Gamble, Oliver Wheatley, Paul Montford, Abraham Broadbent, A.G. Walker, A.B. Pegram, F. Lynn Jenkins, Ernest Gillick, Stanley Nicholson Babb, Reuben Sheppard, Gilbert Bayes, W.S. Frith, Albert Hodge and four advanced students at the Royal College of Art working under the direction of the Professor of Sculpture, Edward Lanteri. W.S. Frith would undertake all purely architectural carving. In May Webb reported that George Frampton, 'who is especially endowed with architectural feeling', was prepared to model and carve the spandrel figures for the sum of £1,000 each.[37] A year later the last niche figures – Edward VII and Queen Alexandra, to flank the entrance bay – were commissioned from Goscombe John.[38]

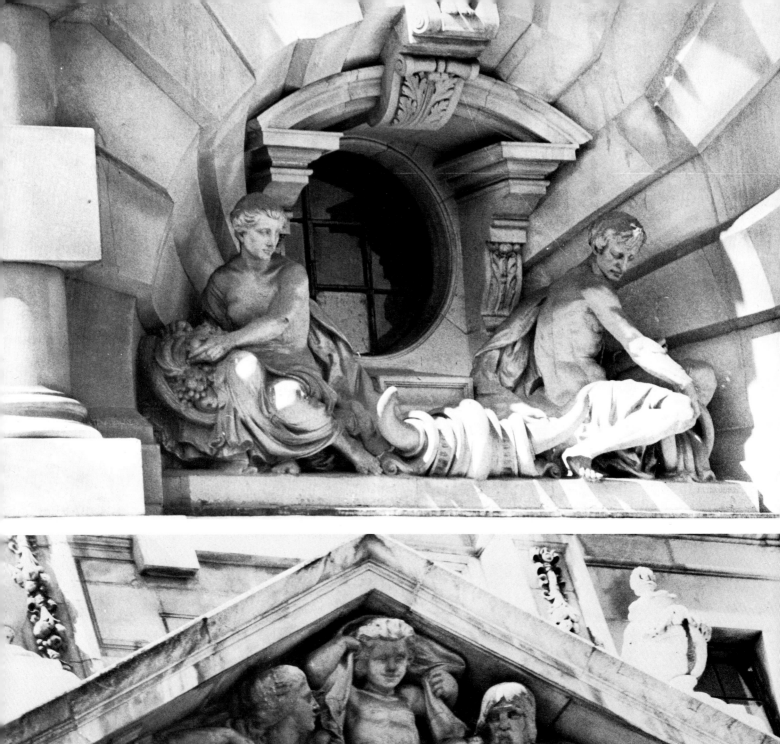
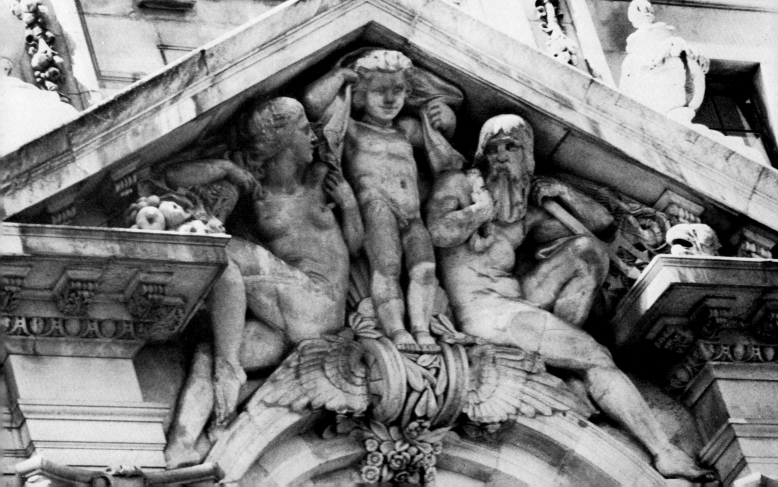

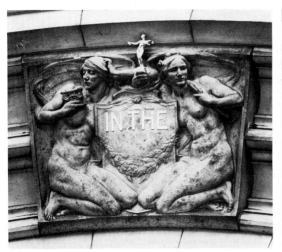

Significantly, the only part of this vast undertaking to receive more than cursory comment from the art press was Drury's series of archivolt panels, the most purely decorative and the most integrated sculptures within the scheme (plates 114–15). The nine panels are carved with female figures in low relief, their crouching or kneeling poses, their attendant children and their flowing drapery forming a rich and intricate accompaniment to the wide curve of the arch. The interdependence of figures, panels and architectural mouldings is further emphasised by the plaques that the women bear, on which, in letters of gold, runs the legend from Sir Joshua Reynold's *Discourses*, 'The excellence of every art must consist in the complete accomplishment of its purpose'. The archivolt reliefs, commented the *Studio*, 'are specially deserving of attention as examples of architectural sculpture at its best. Mr Drury . . . has an infallible instinct for choosing the right middle course between too severe reticence and over-emphatic assertion. Restraint there is, undoubtedly, in everything he does, but it is the restraint of an artist who knows exactly how to keep his work in right relation to its surroundings without stripping it of its individuality.'[39]

But the predicament of the architectural sculptor, neatly defined by the *Studio*, remained inextricably linked to the aims and motivations of architects and was exacerbated now by a profession concerned less with true collaboration than with fashionable adherence to its more superficial aspects. The arguments put forward in open debate at this period suggest that sculptors felt their autonomy and their own standards as decorative artists to be increasingly threatened. There is more than a hint of despair in Stirling Lee's address to the R.I.B.A. in 1905. 'If I have any view at all', he said, 'it is that sculpture is an individual art: it is as much an individual art as painting, and that a man who tackles a piece of stone in a building has to put his own individuality into it . . . What I do feel is that if we are ever to do anything in relation with architecture again we must come back to the first principle, and that is that sculptors and architects must work together.'[40] On the same occasion Reynolds-Stephens appealed for a return to the kind of lucid design that made Leonard Stokes's All Saints' Convent at St Albans 'a really fit modern way of treating a building with sculpture' (plate 116). Here, he pointed out, 'the money available for sculpture has been rightly concentrated upon a long band of rich work just over the main doorway, and three niche figures a few feet higher and all needless ornament avoided. This is the sort of site which would inspire almost any sculptor to do his very best, and I think Mr [Henry] Wilson in his sympathetic work has not wasted his chances, with the result that the sculpture really adds a beauty to the building as a whole.'[41] A similar hardening of attitude towards architects was expressed more directly by Frank Lynn Jenkins in a

114. Alfred Drury, central archivolt relief panel, *c*.1905–7. Victoria and Albert Museum, Cromwell Road elevation (Aston Webb, completed 1909).

115. Alfred Drury, subsidiary reliefs on the archivolt. Victoria and Albert Museum.

112. (facing page top) Frank Lynn Jenkins, stone group above doorway, *c*.1910–12. Thames House, Queen Street, City of London (Collcutt and Hamp, completed 1912).

113. (facing page bottom) J.E. Taylerson, stone pediment group. Thames House.

116. All Saints' Convent, St Albans (Leonard Stokes, 1899–1903, sculptured frieze by Henry Wilson).

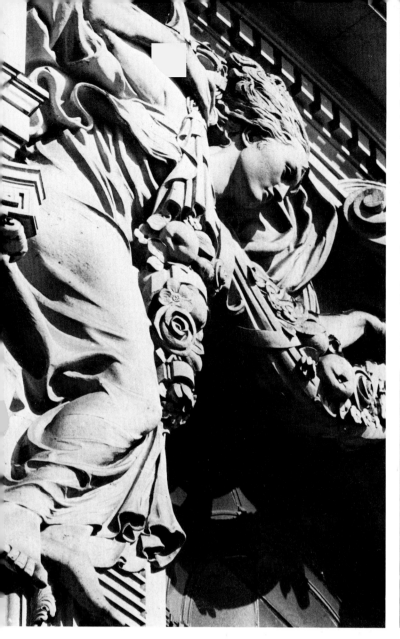

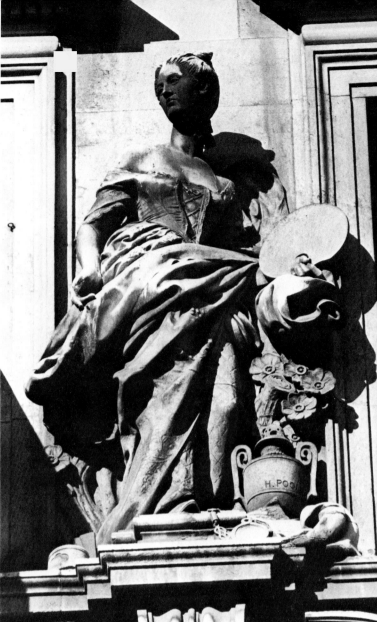

117. Henry Poole, stone spandrel figure. Methodist Central Hall, Westminster (Lanchester and Rickards, 1905–11).

118. Henry Poole, porcelain figure representing Painting, *c*.1911. 144–146 New Bond Street (Lanchester and Rickards, 1911).

paper read at the Art Workers Guild in February 1905 and expanded for the Architectural Association in January 1906. Architects' lack of interest in evolving new ornamental forms had prompted some sculptors – notably, he pointed out, George Frampton – to evolve their own, yet still architects remained unmoved. Still, he protested, 'they have not sufficiently exploited the latent ability of their brother artists . . . to strike with them that complete chord of harmony and refinement which is comparatively rare in the architecture of the present day'. Grimly Jenkins concluded,

> A great deal has been written and there has been endless discussion on the subject of collaboration between architects and sculptors. For my own part, I fail to see how it is possible, under existing circumstances, for true collaboration to occur, and, although in a few isolated instances a great measure of success has been attained, it has, I believe, been more the result of accident than otherwise. Before collaboration can be thorough there must be a common bond of mutual understanding between the sculptor and architect, which certainly does not exist at present.[42]

The portal reliefs of the Victoria and Albert Museum, like Frith's Whitehall bridge spandrels, are among the last complete expressions in architectural decoration of the

130

spirit of the 1890s. The men who had led English sculpture into the twentieth century remained obsessed by the individualist principles of the previous decades and by a vision of collaborative design that was by 1905 – if it had not always been, as Jenkins cynically suggested – impossible to realise except by some freak of circumstance. Their successors at Lambeth, the Royal College and other art schools were less committed to that vision. The advance of Edwardian Baroque had brought with it to prominence a group of young sculptors whose reputations rested almost entirely on carved decoration. Highly skilled and responsive to the individual needs of architects as no early nineteenth-century 'carver' had been, Henry Poole, Albert Hodge, H.C. Fehr, Charles Pibworth and many others developed a hard-edged, formal style singularly appropriate to an architectural context but as limited in range as that of the late neo-classical sculptors of ideal figures and portrait monuments. The compromises made in the service of architects by these younger men were to contribute to the decline of the very movement that had stimulated demand for their work.

The decorative works of Henry Poole, Albert Hodge and Charles Pibworth represent, respectively, three of the chief characteristics that emerged in sculpture after 1905: rigidly symmetrical or otherwise overtly contrived composition, a return to the stern, rhetorical images of neo-classicism and a stripped, geometrical treatment of form. Poole's first major commission, won in the competition of 1900, was to provide one of the figure groups for the pavilions of Cardiff City Hall, the great Baroque palace designed by Lanchester, Stewart and Rickards in 1897. Out of this sprang his friendship with the brilliant young architect A.E. Rickards and many commissions to decorate buildings for which the firm was responsible. Rickards was a superb draughtsman and highly sensitive to sculptural values. Deptford Town Hall of 1902 and the Methodist Central Hall, Westminster, begun in 1905, exemplify the stylish, voluptuous manner in which he worked, dependent upon French and Austrian rather than English Baroque sources. The architect's detailed sketches for the carved decoration of Central Hall demonstrate that Poole's function was to translate into stone concepts that had already been fully developed on the drawing board and he did so in obedience to a strict and frozen symmetry which neither Bates nor Frampton would have tolerated.[43] The twin spandrel figures on the apsidal entrance bay are caught in arrested motion like heraldic motifs and there is no psychological interaction between them as there is between Frampton's Electra House figures with their delicately balanced responding poses and air of spontaneity (plate 117, cf. plates 110–11). The Central Hall reliefs, those on the Town Hall at Deptford and the rococo figure in porcelain on the front of Partridge's premises in New Bond Street (plate 118) are immaculately matched with their architectural setting and have relinquished, to this end, much of their autonomy and pathos as works of art. Likewise, Albert Hodge's neo-classical gods and goddesses in stone and white metal decorating the front of 99 Aldwych, are remote as cyphers from human experience (plate 119). 'He does not allow you to think of flesh', said M.H. Spielmann; his constant aim was 'the subjection of the sculpture to the architecture'.[44] Just as Hodge's use of a neo-classical formula secures a discreet anonymity for his figure sculpture, so historical pageantry became a means to the same end in Henry Fehr's frieze for Middlesex Guildhall (plate 120) and Charles Pibworth's panels for the Deanery Road front of Bristol Central Library, designed by Charles Holden (plate 121). The work of Pibworth contains, moreover, a threat to the standards of the New Sculpture more serious than either neo-classicism or historical anecdote: his harsh simplifications and concern to echo the geometry of the masonry block, particularly evident in the sculptures on Holden's library extension to

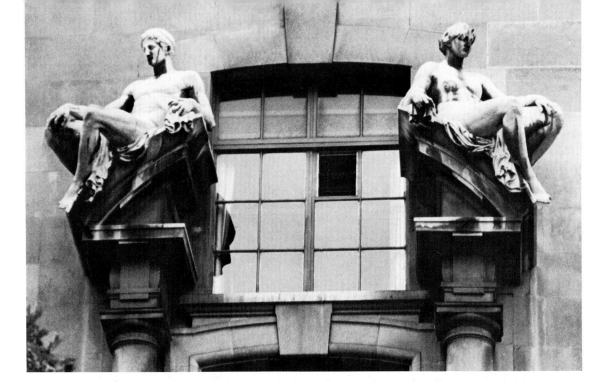

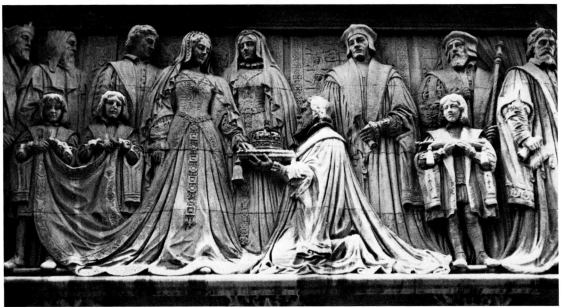

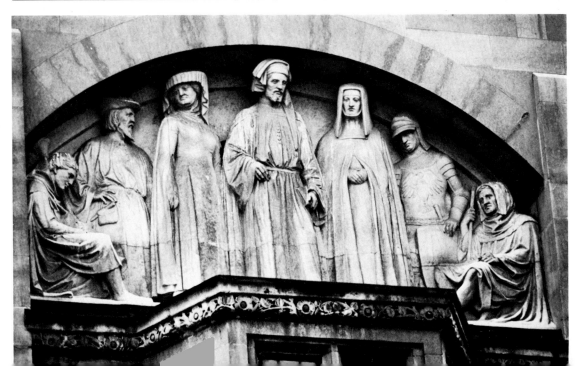

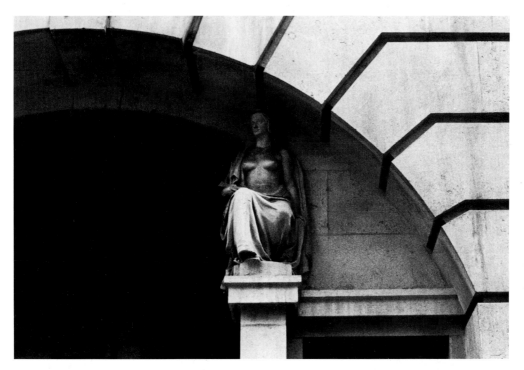

122. Charles Pibworth, stone figure in window recess, *c.*1904. Library block, Law Society, Chancery Lane (Charles Holden, completed 1904).

the Law Society's premises in Chancery Lane (plate 122) do much to explain why he was succeeded in the architect's favour by Jacob Epstein and Eric Gill.

By 1906 the great building boom of the turn of the century was over and Edwardian Baroque had passed the peak of its development. Demand for sculpture began to recede as the purer and tidier classicism of the Beaux-Arts tradition strengthened its hold in England. It was clear by 1910 that architects were fast relinquishing their hold on Arts and Crafts ideals and their belief in the possibility of developing a genuinely 'free' style by reference to the styles of the past. 'The Arts and Crafts movement', the *Architectural Review* was to observe, 'has led its votaries into a species of mental cul-de-sac.'[45] Beaux-Arts classicism, steel-framed construction and simple economic necessity all played a part in eroding the relevance of sculptural decoration at a time when a spontaneous reaction against all excessive ornament had already set in. 'We cannot help asking ourselves', wrote the *Architects' and Builders' Journal* of the designs submitted for the St Marylebone Town Hall competition in 1911, 'whether all these colossal columns, domes, towers, groups of sculpture and other imposing features are felt by their authors to be the only natural and inevitable expression of the necessities of the case.'[46] Though Charles Holden's early buildings in his stripped classical manner show a deep understanding of the principles that had drawn architects and sculptors together in the 1890s they point forward, at the same time, to the rationalist ethic of the Modern Movement in which applied decoration held no significant place.

The sense of impending crisis, not only among the New Sculptors but among their younger contemporaries, is reflected nowhere more clearly than in the formation, during 1904, of a professional body to represent their interests. Never before had English sculptors made any serious, united attempt to close ranks in such a way. The movement begun in the 1880s had provided its own momentum and sense of solidarity and the very role of sculpture had been defined by its relationship with other arts. Whatever need sculptors felt for co-operative action and discussion had been amply served by the Art Workers Guild and the Arts and Crafts Exhibition Society.

119. (facing page top) Albert Hodge, stone pediment figures. 99 Aldwych, Westminster (J.J. Burnet, 1911).

120. (facing page middle) Henry C. Fehr, detail of stone frieze. Middlesex Guildhall, Parliament Square (J.S. Gibson & partners, completed 1913).

121. (facing page bottom) Charles Pibworth, stone relief panel, *c.*1906–7. Bristol Central Library (Charles Holden, completed 1907).

The first suggestions for a Society of British Sculptors were put forward at a small gathering in Derwent Wood's studio in the autumn of 1903.[47] At larger meetings in November and the early months of 1904 a provisional committee including Frampton, Frith, Lynn Jenkins, Reynolds-Stephens, Derwent Wood and Thomas Brock was formed and empowered to 'establish a Society having for its object the protection of the interests of British Sculptors and the consolidation of the profession of Sculpture'. The first Statutory General Meeting was held at the galleries of the Royal Society of British Artists on 13 February 1905. Thomas Brock was elected President and the first members of Council were Drury, Frampton, Frith, Jenkins, Goscombe John, Sir Charles Lawes-Wittewronge, Stirling Lee, David McGill, F.W. Pomeroy, Reynolds-Stephens, Thornycroft and Derwent Wood. It was resolved to propose Armstead (then in the last year of his life), Gilbert (then self-exiled in Bruges) and John Sargent as honorary members. By May 1905 the membership numbered fifty-one and by 1907 included every sculptor of standing in the country. Early in 1911 the prefix Royal was added to the name of the Society.[48] The scant records that survive, and the brief and tersely worded annual reports, suggest that the Society did little more, in its early years, than agitate for better exhibition conditions in London and the provinces. There is a certain tragic irony in the fact that the first opportunity which did arise for direct action on behalf of members was in connection with one of the last and most extravagantly Baroque buildings of the Edwardian age and that it caused the Society to be disrupted by jealousy and misunderstanding.

In 1913 D.A. Thomas (later Lord Rhondda) offered to provide ten statues of Welsh celebrities to supplement the decoration of Cardiff City Hall. The President, then George Frampton, and Council members were asked to advise on the method by which sculptors should be selected and James Havard Thomas was appointed to go to Cardiff as the Society's representative. When the members learned that the ten proposed pieces of sculpture had been allotted, without competition, to Goscombe John, Ernest Gillick, Henry Pegram, David McGill, John Tweed, Pomeroy, Henry Poole, Alfred Turner, T.M. Crook and Havard Thomas himself, there was an instant outcry. In reply to accusations that he had, in self-interest, encouraged the donor to abandon the idea of a limited competition, Havard Thomas declared that the decision had been taken before his arrival in Cardiff and that when he, with Frampton and John, had been offered a part in the work, he had flatly refused it, as also had Frampton. But, said the sculptor, D.A. Thomas had protested that 'I should be proud to employ my talents in a National undertaking and that he could not accept my refusal'. Nevertheless, letters resigning their position on the Council were received from Albert Hodge, Jenkins, Paul Montford and Derwent Wood, all of whom had been absent from the nominations, and at an extraordinary general meeting in January 1914 a vote of censure was passed on the President and Council who promptly resigned office while several sculptors including Frampton, John, Pomeroy and Havard Thomas went further and renounced their membership of the Society.[49] Not until 1926 had the bitterness engendered by the affair receded sufficiently for the vote of censure to be formally expunged from the records. Mysteriously, a letter from Lord Rhondda dated 10 January 1914 had come to light which confirmed Havard Thomas's story. If, it was declared, this letter had been produced in 1914 the whole unfortunate misunderstanding could have been avoided.[50] And so, with euphemistic phrases, was closed an incident that must have seemed then, as it seems today, to symbolise the state of disarray and apprehension in which sculptors had faced, at last, the end of an era.

6. *The Search for a New Aesthetic*

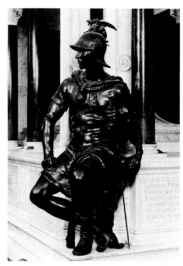

123. Paul Dubois, *Le Courage Militaire* (Paris Salon 1876 in bronze; Grosvenor Gallery 1877 in plaster). Nantes Cathedral.

As C.R. Ashbee remarked in 1938, the primary concern of English sculptors at the turn of the century was to 'get loose' from inherited conventions of function and form.[1] The revival of architectural decoration may be seen as their greatest achievement in the struggle for freedom of function, for it brought sculpture as high art out of the elitist context of the exhibition gallery into direct confrontation with the public at large. Thus it made public, too, that simultaneous struggle for ideological freedom which is reflected in the development of ideal sculpture after 1880. It was in their private pursuit of the means to express a new range and depth of feeling and a new comprehension of reality that the New Sculptors established a unique relationship with the most powerful force in contemporary painting and literature, the symbolist movement.

The issue of symbolism in sculpture has been persistently clouded by the confused efforts of critics – notably, in England, Edmund Gosse – to evaluate all sculptural achievement in terms of 'truth to nature', while recoiling in dismay whenever 'realism' in the form of an imperfectly proportioned figure threatened the 'dignity' of the art. Perhaps, by its very nature as solid, three-dimensional form, sculpture resists identification with the essentially anti-materialist concepts of symbolist painting and poetry. 'It seems to me', said Rodin, 'that I have remained a realist, a sculptor', and indeed there was not one of his English contemporaries who would not also have claimed nature as inspiration and starting-point. Yet the aim of the symbolist was not to reject nature, but to approach it in a new way, as the outward expression of an inner reality: the world of thought, emotion and imagination.

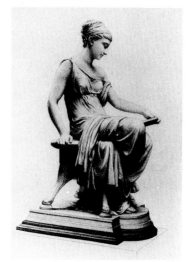

124. Thomas Nelson MacLean, *Ione* (Royal Academy 1875, Grosvenor Gallery 1877 in terracotta; produced also in marble). From *Art Journal* 1880, p. 272. Present location unknown.

Early manifestations of the symbolist aesthetic in French painting of the 1860s and in the work of Rossetti, Burne-Jones, Albert Moore, Whistler and Watts, had no parallel in sculpture. In England sculptors continued to work within the suffocating confines of neo-classical tradition, only Stevens and the occasional sculptural experiments of Watts suggesting the possibility of radical change. In France, meanwhile, the vivid romanticism of Carpeaux and Préault and a revival of interest in Michelangelo heralded a renaissance that clung obstinately, nevertheless, to rhetorical sentiments and conventional allegory. It was not until the 1880s that a sustained attempt was made to question the very motive of sculpture as a visual art. Seizing a new vocabulary where they could – from Stevens and Watts, from French romantic realism, from the late Pre-Raphaelite painters, pragmatic in aim and committed only to self-determination, Alfred Gilbert and his contemporaries in England evolved a language of sculpture more consistently symbolist in spirit than any in Europe.

No sculptor starting out upon his training in London in the 1870s could have failed to

135

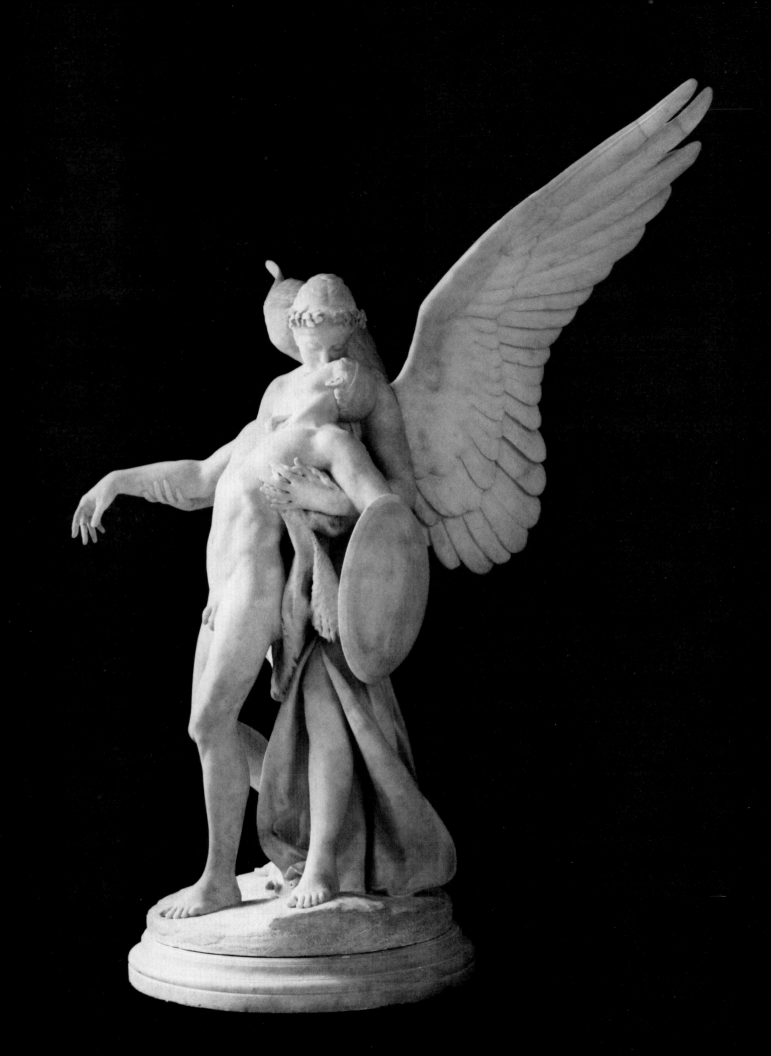

recognise the existence of a vigorous alternative to the *impasse* of mid-nineteenth-century neo-classicism. Jules Dalou was not the only French sculptor whose work, by an accident of political history, now appeared for the first time at the Royal Academy. In 1871 his fellow expatriate Jean Baptiste Carpeaux showed four pieces there, including *Ugolino*, the agonised giant that was the precursor of Rodin's *Thinker*. Between 1872 and 1874 he exhibited six works, culminating in a terracotta version of the group *La Danse* for the Paris Opera House. Carrier-Belleuse showed a terracotta statuette in 1873. In 1876 the work of Stevens was represented at the Academy for the first time with the group *Valour and Cowardice* for the Wellington Monument (plate 4). The impact of the warrior-figure of Valour with her Michelangelesque largeness of pose and gesture and mood of heroic contemplation was reinforced the following year by the exhibition of *Le Courage Militaire* by Paul Dubois at the newly opened Grosvenor Gallery. A plaster cast of the cloaked and helmeted figure for the monument to General Lamoricière in Nantes Cathedral (plate 123) was given pride of place in a display of sculpture that also included *Education Maternelle* by Eugène Delaplanche and *Jeanne d'Arc à Domrémy* by Henri Chapu. Though Sir Coutts Lindsay's choice of sculptor-exhibitors was and continued to be governed rather by his instinct for the socially acceptable than by any deep feeling for their art, he achieved, perhaps inadvertently, something of unique importance at his first exhibition: a juxtaposition of French romantic-realist sculpture – extrovert and coolly objective – and a group of paintings whose most dominant shared characteristics were their introversion and their subjectivity, their tendency to blur the boundaries between visible reality and imagination. Lindsay had, indeed, invited Gustave Moreau to contribute *L'Apparition*, first shown at the Paris Salon of the previous year and a seminal work of the symbolist movement. Moreau's watercolour, Watts's *Love and Death*, Burne-Jones's *The Beguiling of Merlin*, and the *Seven Days of Creation* panels, Whistler's four *Nocturnes* and Albert Moore's *Sapphires* evoked, together, a poetic and private dream-world, silent and intense, that was new in Victorian painting and – so it must then have seemed – beyond both the capabilities and the proper boundaries of sculpture.

Paris had exerted little appeal as a training ground for English sculptors before 1876. Thomas Nelson MacLean was exceptional in having entered the studio of Carrier-Belleuse in 1859 and the École des Beaux-Arts two years later and it is significant that Gosse identified him at an early stage with the new movement.[2] He was active in promoting small-scale, domestic sculpture (see Chapter 7) and was among the first to reflect the influence of contemporary painting. *Ione* of 1875 (plate 124), exhibited at the Grosvenor Gallery in 1877, has much in common with the classically draped, languorous maidens of Albert Moore. One of MacLean's later groups, *Spring Festival*, was directly inspired by Alma-Tadema's painting shown at the Academy in 1880. The quiet grace of his style may well in turn have influenced the early work of sculptors such as Thornycroft and Onslow Ford who had no direct experience of Beaux-Arts training.

The general exodus to Paris was led, appropriately, by Alfred Gilbert who entered the studio of J.P. Cavelier early in 1876. In 1878 the award of the Royal Academy's travelling studentship enabled Stirling Lee to join him at the École des Beaux-Arts. By 1879 Dalou was completing his two-year term as a modelling instructor in Kensington and Lambeth. In 1881 Drury became his assistant in Paris; in the same year the Academy made the decision to award the studentship every second year instead of every fourth and to Paris in rapid succession between 1882 and 1889 went Harry Bates, Pomeroy, Frampton and William Goscombe John. Bertram Mackennal made the same pilgrimage independently during the 1880s. At home, meanwhile, opportunities

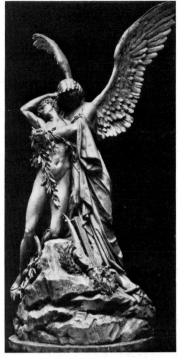

126. Gustave Doré, *La Gloire* (Paris Salon 1878 in plaster). Group survives in damaged state at Musée des Beaux-Arts, Maubeuge.

127. Antonin Mercié, *Gloria Victis* (Paris Salon 1874 in plaster, 1875 in bronze; Paris International Exhibition 1878 in plaster). Bordeaux.

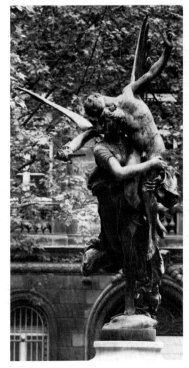

125. (facing page) Alfred Gilbert, *The Kiss of Victory*, 1878–81. Marble, 58 in. Minneapolis Institute of Arts.

to confront the possibility of a new kind of expression in sculpture were rapidly accumulating. Rodin's visit to London in 1882 was marked at the Grosvenor Gallery with his bronze portrait of Alphonse Legros and at the Academy with the bust of St John the Baptist. His *Age of Bronze* was the sensation of 1884. Most important of all, the works produced by English sculptors during or immediately after their journeys abroad were beginning to appear, like outriders of the new movement, in London exhibitions.

Between 1882, four years after leaving France for Italy, and 1886, some eighteen months after his return to London, Alfred Gilbert presented at the Grosvenor Gallery and the Academy a group of works that clearly reveal the chief stylistic sources and impulses from which the New Sculpture was to develop. They reflect, above all, a struggle first to assimilate and then to break free from the influence of France. The marble *Kiss of Victory* (plate 125) sent to the Academy in 1882 is heavily indebted to Gustave Doré's *La Gloire* of 1878 (plate 126) and, as Edmund Gosse observed, to Antonin Mercié's *Gloria Victis* (plate 127) nationally acclaimed and cast in bronze at public expense after its first appearance at the Salon of 1874.[3] Gilbert's group is considerably less theatrical in effect than either of its precedents, still close in feeling, choice of material and technique to neo-classical, Canovesque convention. The derivation of both theme and composition, the spiralling column of limbs balanced by the outspread wings of Victory and the arms of the upheld warrior, is, however, unmistakable.

Mercié, born in 1845, was the youngest of the Frenchmen whose monuments, exhibited in the Salon or recently set up in the streets of Paris, would have roused the intense interest of Gilbert and his contemporaries. Like Falguière and Frémiet, Dubois, Dalou and Rodin himself, Mercié was chiefly concerned to express physical and emotional energy not only through the representation of the human figure, but through technique and the handling of bronze. The veneration for Michelangelo and for the Italian Renaissance in general which Stevens had represented almost in isolation in England was widely shared and well established in France when Gilbert arrived there. While in Rome during the early 1870s Mercié had produced the plaster model for a figure which summarised his ideals: the life-sized bronze version of *David with the Head of Goliath* was exhibited with *Gloria Victis* at the International Exhibition in Paris in 1878 (plate 128). Nude but for the pleated cloth that binds his forehead, the hero stands with head bent low, relaxed in pose with one foot resting nonchalantly on the head of his victim and one arm raised to plunge the sword back into its sheath. Behind the figure's graceful naturalism lie three chief sources: Donatello's bronze *David* in the Bargello, Florence, Cellini's *Perseus* in the Loggia dei Lanzi and the *ignudi* and sibyls of the Sistine Chapel. Reluctant, perhaps, to admit the extent of his debt to Mercié, Gilbert maintained that he was too poor to visit exhibitions when he was in Paris, but it is impossible to believe that he was not thoroughly familiar with the *David* when, late in 1878, he went to Rome and from there, about 1880–1, to Florence, to discover for himself the implications of those very sources.

The bronze nude *Perseus Arming* (plate 129), originally conceived as a 29-inch-high statuette and exhibited at the Grosvenor Gallery in 1882, shows Gilbert's first tentative step towards that fusion of art and idea which was to become his obsessive concern. Its subject is the *Perseus* of Cellini; its theme, derived from Donatello's *David*, is the vulnerability of adolescence, but its true motive is the evocation of the sculptor's own innermost mood. Clothed only in a heavy helmet and one winged sandal, the figure glances down over the right shoulder to check the sandal's fit, the right arm extended, in a gesture of sweet spontaneity, to maintain equilibrium. Beside Mercié's confident

128. Antonin Mercié, *David with the Head of Goliath* (Paris Salon 1872 in plaster; Paris International Exhibition 1878 in bronze). Musée d'Orsay, Paris.

129. Alfred Gilbert, *Perseus Arming* (*c*.1881–2). Bronze, 14½ in. (reduction). Tate Gallery.

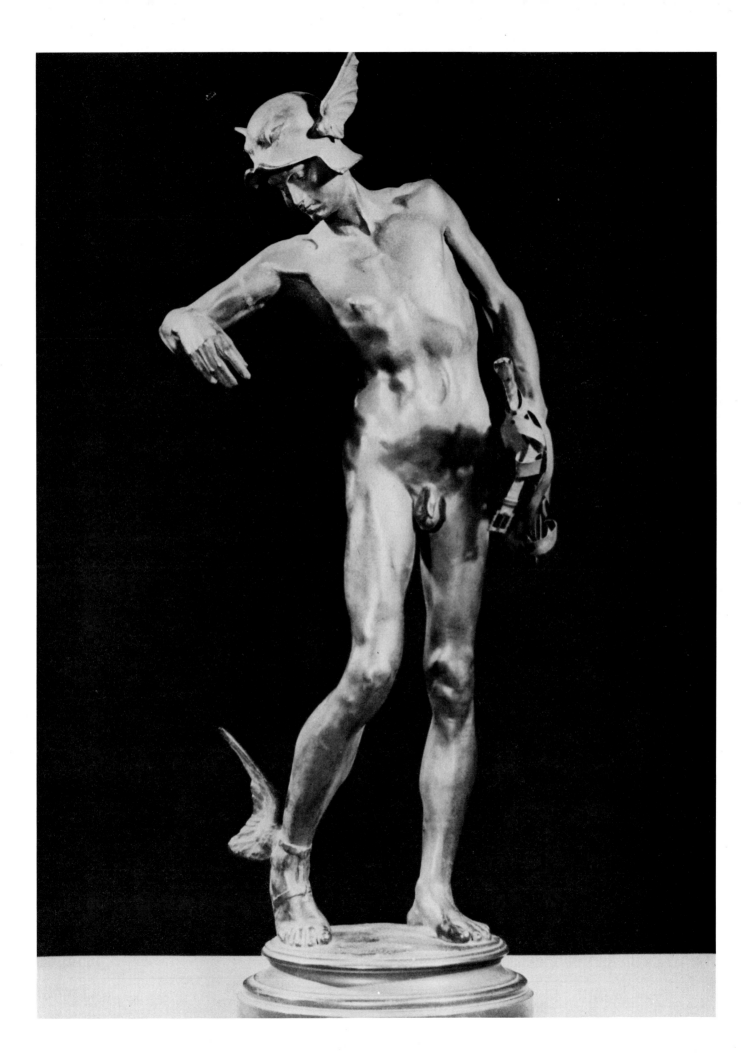

David with its effect of inherent vigour, of physical power held in check, Gilbert's nude boy is wistful and sad, by no means sure of victory but anxiously prolonging the moment before battle. 'The reason I chose the subject', Gilbert told Joseph Hatton,

> was that, from evidence I had witnessed in Florence . . . I had become convinced that after all there might be nothing more original . . . , than the banal or old-time story; but that in its exposition every story has two sides – the one being the accepted and literal test, and the other which the text suggests. After seeing the wonderful and heroic statue by Cellini, amazed as I was by that great work, it still left me somewhat cold, insomuch that it failed to touch my human sympathies. As at that time my whole thoughts were of my artistic equipment for the future, I conceived the idea that Perseus before becoming a hero was a mere mortal, and that he had to look to his equipment.[4]

In 1883 Gilbert was represented at the Academy again, by *Study of a Head* in bronze (plate 130). Though it is modelled upon an Italian servant-girl, the head is not a portrait in the narrow sense but a concentrated investigation of the same reflective mood that is evoked in *Perseus Arming*. Its abstract quality is intensified by the introduction of a hair-concealing bandeau similar to that worn by Mercié's David and derived ultimately from Michelangelo. 'It brought about a new outlook in sculpture', recalled Goscombe John sixty-three years after the first showing of the head in England.[5] A comparison of MacLean's precisely contemporary work *Meditation* (plate 131) with a long series of later studies that include Harry Bates's *Rhodope* of 1887 (plate 132), a bust by Onslow Ford (plate 146), Goscombe John's own portrait of his daughter Muriel of 1896 (plate 186) and Thomas Brock's head of Sculpture for the Leighton Memorial (plate 226), confirms the truth of that statement. There can be few idealised

130. Alfred Gilbert, *Study of a Head* (1882–3). Bronze, 15 in. National Museum of Wales, Cardiff.

131. Thomas Nelson MacLean, *Meditation*, 1883. Marble, 18½ in. Private collection.

132. Harry Bates, *Rhodope* (Grosvenor Gallery 1887 in bronze; produced also in marble). From *Magazine of Art* 1887, p. 343. Present location unknown.

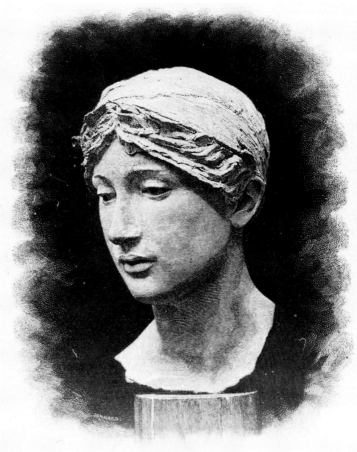

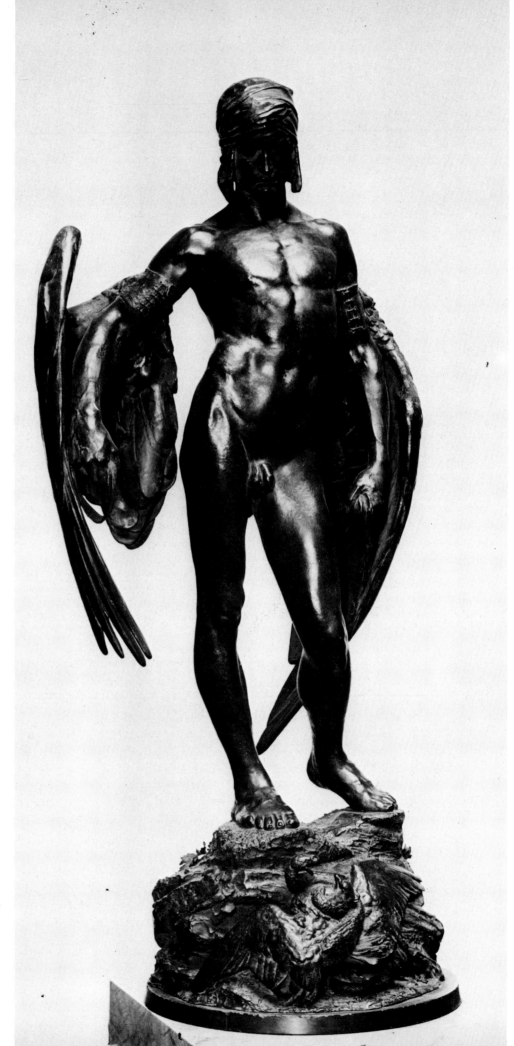

133. Alfred Gilbert, *Icarus*, 1884. Bronze, 42 in. National Museum of Wales, Cardiff.

female portraits in late Victorian sculpture that do not owe something, directly or indirectly, to Gilbert's *Study*.

The astonishingly rapid development of Gilbert's personal style as he assimilated the experiences of France and Italy was displayed once more at the Academy before his return to England. The bronze statuette *Icarus* (plate 133), exhibited there in 1884, unites elements of *Perseus* and the portrait study and advances beyond them both towards a symbolist aesthetic. With growing confidence in his own power of self-expression, Gilbert revealed here more clearly than in *Perseus* his debt to Donatello, Cellini and Mercié. The intensity with which the detail is observed in the boy's wings and the leather braces that bind them to his arms and in the crusty mound of rocks, leaves and symbolic snake and bird at his feet demonstrates a consuming struggle to grasp the whole implication of Florentine quattrocento sculpture. Gilbert suggested, in conversation with Hatton, that he had been surprised by the success of *Perseus*, having always, without quite knowing why, considered this early work in some way 'incomplete'. Puzzling over this once more, he had suddenly recognised where its incompleteness lay:

> I had made a statuette but its pedestal, to my horror, was a mere carpenter's job, made for an exhibition. At once I felt the necessity of taking a further lesson, or, rather, of picking up one which I had failed to seize from the Florentines. I awoke to the conviction that they had not made the pedestals to their figures for nothing . . . This lesson revolutionized the whole train of my thoughts. Being unwilling to copy or steal the method of ornament I had so strangely neglected, I set myself a new task, the hardest task of my life, which some day may bear fruit.[6]

It is easy to read too much into Gilbert's often perversely enigmatic statements about his art, but the implication of his words here seems clear: the Donatellesque treatment of the pedestal as a means of echoing and extending the significance of the figure it supports had revealed to him the possibility of taking sculpture beyond the figurative towards pure expressive form. The task he set himself, anticipating the leap from symbolism to abstraction, led to the development of the flowing, molten style of decoration, often misleadingly described as 'Art Nouveau', which is a recurring feature of his metal work and monumental sculpture after 1887.

The early stages of this development are marked by the pedestals of the three major works which followed *Perseus Arming*. The clutter of objects at the feet of *Icarus* is still closely related to the treatment of the pedestal in Donatello's *David*. The sacrificial child-woman of *An Offering to Hymen* (plate 134), shown at the Grosvenor Gallery in 1886, stands on a base modelled with grotesques so stylised as to suggest the hieroglyphics on a pagan altar, the pedestal thus echoing the symbolism of the statuette. In *The Enchanted Chair* (plate 135), a life-sized plaster group which Gilbert sent to the Academy in the same year, subject and pedestal were merged into one sculptural entity. The threatening forces of the unconscious mind to which the sleeping nude is exposed are suggested not only in the conventional symbol of the eagle perched upon the chair back but, more potently, in the near-abstract loops and striations of the cherubs' wings that form the base and rise about her feet with rhythmic motion. *The Enchanted Chair* broke new ground in Gilbert's investigation of symbolist ideas but at the same time looked back on the academic tradition from which he had emerged. Its theme was borrowed directly from Carrier-Belleuse's *Sleeping Hebe* (plate 136), one of the most neo-classical groups in recent French sculpture, which portrays the half-nude cupbearer of the gods asleep, the eagle of Jupiter perched with outstretched wings on

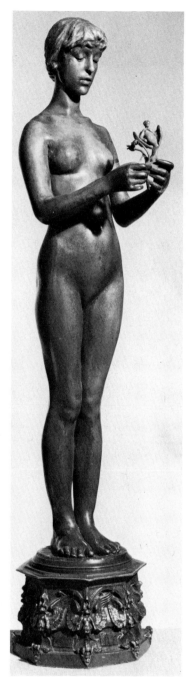

134. Alfred Gilbert, *An Offering to Hymen* (c.1884). Bronze, $11\frac{1}{2}$ in. Private collection.

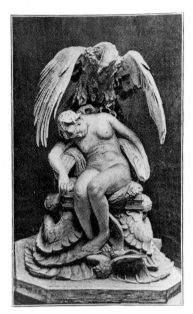

135. Alfred Gilbert, *The Enchanted Chair*, 1886. Plaster, LS. Destroyed 1901. From *Art Journal* 1886, p. 332.

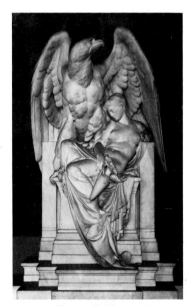

136. A. Carrier-Belleuse, *Sleeping Hebe* (marble group exhibited in Musée de Luxembourg after its completion in 1869). Réserve du Louvre, Paris.

the back of her throne. Gilbert's choice of this group as the basis for the most daring experiment he had yet undertaken demonstrates his almost obsessive concern to liberate sculpture from the *cordon sanitaire* of classical myth and to charge it with emotion. *The Enchanted Chair* was, Gilbert told Hatton, 'entirely suggested by my dreams of hope and my desire at that time to break away from mere material and matter-of-fact expression in my art'.[7]

There can be little doubt that this desire had intensified when Gilbert returned to London in 1884 and saw, for the first time in nine years, what was happening in English painting. He first met Burne-Jones at the Grosvenor Gallery in 1886 when both men were exhibitors and shortly afterwards was invited to the painter's studio. His comments on Burne-Jones, both as a personality and as an artist, are revealing. 'I know of no other example, except that of Michael Angelo, where personality and production are so intimately wedded', he said, discovering in the painter the very qualities he had imagined him to possess when, as a young student in London, he had studied and admired *Love among the Ruins*. Confronted now by *King Cophetua and the Beggar Maid*, Gilbert was overwhelmed by 'mingled feelings of wonder and joy', and recognised, he said, in the incomplete Briar Rose series, a triumph of imagination over 'material effort'.[8] His ability to identify with the aims of Burne-Jones strengthened Gilbert's belief in the possibility of a closer relationship between sculpture and painting. He told Hatton that *The Enchanted Chair* was 'an attempt to incorporate life with realistic representation and the romantic side, which in painting always holds good, and in sculpture is too often conspicuous by its absence'.[9] According to Gilbert it was because the group was severely criticised for being 'too picturesque' that he never progressed beyond the plaster model; perhaps he himself was uneasy with its evident romanticism and with the close links it maintained with French academic sculpture, for he destroyed it when he left the Maida Vale studio after his bankruptcy in 1901. Scarcely a hint of any such criticism is revealed, however, in the contemporary press. *The Enchanted Chair* was a sensation among artists, wrote Gosse, going on to describe its lightness and mystery of conception, 'imaginative to the highest degree'.[10] The *Spectator* praised its 'extremely refined and subtle combination of imagination and reality'.[11] Walter Armstrong's suggestion that Gilbert's work sometimes lacked 'sculpturesque' quality may represent the kind of comment that the sculptor feared. But Armstrong was the biographer of Stevens: it is no accident that he was also the first to perceive what was new and revolutionary in Gilbert's approach. Both *Icarus* and *The Enchanted Chair* displayed, he wrote, 'a potential life in quietude which I can see in the work of no other living Englishman', an observation that comes close to identifying their deeply symbolist intentions.[12]

Gilbert's anxiety over *The Enchanted Chair* may well have been related also to the vexed question of *couleur*. The term was originally coined to decribe the vigorous modelling and contrasts of light and shade that characterised romantic sculpture in France and by the late 1880s it was commonly applied to any work that showed signs of French influence. The plaster group, wrote Gosse, had 'pushed to the last extreme that research after "colour" which had been Mr Gilbert's great aim',[13] and there is evidence that the sculptor deeply resented the implication that his chief concern was to develop borrowed ideas and techniques. The essay published in the *Universal Review* in 1888 sets forth his own interpretation of the word *couleur* as applied to sculpture. It was true, he wrote, that students who had benefited from a Beaux-Arts training showed a technical excellence, an ability to handle relief and relationships of light and shade, that was quite beyond the scope of English art schools. Yet there was more to *couleur* than this. 'We all know full well', he explained in a crucial paragraph,

that in looking at a picture its merits do not appeal to us only through the amount of pigment which may be crowded on the canvas, or by the manner it is applied; ... in like manner, it is not only clever handwork and trick which attracts us in a work of sculpture: we are astonished and no more; but the qualities which are inseparable from a good picture are necessary to a work in sculpture, and these command our admiration. This consideration then points to the near affinity of the two arts, and suggest therefore that the word "couleur" ... is, after all, nothing more than the most proper and natural expression of the sense of the presence in a piece of sculpture of those qualities.[14]

It is clear that the term with its painterly associations had acquired a special significance for Gilbert. It stood for the freedom of sculpture to probe, as painting did, beyond the surface of things, to establish a link between external reality and the unseen world of the imagination. It stood, paradoxically, for an approach to sculpture widely different from that encountered by Gilbert in Paris.

In 1886 Gilbert was at work on the Fawcett Memorial in Westminster Abbey, whose

137. William Hamo Thornycroft, *Lot's Wife*, 1877–8. Marble, 72 in. Leighton House.

138. G.F. Watts, *Clytie* (first marble version 1867–8). Bronze, 33 in. Tate Gallery.

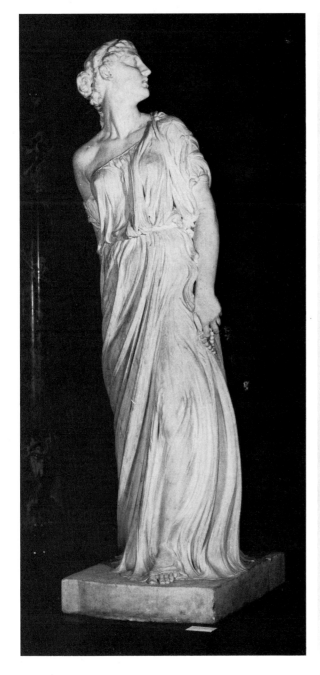

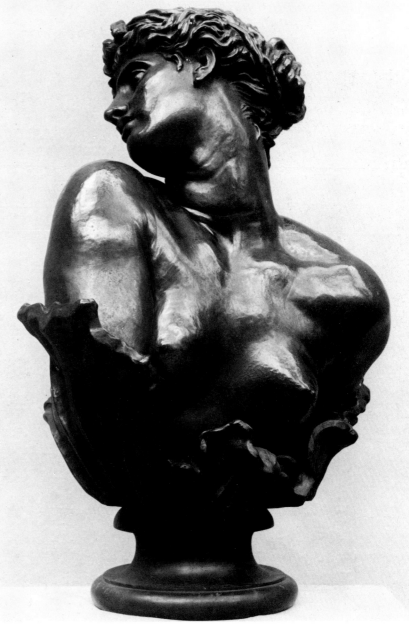

seven tiny allegorical figures in bronze placed within their Gothic trefoil are an embodiment of the 'wonder and joy' he had felt before the paintings of Burne-Jones.[15] That response motivated the introduction here, for the first time in his work, of colour in the literal sense, with different patinations of bronze, gold, silver and semi-precious stones. It helps to explain the strange fancy of the figure of Sympathy enclosed in tangled briars, the predominance here, and in Gilbert's subsequent work, of female over male figures and his interest in the expressive potential of elaborate drapery and armour at the expense of the nude. The unveiling of the memorial early in 1887 not only marked the beginning of a new phase in Gilbert's development but coincided with the emergence of the New Sculpture as a coherent movement with a clear stylistic identity. While he fought on to relate his sculpture to his own feelings and aspirations, the work of his three close contemporaries, Hamo Thornycroft, Onslow Ford and Harry Bates, was beginning to reflect similar concerns.

139. William Hamo Thornycroft, *Artemis*, 1880–1. Plaster, LS. Macclesfield Town Hall.

140. William Hamo Thornycroft, *Teucer*, 1881. Bronze, 82 in. Tate Gallery.

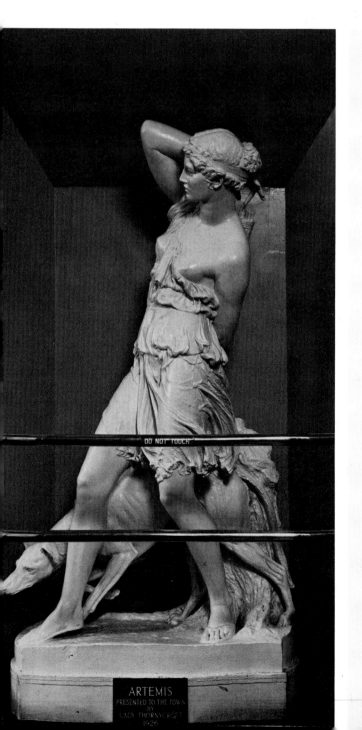

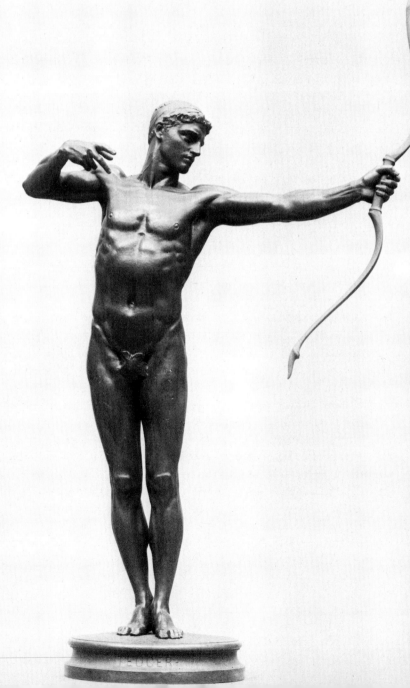

'The Royal Academy and the Elgin Room were my only masters', Thornycroft told Edmund Gosse.[16] *Lot's Wife* (plate 137), the life-sized marble figure which was his first major ideal work after winning the Academy's gold medal for sculpture in 1875, reveals, however, the overwhelming influence, not of Henry Weekes or even of the Parthenon frieze, but of G.F. Watts and his most celebrated essay in sculpture, the bust of *Clytie* (plate 138). The pose of Clytie, the head twisted vigorously back on the muscular column of the neck to gaze over the raised right shoulder, is strikingly Michelangelesque: perhaps it was this that first caught Thornycroft's imagination, for he had been to Italy in 1871 at the age of twenty-one and told Gosse that the study of Michelangelo had brought about 'a great modification of his aims in art'. Watts had undertaken the bust in conscious revolt against the 'bare, cold work' of the nineteenth-century neo-classicists who, he wrote, in their search for 'purity and gravity', had lost sight of those other qualities in classical sculpture, 'flexibility, impression of colour and largeness of character'.[17] But *Clytie* is more than an attempt to rejuvenate the classical tradition. The great precursor of symbolist art in England, who described his paintings as 'thoughts, attempts to embody visionary ideas',[18] chose a subject peculiarly suited to symbolist interpretation: the moment when Clytie, yearning for the sun-god Apollo, is transformed into the flower that slowly turns forever in the direction of the sun. It is a theme which deals with the predominance of emotional over physical life, with doomed beauty and passive, silent grief. The similarity of Thornycroft's subject seems too close to be coincidental. He too chose to portray a metamorphosis. *Lot's Wife*, exhibited in marble at the Academy in 1878, shows the figure gazing back with fear and longing on the destruction of her city, the dense pleating of her drapery already resembling the stratifications of rock. Though by no means fully explored, the symbolist qualities of both works are clear. Both portray their subjects in a state of isolation from the physical world, imprisoned by anguished thought. In both, the human head takes on the significance of a symbolic fragment, an idea later to be investigated in the paintings of Odilon Redon and touched upon also by Rodin and Alfred Gilbert.

It is interesting to speculate what course Thornycroft's development would have taken if he had immediately followed through the ideas implicit in *Lot's Wife* and had not been diverted from them by the powerful influence of Leighton and, through him, of modern French sculpture. *Artemis* (plate 139), shown as a life-sized plaster at the Academy in 1880 and commissioned in marble by the Duke of Westminster for Eaton Hall, Cheshire, reveals that interest in the portrayal of movement and physical grace for its own sake which was later to dominate and finally suppress his symbolist preoccupations. *Artemis* is the female counterpart to Leighton's bronze *Athlete* (plate 6), her body captured, like his, in a single tense moment of arrested action. The similarities between the two figures were even more apparent at the early stages of the clay model, illustrated by Gosse in his first New Sculpture article, before the addition of the light Grecian tunic.[19] Gosse implied, moreover, in a letter of August 1879, that Thornycroft was then seriously considering casting the statue in bronze. 'I have found a little Greek poem by Diotimus', the critic told his friend, 'which has an interest for you. It is supposed to be inscribed on the pedestal of a statue of Diana . . . "I am Diana. As is meet, I am made of bronze, being daughter of Zeus and of no other god. Behold the vigour and audacity of the young goddess, and confess that the earth itself is too narrow for so swift a huntress." I am pleased to have come across this, because it is a fine argument in favour of bronze.'[20] Concurrently with his work on *Artemis* Thornycroft was engaged on a bronze statuette, the *Stone Putter*, shown at the Academy in the same year, and followed it with the monumental bronze figure of *Teucer* (plate 140), both of

141. William Hamo Thornycroft,
The Mower, 1884. Bronze, LS.
Walker Art Gallery, Liverpool.

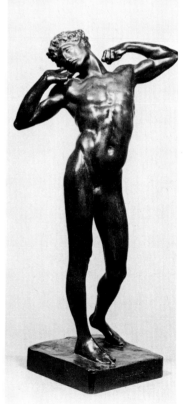

142. William Hamo Thornycroft, detail of the *Sower* (1885–6). Bronze, LS. Kew Gardens.

143. Frederic Leighton, *Sluggard* (1885). Bronze, 20½ in. Published by Arthur Collie, 1890, from sketch model for LS bronze figure now in Tate Gallery. Private collection.

which relate closely to the *Athlete* in subject, feeling and treatment of material. According to Gosse he intended the *Stone Putter* to be the first of a series of small bronzes 'illustrative of English games'.[21] That this project was indefinitely postponed may have been simply for lack of time and opportunity but was more probably due to the impact on Thornycroft of the events of 1882 and 1884.

In 1881, probably on the strength of the success of *Artemis*, the sculptor was invited to exhibit at the Grosvenor Gallery. Showing there again in 1882, he found himself a co-exhibitor with Alfred Gilbert and Rodin. At the Academy in the same year Rodin's bust of St John the Baptist stood with the completed *Artemis* in marble and *Teucer* in bronze. Thornycroft contributed nothing but portraits to the summer exhibition in 1883 but by the following year he had prepared the plaster model for a new ideal figure, the *Mower* (plate 141), accompanied in the Academy catalogue by a passage from

Matthew Arnold's pastoral lament 'Thyrsis' of 1867. Profoundly different in quality from *Artemis* and his early athlete-gods, the *Mower* suggests that in Gilbert's gentle *Perseus* and the vibrant surfaces of Rodin's bronzes Thornycroft had understood the implications of quattrocento sculpture for the first time and recognised a new way forward for his own art. With wide-brimmed hat, breeches and boots, the figure stands in a moment of idleness, his weight on the left leg. The right hand supports the scythe and the left arm is bent, the back of the hand resting lightly on the hip. In both posture and mood it is closer than either *Perseus* or *Icarus* to Donatello's bronze *David*. Reminiscent of Meunier's labourers though the *Mower* is, Thornycroft was concerned here not so much with social comment or the dignity of labour, as with the evocation of stillness and reverie and the exquisite melancholy of Arnold's poem, the subject merely a convenient starting-point for a deeper investigation of sculpture's propensity to deal with states of mind. In the closely related figure of the *Sower*, shown at the Academy in 1886, Thornycroft explored the possibility of portraying movement while still preserving the sense of isolation and extreme introversion of the earlier work. The marvellously expressive kerchiefed head (plate 142) with its highly articulated hollows and planes suggests that he had looked closely at Gilbert's turbanned head of a girl when it appeared at the Academy in 1883.

While he was at work on the *Sower* Thornycroft undertook a commission that was to be as vital in disseminating the new aesthetic principles of sculpture as his work for John Belcher was vital in extending its role: the Gordon Memorial now on the Thames Embankment (plate 200), was amongst the first attempts to reconcile the exhausted tradition of the public monument with the anti-materialist, innately symbolist ideals expressed in *Icarus* and the *Mower* (see Chapter 8).

The appearance of *Perseus Arming* and Rodin's *St John the Baptist* in 1882, followed in 1884 by *Icarus* and the *Age of Bronze*, affected the attitudes and expectations of all concerned with the art of sculpture. Sculpture must 'touch the inner springs of feeling', demanded the *Magazine of Art*, protesting at the 'vast amount of scrupulous mediocrity' at the Academy in 1883.[22] Leighton's life-sized male nude figure the *Sluggard* of 1886 (plate 143), however feeble a variation on Rodin's theme, records a dramatic change in the attitude to sculpture represented, ten years earlier, by the *Athlete wrestling with a Python*. A similar change, owing directly to Gilbert, was to be observed that year in the work of Edward Onslow Ford.

When Ford moved in 1881 to The Avenue (now Sydney Mews), the block of studios off the Fulham Road occupied by Edgar Boehm, he had recently won the competition for the statue of Sir Rowland Hill to be erected at the Royal Exchange (plate 202) and was set upon a career as a portrait sculptor. He had exhibited portraits each year at the Academy since 1875 and it was not until 1884 that the sequence was broken with a major ideal work. The life-sized bronze nude *Linus*, now at the Lady Lever Art Gallery, Port Sunlight, is loosely based upon Thornycroft's Greek athletes and heralded an *oeuvre* notable for a brilliant and wide-ranging eclecticism. Ford's formidable 'powers of assimilation' to which Gilbert's biographer Isabel McAllister pointedly referred,[23] were brought into full play for the first time when Gilbert, returning from Rome, took studio no.4 in The Avenue, close to his own at no.6. McAllister records that the sculptor was assisted by Ford and Stirling Lee at this period in his experiments with lost-wax casting.[24] Both Gilbert and Lee were then also much concerned with the portrayal in sculpture of adolescent girlhood. The second of Lee's marble reliefs with its controversial nude was about to be erected on St George's Hall and Gilbert was preparing to exhibit *An Offering to Hymen* at the Grosvenor Gallery.

I. George Frampton, *Lamia*, 1899–1900. Bronze, ivory and opals, 23½ in. Royal Academy of Arts.

Folly (plate 144), the first of a long series of bronze statuettes in which Ford exploited the same theme, appeared at the Academy in 1886. 'It made the fortunes of its creator,' wrote Marion Hepworth Dixon, 'for here in a seductively direct and simple realisation the sculptor both found and made known his special gifts.'[25] The slight nude figure is poised precariously on a serpentine base in the form of a rock, her toes curled over its edge. One hand is raised to point languorously into the distance, the other lowered to beckon to some unseen companion. While Gilbert's early bronzes evidently provided the immediate inspiration for the statuette – even the rocky pedestal refers to *Icarus* – it seems also to have independently absorbed qualities from late Pre-Raphaelite painting, especially as represented at the Grosvenor Gallery. The figure combines frail grace and a certain spiky awkwardness in a manner reminiscent of the style of Walter Crane. Its lack of any allusion to legend, classical or otherwise, has a precedent in the

144. Edward Onslow Ford, *Folly*, 1885–6. Bronze, 36 in. Tate Gallery.

145. Edward Onslow Ford, *Peace* (1886–7). Bronze, 19 in. Reduction published by Arthur Collie, 1890, from LS bronze figure now in Walker Art Gallery, Liverpool. Private collection.

153

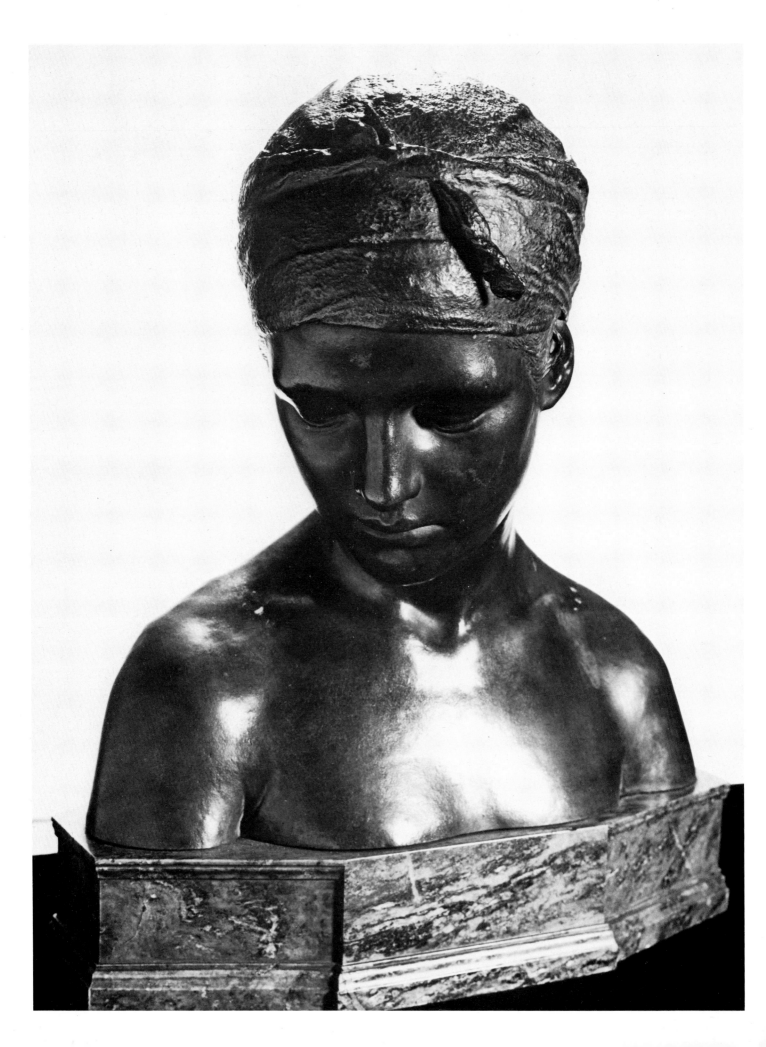

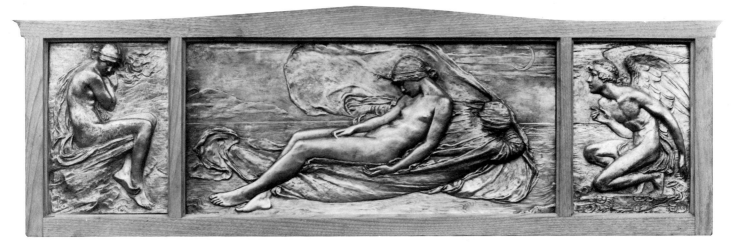

'subjectless' paintings of Albert Moore, and Ford chose as his title not the name of an object from the visible world but an idea. Though *Folly* is, in the strict sense, an allegory, it carries none of the accessories or attributes of the abstract theme it represents and has no didactic purpose. Less serious a work of art than either *An Offering to Hymen* or the *Mower*, *Folly* is nevertheless an attempt to convey pure feeling in realist terms.

It is characteristic of Onslow Ford that he was able to grasp the most crucial new concept in the work of Gilbert and Thornycroft and present it in a form that had immediate popular appeal. *Folly* was acquired by the Trustees of the Chantrey Bequest in 1886 and she and her successors, notably *Peace* of 1887 (plate 145), the *Singer* of 1889 and *Echo* of 1895, were widely and extravagantly praised. Many critics began to regard Ford as the supreme representative of the new school and his work inspired the more successful attempts to define its special identity. It was in his essay on Ford that Marion Hepworth Dixon pronounced the 'new men' to be poets as much as sculptors, 'who will hold us, not so much by the commanding force of a Dalou or a Rodin, as by the cunning of some hidden meaning, some suggestive grace, by I know not what of allurement by which we are beckoned into other and ideal worlds'. Of the bust of a girl with bound head and downcast eyes (cf. plate 146), offspring of Gilbert's *Study* of 1883, the same critic wrote, 'Mr Ford's "Study" is not simply a young girl, it is *the* young girl, soft-breathing in her fugitive grace, her exquisite unconsciousness . . . In looking at it we feel that we have that evanescent and elusive thing, an idea carved in the sternest of materials. It is an ideal wrought in stone.'[26]

Harry Bates was the most devout classicist of the group who, by 1888, had established new terms of reference for sculpture and for this reason, perhaps, his work seems the most self-contained and its symbolist content the most diffuse. It is an indication of the movement's unity of purpose, however, that soon after his return to London in 1885, equipped like Gilbert with an intimate knowledge of French modelling technique and the means to carry over into sculpture something of the freedom and 'colour' of painting, Bates turned to the work of G.F. Watts. In 1887 he exhibited three bronze bas-reliefs at the Academy, grouped in the painterly form of a triptych, *The Story of Psyche* (plate 147). The withdrawn figure of Psyche in the left-hand panel recalls that of Watts's *Hope*, shown the previous year at the Grosvenor Gallery; the hooded and shrouded form of Zephyrus in the central relief appears to owe much to the similarly powerful image of Death in Watts's painting *Love and Death*.

The related picture *Love and Life* was to inspire one of Bates's last works, the ivory and bronze group exhibited posthumously at the Academy in 1899 and known as *Mors Janua Vitae* (colour plate II). In the painting a nude girl, Life, is sheltered by the wing

147. Harry Bates, *The Story of Psyche* (1887). Silvered bronze, side panels 13 × 9½ in., centre panel 13 × 29½ in. Walker Art Gallery, Liverpool.

146. (facing page) Edward Onslow Ford, *A Study*, ?1886. Bronze, 15 in. Aberdeen Art Gallery.

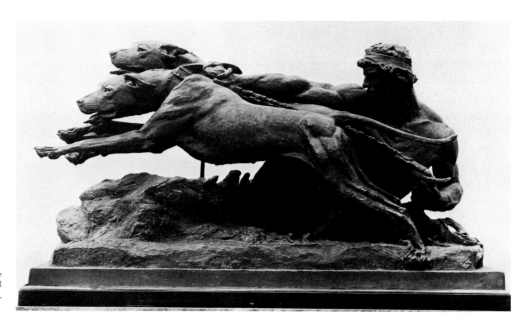

148. Harry Bates, *Hounds in Leash*, 1889. Plaster model for the bronze at Gosford House, East Lothian, 42 in. Tate Gallery.

of Love, a dark and strangely threatening figure beside her pale and fragile body. In Bates's group which follows Watts's composition closely, the melancholy symbolism is heightened by the substitution of Death for Love and the dramatic contrast of tone is echoed and sharply emphasised by the use of ivory for the nude girl and bronze for the figure of winged Death.

In his treatment of the pedestal of *Mors Janua Vitae* Bates indulged in a fantasy entirely his own, achieving, as will be shown, a remarkable and apparently quite spontaneous parallel with the imagery of Alfred Gilbert. For most of his life, however, Bates's approach to both form and content differed widely from Gilbert's. Only in the bronze head *Rhodope* (plate 132) does there seem to be evidence of direct influence, though Bates was still in Paris when Gilbert's *Study* was exhibited in 1883. The sculptor with whom he identified most closely during the 1880s was Hamo Thornycroft. The Reaper in the bakery frieze of 1886 (plate 21) is a descendant of the *Mower*, showing a similar fascination with sculpture's power to suggest latent physical energy. It may be no more than a coincidence that the life-sized bronze group *Hounds in Leash* of 1889 (plate 148) echoes an early idea for *Artemis*, worked out by Thornycroft in a wax sketch now at the Tate Gallery, where two hounds accompany the stooping goddess, one straining forward against her hands. A more obvious source for the group is French animal sculpture, but the parallelism of the leaping beasts and the heroic nude braced in a moment of stasis to restrain them gives the bronze a psychological tension that has no equal in the work of Barye or Frémiet. The terms carved soon afterwards for the Institute of Chartered Accountants likewise derive much of their unique character from the sculptor's ability to suggest a psychological reality beyond the mere representation of decorative classical masks (plate 43).

In 1889 – by apt coincidence the same year in which Arthur Symons, England's most francophile and overtly symbolist poet, published his first volume of verse – the most concentrated display of the New Sculpture yet seen was mounted in Paris. The British Fine Art section of the International Exhibition included Gilbert's *Icarus*, *Perseus Arming*, *An Offering to Hymen* and *Study of a Head*, Onslow Ford's *Folly* and *Peace*, Leighton's *Sluggard* and Thornycroft's *Teucer* and *Mower*. Comparison of this group with the French works shown in the Decorative Art section of the same exhibition

156

highlights the widening difference of aim between the two schools and the deepening relationship of English sculpture with symbolist values. Mercié's *Amphitrite* (plate 149), a statuette in ivory and gold on a silver base, exemplifies the studied grace and sheer virtuosity of French academic sculpture at this date. The rhetorical, expansive gestures and contrived, fluttering draperies are conceived purely in terms of visual effect and there is no suggestion that the figure holds any significance beyond the detached portrayal of a physical ideal. It represents the concept of 'style' as a finite commodity, to be learned and perfected like technique, a concept in direct opposition to the individualist philosophies of symbolism.

Despite the awe in which French sculpture and French training were held in England during the second half of the century there remained a steady undercurrent of distrust for this approach, a conviction that the expression of an artist's inner self must be more vital to sculpture than acquired style or refinement of taste. 'The artists turned out by the regular Parisian studio', commented Armstrong, 'are, as a rule, far too much of a pattern', and it was for this very reason, he implied, that Harry Bates had chosen to remain independent of the Beaux-Arts system. Gilbert told Hatton that, by 1878, 'I had grown tired of French influence, in which I felt my own individuality was overshadowed'. His account of his arrival in Italy says much about the limitations of the system he had left behind. 'The scales fell from my eyes', he recalled; 'I saw, for the first time in my life, the works of the fathers of the Renaissance; . . . they seemed to reveal to me what I then understood as style, and which I have since learnt to regard as the expression of an individuality.'[27] 'The French', pronounced William Morris in 1882, 'are above all things masters of style . . . For my own part, I doubt if they have so much innate love of beauty as a great part of our population has. In matters of style the French are supreme; they can take two or three ugly things and combine them into a congruous whole, which looks plausible at least.'[28] The very excellence of French modelling technique, Pomeroy warned a group of students in 1899, could work against the best interests of sculpture if too slavishly copied: 'Whatever the French sculptor has in his mind he works out with consummate skill, though this very facility has led to a lack of the true sculptural instinct in the choice of what might be represented. Anyone who has visited the Paris Salons must have been struck at the fly-away effect produced by the number of statues with their arms and legs thrown about in an extremely restless and startling manner.'[29] English sculpture's relationship with France during the 1890s and the survival, for this crucial period, of its unique identity in the face of a potentially engulfing, stifling influence, owe much to that mood of gentle mockery.

It is ironic that French academic sculpture, effectively debarred by entrenched attitudes to 'style' from identifying with the aims of symbolism, should have been the source of many of the ideas that enabled those aims to be expressed with increasing intensity in England. Among the most outstanding examples of the use of a French work of relatively minor significance as the basis for an investigation of the 'inward world of thought and feeling' are George Frampton's two decorative busts, *Mysteriarch* and *Lamia*.

The end of Frampton's two-year studentship in Paris was marked by the award of honourable mention for the two works he exhibited at the Salon in 1889, the *Angel of Death*, a life-sized figure in plaster and a bust, also in plaster, entitled *Christabel* (plate 150).[30] Describing himself in the catalogue as 'pupil of Mercié', he paid homage in the theatrical concept of the angel to the fluid grace of his master's style while declaring the basis of his own in *Christabel*, modelled on the marble portrait busts of Desiderio da Settignano and Antonio Rossellino. Already exploring the possibilities of the bust as a

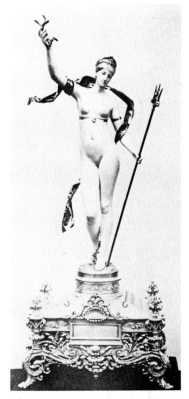

149. Antonin Mercié, *Amphitrite* (Paris International Exhibition 1889 in ivory and gold). From *L'Art Decoratif à l'Exposition Universelle de 1889*, Paris 1890, plate 3. (Version in Walters Art Gallery, Baltimore.)

157

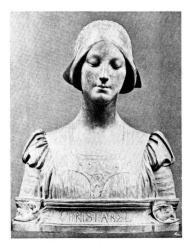

150. George Frampton, *Christabel* (Paris Salon 1889 in polychromed plaster). From *Studio* January 1896, vol. 6, p. 207. Present location unknown.

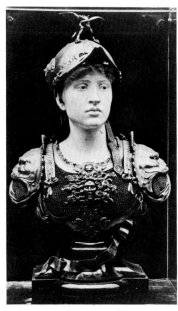

151. Moreau Vauthier, *Gallia* (Paris International Exhibition 1889 in ivory and silver). From *L'Art Decoratif à Exposition Universelle de 1889*, Paris 1890, plate 1. Present location unknown.

152. George Frampton, *Mysteriarch*, 1892. Polychromed plaster, 36 in. Walker Art Gallery, Liverpool.

sculptural form divorced from its function as portraiture, Frampton encountered in the same year a work which was to affect radically his development of this theme. At the International Exhibition appeared a half-life-sized bust called *Gallia* (plate 151), designed by the sculptor Moreau Vauthier. It is a conventional, even commonplace image of a female warrior that takes on a startling and almost supernatural quality from the materials and the manner in which it is worked. The fleshy face is of ivory, its smoothness and pallor sharply offset by the richly chased and gilded silverwork of the armour.[31] A Medusa head decorates Gallia's breast and a winged beast surmounts her helmet. There is no suggestion, however, either in her impassive averted gaze or in the treatment of her decorative accessories, that she is intended to convey a meaning beyond straightforward allegory. Frampton's reworking of Moreau Vauthier's theme in symbolist terms began with the life-sized plaster bust *Mysteriarch* of 1892 (plate 152).[32] The ivory tint and sheen given to the plaster, the rigid set and abstracted gaze of the head, the Medusa brooch and the stiff, metallic quality of the bodice are all readily identifiable allusions to the French sculpture. There might have been more but by 1892 other interests were competing for Frampton's attention. Part of his aim in *Mysteriarch* was to express in three-dimensional form the medievalising reverie of late Pre-Raphaelite painting: the feathery hair and winged headdress, the pleated and bound sleeves and even the symbolic disc that frames the head, comparable in significance with the spheres held by the angels in *The Seven Days of Creation*, recall the imagery of Burne-Jones.

That Frampton was also consciously identifying with the aims of European symbolist painters at this period is indicated by his participation in the first exhibition of La Libre Esthétique, the reorganised form of Octave Maus's Les Vingts group, held in Brussels in 1894. The response of the critic Roger Marx to Frampton's entries, which included *Mysteriarch* and two bas-reliefs, *St Christina* of 1889 (plate 68) and *The Vision* of 1893,[33] is of particular interest and relevance, for among the sculptor's co-exhibitors were Odilon Redon, Gauguin, Maurice Denis, Puvis de Chavannes, Eugène Carrière and Jan Toorop. 'Beyond our frontiers', wrote Marx in a general review of the exhibition for *La Revue Encyclopédique*, 'the movement against materialism accelerates: a Dutch artist Jan Toorop works with rhythmic lines that are like the cadences of a love song, that seem to reflect some ecstatic vision. The fight for spiritual expression was taken up in England by Watts . . . and is now continued by another artist from across the Channel, Mr George Frampton, a sculptor-decorator obsessed with dream and mysticism.'[34] Many English critics, on the other hand, seem to have been merely baffled by Frampton's attempts to create a sculptural equivalent for the mystical language of contemporary painting, or to have dismissed them as unworthy of serious consideration. In 1894 when he exhibited one of his most enigmatic and painterly works at the Academy, a panel modelled in low relief entitled *My Thoughts are my Children* (plate 153), Claude Phillips flatly remarked that it was 'a more definite expression of that pseudo-mysticism which coloured the "Mysteriarch" . . . Its attempt to give back what, if anything, is a dream-vision – one, however, which I shall not attempt to unravel – in all too human shapes of a studied naturalism, recalls the fantastic, half-realistic, half-idealistic French art of to-day.'[35]

In the immediate foreground of the narrow perpendicular panel a woman holding a lily stands at right angles to the picture plane but turns, bare-breasted, to confront the observer with a direct and challenging gaze. Beyond her, at the top of the relief, a second female figure with eyes closed and in a frontal trance-like pose is set against the rays of a rising sun, her arms and veil spread out to enclose the children on her lap. The

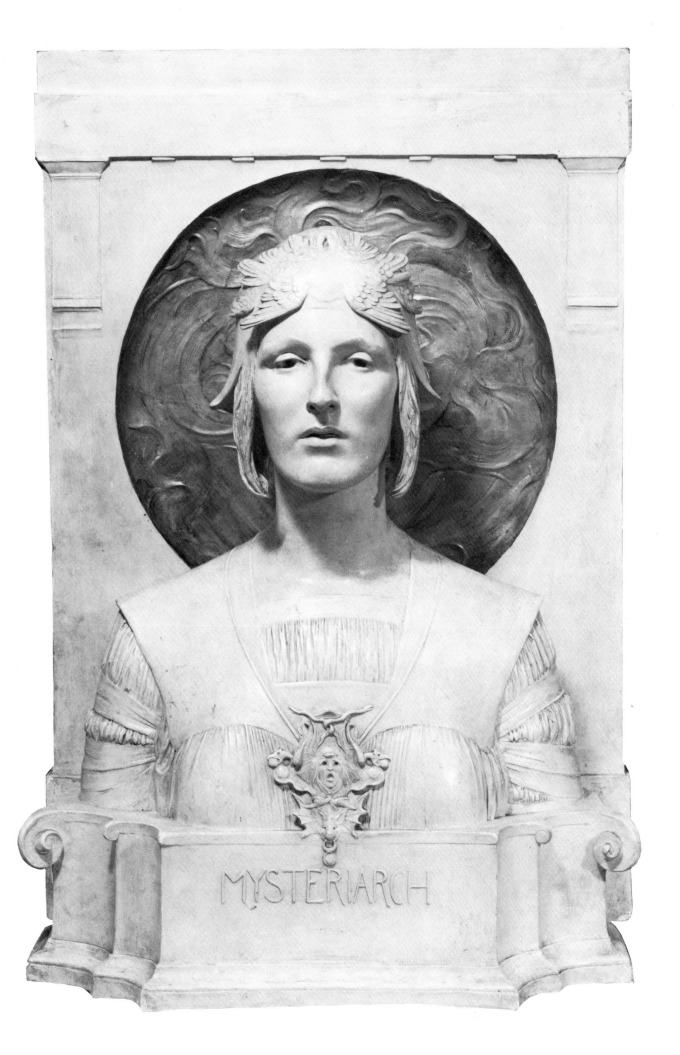

MYSTERIARCH

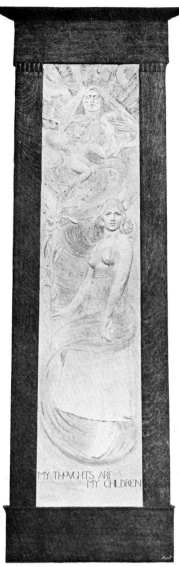

153. George Frampton, *My Thoughts are my Children*, 1894. Bas-relief produced in polychromed plaster and in bronze. From *Royal Academy Pictures*, 1894, p. 180, described as 10 ft. 6 in. high. Present location unknown.

two parts of the relief are linked by a swathe of drapery that, taking on a life of its own, not only unites but flattens the composition in one rhythmic arabesque. The very title of the work suggests that it held a relevance for Frampton as personal as that of *Soyez . . . Heureuses* for Gauguin, and was as tinged with irony. His wife had given birth to a son in March 1894, an only child towards whom, in later life at least, Frampton's attitude was ambivalent.[36] The relief may well reflect emotional conflicts directly related to that event. Certainly it unites those three obsessive and conflicting images of the 1890s: woman as symbol of purity, as predator and as nurturing mother. Whether Frampton knew Gauguin's carved wood panels *Soyez . . . Heureuses* and *Soyez Mysterieuses*, both shown with Les Vingts in Brussels in 1891, it is not yet possible to determine. Perhaps *My Thoughts . . .* was no more than a stage in his independent search for the primitive 'mystery', 'palpitation' and musical qualities of his beloved quattrocento carvings.

Like much of his work in relief, the panel seems to have held a crucial place in Frampton's development as a sculptor in the round. It investigated the possibility, inherent in *Mysteriarch*, of new and radical simplifications of form and led on to the remarkable synthesis of volume and plane that takes place in the bust of his wife and child shown in silvered bronze at the Academy in 1895 (plate 154). That Frampton himself saw the two works as important and closely related is suggested by his inclusion of them both, in bronze, among his entries for the Paris International Exhibition in 1900. The *Mother and Child* has the same basic format as *Mysteriarch*. It is set upon a deep plinth and was originally framed by a rectangular panel in copper inset with a disc of white enamel forming a halo behind the two heads. The bust of Christabel is cut off well below the shoulders and both arms are visible, raised to support the baby who is shown full-length, seated on the plinth, one tiny foot appearing from beneath the spreading robe. Each element in the composition, from the nucleus of the touching heads and the cone of the baby's frock, to the intricate folds of the woman's sleeve and the abstractions of her looped and rolled coiffure, has a geometric clarity, a Düreresque precision. The generalisations of form, combined as they are with an almost obsessive concern for detail and outline, were widely misunderstood. Claude Phillips pronounced the modelling to show 'boldness and dash rather than academic thoroughness' and was evidently much troubled by the sculptor's 'unconventional' approach to this traditional subject. 'One of Mr Frampton's pseudo-mystic figures', he carped, 'such as . . . the so-called "Mysteriarch" would perhaps have lent itself much better to such curious decorative treatment as this group receives.'[37]

With the emergence of his mature style in 1895 Frampton was ready to embrace that concept which he had recognised in *Gallia* and which is inherent in much symbolist painting, the concept of the work of art as cult object in which spirituality and exoticism are morbidly combined. When he began the model for *Lamia* (plate 155, colour plate I) it seems to have been his intention to draw an even closer parallel with *Gallia* than the completed bust suggests. Aymer Vallance who watched him at work on the clay recorded that 'the flesh parts are to be carried out in ivory, to meet the resources and limitations of which the artist has to exercise particular ingenuity, contriving to veil the joints of the material with an ornamental network of gold about the throat and forehead. The sleeves and drapery are to be of silver, embellished with mother-of-pearl.'[38] In the final work and no doubt principally for economic reasons Frampton substituted bronze with inset opals for gold, silver and mother-of-pearl. *Lamia* remains one of the most truly symbolist sculptures in western art. It exploits the major advantage that figure sculpture has over painting in the expression of symbolist ideas. Unlike the painted image which carries with it its own context of painted

160

foreground and background, light and shade, sculpture stands alone in the real world, sharing something of the human condition if only by virtue of its existence in three dimensions and its subjection to the same play of light. From this affinity, perhaps, stems its power to convey an almost oppressive sense of stillness, isolation and silence, the central aim of Redon, Munch, Knopff and many other symbolist painters. Frampton's determination to make the bust life-size and his use of ivory with its eerie likeness to flesh are evidence of his intention to exploit those attributes of sculpture which are outside the scope of painting and to confuse further the boundaries between art, material reality and imagination.

'I cannot recall anything quite like this', wrote a visitor to the Academy exhibition in 1900:

> I had been in the sculpture gallery some minutes before my eye fell on this strange and fascinating Lamia. Imagine a life-size face of extraordinary beauty, mysterious and sad, carved in ivory that in a minute becomes flesh to the eye, the hair and shoulders covered with a close-fitting head-dress and robe. As you gaze, a faint colour comes to the lips – the loveliest, most sensitive of mouths – the eyelids quiver a very little, and her expression changes, but never loses its mystery or its sadness. She makes an absolute silence in the room; whoever turns his head in passing stops and remains as one enchanted.[39]

With the exception of the opals, traditionally associated with doom, that are set into bodice and headdress, no explicit allegory or iconography disturbs the tension of the image. Though the subject is literary in that it derives from Keats's poem and the costume from some Tennysonian dream-world of medieval princesses, the significance of *Lamia* is conveyed entirely by suggestion: the mute face and lowered eyes, the confronting pose, the cold grip of the bronze cape and headdress on the ivory skin, the excessive stylisation and manipulation of the hair, combine to evoke a mood of

154. George Frampton, *Mother and Child*, 1894–5. Silvered bronze against copper panel with enamel disc, LS. From *Royal Academy Pictures*, 1895, p. 109. (Bronze version, without copper panel, in private collection.)

155. George Frampton, *Lamia*, 1899–1900. Bronze and ivory with opals, $23\frac{1}{2}$ in. Royal Academy of Arts. (See also colour plate I.)

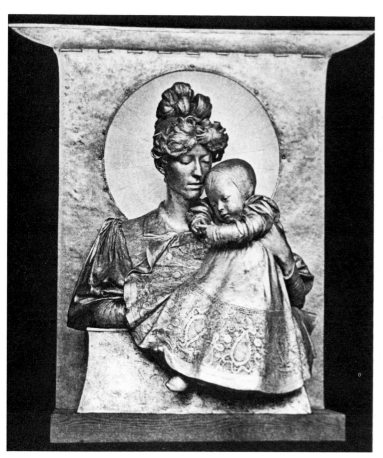

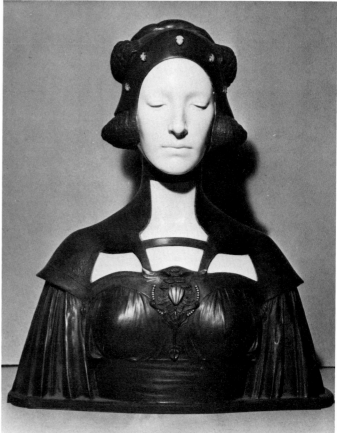

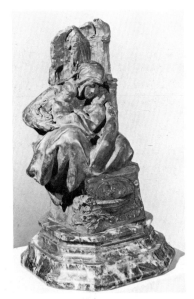

156. Alfred Gilbert, *The Broken Shrine* (1900–1). Bronze, 14 in. Tate Gallery.

157. Alfred Gilbert, *Comedy and Tragedy* (1891–2). Bronze, 15½ in. Tate Gallery.

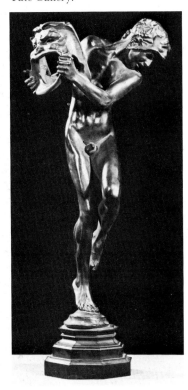

158. (facing page left) Alfred Gilbert, bronze figure of the Virgin from the Clarence Tomb (c.1894–6). (Early version in bronze, ivory and tin, 19½ in, at Kippen Parish Church, Stirlingshire.)

159. (facing page right) Alfred Gilbert, bronze figure of St Elizabeth of Hungary from the Clarence Tomb (c.1894–6). (Early version in bronze, ivory, and tin with mother-of-pearl and semi-precious stones, 21 in., at Kippen Parish Church, Stirlingshire.)

disturbing intensity. Like the brooch of *Mysteriarch* the jewel on the bodice is displayed as if it were a key to the sculpture's meaning but instead draws the spectator deeper into mystery and suggestion. It is formed, in bronze, of a strange hybrid plant whose claw-like roots enclose a crystal sphere and whose leaves open to reveal a tiny nude figure. Above, among its spreading branches, is set a huge opal caged in bronze wires, and the brooch terminates in a pair of spreading wings that merge, finally, with the fabric of the bodice. In comparison with *Lamia*, whose every form and detail reflects the sculptor's yearning to reach beyond superficial appearance and conventional, explicit symbolism towards pure idea and feeling, Moreau Vauthier's *Gallia* seems no more than a technical curiosity, its meaning banal and its sumptuous decoration merely tawdry in effect.

The remarkably clear and consistent progress of Frampton's decorative and ideal sculpture of the 1890s towards the expression of symbolist ideals provides an appropriate background against which to assess the general development of the New Sculpture during that period. While the new aims set forth by Gilbert and Thornycroft in the 1880s attracted an increasing number of followers, the influence of France remained as powerful. The difficulties of reconciling their spiritual, essentially private concerns with the voluptuous, declamatory sculptural style that continued to dominate Paris exhibitions became more and not less evident during the last decade of the century. They are reflected even in the work of Gilbert, who had begun his struggle for independence some ten years earlier than Frampton.

It was not until about 1900 that the problems confronted in *The Enchanted Chair* were fully resolved. In *The Broken Shrine* (plate 156), a group exhibited in plaster at the Clifford Gallery in 1901, the clumsy symbolic apparatus and overt sensuality of the earlier work are cleared away: the crouching figure of the woman with her pathetic burden and bluntly modelled drapery is itself the embodiment of that mood of despair and resignation which is the sculpture's subject. But between the two groups and the stages of development they represent lay much prevarication. For example, Gilbert followed the early symbolist statement of *An Offering to Hymen* by *Comedy and Tragedy*, a tritely allegorical statuette on a plain pedestal, exhibited at the Academy in 1892 (plate 157). A nude boy, holding a comic mask but grimacing in pain, spins round on one foot to look down at a bee-sting on his leg – a double allusion to the sculptor's public life in London society and to his inner torment as an artist.[40] Like the work of Falguière – who seems frequently to have deflected Gilbert's symbolist aims and whose *Hunting Nymph* may well have been a source for the figure of Eros on the Shaftesbury Memorial (plate 218) – the bronze is mannered and unpleasantly vivacious, a kind of parody of Giambologna. Four years later, however, while at work on the Clarence Tomb for the Albert Memorial Chapel, Windsor, Gilbert was to achieve an exquisite purity of symbolist expression in two polychromed bronze statuettes of the Virgin and St Elizabeth of Hungary (plates 158–9). The figures form part of the series of twelve saints that decorates the grille round the sarcophagus.[41] Nevertheless, to evaluate them in isolation is not unfair, for Gilbert himself evidently considered them capable of standing alone as independent images: he sold the bronze and ivory models for both figures into private hands long before the memorial was completed. Foreshadowed by the decorative statuettes in precious materials that were already popular in France and in Gilbert's own work by the polychromed figures of the Fawcett Memorial, *The Virgin* and *St Elizabeth of Hungary* were conceived some four years earlier than Frampton's *Lamia*.[42] Their hieratic intensity of vision has less in common with paintings of Burne-Jones than with those of Jan Toorop, whose *Three Brides* had been illustrated in the

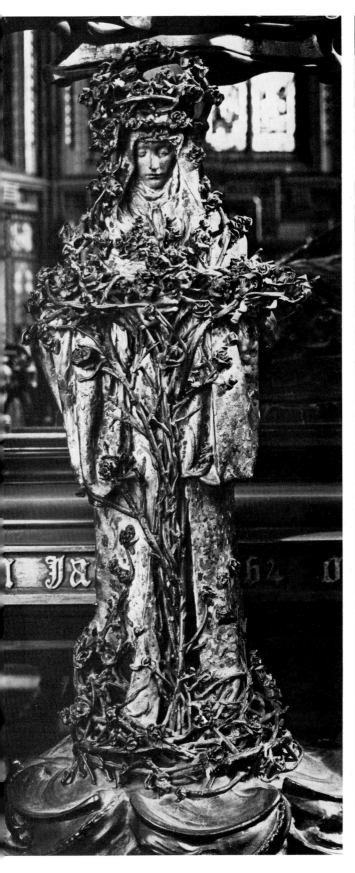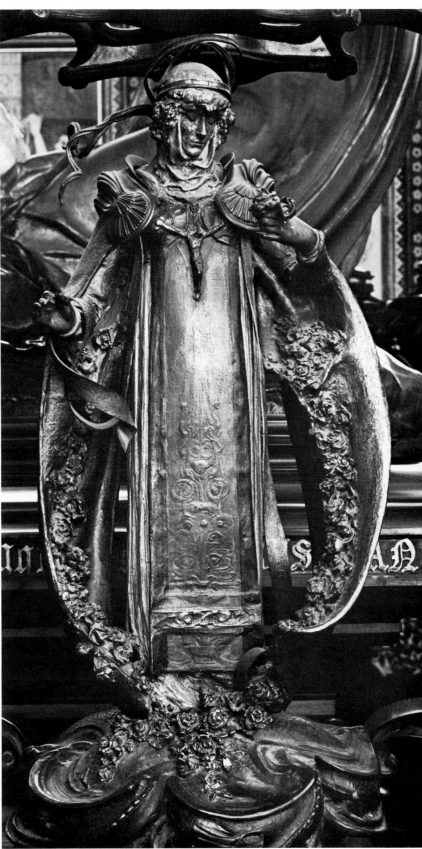

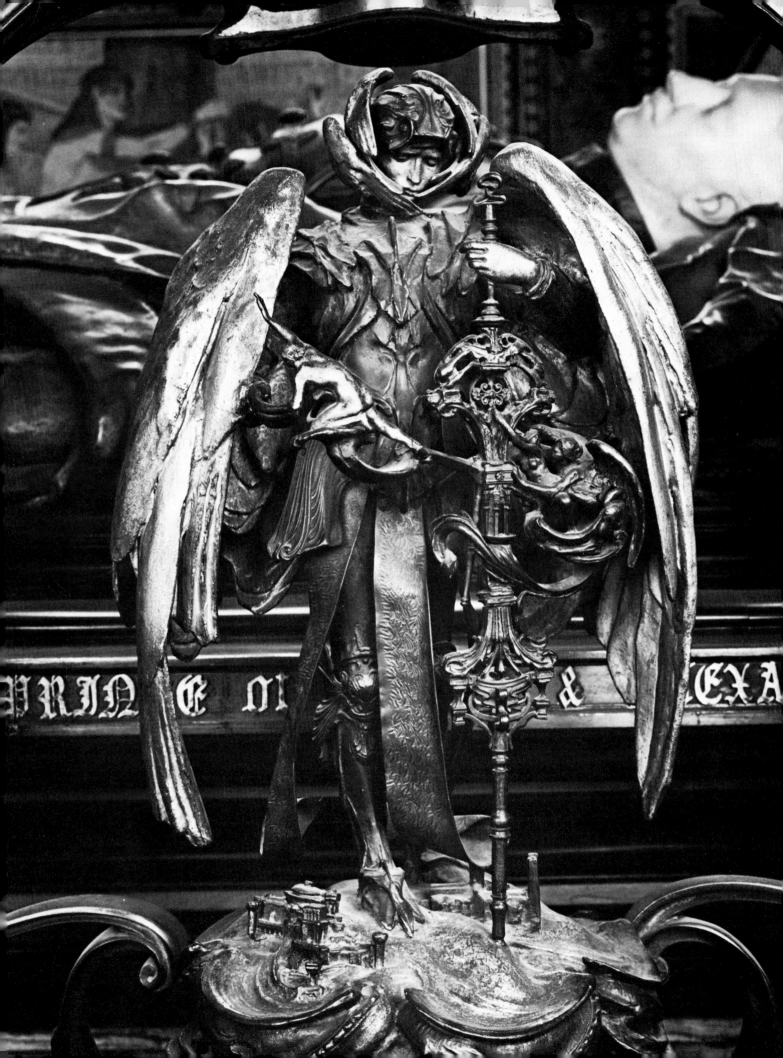

161. Alfred Gilbert, Tomb of the Duke of Clarence, 1892–9, with additions, 1926–8. Bronze, marble, aluminium, ivory and brass, 69 in. high. Albert Memorial Chapel, Windsor Castle.

162. Emmanuel Frémiet, *St Michael* (Paris Salon 1879 in gilded bronze, Paris International Exhibition 1889). Bronze, 22½ in. Private collection.

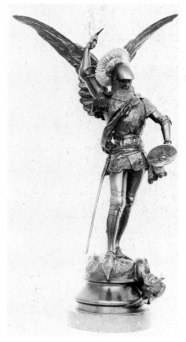

Studio in March 1893. The immobility and verticality of the figures, emphasised by the rhythmic, swirling forms of their pedestals and by the wiry vitality of their robes and accessories, the impression of deep silence and preoccupation conveyed by the ivory faces, the roses that envelop one and frame the other, are all paralleled in the painting. It would be rash, perhaps, to infer that there was a direct relationship between Gilbert's sculpture and the Dutchman's work: their similarities more probably sprang from a shared concern, to portray the human spirit isolated and constrained by forces beyond ordinary comprehension. That Gilbert was concerned with no conventional ecclesiastical image of the Virgin is implicit in his own comment: 'She is meant', he said, 'to be in an attitude of resignation rather than that of prayer.'[43]

It is the same underlying motive which distinguishes the figures of St George and St Michael (plate 160), both also for the Clarence Tomb, from the type in which they have their origin. Frémiet's gilded bronze statuette of a heavily armoured *St Michael* (plate 162), shown in the Decorative Art section of the 1889 Exhibition, has few psychological implications: the bold gestures, agitated neo-Baroque silhouette and intricately detailed accessories suggest that 'style' for its own sake and the display of technical virtuosity were the sculptor's major preoccupations. The spiky Gothic outlines and tortured layering and stratification of bronze in Gilbert's saint express an emotional turbulence far beyond such superficialities. The addition of a miniature city at the feet of St Michael, a fantasy as strange and complex as the demon hovering about his sword, lends the figure gigantic scale and may, indeed, be intended as a symbol of the material world, dwarfed by the vast, dark presence of the unconscious mind.

Harry Bates's output of ideal work was relatively small during the 1890s and it is difficult to establish the stages by which he achieved, in *Mors Janua Vitae* (colour plate II), a visionary force of expression comparable with that of *St Michael*. The pedestals of the two statuettes, which seem to have been completed almost simultaneously, are

strikingly similar. From Bates's microcosm of the visible world rise the towers of Westminster Abbey and the dome of St Paul's Cathedral. Pools of mother-of-pearl and clusters of ivory angels surround its circumference and the heavy bronze wings of the figure of Death are poised threateningly above, like those of St Michael, as if about to overwhelm it.

The earliest evidence of the influence on Bates of French chryselephantine sculpture is *Pandora* of 1890 (plate 163), a work which reveals, at the same time, how widely his approach to the nude differed from that of his contemporaries in France. The life-sized crouching figure, carved in marble, holds before her an ivory casket exquisitely decorated with figures in bronze and ivory. The tiny group carved on the lid in the round represents the sleeping Pandora borne on a horse-drawn chariot, an image much loved by Bates and developed in the large relief *Endymion and Selene* shown at the Academy in 1892. The marble is similar in subject and arrangement and close in date to Eugène Delaplanche's marble *Eve before committing the Sin* (plate 164) shown at the Salon in 1891. If *Eve* may be said to convey a mood, however, it is one of vapid sentimentality, the obvious symbolism an expendable and faintly ridiculous accessory lending biblical respectability to the coquettish Venus which is the sculptor's true subject. The treatment of the dimpled flesh is in striking contrast to Bates's smooth, almost neo-classical handling of *Pandora* where the principal theme is not the nude herself but the mood of wonder and melancholy provoked by her contemplation of the casket. The precious materials that Mercié, Gérôme and Barrias used primarily for decorative or life-like effects are introduced here, as in the work of Gilbert and Frampton, in order to bring sharply into focus the unearthly, dreamlike quality of the figure. Like the use of colour in symbolist painting, they serve to emphasise its very remoteness from the material world.

A more purely decorative approach to colour is represented by the work of William Reynolds-Stephens. *Guinevere's Redeeming* (plate 166) is one of three related statuettes in coloured metals, ivory and gems, produced at the turn of the century, in which the influence of French decorative sculpture, Gilbert's use of materials and Frampton's Tennysonian iconography are combined.[44] With his feeling for the dainty, the picturesque, Reynolds-Stephens was essentially an illustrator and never wholly committed to symbolist ideals. In his work, too, nevertheless, colour and mixed materials contribute to the evocation of a poetic dream-world that plays little or no part in the ideology of French sculpture.

The dual role of French romantic realism as both liberating and inhibiting influence on the development of English sculpture is clearly apparent in the early work of Alfred Drury. That he did not emerge as a leading figure until the late 1890s is directly attributable to the close pupil–master relationship he had established with Dalou. Returning to London in 1885, he had set to work on a series of small figure groups that are simple homages to his master. His first Academy exhibit, the terracotta *Triumph of Silenus*, imitated the lusty quality of Dalou's group, representing precisely the same subject, which appeared at the Salon in 1885. Genre works such as *The First Lesson* of 1886 (plate 165) and *The First Reflection* of 1889[45] are variations on the terracotta statuettes of peasant mothers and their babies modelled by the French sculptor during his exile in England and tread an equally precarious line between realism and sentimentality. Then, in 1893, Drury exhibited at the Academy a model for a life-sized figure which reveals a changing and increasingly diffuse relationship with France. *Circe*, cast in bronze for the exhibition of the following year, portrays the nude sorceress with arms outstretched (and in her hands, originally, a cup and wand), standing on a

164. Eugène Delaplanche, *Eve before committing the Sin* (Paris Salon 1891 in marble). Musée d'Orsay, Paris.

163. (facing page) Harry Bates, *Pandora*, 1890. Marble with ivory and bronze, 42 in. Tate Gallery.

166. William Reynolds-Stephens, *Guinevere's Redeeming*, c.1900–7. Bronze and ivory, 36 in. Nottingham Castle Museum.

165. Alfred Drury, *The First Lesson*, 1885–6. Terracotta, 15 in. Birmingham City Art Gallery.

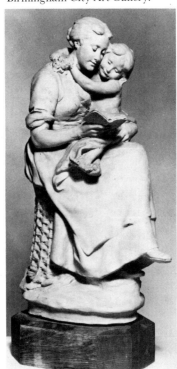

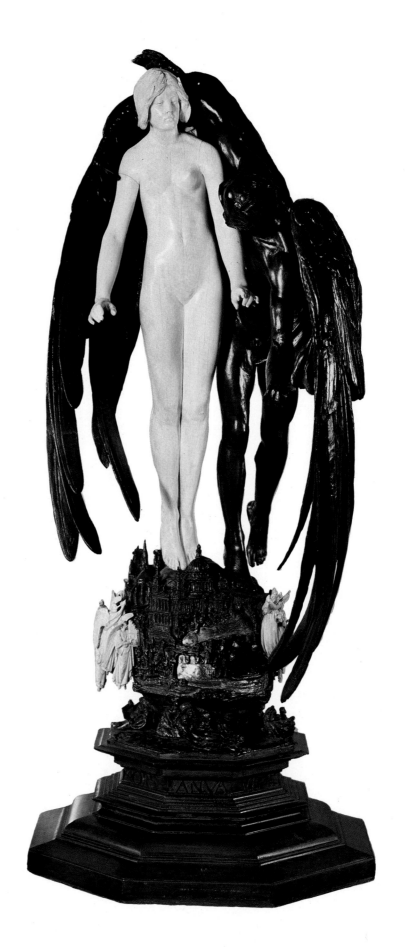

II. Harry Bates, *Mors Janua Vitae*, 1899. Bronze, ivory and mother-of-pearl, 37 in. Walker Art Gallery, Liverpool. (The group now lacks the crown that winged Death originally held above the head of the female figure.)

170

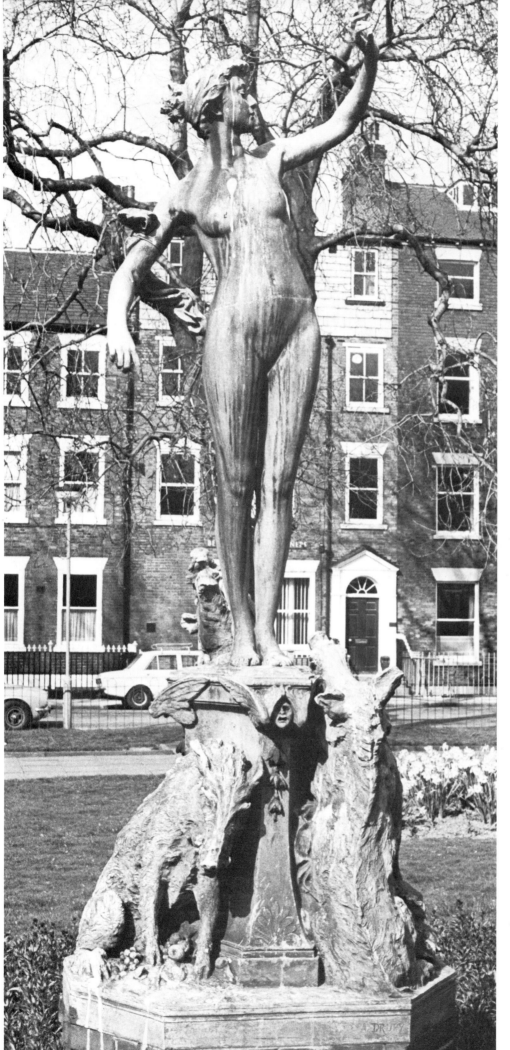

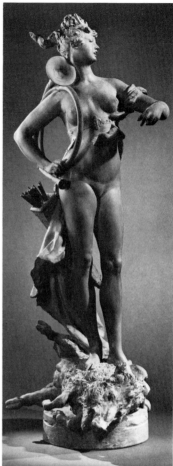

168. A. Carrier-Belleuse, *Diana Victorious* (Paris Salon 1885 in plaster). Terracotta, 26¾ in., reduction from LS marble. Private collection.

167. (left) Alfred Drury, *Circe*, 1893–4. Bronze, LS. Leeds City Art Gallery.

pedestal decorated with winged tragic masks and pendant garlands in relief (plates 167, 86). Round the base of the pedestal are ranged three large and vivacious wild boars, one of which, catching a piece of Circe's drapery in its snout, rears up to fix her with a beady stare. Another fragment of drapery flutters from a bangle on her upper arm, a modification of the original design where the two pieces of cloth formed one length tautly stretched between her arm and the jaws of the boar.[46] Drury's idea appears to be based on Carrier-Belleuse's *Diana Victorious*, shown for the first time as a plaster model at the Salon of 1885 (plate 168). The nude figure of Diana is poised in graceful contrapposto on the body of a boar killed in the hunt and a length of drapery is coiled about her upper arm to fall in a cascade at her back. The contrived, elegant pose, the theatrical 'props' of hunting horn, quiver and flaring drapery, and the sensual contrast of Diana's smooth, rounded limbs with the rough coat and stiffening legs of the beast are part of a highly self-conscious demonstration of the sculptor's skill as a modeller. Drury's different aims are apparent in his choice of the more sexually provocative and ambiguous legend of Circe with her malevolent power over the lives of men. By giving her pose something of the ingenuous simplicity of Onslow Ford's *Folly* and setting her on an altar-like pedestal, he contrived to suggest the ambivalence which characterises the portrayal of women in symbolist painting and literature. In contrast to Diana's prey which carries no hidden significance, even the swine play a complex role in establishing the sculpture's inner meaning. Visible evidence of Circe's fatal power, their coarse physical presence acts as a foil for the mystical ideals of innocence and purity that are implied in the figure and its pedestal.

As Drury's ties with France loosened, so he became increasingly susceptible to the influence of Gilbert and Frampton. The calm, abstracted head of *St Agnes* (plate 169),

173. F.W. Pomeroy, *Pensée*, 1895–6. Statuette, from *Studio* November 1898, vol. 15, p. 85. Present location unknown.

169. (facing page top left) Alfred Drury, *St Agnes*, 1893–4. Bronze, LS. From M.H. Spielmann, *British Sculpture and Sculptors of To-day*, 1901, p. 111. Formerly Leeds City Art Gallery.

170. (facing page top right) Alfred Drury, *Griselda*, 1896. Bronze, 21 in. Tate Gallery.

171. (facing page bottom left) Alfred Drury, *The Prophetess of Fate*, 1899–1900. Bronze, 36 in. From *Royal Academy Pictures*, 1900, p. 124. Present location unknown.

172. (facing page bottom right) George Frampton, *The Marchioness of Granby*, c.1901–2. Marble, LS. From *Royal Academy Pictures*, 1902, p. 3. Diploma work deposited at Royal Academy of Arts.

174. Bertram Mackennal, *For she sitteth on a seat in the high places of the city*, 1894–5. From *Royal Academy Pictures*, 1895, p. 28, described as 10 ft. high. Present location unknown.

175. Jean-Léon Gérôme, *Tanagra* (Paris Salon 1890 in polychromed marble). Musée du Louvre, Paris.

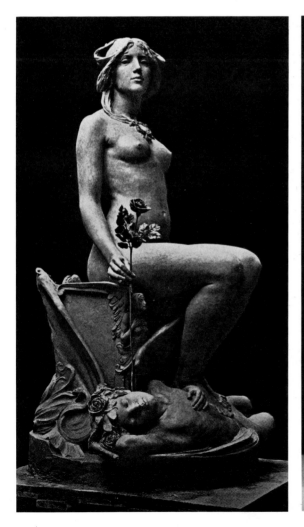

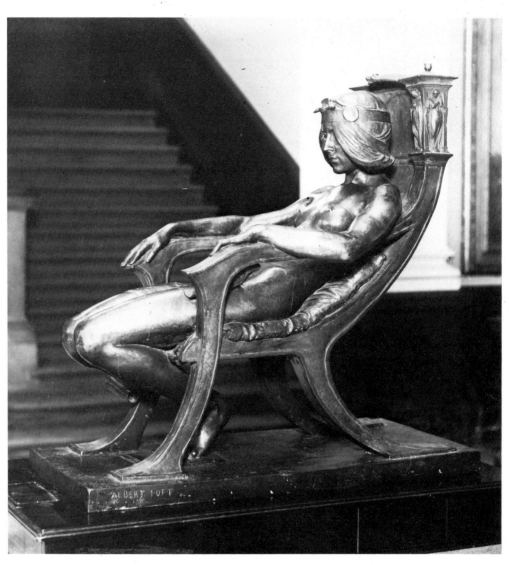

176. Albert Toft, *The Spirit of Contemplation*, 1899–1900. Bronze, 38 in. Laing Art Gallery, Newcastle-upon-Tyne.

177. Thomas Brock, *Eve*, 1900. Plaster (model for the bronze in the Tate Gallery), 69 in. National Museum of Wales, Cardiff.

178. F.W. Pomeroy, *Perseus*, 1898. Bronze, 82 in. National Museum of Wales, Cardiff.

shown in bronze at the Academy in 1894, closely resembles in mood Frampton's *St Christina* relief exhibited in 1890 (plate 68): the subject, with its intimations of religious fervour, innocence and death, is all but identical.[47] *Griselda* (plate 170) and *The Age of Innocence* of 1896 and 1897 are mood portraits of the type established by Gilbert in his *Study* of 1883. With that strange, collective impulse which led many sculptors to produce their most intensely symbolist works at the turn of the century, Drury prepared for exhibition in 1900 a fantasy portrait that represents the height of his involvement with Frampton's aims. *The Prophetess of Fate*, a half-length figure in bronze which appeared at the Academy in the same year as *Lamia*, is now known only from photographs (plate 171). Erect, still and emaciated as if literally consumed by thought, she is draped in a heavy cloak that falls in perfect symmetry over the sides of the low pedestal. Between her fingers is a crystal globe, emblem of the mysteries she contemplates with rapt and melancholy gaze. It is characteristic of the sculptor, however, that the *Prophetess* lacks the threatening, highly charged quality of *Lamia*. The gentle pathos of the figure and the softness of its modelling may in turn have influenced Frampton's treatment of his portrait of the Marchioness of Granby, exhibited in marble, and presented as his Diploma work, at the Academy in 1902 (plate 172).

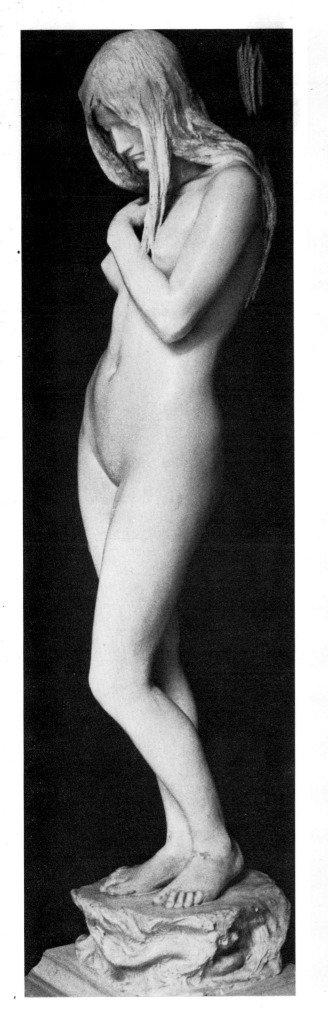

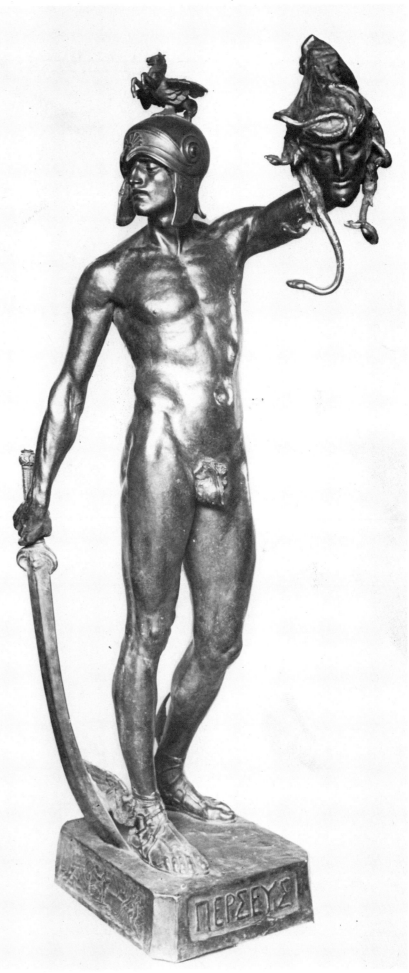

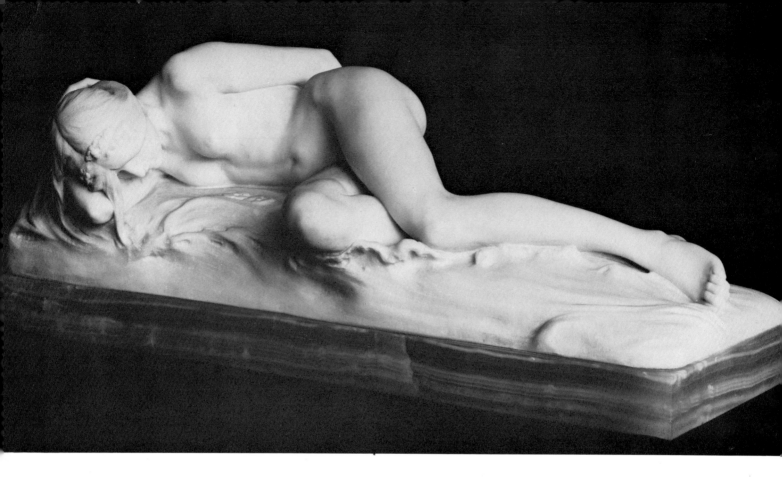

179. F.W. Pomeroy, *The Nymph of Loch Awe*, 1897. Marble, 10 in. Tate Gallery.

The qualities that distinguish *Pandora* from Delaplanche's *Eve* and *Circe* from Carrier-Belleuse's *Diana* were those to which, by 1895, every representation of the female nude in English sculpture seems to have aspired. Even when French precedent was followed particularly closely, as in Pomeroy's *Pensée* (plate 173),[48] related to figures of *Eve* by Paul Dubois and by Falguière, or in Bertram Mackennal's *For she sitteth on a seat in the high places of the city* (plate 174), counterpart of Gérôme's *Tanagra* (plate 175), the very title betrayed the artist's intention to represent more than a physical image. The obscure verse from the Book of Proverbs introduces a group that is a microcosm of sexual neurosis, while *Tanagra* is presented as a lofty ideal. As a contemporary critic wrily observed, Mackennal's work 'is eloquent of more than is here set forth'.[49] The same might be said of *The Spirit of Contemplation*, Albert Toft's seated nude first exhibited at the Academy in 1901 (plate 176). Among the few works by Foley's pupil Thomas Brock which belong within the mainstream of the New Sculpture movement is

180. Dennis Puech, *The Nymph of the Seine* (Paris Salon 1894 in marble). Musée Puech, Rodez.

Eve of 1898 (plate 177). Though encumbered by the title given to so many voluptuous figures in the Paris Salons, it is free from arch allusion, as tentative, subjective and poignant as Alfred Gilbert's early statuettes.

It is significant that, after *Circe*, Drury produced only two ideal works of importance that take the female nude as their theme, the figures of *Morning* and *Evening* for Leeds City Square (see Chapter 5). The nude, shunned by Gilbert after 1887 with the significant exception of *Comedy and Tragedy*, and by Frampton too after the Salon-inspired experiment of *Caprice*, shown at the Academy in 1891,[50] seems to have presented major problems as a means of expressing symbolist ideas. Its increasing preponderance over the clothed figure and the ideal bust in the work of other English sculptors was to contribute to the collapse of the New Sculpture as a unified movement. Those who chose to represent the nude were especially vulnerable to the influence of France, where, rendered with increasing naturalism and gusto, it remained the central theme of ideal sculpture. The work of F.W. Pomeroy and Onslow Ford in the late 1890s shows a marked reluctance to break new ground and an increasing reliance on received ideas. Pomeroy's monumental bronze *Perseus* of 1898 (plate 178), is little more than a restatement of the technical and expressive objectives of Mercié's *David*, a work he must have first encountered at least seventeen years earlier. *The Nymph of Loch Awe* (plate 179), a marble statuette exhibited at the Academy in 1897, is a variation on the well-worn French theme of a dead or dying nude prostrate on the ground, recently revived

181. W.R. Colton, *The Girdle*, 1898. Bronze, 52 in. Tate Gallery.

182. Andrea Lucchesi, *The Myrtle's Altar* (1899). Bronze, 14 in. (reduction). Harris Museum and Art Gallery, Preston.

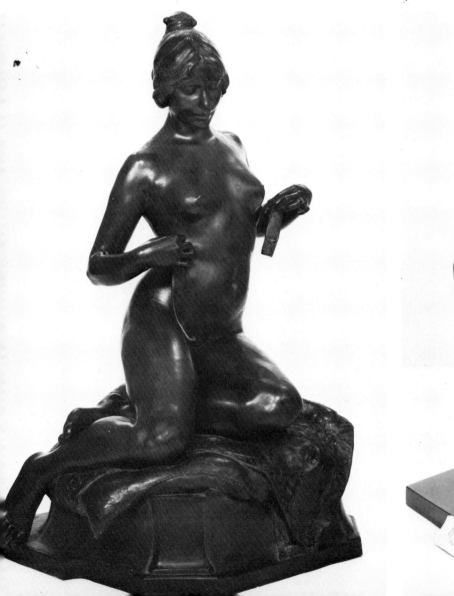

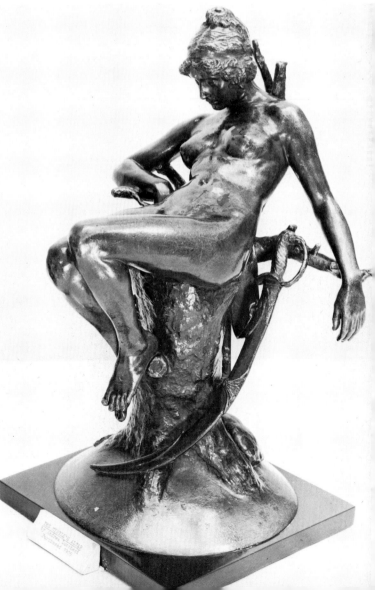

183. Henry C. Fehr, *St George and the Rescued Maiden*, 1898. From *Royal Academy Pictures*, 1898, p. 120, described as 9 ft. high. Present location unknown.

184. Henry Pegram, *Fortune*, 1900. From M.H. Spielmann, *British Sculpture and Sculptors of To-Day*, 1901, p. 99. Present location unknown.

185. (right) C.J. Allen, *Love and the Mermaid*, 1895. Bronze, 46 in. Walker Art Gallery, Liverpool.

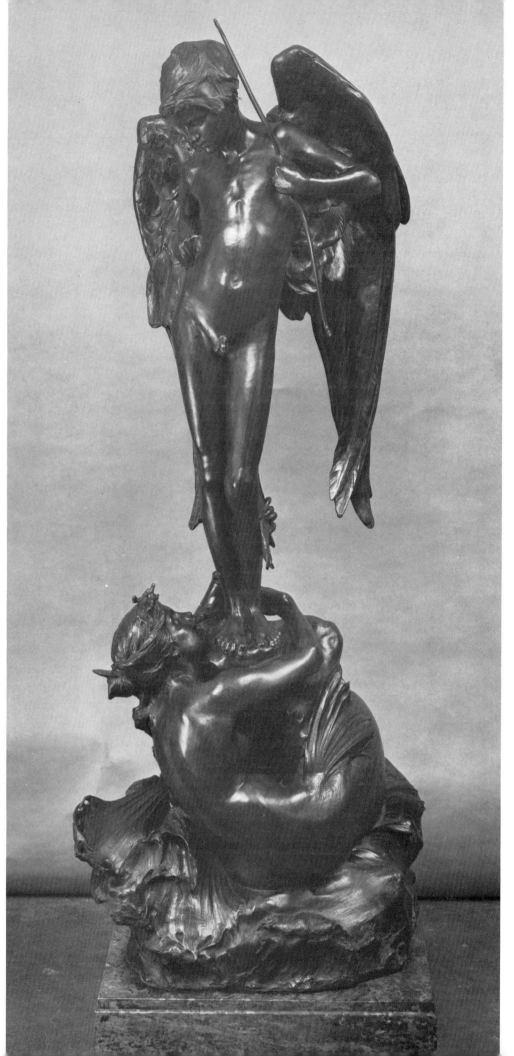

by Dennis Puech in his *Nymph of the Seine*, shown at the Salon in 1894 (plate 180). It is evident that Puech's marble relief, praised and illustrated in many English journals including the *Magazine of Art*, was the source for the later work though, characteristically, Pomeroy's nymph is not laughing but asleep, her grave head framed, like that of Brock's *Eve*, by falling strands of hair. The arrangement of limbs, one arm thrown back and one knee drawn up to the body, suggests both vulnerability and withdrawal, in striking contrast with the inviting, sensual pose of the French work. During the last months before his death Onslow Ford was at work on the marble statuette *Snowdrift*, exhibited posthumously at the Academy in 1902 and now at Port Sunlight. This too looks back, not only to Puech's relief recently reacclaimed at the Paris Exhibition of 1900, but to Ford's own portrayal of the drowned Shelley in the Shelley Memorial of 1892 and, no doubt, to *The Nymph of Loch Awe* herself.

A second major danger faced the sculptor of the nude: that of compromising symbolist ideals for the uneasy alliance of sentiment and sensuality which informs

179

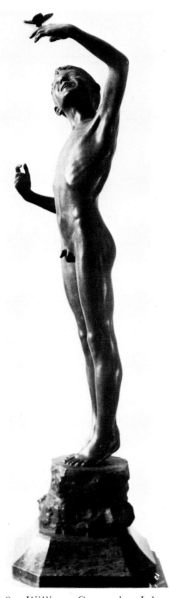

187. William Goscombe John, *Joyance* (1899). Bronze, 69½ in. National Museum of Wales, Cardiff.

much early and mid-Victorian sculpture. The shapely nude of W.R. Colton's *The Girdle* (plate 181) contemplates nothing more significant than the ribbon she is tying round her waist. Her arch self-awareness is the very antithesis of the highly charged self-preoccupation of the girl in Gilbert's *An Offering to Hymen* (plate 134). The tree trunk in Andrea Lucchesi's *Myrtle's Altar* of 1899 (plate 182) is bedecked with mystical symbols, but the salacious little figure sprawled upon it is suggestive only of itself. A striking example of the abuse of the New Sculpture's delicate symbolist imagery and the misinterpretation of its motives is Henry Fehr's *St George and the Rescued Maiden* of 1898 (plate 183), a double parody of Mercié's *Gloria Victis* and Gilbert's contemplative *St George* of 1896 for the Clarence Tomb. In 1900, while Frampton was at work on the decorative figures for Lloyd's Registry, Henry Pegram produced *Fortune* (plate 184), a flamboyant nude described by Spielmann as 'distinctly architectural in feeling' but which is destitute of those abstract qualities which give the Registry bronzes their unique relevance to architecture. Only in the decoration of the ship's prow on which the figure sits, where rhythmic abstracted forms of shells and waves enclose a baby's head in relief, is there any clear reflection of the new thought that characterises the work of Pegram's great contemporaries.

A strong tendency to confuse symbolism with sentimentality and whimsy is to be seen also in the growing popularity during the 1890s of mermaids and sprite-like nude children as subjects for ideal sculpture. *Love and the Mermaid* by Charles Allen, exhibited at the Academy in 1895, combines both themes (plate 185). The animal sculptor John Macallan Swan produced, at the same date, a statuette that portrays a sprite-child in the guise of *Orpheus*. William Goscombe John's *Boy at Play*, also of 1895, is a variation on the same idea. In 1897 John showed at the Academy a bronze bust of his daughter Muriel, adapted from the full-length portrait of the previous year (plate 186). As an evocation of inner life and as expressive form it has a place in the sequence of mood portraits to which Gilbert's *Study* and Drury's recently exhibited *Griselda* belong, but it remained an isolated experiment. The sculptor retreated soon afterwards into the pretty conceits of *The Elf* and *Joyance* (plate 187), a life-sized adolescent boy whose laughing features and movemented pose hark dully back, like *Boy at Play*, to such well-known Salon works as Moulin's *Une Trouvaille à Pompeii*.

Goscombe John, pupil of Rodin in Paris and passionate admirer of Gilbert, was by no means as peripheral to the mainstream of the New Sculpture movement as were Pegram or Fehr, Lucchesi, Allen or W.R. Colton. His failure nevertheless fully to comprehend or follow through its symbolist implications reveals the extent to which the movement was threatened by reactionary forces even as it entered the phase of its highest achievement at the turn of the century.

7. *The Cult of the Statuette*

'THE early Victorian sculptors', observed Edmund Gosse, '. . . kept up a sort of pompous mystery about their business, and could not stoop to the practical needs of their clients. Gibson pushed the solemnity of the craft to a pitch that was almost imbecile.'[1] By 1895 when those words were written the bronze statuette had come to symbolise for Gosse the liberation of sculpture from 'pompous mystery'. Capable of reproduction in large numbers and thus potentially cheaper than the unique work, small enough to be set on library shelf or drawing-room table, it represented the very antithesis of Gibson's haughty ideal.

Interest in 'sculpture for the home', like the campaign to improve the quality of architectural decoration, was closely related to the issue of art in industry. Commonly acknowledged to have reached the proportions of a cult by the turn of the century, it had first arisen many years before the practical and aesthetic problems of the small bronze were faced by Gilbert and his contemporaries.

In 1837 a society was founded 'to aid in extending the love of the Arts of Design throughout the United Kingdom' and to encourage high aesthetic standards among artists and manufacturers producing decorative wares. For an annual fee of one guinea members of the Art Union of London were entitled to receive, yearly, one large engraving and the chance to win money prizes in an annual draw which were to be put towards the purchase of original works of art. The scheme was highly successful: by 1841 the sum of £7,773 5s. had been spent on prizes and the committee of management decided that the time had come to reappraise its aims and consider 'the most efficient mode of working the enlarged means of the association'. The report of the sub-committee appointed to do so revealed that the whole of the prize money had been applied 'to the purchase of pictures in oils or watercolours, with the exception, during the last year, of a prize of £60, to which the holder added £20 and bought the marble statue of a Magdalen, by F. Thrupp, at the Royal Academy'. The sub-committee members' conclusions read like the outline of a campaign to rescue sculpture from a state of oblivion. 'We think', they wrote, 'that the subscribers generally should be aware that it is the object of the Art-Union to call into action the skill and taste of our countrymen in every department of the fine arts.' In view of the urgent need to stimulate interest in the least popular of those arts they were 'prepared to recommend that specific prizes, amounting to £200 and £150 should be appropriated for the purchase of sculpture'. They were, moreover, unanimously of the opinion that 'if a reduced model were to be made of some celebrated group or piece of sculpture, to a size fitted for a drawing-room table, and if ten or twenty casts were to be made in bronze

and annually to form a portion of the prizes, it would meet the general approval of the subscribers'.[2] The general committee resolved to act upon both recommendations immediately and as immediately was confronted by a new problem, outlined with tantalising brevity in the annual report for 1842. At the last distribution, subscribers were reminded, a sum of money had been reserved for the production of twenty bronzes. Permission was obtained from the owner to copy Flaxman's group *St Michael and Satan* and the sculptor Edward Wyon, of the family of medallists, was commissioned to prepare a model on a reduced scale and to supervise its casting in bronze. 'The model', explained the committee,

> was completed several months ago, but the artist has experienced so much difficulty in finding parties competent to cast it in a perfect manner, that the bronzes are even now hardly finished. This circumstance, annoying as it has proved, tends to shew the good which may result from the Society's operations . . . By forming a school of modellers, and inducing the practice of artistical casting, a branch of art may probably be established which, at present, requires great improvement, even in a mechanical process. For the present year Sir Richard Westmacott kindly afforded the Committee the use of his group known as a Nymph and Child – and it was placed with Mr Woodington to be reduced and cast. The same difficulties occurred in the one case as in the other, but . . . the bronzes are nearly ready.[3]

The process of mechanical reduction, invented in France by Achille Collas and patented in 1834, had been developed there with outstanding success after 1839 by the Barbedienne foundry. It was unexplored in England when Wyon undertook his first work for the Art Union and remained so until after 1851 when Barbedienne's bronzes attracted much interest at the Great Exhibition. Foundries, little used by early Victorian sculptors with their overriding preference for marble, served a primarily industrial function and were ill-equipped to deal with the problems of casting small and delicate models in bronze. The Union's annual report for 1885 revealed, in a note recording Wyon's death that year, that he had 'actually to personally supervise and aid in building the furnace necessary for the purpose'. No further details of that early endeavour are known, but in 1860 the Union proudly announced that a total of 313 bronze statuettes and busts had been produced under its auspices; the number would have been much larger 'but for the circumstance that in the early years of the Society . . . the art of casting statuettes in bronze [was] almost unpractised in this country'. The committee confidently claimed 'the largest share of the credit of fostering a branch of art-industry to which there is scarcely a household that is not indebted for one or two reproductions of some beautiful work of an ancient or modern sculptor'.[4]

The Union's policy in selecting modern works suitable for reproduction had become increasingly adventurous. Open competitions were held and little-known sculptors encouraged to submit plaster models for small-scale figures and groups, the winning design to be carried out in bronze or Parian ware. The exhibited work of leading artists was under constant surveillance and particular care was taken in the annual reports to draw the attention of subscribers (now spread, it was boasted, to every city, town and village of the United Kingdom and beyond) to sculpture's special need for wider support and patronage. Arrangements were made with J.H. Foley in 1860 to publish a reduction of his *Caractacus*, recently commissioned by the City of London for the Egyptian Hall at the Mansion House. The first series of *Caractacus* statuettes, cast by Elkington & Co. of Birmingham, and among the most popular of Art Union bronzes, was distributed in 1861 (plate 2). The occasion was marked in the annual report by a

short homily on the good-fortune of those subscribers who had received these casts, on the City's praiseworthy efforts to encourage sculpture, and on the relevance of art to everyday life. 'The present', commented the committee, 'would seem to offer the sculptors a domain as yet but partially subjugated by them. They who would seize and appropriate it will find in it the most powerful means of appealing to the feelings of the people, and of making their art to be regarded as a refining, joy-giving, household friend . . . Art should not be viewed as a mere accomplishment, but as essential to the well-being of the State. It is not to be cultivated solely as a luxury for the few, but made to enter into, cheer, adorn, and elevate the whole life of the whole people.'[5]

In 1876 the Art Union took a step which, in the light of later developments, seems peculiarly significant. The figure group *A Warrior bearing a Wounded Youth from Battle*, for which Hamo Thornycroft was awarded the Royal Academy's gold medal for sculpture, appeared that year in the summer exhibition (plate 8). As subscribers were shortly informed, 'the Council, always anxious to give encouragement to rising talent, thought the statuette so good . . . that they have entered into a negotiation with the author for its purchase, and a reduced copy in bronze is being prepared, and will be included in the list of prizes of a future year'.[6] It is tempting to believe that this commission, gained at the outset of his career as an independent sculptor, was a formative influence on Thornycroft's keen and life-long interest in bronze reductions and in small-scale sculpture generally.

The Art Union's alignment with the New Sculpture movement at this early date appears to have gone unrecognised. Ironically, the society's pioneering efforts to establish new technical standards for small sculpture were to attract increasing criticism as the superior skills of French bronze founders became known and acknowledged in England. In 1875 the *Building News* published a lengthy comment on bronze statuettes – one of a series of articles on art industries – which highlights the changes that had been taking place in public attitudes and in the bronze founding industry itself since the Union's foundation. The emigration of large numbers of skilled French artisans to England since the fall of the Commune had

> contributed in some measure to develop higher tastes among the English people, and in all cases we can now appreciate arts which our forefathers completely ignored. Among these arts a love for small bronze statuettes has been imported in our midst. The facility of intercourse between Paris and London has also greatly helped to familiarise the works sold by Barbedienne, Lerolle and others to the more refined among the wealthy classes of this country; for long it was a grievance that these exquisite reproductions of life in durable but expressive bronze could not be attempted in London. English ironfounders were able to cast large bronze statues; but the minute workmanship and delicate detail of the statuette for mantelpiece, studio, hall, and drawing-room, was altogether beyond the power of our workmen . . . The practical English metal-worker could scarcely understand the genius that gave great value to a little bronze object which a child might carry under its arm.

Claiming that England could now boast of a 'rising school in bronze-moulding', the journal went on to relate that J.E. Boehm, instrumental in spreading the taste for bronze statuary in England, had been forced, until a few years ago, to use foundries in Paris, Berlin or Vienna whenever he wanted to reproduce a small work in bronze. 'At last, however, the firm of Messrs Young and Co., now in possession of the Ecclestone Ironworks, Pimlico, determined to make a more fruitful effort.' They had assembled a group of experienced French bronze-moulders and chasers and were presently

producing the bronze portions of Alfred Stevens's Wellington Monument by the sand-casting method.[7]

The establishment of Henry Young's firm in Pimlico in the 1860s was symptomatic of a general expansion of 'artistic' bronze founding in England. In 1874 a factory designed specifically for the casting of statuary was built by a firm of ecclesiastical suppliers, Cox & Sons, at Thames Ditton. By 1889, when the *Portfolio* was reviling the Art Union for its 'soapy reproductions of mediocre originals',[8] a major new foundry had been set up at Frome in Somerset by J.W. Singer, soon to become renowned for the production of finely cast statuettes. The Union, meanwhile, faced repeated criticism with equanimity, claiming a pioneering role in establishing the new standards by which its own productions were now judged. The Flaxman reduction, stated the report for 1885, 'was the inauguration of that series of bronzes to which we can point with satisfaction as not yielding in excellence to the work produced by Barbedienne or any other foreign house. Of fine works of this kind in England this society was undeniably the originator.'[9]

The popularity of bronze during the second half of the century reflects that craving for freedom of expression which informs the whole New Sculpture movement. Writing to Thornycroft in 1884, Edmund Gosse described his visit to the studio of Augustus St Gaudens in Boston where he had seen quantities of low relief modelling commissioned by 'the new school of architects'. 'I wish', he told his friend, 'you got that sort of thing to do; mostly bronze, into which he is free to let his imagination go out.'[10] Precisely the same correlation of bronze with freedom occurs in Gilbert's *Universal Review* article of 1888. Sculpture, he argued, 'in whatever form, really depends on modelling, which is a means of expression for the ideas of an artist, at once the simplest and most direct in the practice of art. A model finished in clay is the last expression of the brain of its fashioner; . . . every touch conveys a meaning, and is an utterance of the soul of the artist.' The sculptor preparing the clay model for a work in marble could allow himself no such self-expression. He must constantly remember that 'marble is a material suggestive of repose and solidity, and at the same time . . . fragile and susceptible to injury'. His scope was thus 'far more limited than when bronze is employed, which practically has no limits'.[11]

The greater the importance placed on the clay model, the more vital it was for the bronze cast to reproduce its qualities exactly. Gilbert's first founder, Sabatino de Angelis of Naples, had introduced him to the 'lost-wax' process, a method of casting that had fallen into disuse in England but which, if undertaken successfully, produced a perfect reproduction of the sculptor's wax model, however subtle the articulation of the surface and however deep the undercutting. Complex and laborious, entailing long periods of firing at very high temperatures, the technique as then developed was ideally suited to small works that could be cast in one piece. By 1878 when he arrived in Italy Gilbert would have been familiar with Barbedienne's bronze reductions. (It is interesting that one of the sizes in which the French founder cast Mercié's *David* was 29 inches high, identical with that of the first casts of *Perseus Arming*.) It seems likely, however, that the influence they undoubtedly exerted on his life-long preference for the statuette form was powerfully reinforced by his knowledge of the strengths and limitations of lost-wax casting. Gilbert returned to England intent on pursuing his investigation of the technique. In April 1885 he wrote to M.H. Spielmann: 'I have been away from my studio for some time past working in my foundry on experiments in the "Cera Perduta" system of casting, and I have been entirely taken up by them and so thoroughly absorbed that I have been obliged to neglect everything else.'[12]

McAllister described how the sculptor, using the foundry of his friend Stirling Lee, struggled to keep the furnace alight for ninety-eight hours on end, enlisting the help of Ford and Lee as stokers but continuing alone, when their enthusiasm flagged, 'with a dogged persistence until he was found unconscious'.[13]

During the 1880s the cause of lost-wax casting was taken up with missionary fervour, not only by Gilbert and other sculptors such as Ford, Lee and Bates in lone experiments, but in open discussion in schools and societies. 'The question of reviving the cire perdu method [is] rapidly coming to the front', observed John Sparkes in 1888: 'Some time ago an effort was made to induce the Committee of the City Guilds to allow a manufactory to be established at Kennington, but it fell through.'[14] While English foundries continued to fall far short of their European counterparts in expertise and facilities, it seemed that the 'autograph' statuette offered the only possibility of radical reform. In 1886 George Simonds, first President of the Art Workers Guild, made an impassioned appeal to sculptors to do their own casting, attacking, in the most supercilious terms, the growing public taste for small sculpture. Some people, he said, thought that a work was finished

in proportion as its surface presents a polished uniformity. This idea is fostered by the miserable cabinet bronzes which are turned out wholesale by certain manufacturers, and are termed 'art bronzes'. These are often copies of fine originals, but most of their value is lost from the fact that they are cast in many pieces, which are then joined together, filed, and chased up in a happy-go-lucky commercial style by a not over-skillful artisan. Thus every trace of the original hand is obliterated . . . Yet, such as they are, these *soi-disant* 'art' bronzes are replicated *ad nauseam* and do duty as sculpture in the homes of the wealthy and well-to-do classes, who I venture, however, to predict, will, before many years are over, be as keenly alive to the merits of a bronze as they are already to those of a picture. It will be an unspeakable comfort when these purely commercial productions shall be . . . relegated to the possession of those whose purses are too slender for the purchase of original works. These can only be produced by the wax process, and by the artist himself, or at least under his own immediate care and supervision.[15]

Rudely contradicting the idea of sculpture as a popular art and thus faithfully reflecting the bitter conflict of ideals which characterises the Arts and Crafts movement, Simonds's outburst is in stark contrast to the remarkable attempt made a year earlier in London to stimulate public interest in sculpture through the intervention of commerce. In 1885 an exhibition of forty-two works in terracotta, marble and bronze by Thomas Nelson MacLean was held at the sculpture gallery opened that year in Piccadilly by Bellman & Ivey (later Bellman, Ivey & Carter), a well-established firm of plasterers and cement manufactureres. The exhibition and the introduction to its catalogue, written by T. Humphrey Ward, set out to demonstrate not only the merits of modern sculpture but its accessibility to society at large. MacLean's works, varying in size from 'bookcase ornaments' to life-sized groups, had been brought together 'to show that sculpture in England has not yet had its fair chance, and to convince those who are interested in Art that the work of the sculptor is just as appropriate for the decoration of the ordinary English room as is the work of the painter or the engraver'. Most of the exhibits were small terracotta models, worked in Doulton clay, for figures and portraits intended for final execution in marble. As the catalogue entries make plain, however, and as Ward emphasised in his introduction, the principal object of the enterprise was to market replicas in bronze. Why, he demanded, were fine bronzes still so rare in

England and the bronze industry, which employed some 25,000 men in Paris, virtually extinct here? The 'prodigious success of Mr Alfred Gilbert's Icarus last year' proved that good work was appreciated when it did appear. The present exhibition would, it was hoped, be the first of many attempts to do for English sculptors what had long been done for their French brethren. Ward recalled, in conclusion, having once asked a 'leading sculptor' why he did not establish an agency for the publication of his bronzes, as painters had agencies for the sale of their pictures and engravers for the issue of their work: 'He could give no answer, except that such a venture would be very desirable, and would probably succeed. Messrs Bellman & Ivey have volunteered to undertake such an agency, and all who care for English sculpture will wish them success.'[16]

As far as can be inferred from the catalogue, the scheme was extraordinarily ambitious, though nothing is known either of the means by which it was carried out or of its success commercially. It was Bellman & Ivey's intention to publish fifty copies in bronze of each of eight exhibits, including no. 17, *Meditation*, the original study in terracotta for the bust in marble (plate 131), and no. 24, the terracotta study for *Ione* (plate 124).[17] Ward stated that all the bronzes already on display in the gallery were produced by the old sand-casting method though 'made as finely as possible in order to dispense altogether with the chaser's work'. He commented too on the current tendency of sculptors to favour lost-wax casting despite the extra expense it incurred. (An increase of about £10 might be expected on a figure costing £15 by the sand-casting method.) Several of MacLean's terracottas – none, however, of those intended for multiple reproduction – were accompanied in the catalogue by the note 'To be executed in bronze (cire perdue)'. No prices or sizes are given but bronze casts of *Art* and *Science*, nos. 18 and 19 in Bellman & Ivey's list, were offered for sale elsewhere in London during the following year at fifteen guineas each.[18]

The exhibition was well received by the press. It had clearly established, wrote the *Magazine of Art*, 'that by means of artistic reproduction in bronze the most beautiful creations of contemporary sculpture may take their rightful place among etchings, drawings, and other objects of decoration. If it were not for a wide-spread misapprehension of the decorative value of sculpture in the house there would be no obstacle to the circulation of fine casts from statuettes.' It was deplorable, declared the journal, that sculptors had had to rely for so long on portraiture as their chief means of support and that, for lack of demand, 'almost the whole of their life-work should have been rendered barren of imaginative art'.[19] In his presidential address to the sculpture section of the Art Congress held in Edinburgh in 1889 Onslow Ford took up this theme with angry enthusiasm. 'If I had to make a statue representing the "Genius of Sculpture",' he said, 'fidelity to truth would require the figure to be a fair young maiden with blindfold eyes and fettered hands and feet – the fetters of such weight that passers by would wonder how a maid so young and delicate could stand at all, thus hung about with chains and manacles.' Sculptors needed not only the support of the State but the encouragement of seeing their independent, imaginative work appreciated by a wide section of the public. Yet there would never be a popular demand for the 'works of fancy' that now filled the exhibitions unless these could be produced at popular prices through the intervention of enterprising dealers or publishing companies. 'It is quite impossible', he declared, 'for an artist to be his own publisher.'[20]

In the course of that very year, as Ford must have been aware, just such a firm had been set up by one Arthur Leslie Collie in premises shared with Thomas Agnew at 39B Old Bond Street. Collie appeared in the Post Office Directory for the first time in 1889,

listed as an 'art decorator'. He seems to have attracted no comment in the press until, on 31 May 1890, the *Saturday Review* printed an article entitled 'Small Bronzes'. The anonymous contributor began by reminding readers of the situation in France where 'sculpture lives and thrives' largely through the publication of reductions, 'principally in bronze, of large figures and groups which have attracted critical attention at the Salon'. It showed, he suggested, a lamentable lack of enterprise among English sculptors that 'scarcely anything has yet been done by them to bring their work within the range of the pocket and the house of the ordinary buyer of pretty objects'. Quite recently, however, there had been signs of real progress.

Mr Collie, who published a bronze reduction of Mr Thornycroft's 'Gordon' last year [plate 188, cf. plate 202], has been so much encouraged by the success of that solitary effort that he has just opened at his gallery . . . a little collection of small modern bronzes, which he is publishing, as though they were etchings, in a strictly limited and numbered issue. Mr Onslow Ford's elegant and spirited work specially lends itself to reproduction in miniature. No specimen in Mr Collie's gallery is more delightful than the 'Peace', a little nude female figure in a caressing and conciliating attitude, waving a palm branch . . . [plates 189, 145] Other works of Mr Onslow Ford's at this gallery are a reduction of his 'Folly', and a very refined bust of a girl, with a pensive look, somewhat in that Tuscan manner which we commonly identify with Donatello. But, for the purpose Mr Collie has in view, namely, the purchase of these little bronzes for drawing-rooms, it is the 'Peace' with its exiguous proportions, its extreme delicacy and finish, and its exquisite thin golden patina, that we hold to be especially successful. In the same gallery is a small bronze of Sir Frederic Leighton's statue 'The Sluggard' [plates 190, 143]. This is a very rough sketch in plaster, transferred to the metal without alteration.[21]

Though the writer specifically refers to 'limited and numbered editions' no such numbering appears on bronzes known to have been issued by Collie. Nor is it certain that the publisher always signed his work. No Collie inscription is recorded for the $14\frac{1}{4}$-inch-high *General Gordon* statuette which was exhibited at the Fine Art Society in 1968,[22] but the issue is confused by the fact that Thornycroft also had several small copies of the *Gordon* figure cast at his own instigation: in 1889 he exhibited one of them at the Academy, marked for sale at £10.[23] Versions of the statuette which have appeared on the art market in recent years, all about 14 inches in height, are inscribed, 'Published by Arthur Leslie Collie 39B Old Bond St London May 6 1889', as also is the cast now in the Ashmolean Museum, Oxford. The $20\frac{1}{2}$ inch cast from Leighton's model for the *Sluggard* shown at the Fine Art Society in 1968 (plate 143)[24] and that in the Harris Museum and Art Gallery, Preston, are also so inscribed and dated 1 May 1890. Several inscribed Collie reductions of Ford's *Peace*, including that at the Cecil Higgins Art Gallery, Bedford, and that illustrated in plate 145, are dated 8 May 1890. They are all about $23\frac{1}{2}$ inches in height, depending on the depth of their bases, and appear to be the largest of Collie's bronzes. It is not known whether the figure conforms in size to the statuette first exhibited by Ford at the Academy in 1887 and which, by 1889, he had enlarged to the life-sized version now at the Walker Art Gallery, Liverpool. The casts of *Folly* in the Tate Gallery (plate 144) and the National Gallery of Scotland, which correspond in size with the statuette shown at the Academy in 1886, are 36 inches high, while the version in the Ashmolean Museum is only 19 inches and may be identical with the Collie edition recorded by the *Saturday Review*, though it bears no inscriptions. The 'bust of a girl' shown at Old Bond Street in 1890 was probably identical with plate

146, a 15 inch bronze version of the marble bust shown at the Academy in 1891 (see Chapter 6, note 26).

When Collie marked the launching of his new venture by showing with the Arts and Crafts Society in 1890 he chose to exhibit only three statuettes: *Gordon*, *Peace* and an unidentified figure by Leighton, presumably the *Sluggard*. The fact that these are the very three Collie bronzes which appear most frequently on the present-day art market supports the implication that they were already the most popular of his sculptures and were hence the most frequently reproduced. At least two other bronzes appeared under the aegis of Arthur Collie. In 1891 the *Academy* reported that the publisher 'has acquired the copyright of Mr Hamo Thornycroft's fine statue of John Bright [then recently erected at Rochdale] and is issuing bronze statuettes from the original model, uniform with the statuettes of the same sculptor's "General Gordon".'[25] Bertram Mackennal's 22½ inch bronze bust of Queen Victoria, exhibited at the Fine Art Society in 1968, bears Collie's stamp and is dated 10 March 1897.[26]

Among the most intriguing aspects of the Collie venture is the possibility that it was closely linked with the activities of the Art Workers Guild through Thornycroft and Ford and hence also with the development of commercial lost-wax casting and the rise of one of the most important bronze foundries of the period, J.W. Singer & Sons of Frome. John Webb Singer had begun his working life as a watchmaker and jeweller and had set up the Frome Art Metalworks in 1848, specialising in the production of church furnishings. It is not certain when he began to develop an interest in the casting of bronze statuary, but he is known to have conferred directly with Thornycroft and Ford shortly after the formation of the Guild in 1884.[27] By 1888 a new foundry equipped for both sand and lost-wax casting had been built as an extension to his factory on the outskirts of Frome.[28] The *Gordon*, *Peace* and *Sluggard* statuettes shown at the Arts and Crafts Exhibition in 1890 are all described in the catalogue as 'cast by Singer & Sons'. In 1892 an article entitled 'Singer's Metal-Work' was published in the *Portfolio*, stating that monumental works such as Boehm's *Lord Napier* (now in Queen's Gate) and Onslow Ford's statue of General Gordon seated on a camel were cast at the foundry by the sand process and that the lost-wax method was used for small sculptures. The writer cited only one example of the foundry's small-scale work – the series of statuettes published by Collie, of which he named four, the *Sluggard*, *Gordon*, *John Bright* and *Peace*.[29] In 1889 Herbert, the elder of Singer's two sons, was elected to membership of the Art Workers Guild. The possibility cannot be discounted that the two first sculptor-members of the Guild, in entering their negotiations with Arthur Collie, had recommended the Singer foundry to him and that the election of Herbert Singer was in some way related to the successful casting, by the lost-wax process, of the first issue of Collie reductions.

Thornycroft may well have had a more personal reason for acknowledging the foundry's skill in handling small sculptures. It is likely that Singer & Sons were involved with the second major development described by the *Saturday Review* in May 1890. Concluding his account of Collie's exhibition, the writer went on to report that

> Mr Hamo Thornycroft, turning his own publisher, like Mr Whistler, issues a circular announcing the publication of a limited number of bronze reductions of two of his best-known statues – of 'The Mower' [plate 191, cf. plate 141] . . . and of 'Teucer' . . . Specimens of these statuettes are now on view at his studio, Moreton House, Melbury Road, Kensington. Each is twenty-two inches high. The sculptor has tried various kinds of patina. One or two of them seem to us a little too thick . . .
>
> Some of his bronzes have an exquisite patina of dark green, as beautiful, in its way, as

the golden-brown of Mr Ford's 'Peace'. The point which we are anxious to emphasize, in the one exhibition as the other, is that here at last is an opportunity for amateurs to secure, for their private collections, works of the highest individual merit, of an issue more limited than that of most etchings, of a convenient size, and of a very reasonable price . . . There ought to be no difficulty in filling up both subscriptions without a delay.[30]

The extreme paucity or inaccessibility of surviving archival material, and early published sources that are at best fragmentary and at worst ill-informed, combine to make statuette production among the most obscure and bewildering aspects of late nineteenth-century sculpture. Singer's, in common with other foundries, rarely marked small bronzes. The earliest surviving documents of any significance relating to the firm are illustrated catalogues produced shortly after 1910 and a day-book dating from the early 1920s.[31] No trace of Collie's business as a purveyor of art bronzes appears to have survived. Even Gosse seems to have had only the vaguest apprehension of its scope. In his essay 'Sculpture in the House' of 1895, he introduced two simple errors of fact.[32] The four illustrations (plates 188–91) show well-appointed interiors in which the *Gordon*, *Peace*, *Sluggard* and *Mower* statuettes are displayed among paintings and other decorative objects. The captions, identifying title and artist correctly, describe all the bronzes as 'Published by George Collie'. Gosse's confusion over the publisher's name and his inclusion of the *Mower* as a Collie bronze are the more puzzling in the light of his friendship with Thornycroft and his association with the *Saturday Review*. They cast doubt on the reliability of his statement, in the same article, that Collie also handled the work of Frampton. No firm evidence of such an association has yet come to light.[33]

It is clear, however, that by 1890 small, portable bronzes and their implications for sculpture and society were generating unprecedented interest among artists and critics alike, and that the part played by Thornycroft in this development was as decisive as his parallel role in establishing a new status for architectural decoration. Sculpture, concerned now as never before with commonly shared emotional experience, must, it was increasingly argued, be made accessible to all. 'We have had in England almost to the present day', wrote Cosmo Monkhouse, 'on the one hand a public who have never known what it is to care for sculpture, nor what it is in sculpture that they should care about', and, on the other, 'a school of sculptors in which the scholars were scholars only, who never used their art as a mode of personal expression, and did not know how so to use it'. In touch, at last, with 'modern feelings', the modeller's art must no longer be 'a mere object of admiration at exhibitions, in churches and public places, but should enter our homes in statuette, in frieze, and mantelpiece, in articles of personal adornment and domestic use'.[34] There were two ways, suggested the *Magazine of Art*, of reviving interest in sculpture among the public: through the decoration of buildings and the issue of small-scale bronze reproductions of works by modern artists.[35] The same journal welcomed the appearance at the Academy in 1889 of small versions of *Teucer* and *General Gordon*: 'If sculpture is to become a popular art, there can be no doubt that it will become so through the publication of reductions of well-known works such as these.'[36] Again it was the work of Thornycroft which prompted the *Portfolio* to plead that more sculptors should use their skill 'for the benefit of those with shallow purses and narrow homes'. They must be prepared to make replicas of successful works for casting in bronze 'on such a scale that they may be used for decorating the rooms in which we live'. Lacking 'statue-publishers' like Barbedienne, England was at a severe disadvantage but at last there were signs of progress: 'Mr Thornycroft . . . has repeated his "Mower" . . . in small, and the bronzes will soon be within the reach of those who

190

admired the large statue. The "Gordon" too . . . is to be published, in the same fashion, while some . . . of our readers will remember the relief of "Artemis" . . . which hung in the "Arts and Crafts" Exhibition last autumn.'[37] (It is again puzzling that the commentator showed no knowledge of the existence of Arthur Collie and no interest in the special circumstances surrounding the issue of the *Mower* statuette.)

By the early 1890s sculptors were no longer under such pressure to carry out their own casting, for the choice of commercial foundries capable in both sand and lost-wax methods was steadily widening. In 1883, after a brief period under the new management of Drew & Company, the foundry established by Cox & Sons at Thames Ditton came under the control of James Moore. Before he joined Cox & Sons in the 1870s Moore had been foundry assistant to Thomas Thornycroft and his continuing link with the sculptor's family is reflected in his election, in 1885, to membership of the Art Workers Guild; he and Herbert Singer were the only bronze founders to receive that honour before 1910. It was under Moore's directorship that Thornycroft's monument to General Gordon was cast in 1888 (see Chapter 8) and the lost-wax process introduced at Thames Ditton shortly after 1890. When the firm was taken over in 1897 by Arthur John Hollinshead and Arthur Bryant Burton it had already become chief competitor to Singer & Sons and continued to flourish, under the title A.B. Burton, throughout the Edwardian period.[38] Among the sculptors who frequently had work cast at Thames Ditton were Boehm, Thornycroft and Frampton, though there appears to have been no consistent use of one foundry. Frampton sent work also to Frome. Gilbert favoured the Compagnie de Bronzes in Brussels and, during the late 1890s, the Italian founder Parlanti at Parson's Green. Alfred Drury too used Parlanti while maintaining a steady working relationship with Singer & Sons.

Like the expansion of the bronze founding industry, special exhibitions played a vital part in establishing the new aesthetic significance of the statuette. The Arts and Crafts Society provided an environment where the boundaries between fine and applied art were deliberately obscured. Side by side with electric light brackets and doorknockers, fireplace panels and decorative tableware, works of pure sculpture such as Pomeroy's bronzed plaster statuettes or Collie's reductions appeared in a new light – not as 'high' art, but as covetable accessories easily imagined in the setting of the spectator's own home. The Bellman & Ivey gallery continued to serve a similar purpose. Its exhibitions had a stong international flavour, combining the work of young English sculptors with reductions of the latest Salon successes. Sculpture as household decoration remained their dominant theme. In 1887 'some spirited little clay sketches by Mr Alfred Drury' shared the gallery with a bronze reduction of Falguière's *Diana* which had appeared that year in the Salon as a life-sized marble figure.[39] Among the exhibits in 1894 were Frémiet's bronze statuette of St George, bas-reliefs by Frampton and the dance indicator and photograph frame previously shown by William Reynolds-Stephens at the Arts and Crafts Exhibition.[40] 'There is', observed the critic Robert Jope-Slade after a visit to the gallery in that year, 'no feature more marked in the tendency of the day, and certainly none more commendable, than the growing endeavour to adapt art to the beautifying of our domestic life . . . The movement is especially to be noted among sculptors; whilst a great change has come over their patrons during the century which now speeds to its close.' The new industrialists wanted sculpture to be decorative, intimate and informal and there was nothing, he believed, that could supply this need more effectively than the statuette, 'nothing of which the owner grows fonder, or around which associations more easily entwine. It can be disposed so that all its beauties can be seen to the best possible advantage . . . It may be always accessible.'

188. (top left) View of a library with bronze reductions of Hamo Thornycroft's *John Bright* (left) and *General Gordon* (right), published by Arthur Collie. From *Magazine of Art* 1895, p. 368.

189. (top right) View of a drawing room with bronze reduction of Onslow Ford's *Peace*, published by Arthur Collie. From *Magazine of Art* 1895, p. 369.

190. (bottom left) View of a library with bronze statuette cast from Frederic Leighton's sketch model for the *Sluggard*, published by Arthur Collie. From *Magazine of Art* 1895, p. 372.

191. (bottom right) View of a drawing room with bronze reduction of Hamo Thornycroft's *Mower*, published by the sculptor. From *Magazine of Art* 1895, p. 371.

The cost of statuettes – especially those cast by the lost-wax method – was, the critic admitted, a serious problem, but the gallery's proprietors had proved most helpful in this respect: 'Visiting all the greater exhibitions and studios of Europe, they acquire the right of reproduction in miniature of many of the best things of the season; and every spring we find the pieces of statuary we have most admired during the previous year in the noble open spaces of the Champs Élysées or the Champ de Mars, or in the cramped rooms vouchsafed to art in marble, bronze and plaster at the Royal Academy, reappearing at this gallery in diminished stature, but undiminished charm, and often gems of perfect casting.'[41] Evidence to support the wide implications of this statement remains exasperatingly elusive.

Smallness of scale may be seen as one of the most powerful tools used by the New Sculptors in their search for flexibility and freedom from the institutionalised image of their art. Alfred Gilbert was obsessed with it, imposing, wherever he could, a sensuous intimacy on the monumental. The Victoria Memorial at Winchester (see Chapter 8) and the Clarence Tomb, large in their overall dimensions, are heavily dependent for their effect on the miniature figures that adorn them, figures that might have been devised for the shelves and mantelpiece of a small drawing room. (The eagerness with which replicas – or even, in the case of the Clarence Tomb, the prototype figures themselves – were sought by private collectors is a measure of the extraordinary popular interest in small sculpture that he and his contemporaries had helped to arouse. No sooner was Gilbert's Memorial Candlestick to Lord Arthur Russell for St Michael's Church, Chenies, completed in 1900 than casts of the four 15 inch bronze statuettes of Courage, Charity, Truth and Piety which cluster round its 9 foot shaft were ordered by the patron and the sculptor's solicitor.) Within the Royal Academy itself there were signs of a fast-diminishing concern for the monumental. Of the eleven ideal works shown there by F.W. Pomeroy between 1890 and 1900 eight were statuettes (originally conceived as such, not reductions from larger statues). One was the *Perseus* which became, in its reduced form, his best-known work (plates 192, 178). 'He has done much', wrote A.L. Baldry in 1898, 'to convince the most sceptical that art is not a luxury reserved only for the enjoyment of the privileged few, but rather a wide-spreading and dominant influence which can make itself felt in very many directions . . . as much . . . among ordinary surroundings as under the conditions which have hitherto been supposed to be indispensable for its proper development'.[42] Few observers at the Academy in 1893 can have failed to recognise that the gentle little nude figure of Pomeroy's *Love the Conqueror* (plate 193), herself originally clasping a tiny statuette, was conceived for the intimate setting of the private house. So too, yet more explicitly, were the exhibits of William Reynolds-Stephens. In 1896 he submitted a small low-relief panel in bronze with decorative detail in gold and mother-of-pearl, entitled *Happy in Beauty, Life and Love and Everything* (plate 194). It depicts a young girl sitting with her back to a mirror in which the rays of a rising sun are reflected.[43] The figure is strikingly similar to the Arthurian heroines invented by Frampton for the Astor House door panels, shown at the Academy in the same year (plate 71); like them the relief was intended not as a self-sufficient work of art for display in sterile isolation, but as a piece of furniture, to take its place among the paraphernalia of private life. In order to make his intention plain the sculptor devised a stand of carved wood on which to display the panel, 'a column with a revolving top and carrying a swing arrangement which would admit of the relief being adjusted at any angle that might allow it to be seen to advantage in a room with ordinary lighting'. With its bird and flower enrichments in bronze and copper the stand was, wrote Baldry, 'a decorative object of

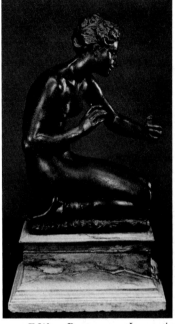

192. (facing page) F.W. Pomeroy with his statuette *Perseus*. From photograph in a private collection.

193. F.W. Pomeroy, *Love the Conqueror* (1892–3). Bronze, 13½ in. Walker Art Gallery, Liverpool.

194. William Reynolds-Stephens, *Happy in Beauty, Life and Love and Everything*, 1895–6. Detail of bronze bas-relief on wooden stand, with ornament in gold, mother-of-pearl and copper, 20 × 15 in. Harris Museum and Art Gallery, Preston.

193

195. William Reynolds-Stephens, bronze version, with inset abalone shell, of silver bon-bon dish (1896–7). 4½ × 12½ in. Private collection.

very considerable beauty . . . and fortunately its right to consideration as a complete achievement proved great enough to convince the Academy authorities'.[44] In 1897 Reynolds-Stephens again submitted a work designed to demonstrate 'the necessity for an intimate connection between a work of art and its setting'. *Sleeping Beauty*, a low-relief panel in bronze, was destined to fill the semicircular-headed overmantel of a chimneypiece designed by Norman Shaw. A model of the chimneypiece was made especially for the exhibition but rejected by the selection committee and the detached relief was hung on the gallery wall 'without any setting whatsoever'.[45] It must have been of some comfort to Reynolds-Stephens that in the same year he achieved a small triumph for household sculpture in gaining acceptance for a silver bon-bon dish: kneeling upon its base and leaning back against the bowl were two exquisite female nudes, modelled in the round and physically indivisible from their immediate 'setting' (cf. plate 195).

The new prestige won for small-scale decorative modelling profoundly affected the young men and women completing their training as modellers during the 1890s, a phenomenon that the Art Union was among the first to observe and encourage. In 1894 the Council decided to launch a new series of competitions that would provide an incentive for young artists in general and give particular encouragement to sculpture, 'a branch of art which has shown more striking development among British artists in recent years than perhaps any other'.[46]

The £12 premium offered in the first competition – for an original design by a student – was won by Lilian Simpson of the National Art Training School with her 'imaginative modelled design for a book cover, which will be executed in silver, and issued as prizes to Members'. Announcing the result in the report for 1895, the Council took the opportunity to summarise the achievements of the past decade:

No-one interested in the development of the Fine Arts in this country during the last ten years can fail to be struck with the strong tendency it has exhibited towards the application of the Arts to decorative purposes. We see it in much of the best work of some of the leading sculptors of the day as much as in the direction which the work of the more talented students of our Art Schools seems instinctively to take. It is indicated by the increasing attention bestowed upon the production of really artistic creations in hammered iron work, in copper and brass repoussé, in carved wood, and other decorative media; by the interest aroused by Exhibitions like those of the 'Arts and Crafts', and more especially by such examples of the sculptor's art as are associated with the names of Gilbert, Bates, Frampton, Pegram, Pomeroy and others

194

of the Modern School of English Sculpture. It may be said that this tendency is the natural outcome of a utilitarian age, but a sounder explanation seems to be that in such applications of design, and in the fuller power of expression to which the modelled form lends itself, the younger generation . . . finds freer scope for the imaginative faculty, which has always distinguished our National Art.'[47]

Lilian Simpson was the contemporary in Edward Lanteri's modelling classes at South Kensington of Florence Steele, Margaret Giles, Ruby Levick, Esther Moore and Gwendolen Williams. Her design for a book cover in low relief had won her a gold medal in the National Art Competition of 1894. It was while in Italy on the travelling studentship which accompanied the award that she died of typhoid fever in 1897, aged twenty-six.[48] She exhibited only two works at the Academy – the book cover design and a bronze casket, both shown in 1896. In the same year she entered the model for the casket in the Arts and Crafts Society's exhibition. Her career, though shockingly brief, was peculiarly characteristic of her time. It may be argued that the dramatic rise of women sculptors to prominence in the 1890s was directly related to the changing image of the art. The cult, not only of the statuette, but of modelling as the sculptor's most direct means of self-expression, and the consequent revolution in the commercial bronze founding industry, had deeply undermined the principal argument against women's involvement in sculpture, their inability to cope with the sheer physical effort it required. An entertaining and quite involuntary impression of a male province under

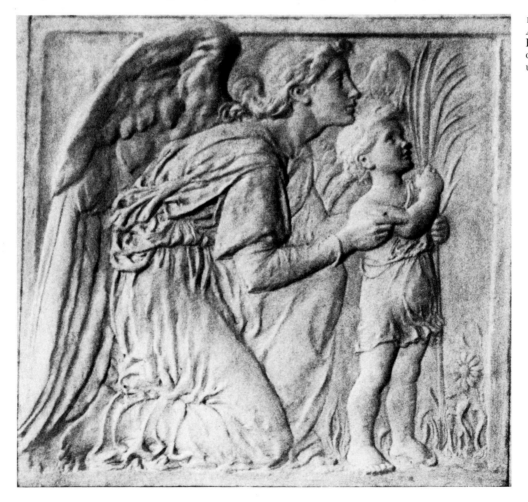

196. Ellen Mary Rope, *A Guardian Angel*, *c.*1895–6. Plaster bas-relief. From photograph in a private collection. Present location unknown.

siege is given by the writer 'E.B.S.' who interviewed Frampton for the *Studio* in 1896. Describing the sculptor's workshop, thick with clay dust, he reassured his readers: 'No matter how poetic the idea, how ethereal the finished bas-relief or statue . . . the art of the sculptor in its noblest form demands strenuous labour so that you may regard it as being tolerably secure from invasion by the new woman, or the mere dilettante; for it is a most perfect instance of fine art inextricably allied with fine craft.'[49]

Among the first 'new women' to reach for precisely that alliance of sculptural art and craft was Ellen Mary Rope. Between 1877 and 1885 Rope was a student at the Slade School where she attended the general course in sculpture instituted in 1880–1 and taught by the Slade Professor himself, Alphonse Legros.[50] She began to exhibit at the Academy in 1885; many of the plaster bas-reliefs in which she specialised were offered for sale at prices ranging from two guineas to £25. She was represented at each of the seven exhibitions of the Arts and Crafts Society held between 1889 and 1906 by small-scale decorative work in plaster and bronze, including a cinerary urn (1889), an electric light bracket (1893), a bronze mirror frame and three panels in coloured plaster (1896; plate 196),[51] panels 'for ceiling or wall decoration' (1903) and a 'sketch for a capital, St Peter's Church, Cricklewood' (1906). The first of the South Kensington women sculptors to show with the Society were Esther Moore in 1893 with her 'bracket for Electric Light' and Margaret Giles in the same year with a design in wax for a salt-cellar and a 'model for a street-lamp with finger post'. Florence Steele followed in 1896 with a silvered bronze piano front and a steel and wood casket, Ruby Levick in 1899 with a doorknocker design and Gwendolen Williams with two statuettes in 1906. All were frequent exhibitors at the Academy. It is above all in their small ideal figures conceived for casting in bronze that the special contribution of women to sculpture at the turn of the century is revealed.

Despite the interest taken in the statuette since the mid-1880s surprisingly little attention had been given to the question of the relationship between scale and design. With the exception of the *Stone Putter* and a bronze cat shown at the Academy in 1884, every statuette produced by Thornycroft before the *Bather* of 1898 was a model for or a reduction from a monumental figure. Gilbert too had a remarkably casual attitude to the size of his sculptures. The marble group *Kiss of Victory*, 58 inches in height, was later reproduced as a 23 inch bronze. *Perseus Arming* exists in three height sizes: 29, $14\frac{1}{2}$ and 6 inches, while the *Victory*, first conceived as a tiny decorative motif on the orb of the Winchester Memorial (see Chapter 8), was adapted as an independent figure for heights varying from a few inches to some thirty feet. Much of the work of the women sculptors trained at South Kensington remains to be discovered, but present evidence suggests that the statuettes they produced were all originally conceived as such and that theme, composition and modelling technique were carefully adjusted to suit the chosen scale. The group of wrestling boys (plate 198) which won a gold medal for Levick in the National Art Competition of 1897 and appeared at the Academy in the following year was conceded by the *Studio* to be 'handled with something like mastery'.[52] It should be compared, as a design for small-scale figure sculpture in a domestic setting, with the highly pretentious *Athlete wrestling with a Python* (plate 6), regarded by Leighton as perfectly suitable, nevertheless, for reproduction in miniature.[53] In 1906 Gwendolen Williams showed a $10\frac{3}{4}$ inch bronze at the Walker Art Gallery's Autumn Exhibition entitled *Queen of Dreams* (plate 197), a half-length figure, on a circular base, of a woman with a winged headdress clasping a baby in her arms. Its tightly compacted forms and intense, devotional quality both spring from and respond to the idea of smallness and intimacy. The complex, spiralling composition of Margaret Giles's *Hero* (plate 199) is

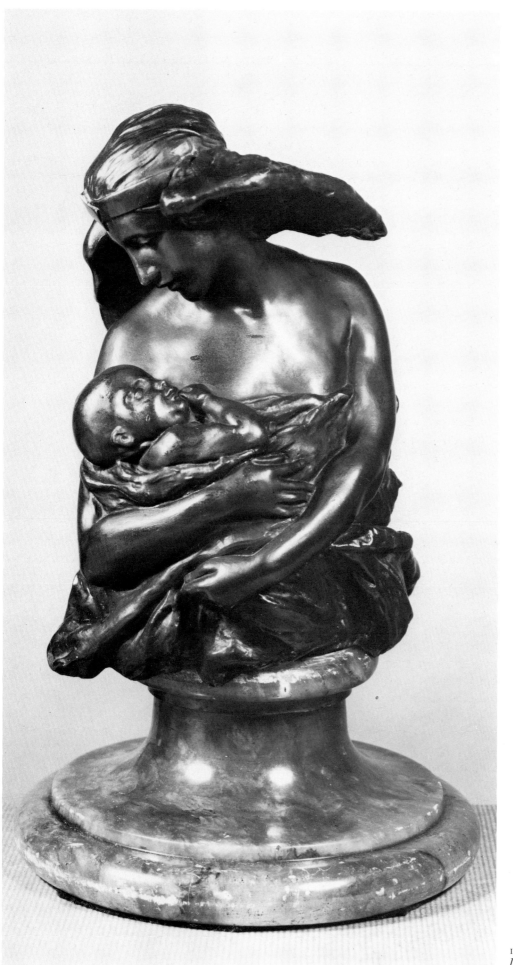

197. Gwendolen Williams, *Queen of Dreams* (1905–6). Bronze, 10¾ in. Private collection.

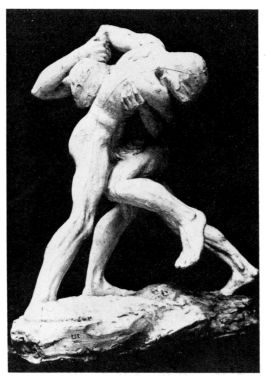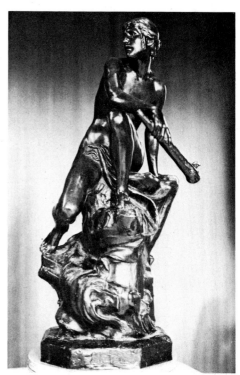

198. Ruby Levick, *Wrestling Boys*, 1897. Plaster statuette. From *Studio* September 1897, vol. 11, p. 249. Present location unknown.

199. Margaret Giles, *Hero* (1895–6). Bronze, published by Art Union of London, 20½ in. Private collection.

similarly related to the actual size of the bronze. She has presupposed the ability and inclination of its owner to vary its position, and so gradually discover, from a fixed viewpoint, its whole implication as a three-dimensional work of art.

Combining delicate detail with epigrammatic brevity, the modelling of *Hero* was a brilliant response to the discipline of the statuette form and it established Giles's reputation as a sculptor. In the second of the competitions announced by the Art Union in 1894 sculptors were invited to submit models for a statuette, the winning entry to be cast in bronze under the aegis of the Society and added to the list of lottery prizes. Leighton, much to the delight of the Council, agreed to act as adviser and final adjudicator. His choice of Giles's work from the thirty-six sketch models submitted and the award to her of the first premium of £150 were announced in 1896.[54] In the same year the winning design was shown at the Academy and in 1897 the first two bronzes, cast by J.W. Singer & Sons, appeared in the prize lists. The purchase of *Hero* was perhaps the Art Union's most significant single act in its self-appointed role as sponsor of modern sculpture. Many vital strands of the new movement are gathered together within the yearning, solitary figure: the development of symbolist expression and the concept of popular art, educational reform, the influence of Dalou, through Lanteri, on modelling technique, and the renaissance of commercial bronze founding. Selected by Leighton, *Hero* is curiously linked also with the movement's origins in the 1870s and his early campaign to influence the course of its development.

Critical recognition for the achievement of the South Kensington women in establishing a direct relationship between smallness of scale and style, technique and content remained, predictably perhaps, unforthcoming and was bestowed instead upon their successor in Lanteri's classes, Reginald Fairfax Wells. Reviewing Wells's work in 1903, the *Studio* noted that the realism of his statuettes of labourers, peasant women and children would be excessive if applied to larger figures: his grasp of the special requirements of the statuette was in marked contrast to the attitude of many sculptors, 'who think that a good statuette may be easily made by repeating their large statues in reduced copies; so little are they aware that [it] is a separate and distinct form

of art, as remarkable in sculpture as a short story is in literature. Indeed', the journal concluded, 'when considered in its relation to large statuary, it is found to have much in common with the essential difference of aim separating the short story from the novel.'[55]

No sooner had the statuette attained an unprecedented status in English art than the cherished hope that it would bring about a revolution in public demand for ideal sculpture began a rapid decline. Gosse was already obsessed, by 1895, with the idea that the continuing vitality of the movement he had so diligently encouraged was now dependent on the number of works sold. In his series of articles 'The Place of Sculpture in Daily Life' he implied that the purchase of statuettes was one of 'the more obvious ways in which a little attention on the part of amateurs would revive and restore a profession which is in the extraordinary state of being recognised and discussed and praised, but not employed'.[56] Collie, he wrote, was to be highly commended 'for the zeal with which he has sought to encourage this department of the art',[57] but a deep gloom pervades the critic's last appeal on behalf of the New Sculpture. In 1902 the *Studio* reviewed an exhibition, mounted that year by the Fine Art Society in collaboration with Marion Spielmann, of English and French 'Sculpture for the Home', the most comprehensive of its kind yet seen in London. The review appeared under the title 'The Cult of the Statuette' and as a prelude to it the public was once again accused of gross apathy and a specific charge was laid against it. So oblivious had people been to the 'charms of the statuette maker that the only serious trade endeavour to popularise his products had to be abandoned through lack of patronage'.[58] It seems likely that this was a reference to the recent demise of Arthur Collie's publishing venture. In 1896 he was listed in the Post Office commercial directory as 'Decorator and publisher of sculpture'. By 1901, however, he had reverted to the description 'interior decorator' and by 1906 had vanished from the directory.[59]

An annotated catalogue of the 1902 statuette exhibition, preserved in the library of the Courtauld Institute, offers a more convincing reason than apathy for both Collie's failure and the low demand for household sculpture. Most of the works on display were for sale and their prices are marked in the margin. The average cost of the smaller bronze figures was well over one-twentieth of the annual income of a representative member of the professional middle class.[60] Twenty guineas was the sum asked for Gilbert's *Offering to Hymen*, thirty for Pomeroy's *Perseus* statuette, forty-five for Thornycroft's *Mower*, three hundred for Frampton's gilt and enamelled bronze *St George*.[61]

The seductive idea of household art had brought a new dimension to sculpture's role but had done little to extend the range of patronage. For the vast majority of the public and until the dissolution of the Art Union of London in 1912, the Union lotteries presented the only real chance – and that a slight one – of acquiring a work of modern English sculpture. The decorative accessory and the statuette remained as far removed as the productions of William Morris from 'popular' art in the true sense and the cult that surrounded them, based upon the forever conflicting ideals of fine craftsmanship and 'art for all', was to founder upon the harsh realities outlined by the *Studio* in 1903. 'Perhaps', wrote the critic reviewing the early career of Reginald Wells, 'the only real drawback to the modelling of statuettes is the difficulty of making the art "pay" in the struggle for daily bread. It is expected that a statuette should be sold for a small sum . . . But casting is so expensive that few young sculptors can afford to have their models cast the requisite number of times; and the result is that they fail to hold their own against the cheap statuettes which come into the market, always in large numbers, from Italy and other countries.'[62]

8. Public Image, Private Dreams

STRIVING to establish a new place in the public consciousness through their architectural and domestic decoration, ideal figures and statuettes, sculptors were free to work as pioneers largely on their own terms. Memorial sculpture presented a different and in many ways far more difficult challenge. There was, arguably, no art form in the mid-nineteenth century more 'popular' in the strict sense of the term than the commemorative statue and none, paradoxically, whose relationship with artistic values was more tenuous. Portrait statues of the famous, living or dead, erected in the open air or in buildings with public access were potent symbols of political and moral aspirations, evoking passions that were sometimes intense but seldom aesthetic. A few were funded by the Government or private citizens. Most were communally owned, being financed by that most democratic – if somewhat inadvertent – form of art-patronage, the public subscription system. The choice of a sculptor to record the features of a local or national hero for posterity was often governed as much by political as by financial expediency and by the haphazard opinions of a self-appointed committee concerned chiefly with the prompt delivery of a portrait 'likeness'. Whether the finished monument had aesthetic as well as didactic value seems to have been regarded by committees and subscribers alike as a matter of minor importance.

Among the very few public subscription committee minute books to have survived is that relating to the George Peabody Memorial at the Royal Exchange in the City of London, unveiled by the Prince of Wales on 23 July 1869 (plate 201). Papers and monument together exemplify the attitudes and priorities which had brought memorial sculpture to its near-aphasic condition as an art form in the 1860s.

In April 1866 a meeting presided over by the Lord Mayor was held at the City of London Guildhall. The subject of discussion was 'the munificent gift by Mr George Peabody of a quarter of a million of money for the benefit of the industrious poor of London' and how best to express in some lasting form 'the grateful feelings of the Citizens'.[1] A committee was duly appointed and lost no time in recommending 'the erection of a Statue on some conspicuous spot in the City of London as the most suitable recognition of Mr Peabody's bounty'. The Lord Mayor was to act as Chairman and the opening of a subscription list was to be postponed until after the philanthropist's return to America on 18 May. A short circular was printed and sent to five hundred merchant bankers and other likely sponsors, requesting their attendance at a public meeting in the Mansion House on 24 May. The first lists of subscribers, headed by the Prince of Wales, were published in *The Times* and the *Daily Telegraph* in April 1867. Including contributions by the Prince (£26 5s.) and the Earl of Onslow (£30), the fund then

200. (facing page) William Hamo Thornycroft, detail of monument to General Gordon.

201. William 'Waldo' Story, monument to George Peabody, 1867–9. Bronze. Royal Exchange, City of London.

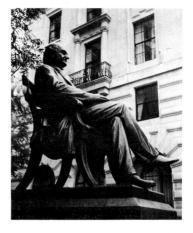

stood at £2,085 4s. By 16 May 1867 it had risen to £2,572 13s. 2d. and included £2 7s. 8d. donated jointly by '87 Workmen in Messrs Read & Fox's Letter Foundry, Fann Street'. The Corporation of London gave 100 guineas and on 13 June a sub-committee was appointed to 'promote the objects of the fund'. On 31 July 'the space of St Benet Fink Churchyard, near Royal Exchange' was chosen as the most desirable site for the monument and on 6 August it was resolved to ask 'Messrs Story, Foley, Baron Marochetti, Theed, Durham, Woolner and Bacon' to submit designs for the statue in competition. Grown sceptical of competitions conducted by public subscription committees, Story, Foley, Marochetti and Woolner all declined the invitation. Durham, Bacon and Theed expressed their willingness to compete. Undeterred, having made a token gesture towards selection by artistic merit, the sub-committee proceeded with what had evidently been the original plan: to gain the services of the American sculptor William Wetmore ('Waldo') Story, in deference to the nationality of George Peabody. Story had a studio in Rome but, with a number of patrons among the English aristocracy, was readily available for work in London.[2] In October when the fund had reached £3,000 and the subscription list was closed, a notice was prepared for the press informing the public that Story was the selected sculptor, that 'Mr Peabody will give sittings in Rome', and that the statue which was to be in bronze would be ready within eighteen months. An agreement between the memorial committee and the sculptor was drawn up and signed by Story on 1 November 1867. In May 1869 the sub-committee was informed that the statue was almost ready for shipment. Arrangements were made for the unveiling ceremony in July and also for the design and erection of a plain granite pedestal under the supervision of the City Architect, Story having, with some alacrity, relinquished all responsibility for it.

At the end of July the sculptor was paid the balance of his fee of £2,300 and received a letter of thanks from the Lord Mayor. 'The Committee', wrote the Chairman, 'congratulate you on the successful accomplishment of a work which by its nobility of conception will increase your already exalted fame and by its fidelity of execution will enable persons of future generations to realise "What manner of man" the great Benefactor of the London Poor was.' Story's reply suggests that even he was abashed by such stilted hyperbole. 'I beg', he wrote,

> to express my thanks to you and the Committee of the Peabody statue for the very flattering letter which you were so good as to write to me in their behalf. It gives me great pleasure to hear that you and they are pleased with the result of my labours – In offering me the commission for this statue I was well aware that you intended not a personal compliment to me, but a compliment to the Country of which both Mr Peabody and myself are citizens, and I was happy in accepting it to think that I might be instrumental in perpetuating the memory of a man to whose acts of benificence both our countries are deeply indebted – Now that my work is done I am heartily pleased to learn that you approve of it. Permit me also to return my thanks to you and to the Committee for the uniform courtesy and consideration I have received at all times and in all matters relating to the statue.'[3]

A touching note in the polite ritual was added by Peabody himself, now a dying man. 'I can but hope', he wrote from Baltimore, 'that the course of my life, now drawing toward its close, may justify, when finished, all the honours which have been so freely bestowed on me, of which this is one of the greatest.'[4] Well-satisfied with its achievement, the sub-committee closed its operations in September 1870.

The result of four years' efficient administration is a stark full-length portrait figure

all but devoid of artistic identity. Seated stiffly upright in his chair, his homely features and the harsh folds of his frock-coat and trousers unrelieved by subtleties of modelling, the philanthropist's bronze effigy exemplifies that prosaic rendering of surface appearance which passed for sculptural realism in the 1860s and 1870s. Exasperation at the growing number of such monuments in towns throughout England had become a recurring theme of art criticism by the early 1880s. 'What a relief it would be to the public', exclaimed the architect Ingress Bell, 'if, for some of our public statues, their exhibition might close – that they might retire into the obscurity of private life, and so rid the streets of some, at least, of the many "sights" of London.'[5] Curiously, most commentators agreed that the character of modern dress was to blame for the deficiencies of the outdoor monument. 'The difficulties which beset the sculptor', explained Francis Ford in 1887, 'are very great – so great, indeed, that only the ablest artists are able to surmount them . . . for the attire of the well-dressed Englishman of the Nineteenth Century is as unpicturesque as can possibly be conceived.' The answer, he claimed, lay in judicious compromise: Foley's 'excellent' statue of Lord Herbert of Lea in Waterloo Place, concealing everyday attire beneath ceremonial robes, should be compared with Story's 'sitting statue of George Peabody . . . with his ugly boots and trousers thrust into the faces of the passer-by with a pertinacity which produces a sense of irritation unfavourable to the calm contemplation of the embodiment of philanthropic munificence'.[6] As late as 1895 Edmund Gosse was still reiterating his opinion that 'a statue, at full length, of a man of light and leading, should never be made, unless some modification in his costume can be adopted'.[7] Boehm, meanwhile, was recommending young sculptors to accept the 'much abused' contemporary costume, to take a positive delight in its textures, fit and detail. 'Treat a coat-sleeve, a woman's gown, *con amore*, ennoble it by art',[8] he said, and achieved remarkable results by following his own advice, as in the seated figure of Carlyle at Chelsea (plate 10) and the magnificently upholstered soldiers on the Wellington Memorial at Hyde Park Corner. Part of the money raised by public subscription for a memorial to Rowland Hill was spent, following the open competition won by Onslow Ford in 1879, on a bronze figure in frock-coat and trousers that owes its considerable strength to Boehm's principle (plate 202). Such monuments belong, nevertheless, to the same tradition as the Peabody statue. They reinterpret the type with skill and vitality, making a virtue of its very mundaneness, but give it no new dimension. The evolution of the commemorative monument was to depend, not, as many critics somewhat naively assumed, on the issue of modern dress, but on the radical reassessment of its formal and expressive possibilities that was undertaken by Hamo Thornycroft and Alfred Gilbert after 1885.

Charles George Gordon of Khartoum, among the best-loved military heroes in nineteenth-century British history, died in January 1885. It is an indication of the mounting resistance to a stale tradition that when the question of his memorial was first discussed at ministerial level there was no instant assumption that it should take the form of a simple full-length portrait figure. The advice of several Royal Academicians, including Millais and Leighton, was obtained and the First Commissioner of Works duly gave some thought to 'an allegorical work of art'.[9] In the event, 'it was deemed more easy to obtain the vote for a statue' and in August the Office of Works, acting, it seems safe to assume, on Leighton's advice, formally commissioned Thornycroft 'to proceed with the statue of the late General Gordon which is to be erected in Trafalgar Square . . . It is understood that the statue shall be similar in size to that of Sir Henry Havelock: *that the pedestal shall be of an ornate character* [my italics] and that the cost of

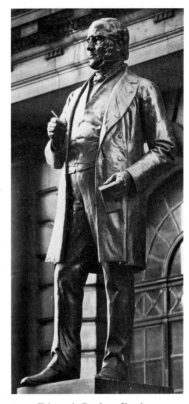

202. Edward Onslow Ford, monument to Rowland Hill, 1879–82. Bronze. King Edward Street, City of London.

both . . . shall be £3,000'.[10] A note appended to the Office's draft of the letter describes the terms under which the sculptor was to work. On completion of the sketch model, before 31 March 1886, he would receive the first instalment of £500 and the second when the full-sized clay model was finished (before 31 March 1887). The balance of £2,000 was to be paid to him on the erection of the work by 31 March 1888.

Thornycroft had already completed the sketch model when, in the early summer of 1886, the Office of Works spent several weeks reappraising the decision to erect the monument as a pendant to Havelock in Trafalgar Square. There had been protests from the descendants of Sir Charles Napier whose statue was to be moved to accommodate Gordon and the Office of Works was asked whether a site in Waterloo Place could be made available instead. The request met with an interesting response. There was no objection in principle to the resiting of the memorial but 'the position is so commanding and important that any monument erected there should not be in the nature of a simple statue on a pedestal like the ordinary London statue but should from its dimensions and . . . by the grouping of figures round a central object or otherwise become a monumental group of importance and worthy of the position'.[11] By

203. William Hamo Thornycroft, monument to General Gordon, 1885–8. Bronze. Victoria Embankment Gardens, Westminster.

204. William Hamo Thornycroft, figures representing Fortitude and Faith, detail of pedestal bas-relief, monument to General Gordon.

September, however, the Office of Works had finally decided on a site mid-way between the fountains in the Square and Thornycroft had turned his attention to the pedestal. He wrote to inform the First Commissioner that he had consulted G.F. Watts on the height of the figure and would have sought the advice of Leighton and Millais too if they had been available. He also reported his intention of consulting Alfred Waterhouse.[12] By the spring of 1888 the memorial was ready for fixing, the bronze casting having been delayed for some six weeks owing to the rush of Jubilee works at James Moore's Thames Ditton foundry.[13] Surprise as well as delight greeted the unveiling at an informal ceremony on 16 November 1888. Thornycroft, it was discovered, had not only produced 'one of the best public monuments London can show'[14] but a true work of art.

The memorial, now resited on the Victoria Embankment, consists of a full-length bronze figure of Gordon, ten feet eight inches high, set on a massive stone pedestal some eighteen feet in height and designed, with the help of Waterhouse, to raise the figure to prominence on the original basin-like site in Trafalgar Square (plates 200, 203–4). On the flanks of the pedestal are set two large bronze low relief panels with standing female figures of Charity and Justice and Fortitude and Faith. Immediately above them and continued on all four sides of the pedestal are a richly elaborate foliated frieze and cornice, carved by Farmer & Brindley, the firm responsible for all the stonework.[15] The stone superstructure is hung with delicate bronze wreaths and garlands.

With one foot resting on a broken cannon, Gordon stands in an attitude of relaxed meditation clearly based on the pose of Foley's Sidney Herbert. Here, however, no rhetorical overtones in gesture or drapery cloud the immediacy and poignancy of the portrait. Its pathos, which reaches beyond the character of Gordon himself to comment on the human condition, is subtly echoed in the pedestal where dreaming ideal figures are substituted for the sharply focused narrative reliefs of the earlier monument. Gordon is represented in the everyday jacket, trousers and long boots of a patrol officer. His chin is sunk in his right hand. The left hand, clasping a pocket Bible, supports the right elbow and tucked beneath the left arm is the short cane known, during his campaign in China, as his wand of victory. At his back, on a strap slung round his body, hangs a pair of field glasses. Each detail, from the veins standing out in the beautiful hands, to the Bible's leather binding, is portrayed with loving fidelity to visible reality and yet like the *Mower*, the figure derives its chief significance from its intangible, abstract qualities. 'The whole aspect of the statue', explained Thornycroft, 'I wished to be resolute, solitary, but not sad.'[16] Concerned, as in his ideal work, with spiritual rather than physical states of being, the sculptor was fortunate in his subject. Gordon appears to have possessed peculiar grace of personality. He was renowned for his asceticism as well as for his humane judgement and genuine horror of war: 'His whole being was dominated by a Christian faith at once so real and so earnest that, although his religious views were tinged with mysticism, the object of his life was the entire surrender of himself to work out whatever he believed to be the will of God.'[17]

By their very existence as expressions of public feeling, the statues of Peabody and Rowland Hill are symbolic objects yet they possess no symbolist qualities. Deprived of their inscriptions they would be reduced to mere reportage, faithful representations of elderly middle-class Victorian gentlemen. The Gordon Memorial commemorates not only the physical appearance of the hero but the ideals he embodied. Its new psychological and aesthetic implications were instantly recognised. 'We know not', wrote Spielmann in 1889, 'where to look in out-door London for such a union . . . of feeling and of sentiment, of elegance and skill.'[18]

Numerous monuments reflect the influence of Thornycroft's *Gordon*: a notable late example is Albert Toft's memorial to Queen Victoria at Nottingham of 1905 (plates 205–6). Toft takes up and brilliantly develops the idea of the pedestal as sculptural counterpoint. The statue of the Queen is in marble and so elevated, indeed, on its granite pedestal as to seem almost superfluous to the complex fantasy explored below. Each side of the pedestal is inset with a tall rectangular bronze relief panel. An escutcheon, plain but for its inscription, fills that on the front elevation. The side panels contain standing figures in flat relief, displayed as if they were part of a continuous frieze. At the back, withheld like a treasured secret until the last, is the aesthetic climax of the monument: a figure of Charity in high relief, with a baby held high on either arm and framed by climbing roses whose branches enclose the three heads in a trefoil arch and shelter nesting birds in their dark recesses. The babies hold toys, a railway engine and an ocean liner, symbols of the age, and Charity, for all the hieratic symmetry of her stance and embroidered robe, has the features and looped coiffure of an Edwardian beauty.

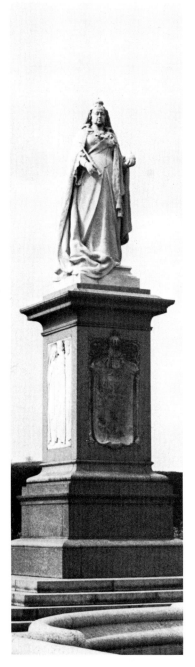

205. Albert Toft, monument to Queen Victoria, erected 1905. Marble with bronze pedestal reliefs. Nottingham.

206. Albert Toft, detail of pedestal relief, monument to Queen Victoria.

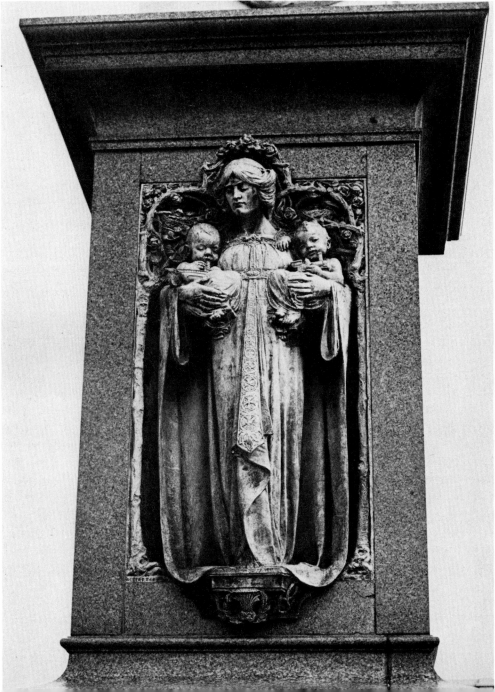

Between the imagery of the Gordon Memorial and the more sophisticated, theatrical interplay of reality and fantasy in the Nottingham pedestal lies the work which proved to be the most important single influence on memorial sculpture in England, Alfred Gilbert's Jubilee monument to Queen Victoria at Winchester (plates 207–8). Originally intended as an indoor monument for the Great Hall of Winchester Castle and to be executed in marble, it was commissioned by the High Sheriff of Hampshire, William Ingham Whitaker. When objections were raised to the indoor position Gilbert changed his medium to bronze and the sculpture was unveiled, still incomplete, on an open-air site on Castle Hill in August of the Jubilee year, 1887. The model was exhibited at the Academy in 1888. In 1912, when various depredations of vandalism and accident had been put to rights and Gilbert had been persuaded at last to supply various missing details, the whole structure was moved inside the Hall and a second unveiling ceremony took place.[19]

Extraordinary in conception and execution, the monument represents the Queen seated, in massive robes of state, on a throne peopled by tiny allegorical figures. Above, as if suspended weightless in mid-air or upon the tendrils of the lilies that writhe about its base, hangs a colossal gilded crown of beaten metal set with white and ruby crystals and forming a canopy over the basilisk-like figure of the monarch. In her hands she holds orb and sceptre, the orb surmounted by a gilded Victory, the first known appearance in Gilbert's work of this much-repeated figure. The throne was originally set on a low plinth to which the term 'pedestal' could scarcely be applied. Before the second unveiling Gilbert had supplied a variant of the bronze socle used in the Queen Victoria Memorial at Newcastle of 1900 (plate 216). It is circular in basic form and densely ringed with mouldings from which emerge, at half-height, those helmeted babies' heads that are another recurring feature in the sculptor's inventory of talisman-like images. Round each of the two main uprights of the throne are clustered three canopied niches filled with statuettes of Faith, Hope, Charity, the Law, the Constitution and the Colonial Empire. On top of the throne-back are two seated figures of History and Science, larger in scale and voluminously draped, while behind it stands Britannia, similarly larger than the niche statuettes, a withheld, exquisite figure that is the precursor of Toft's Charity. She carries a model of the *Royal Harry*, one of the first warships of the British Navy. The precise nature of the allegories is, however, irrelevant to the theme of the monument as a whole which is the triumph of the spiritual and secret over the physical and mundane. Gilbert had to execute the portrait from a photograph and made his own mother his source of inspiration, so that he could draw constantly on a well of personal feeling. Thus, he said, '[I] got a more spiritual representation than if I had merely reproduced the Queen's features and form only'.[20] The free-standing statuettes are as real, in sculptural and emotional terms, as the figure of the Queen, and as drenched in private symbolism.

Baroque in the manipulation of bronze and the great sweep of drapery, Gothic in the marshalling of its detail and Donatellesque in the pathos of its statuettes, the great monument was a melting pot from which memorial sculpture emerged transformed in scope and significance. Examples of the influence of its individual details are countless while its general form and expressive content were the basis of the composite memorial as developed in England during the following three decades. The motif of the Victory statuette was borrowed by most of Gilbert's contemporaries. The orb of Alfred Drury's Bradford *Queen Victoria* is surmounted by a figure of comparable vitality and so too, originally, was that held by the monarch in Frampton's Calcutta monument (plate 209). As Gilbert made plain when he wrote that the 'joyousness' of his Victory was

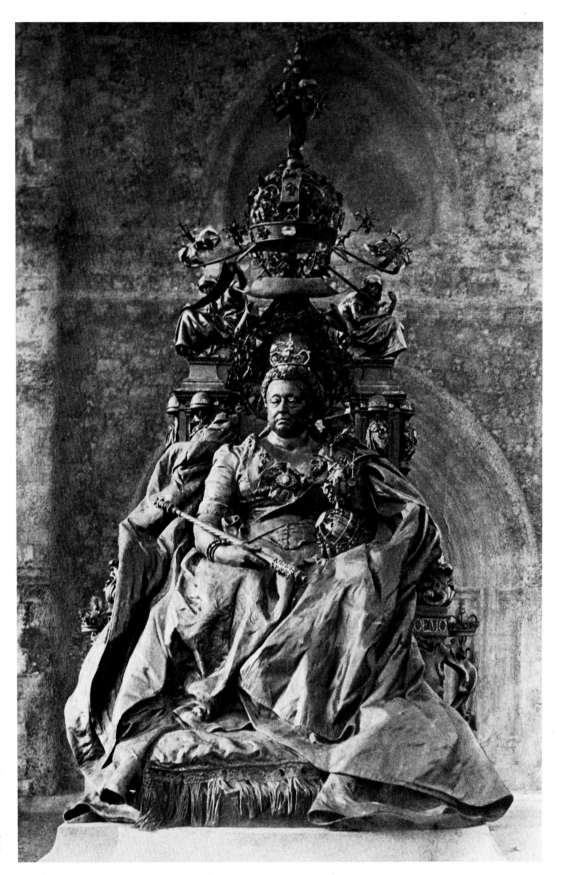

207. Alfred Gilbert, Jubilee monument to Queen Victoria, erected 1887. Bronze. Winchester Castle. From *Easter Art Annual* 1903, illustration facing p. 8.

208. (facing page) Alfred Gilbert, rear view of monument to Queen Victoria, Winchester Castle.

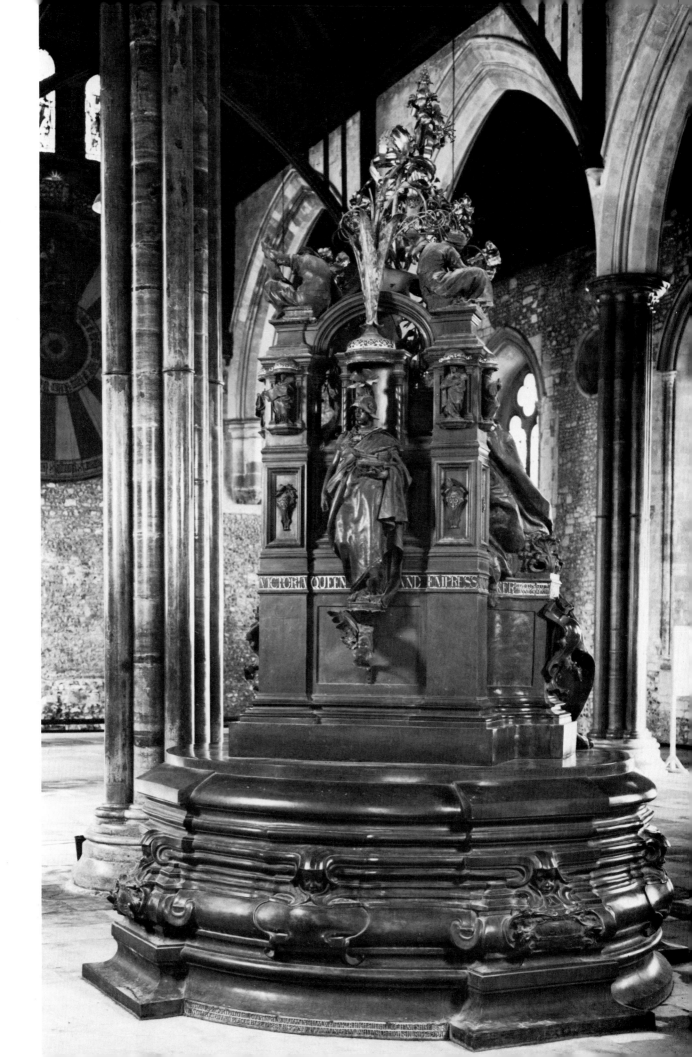

linked with his state of mind during the late 1880s,[21] the significance of such figures far outstrips their surface meaning. Modelled, it seems, with special care, they are self-sufficient works of art with an energy quite superfluous to their role as decoration. Buoyant, erect and free, they represent the spiritual nucleus of the sculptural world they inhabit.

Frampton's opportunity to produce a variation on Gilbert's theme came in 1897. At a public meeting in Calcutta on 22 April of that year it was decided that Her Majesty's second Jubilee should be commemorated by the erection of a statue, to be paid for from funds raised by public subscription. Charles H. Moore, an employee in the firm of Gillanders, Arbuthnot & Co., a Calcutta business agency, was deputed to find a suitable sculptor in England to undertake the work.[22] In July 1898 Frampton's completed model was illustrated and described in the *Studio* (plates 209–10). 'The singularly fine statue of the Queen, which Mr George Frampton, ARA, has designed for Calcutta, is to be placed', wrote the journal's correspondent,

209. George Frampton, Jubilee monument to Queen Victoria for Calcutta, 1897–1901. From *Studio* July 1898, vol. 14, p. 121.

210. George Frampton, rear view of Jubilee monument to Queen Victoria for Calcutta. From *Studio* July 1898, vol. 14, p. 122.

under an enormous canopy, fifty feet high by about forty feet wide, built of Portland stone. The figure, which is some two and a half times larger than life, stands with its pedestal twenty-seven feet high. The figure itself is to be in light bronze, the sceptre of ivory with gold ornaments, the orb of blue lapis-lazuli, surmounted by a golden figure of St George;[23] the crown and wreath will also be in gold, and the cushion behind the figure enamelled, probably in pale blue and white. The robes are those

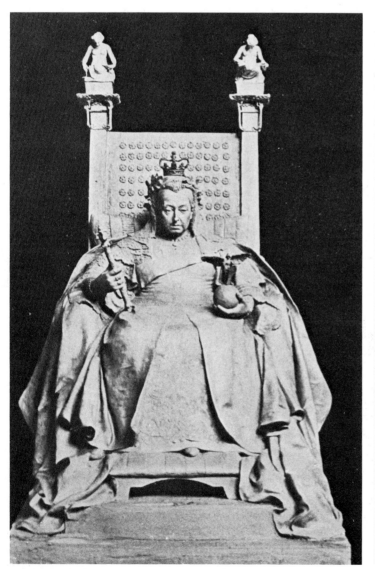
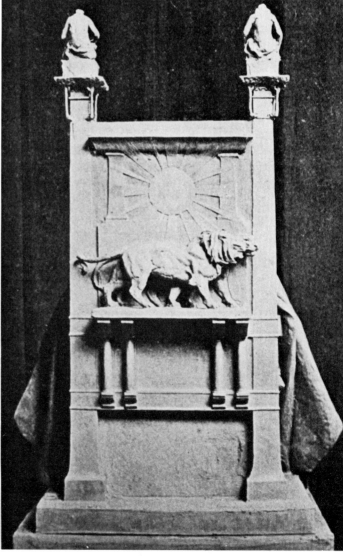

211. George Frampton, Jubilee monument to Queen Victoria, Calcutta Maidan.

pertaining to the Order of the Star of India which Her Majesty wore when she assumed the title of Empress. The lion and tiger side by side on the back of the statue typify respectively the British Kingdom and the Indian Empire. Two figures at the top represent Art and Literature and Justice. The capitals which support them are carved [*sic*] to represent English oak leaves, and a typical Indian tree, which is a sacred symbol of the native religion. Roses ornament the throne behind the head of the Queen. The base, which will be of richly coloured marble, will bear the Royal arms in enamel, supported by bronze figures of two Indians.[24]

212. George Frampton, *Dame Alice Owen*, 1896–7. Bronze and marble, LS. Owen's School, Potter's Bar, Hertfordshire.

It was fortunate, the writer concluded, that 'the flourishing condition of English modern sculpture' should be thus represented in the Indian empire and only regrettable that such a work of art should be lost to this country, where it might have helped to atone for the 'bad statues, royal and civilian, which disfigure so many English towns'.

Early in 1901 the monument was ready for shipment to India. It was unveiled on a temporary site on the Calcutta Maidan by the Viceroy, Lord Curzon of Kedleston, on 19 March 1902, when it was rapidly surrounded by 'thousands of admiring Natives'.[25] The death of the Queen had given rise to new plans for her commemoration. Curzon had commissioned William Emerson to design the Victoria Memorial Hall for the Maidan and Frampton's statue was to be given a permanent site immediately in front of it. H.E.A. Cotton wrote that the monument would be set there 'at the head of a high flight of stairs with an arch or canopy over it'.[26] What became of the canopy or, indeed, whether it was ever carved and despatched to India is unknown. Since the completion of the Memorial Hall in 1921 the sculpture has stood baldly before it on a huge architectural podium built to Emerson's designs and decorated with bronze reliefs, wreaths, railings and lamp standards in discordant juxtaposition with Frampton's crisp, delicate detail (plate 211). It seems likely that, as in *Lamia*, the sculptor substantially modified his original scheme between the completion of the model and the finished work. Cotton implied that all parts of the monument except the pedestal, 'of rich Irish green marble', were in bronze. The orb statuette, mentioned by Cotton in 1907 when it was present on the monument, had disappeared by the time official photographs were taken in 1922.

Spare in outline, rigidly frontal in pose and symmetrical in composition, the Calcutta Queen restates in Frampton's own idiosyncratic terms the turbulent message of the Winchester monument. The suggestion of meaning beyond appearance is

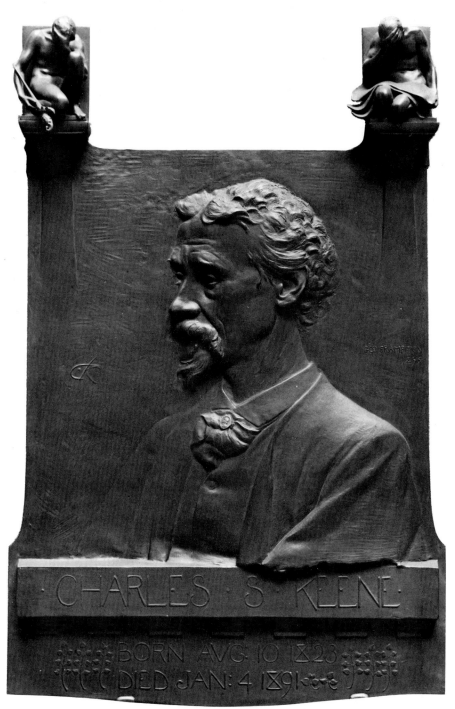

213. George Frampton, *Charles Keene*, 1896. Bronze, 35 × 23½ in. Tate Gallery.

conveyed in the hypnotically clear and precise handling of detail. As in the marble and bronze statue of Dame Alice Owen (plate 212), commissioned for the entrance hall of Owen Boys' School in 1896,[27] Frampton's portrayal of embroidered, pleated, layered fabric not only enhances the purely decorative appeal of the figure but gives it the air of a cult object, repelling comparison with the visible world. Remoteness is implicit too in the tilt of the head and steady, down-cast gaze, characteristics that both figures share with the bust of *Lamia*. It is not surprising that the two statues should display similarities. Recently completed when Frampton began the Calcutta monument, *Alice Owen* was the first large free-standing portrait memorial he had executed. It was exhibited at the Academy in 1897 and if, as seems likely, Charles Moore began his search for a sculptor immediately, it may well have influenced his choice. Also in the

214. George Frampton, detail of monument to Charles William Mitchell, 1903–5. Bronze. St George's Church, Newcastle-upon-Tyne.

215. Albert Toft, detail of monument to Edward VII, 1913. Bronze. Birmingham.

Academy that year was the bronze memorial tablet to Charles Keene which Frampton had completed in 1896 for the Passmore Edwardes Library at Shepherd's Bush (plate 213).[28] The flat panel on which the portrait bust is modelled in three-quarter view is framed by two vestigial pilasters terminated by plain, boldly projecting capitals. Upon these are set two crouching nude figures, Art and Humour, delicate parodies of History and Science on the Winchester throne-back and the immediate precursors of the acolytes that decorate the altar-like throne of the Calcutta memorial. (At Calcutta the impost blocks on which the two figures sit rise from tree capitals closely resembling those designed for the Düsseldorf fireplace; cf. plate 50.) By 1903, when Frampton designed the second of his memorials for the Mitchell family in St George's Church, Newcastle-upon-Tyne (plate 214), the motif of the two brooding, flanking statuettes, first borrowed by Gilbert from the vocabulary of Alfred Stevens, had become part of the common language of the New Sculpture. Its repeated occurrence in memorial statuary – whether stretched to monumental size as in Thomas Brock's Leighton Memorial in St Paul's Cathedral, or reduced to a minimal decorative device, as on the uprights of the chair of Peace in Albert Toft's Edward VII monument of 1913 at Birmingham (plate 215) – eventually roused critics to protest. 'Painfully trite', was the *Architectural Review*'s comment on Frampton's late use of it in the W.S. Gilbert Memorial, erected on the Victoria Embankment in 1915.[29]

So complex were the implications of Gilbert's Winchester statue that few public monuments produced during the following decades remained untouched by it, and indeed, much ideal sculpture was to reflect its influence. Among its more obvious effects was the increasing popularity of the seated pose. Goscombe John's *Duke of Devonshire* at Eastbourne, Frampton's *Marquess of Salisbury* at Hatfield, Onslow Ford's *Queen Victoria* at Manchester are all indebted to that massive, regal figure. Alfred Turner's Queen Victoria Memorial at Tynemouth, Northumberland, has actually been mistaken for Gilbert's work.[30] Niches containing tiny statuettes are set into the main uprights of the chair in which Albert Toft's *Spirit of Contemplation* is seated (plate 176). At a deeper level the Winchester Queen promoted the exploration – begun in Thornycroft's *General Gordon* – of two closely related ideas: the idea of widely extending the expressive range of the monument and of strengthening its impact as three-dimensional form. Part of the function of the great crown and its circlet of lilies apparently hovering above the throne is to counteract the effect of frontality which any portrait figure, seated or standing, must convey. Gilbert himself developed the theme in the Newcastle memorial where

216. Alfred Gilbert, detail of monument to Queen Victoria, 1900. Bronze. Newcastle-upon-Tyne.

217. William Hamo Thornycroft, monument to Dean Colet, 1902. Bronze. St Paul's School, Barnes.

218. (facing page) Alfred Gilbert, monument to Antony Ashley Cooper, seventh Earl of Shaftesbury, 1886–93. Bronze and aluminium. Piccadilly Circus, Westminster.

the figure and the throne are set beneath a circular bronze canopy supported on balusters, as if the crown, hugely enlarged, had descended like a fantastic bird-cage to enclose them (plate 216). The stone canopy originally conceived by Frampton for the Calcutta Queen and the iron baldacchino placed over Thornycroft's Dean Colet Memorial for St Paul's School, Hammersmith (now in Barnes), unveiled in 1902 (plate 217), seem likewise to have been intended not only to impart an air of mystery and detachment to the tableau beneath but to heighten the spectator's awareness of the monument as free-standing form in space.

It was Gilbert himself who carried these ideas to their limit. The memorial to Lord Shaftesbury at Piccadilly Circus totally rejects the mundane demands of the conventional monument (plate 218). Containing no reference to the physical appearance of its subject, it is iconographically free and thus free also from the formal restrictions imposed by the portrait figure on a pedestal. Circular in plan and composition, it is equally valid as sculptural form from any viewpoint. Not surprisingly, Gilbert encountered much opposition to his scheme. The funds donated by the public for a memorial to Antony Ashley Cooper, seventh Earl of Shaftesbury, were to be spent, announced the committee in October 1885, on two statues: one in marble to be placed in Westminster Abbey and the other in bronze for a site yet to be decided, 'the pedestal

of which should record in bas-relief Lord Shaftesbury's principal labours'.[31] No doubt the committee had in mind the type of Foley's *Lord Herbert*. The marble statue was duly commissioned from Boehm but, when the matter of the bronze memorial was raised, the sculptor suggested that not he but his pupil should undertake the work. 'In order to do me a service', related Gilbert, 'he told the committee that he would be unable to have the honour of carrying out the tribute to one he so greatly admired; but he was sure that his former pupil would amply justify the liberty he was taking in proposing him to the committee; but he would not answer as to what form his young friend would suggest for the memorial . . . and . . . anything approaching what is known as the "coat-and-trousers" style would, if insisted upon, lead to his pupil's instant renunciation of so important and tempting an appointment.'[32] Gilbert left the committee in no doubt that Boehm's prediction was justified. 'I can't', he informed the representatives who called at his studio, 'undertake the statue of Lord Shaftesbury; I prefer something that will symbolise his life's work.'[33] The commission hung in the balance. Only Boehm's reassurances calmed the committee's fears and Gilbert's appointment was confirmed in the spring of 1886. The memorial, it was decided, should take the form of a fountain, though how far this reflects Gilbert's own preference is uncertain. After much bureaucratic wrangling and enforced adjustments to his design, it was unveiled in June 1893.

The first stage of the monument is an octagonal basin of bulbous profile, each angle punctuated by elaborate decorative modelling and originally provided with drinking-cups. At its centre rises an octagonal pedestal supporting a second basin of undulating shape on which is piled a mass of writhing bronze: dolphins, shells, helmeted mer-babies, and half-abstract, half-organic forms (plate 219). Overhanging this ecstatic display of imaginative sculpture is a great octagonal cistern decorated with empty cartouches. From this rise, in sequence, the pedestal, urn and conch-shell finial that support the spiralling aluminium figure of Eros. The committee members' misgivings about the absence of any specific reference to Lord Shaftesbury had culminated, in 1891, in their insistence that a portrait bust must feature somewhere in the design. Boehm agreed to provide one and it was incorporated in the stone dwarf-wall that originally, much against Gilbert's wishes, enclosed the memorial. So incongruous was the effect, however, that even the committee was dismayed: the bust and the wall were removed in 1894.

The debate about the meaning of the monument, which began at its unveiling and continues to this day, was and is still rooted in a general misunderstanding of the nature of late nineteenth-century symbolist art. It is hardly surprising that Gilbert was outraged by the notion that the winged god with the shaft missing from his bow contributed to some vulgar pun on the name of Shaftesbury. Irritably and with evident reluctance, some ten years after the unveiling, he explained to Joseph Hatton:

> It is futile to pretend that I started out to make that design with a view of illustrating any particular or symbolical meaning. Knowing that it was to be a fountain, I naturally selected a form which should be most appropriate to the purpose, and it only required a slight stretch of imagination to determine that fish and the offspring of the mermaid would be best adapted to my purpose . . . As to the figure surmounting the whole, if I must confess to a meaning or a *raison d'etre* for its being there, I confess to have been actuated in its design by a desire to symbolise the work of Lord Shaftesbury; the blindfolded Love sending forth indiscriminately, yet with purpose, his missile of kindness, always with the swiftness the bird has from its wings, never ceasing to breathe or reflect critically, but ever soaring onwards, regardless of its own perils and dangers.[34]

219. Alfred Gilbert, detail of upper basin, monument to Lord Shaftesbury.

217

220. Edward Onslow Ford, monument to Hugh Rose, first Baron Strathnairn, 1891–5. Bronze. Private collection.

Like all true symbolism the Shaftesbury Memorial is concerned with suggestion and subjective allusion, not with the clearly defined, objective images of conventional allegory. Reaching towards abstraction in the decorative treatment of the upper basin, it is an attempt to convey pure feeling in sculptural terms. Unlike the static, pattern-making stylistic devices of Art Nouveau, Gilbert's swelling, writhing detail reflects a furious energy. It shows him grappling with the task he had undertaken while at work on the pedestal of *Icarus*: to break away from 'mere material and matter-of-fact expression'[35] toward absolute expressive form.

The Shaftesbury Memorial was difficult to follow. An opportunity to do so, seized by Frampton in the very different circumstances of the Peter Pan Memorial of 1910, seldom arose. Pressure on sculptors to produce portrait likenesses of their subjects was

lifted only in the aftermath of the Boer War when the use of ideal figures to represent the collective spiritual identity of the fallen became an accepted and eventually grossly overworked convention. If, meanwhile, the portrait figure could not be dispensed with altogether, it could, as Gilbert had shown at Winchester, be supplemented in such a way as to affect radically the character of the monument. A comparison of two equestrian portraits, one of the early 1890s and one of 1896, illustrates the scope of his influence.

In 1891 Onslow Ford was commissioned to execute a posthumous portrait of Hugh Rose, first Baron Strathnairn. The £3,500 raised by public subscription was spent on a bronze horse and rider set on a massive architectural pedestal of Portland stone with columns at its sides and angles but without subsidiary sculpture of any kind. The monument was unveiled in June 1895 on an island plot at the junction of Knightsbridge and the Brompton Road.[36] Dismantled in 1931 to make way for the building of Knightsbridge underground station, it was put into store by Westminster City Council. Proposals for its re-erection were persistently resisted and in 1968, having become an embarrassment to its custodians, the pedestal was scrapped and the bronze sold into private hands.[37] Ford's portrait of the stern and elderly Field Marshall, posing self-consciously in his Indian helmet with cascading feathers, is remarkable for its vivacity and sculptural *couleur* (plate 220). So too is the horse itself, similarly still and erect, fixing the spectator with an alert, quizzical gaze. Indeed, the whole treatment of the group – both figures slightly dishevelled despite their formal pose, both bedecked by the minutely observed trappings of their role – has a sprightly humour that would have been difficult perhaps to develop in supporting allegory. It seems significant, nevertheless, that in 1891 the question of composite sculpture did not arise, while scarcely four years later, at work on the Lord Roberts Memorial for Calcutta, Harry Bates considered the inclusion of ideal figures so important that he sacrificed his own financial security in their cause.

The origins of the memorial to Lord Roberts, Commander-in-Chief of Her Majesty's forces in India from 1885 to 1893, were summarised by Sir Patrick Playfair, chairman of the memorial executive committee, at the unveiling ceremony on the Calcutta Maidan in March 1898. The committee, he explained, had at first decided that Roberts should be asked to sit for his portrait (presumably in oils) but the enthusiastic response to the appeal for subscriptions had suggested that 'something more important was required to mark fully the public appreciation of [his] services and military achievements in India; and his sanction having been obtained, it was decided to erect a statue'. C.H. Moore, a member of the executive committee, had been entrusted with the selection of a sculptor in London.[38] It seems likely that, as in his choice of Frampton to execute the Queen Victoria Memorial, Moore was influenced by the Royal Academy's summer exhibition. The records suggest that Bates received the commission for the memorial late in 1894: in that year one of his two Academy exhibits was the plaster model for a bust of Lord Roberts, remarkable for its naturalism, clarity of form and elegance of detail (plate 221).

The funds available were identical to those collected for the Strathnairn monument: £3,500, to cover the cost of a statue and pedestal and the carriage to India.[39] No equestrian memorial produced in England during the nineteenth century incurred such instant and widespread acclaim as the full-sized model that was set up in the courtyard of Burlington House for the summer exhibition of 1896. It was considered 'worthy to be ranked among modern masterpieces',[40] a remarkable portrait from the life of man and horse and a work of high art. Thanking Moore in 1898 for his services on

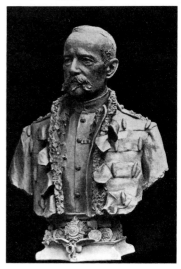

221. Harry Bates, *General Lord Roberts*. LS bust. From *Royal Academy Pictures*, 1894, p. 165.

219

the committee's behalf, Playfair expressed confidence that 'the likeness and artistic design . . . which has been so highly commended by leading members of the Royal Academy will justify [his] choice and add to the distinguished artist's reputation'.[41] Many years later Moore was to write, 'I do not claim sufficient knowledge of Art to make my personal opinion of the statue produced, of any value, but I can quote the opinion of the great Artist, Watts. He told me he considered it was without exception the finest equestrian statue of modern times.'[42]

As a direct result of its enduring reputation, two replicas of the monument were erected in Britain after Robert's death in 1914. The first of these, reproducing the whole of it exactly except for the inscriptions, was unveiled in Kelvingrove Park, Glasgow, in August 1916 (plates 222–3). The second, a reduced copy by Bates's pupil Henry Poole of the bronze horse and rider was erected on a plain pedestal in Horse Guards' Parade, London, in 1924. The Arab charger on which the soldier sits, calm and composed in his sun-helmet and Afghan jacket, is the climax of Bates's achievement as a sculptor of animals. Tense as a coiled spring, the beast is portrayed in an instant of suspended action, head thrust to one side and tail and mane swept forward in magnificent deference to the silent command of its rider.

Though paying tribute to the extraordinarily vitality of the equestrian portrait by reproducing it at Horse Guards' Parade, the Office of Works ignored Bates's overriding intention in the Roberts Memorial: that the portrait should be seen, not, like Ford's *Strathnairn*, in lofty isolation, but as the culmination of an aesthetic experience which begins, in Bates's original design, at the base of the pedestal. On either side of the marble core, flanked by the columns which support the heavy entablature, sit colossal bronze figures modelled in the round. At the back, facing in the direction from which the horse and rider advance, is the male, armoured figure of War. At the front sits Victory, her wreathed head and lightly draped torso framed by a huge billowing standard raised in her right hand (plate 223). Her throne is a ship's prow on which is set a little *tour-de-force* of expressive modelling, an equestrian St George impaling a serpentine monster on his lance. Round the upper part of the pedestal runs a continuous deep frieze of bronze vividly portraying in high relief the horse artillery and native cavalry, Sikhs, Highlanders and Gurkhas that accompanied Roberts on the famous march from Kabul to Kandahar. 'I desire', declared Playfair at the unveiling ceremony, 'to let it be known that this embellishment of the pedestal was not included in the original design accepted by the Committee and has been added by Mr Bates of his own accord and at his own expense, in fulfilment of the artist's sense of beauty and for Calcutta's permanent benefit.' This, he added, 'has been the reason to some extent why the completion of the statue and its surroundings have been delayed rather longer than was at one time anticipated, but I have ascertained that even now the time taken for the work has been short in comparison . . . with the four years that Mr Ford has lately taken to complete Lord Strathnairn's equestrian statue, put up in London, the pedestal of which has no similar adornment'.[43]

Bates must have felt well-pleased that his gift was received by the public with such enthusiasm, but it left him almost destitute. His total effects at the time of his death in January 1899 were £387 1s. 6d. Later that year the Council of the Royal Academy considered an application from his widow Nancie for 'some immediate help, she having been left entirely without means at the death of her husband'. Mrs Bates was given a grant of £50 and placed on the pension list.[44] Twenty years later, when Government negotiations for the second replica were in hand amid much bureaucratic penny-pinching, she admitted to the Office of Works that heavy losses had been incurred on

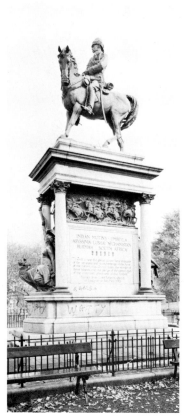

222. Harry Bates, monument to General Lord Roberts (1894–8). Bronze. Kelvingrove Park, Glasgow.

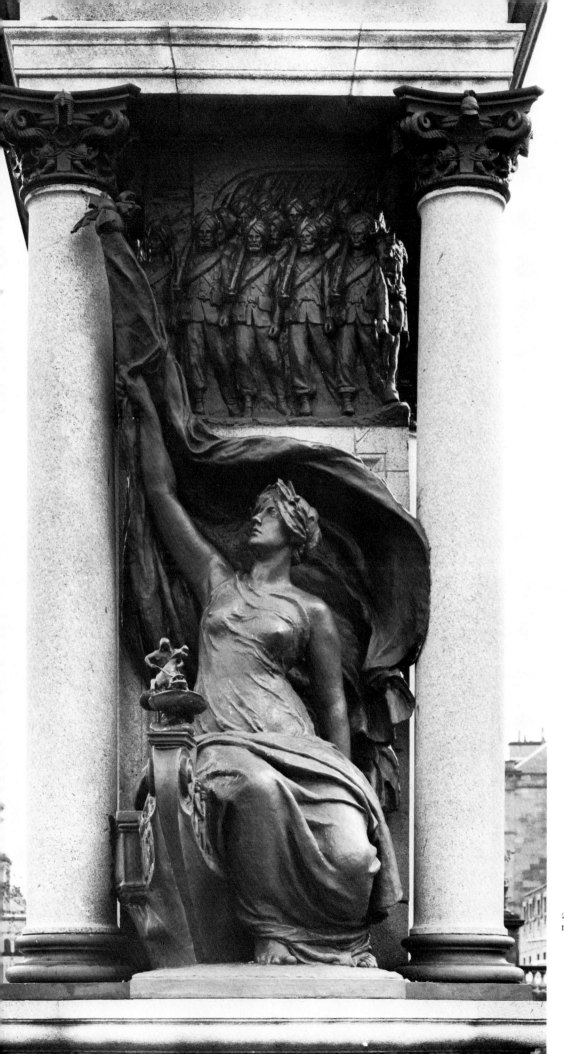

223. Harry Bates, detail of pedestal, monument to Lord Roberts.

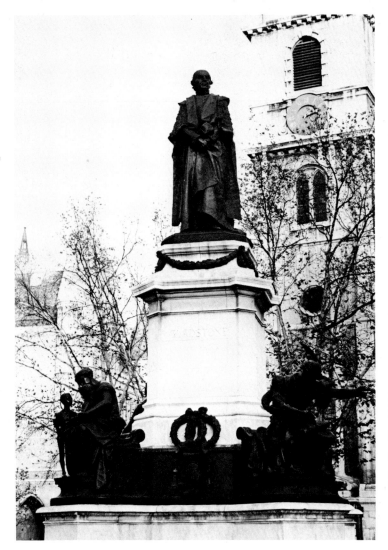

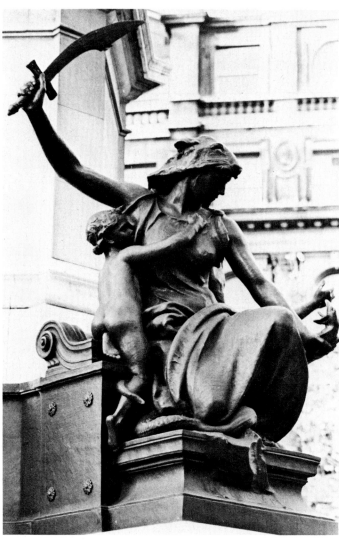

224. William Hamo Thornycroft, monument to W.E. Gladstone, erected 1905. Bronze. Strand, Westminster.

225. William Hamo Thornycroft, figure representing Courage, detail of monument to Gladstone.

the original monument and was duly suspected of attempting, still, to recoup them.[45]

As the reception of Bates's work suggests, the idea of the composite monument, combining reportage with 'high' art, had gained a firm hold on the public imagination. An interesting example of its application is the planning of Leeds City Square as a sculptural enclave (see Chapter 5). The modern rearrangement of the square has obliterated the fact that it was once a realisation on a colossal scale of the open, fountain composition widely adopted in the great composite-sculpture machines of the Edwardian era. Among the most notable of these are the memorials to W.E. Gladstone and Lord Curzon of Kedleston, both by Hamo Thornycroft and erected in 1905 and 1913 respectively.

In the Gladstone Memorial in the Strand (plate 224) the four ideal figures conceived as flat decoration for the flanks of the Gordon pedestal have, as it were, become four free-standing groups set on projecting blocks at the four corners of the podium. Except, inevitably, in the robed portrait figure, the monument has no directional emphasis, offering views of infinite variety but equal importance from whichever direction it is approached. While this centralised scheme owes much to Gilbert's influence, the stylistic identity of the heroic figures of Brotherhood, Aspiration, Education and Courage (plate 225) has an earlier source. It is no accident that the influence of Alfred Stevens is reflected more clearly in memorial sculpture than in any other aspect of the art at the turn of the century. Gilbert's delicate figure style was ill-suited to the

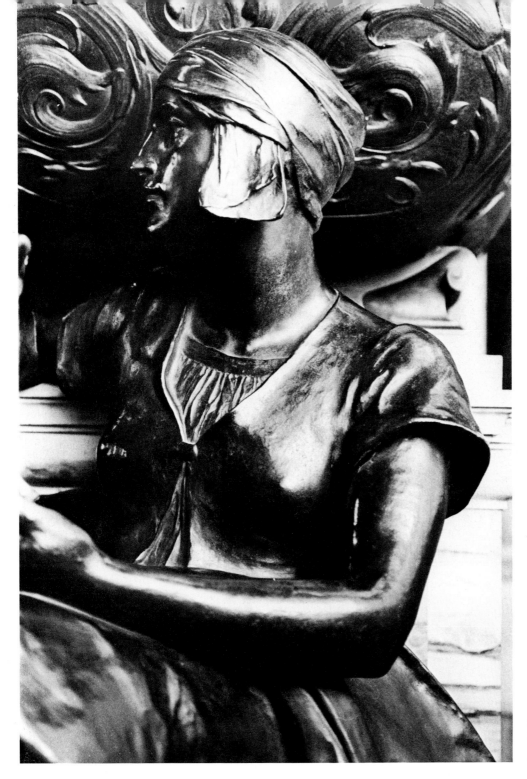

226. Thomas Brock, detail of figure representing Sculpture, 1901. Bronze. Monument to Frederic Leighton, St Paul's Cathedral, City of London.

monumental scale required by most public subscription committees but in the Wellington Monument, one of the greatest composite memorials ever erected in England, there existed two unforgettable prototypes for the supporting group of heroic size. The grave head and pose of Stevens's Valour with her upraised right arm and the balancing curve of the shield (plate 4) are echoed in Bates's Victory (plate 223) and in Brock's figure of Sculpture for the Leighton tomb (plate 226). (Brock's severe limitations as a modeller are exemplified here, however, in the deadened surfaces of neck and forearm, unworthy of comparison with the work of Stevens and Bates.) Thornycroft likewise appears to have modelled the supporting groups for the

223

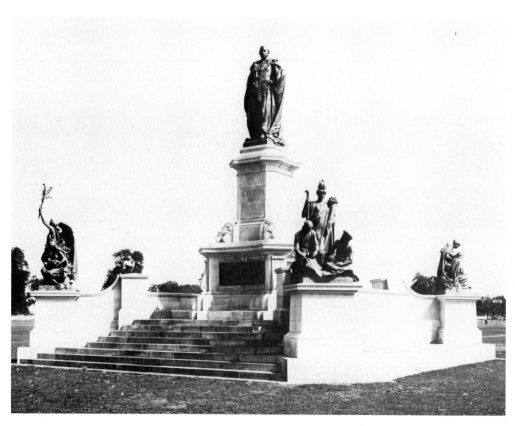

227. William Hamo Thornycroft, monument to Lord Curzon, 1909–13. Bronze. Formerly on the Maidan, Calcutta.

Gladstone podium with constant reference to Valour and Truth, though the interaction of the principal figures with the children that accompany them caused him some difficulty. It is significant that Courage, which owes most to Stevens, was later adapted as an independent statuette and that the sculptor then emphasised its derivation by eliminating the figure of the child.[46]

His design for the Gladstone Memorial secured for Thornycroft one of the choicest commissions of the new decade. The history of the memorial to Lord Curzon, Viceroy of India from 1898 to 1905 (plates 227–9), is minutely recorded in letters preserved by Curzon himself[47] and offers a striking contrast with that of the Peabody statue of 1866. The two monuments differed widely in cost and political status – the first a symbol of parochial piety, the second of imperial might – and yet these differences do not fully explain the contrasting attitudes of indifference to and almost obsessional concern for sculptural qualities which they and their documents reflect.

Early in 1906 Curzon received word that the subscription list for his memorial – ranging from Indian princes and tea companies to 'a few Bengali and Mahammadan Gentlemen' – had reached 90,000 rupees (£6,000). Sir Patrick Playfair, representing the executive committee, would shortly arrive in London to discuss with him the selection of a sculptor and the character and site of the proposed monument. There is no record of what took place at that first meeting but it is clear by implication that among several sculptors mentioned Thornycroft's name predominated and for one specific reason: his authorship of the composite sculpture recently unveiled in the Strand. By the end of March Playfair had already visited Thornycroft's studio and established that the Gladstone fund had exceeded his own by nearly £3,000. Nevertheless, he assured Curzon, the sculptor was confident that he could produce 'an important statue of your Lordship in robes with two allegorical figures or groups on

224

either side of the pedestal, in bronze . . . for a sum of between 5,000 and 6,000 guineas'.[48] In June, evidently anticipating a speedy decision in his favour, Thornycroft wrote to Playfair,

I understand that the site for the . . . statue [in front of the proposed Victoria Memorial Hall on the Maidan] is open and wide: and in that case I think the *pediment* and *base* should be *important* in size. I would suggest that the work consist of a 10 feet bronze statue of Lord Curzon wearing robes of The Star of India, surmounting a high pedestal and wide base of finely wrought Portland stone enriched with two bronze groups ('heroic' in scale) one at either side, and at the front the name or inscription cut, and some smaller bronze enrichment. The groups might represent 'Justice' and 'Sympathy' – or 'Agriculture' and 'Commerce'. The whole of the work, including base, to be almost 30 feet in height. To be delivered in London packed ready for shipment. I estimate the cost of the whole to be £6,500 . . . I should expect to complete the work in three years.[49]

None of Curzon's own letters is included among his memorial papers so that his wishes

228. William Hamo Thornycroft, portrait figure for the monument to Lord Curzon.

229. William Hamo Thornycroft, group representing Famine Relief, detail of the monument to Lord Curzon.

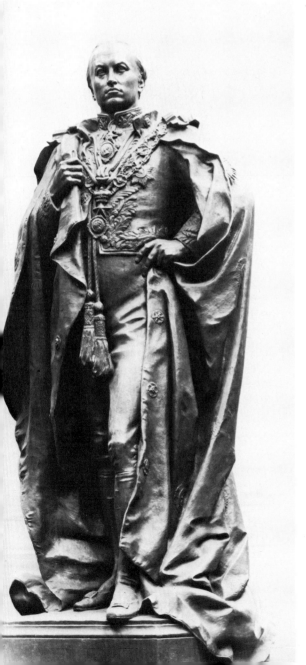

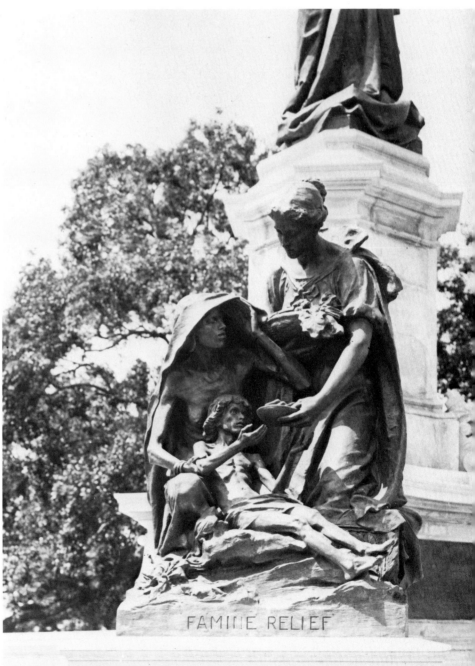

FAMINE RELIEF

can only be inferred from the correspondence of others. It is evident, however, that he was far from satisfied with Thornycroft's proposals.

On 18 June Playfair wrote: 'I know Mr Pomeroy and I shall go and see him, and report to you.' Pomeroy's response, understandably, was enthusiastic. '[He] is familiar with the frieze on the base of Lord Roberts' statue, by his late intimate friend, Mr Harry Bates, and considers that the pediment of your statue might similarly be embellished with illustrations of interesting subjects intimately associated with your term of Viceroy in India. He also thinks that the allegorical groups might be effectively rendered in white marble, and at no greater cost than in bronze. The statue itself would be in bronze, and he apparently considers that . . . a canopy would lend dignity and effect.' Anxious to deflect Curzon from too expensive a scheme, Playfair put forward the names of two highly inappropriate though undoubtedly less ambitious and expensive sculptors who had recently executed portrait busts of Maharajahs.[50] Both suggestions seem to have been instantly rejected. Meanwhile Playfair had referred the whole matter to Calcutta and now placed before Curzon the reply he had received from the secretary of the memorial committee: 'The cost of Mr Gladstone's statue in the Strand, viz, 8,500 gns, would be entirely beyond us, and I trust Mr Thornycroft may be able to modify his terms to something like the figure you name, without interfering with the dignity of the statue or its artistic merit.'[51]

In September Playfair asked Frampton what *he* could produce for £6,000 and learnt that his scheme, likewise, would necessarily be limited to two supporting allegorical figures in addition to a colossal portrait and 'a fine architectural pedestal'. Between September 1906 and July 1907 only one document was added to Curzon's letterbook: a note from the secretary of the Society of British Sculptors enclosing a copy of the regulations for sculptural competitions. It seems that Curzon, unable to obtain the scheme he wanted, had taken refuge in petulant silence or lost patience with the whole affair. On 30 July 1907 Playfair reminded him that the committee was ready to act 'as soon as you feel inclined to consider the selection of a sculptor to undertake a commission for your statue for Calcutta'. In February 1908, after more than six months without progress of any kind, he wrote again to 'enquire if it would now be agreeable to you to consider the selection of a Sculptor'. That Curzon's anxieties centred on the treatment of the pedestal is confirmed by a letter he received in March from J. Starkie Gardner. Apparently on his own initiative he had asked the metalworker for impartial advice and Gardner had lost no time in asserting his ability to provide exactly what was required for the sum available. The entire pedestal would be carried out by himself and would comprise '4 standard lions with shields at the angles . . . and four figures of natives in costume, erect, and four seated figures of Fame, Truth, Justice, Mercy, or any other qualities – Courage, Virtue, Prudence, Charity– . . .'[52]

By mid-March a new and more rational plan had emerged. Curzon and Playfair were to interview personally the seven sculptors most revered in establishment circles at that period (Gilbert, in Bruges and in some disgrace over the Clarence Tomb, being *hors concours*): Thomas Brock, Pomeroy, Frampton, Drury, Thornycroft, Francis Derwent Wood and Bertram Mackennal. A further sum of £1,000 had, by some means not disclosed in Curzon's letterbook, been allocated to the monument and each sculptor was asked what he could provide for £7,000. Brock, in bed with bronchitis at the time of the interviews, failed to respond. Drury, Mackennal, Derwent Wood and Thornycroft all declared themselves able to execute a spreading composite monument with four allegorical figures or groups for the sum named. Pomeroy and Frampton adhered to their original schemes for two supporting allegorical sculptures. The letter

in which Frampton described, sketched and justified his proposal seems to have greatly appealed to the committee. 'I could', he wrote,

> give a bronze portrait of Lord Curzon about 9′ 0″ high (8′ 6″ would be a better proportion), two bronze groups of seated figures about 5′ 0″ high and two reliefs depicting scenes associated with the reign of his Lordship, and a Portland stone pedestal with terrace and steps front and back for the sum of £7,000. The bronze panels would carry the colour of the bronze through and connect up the groups, and the groups seen from the side would have a stone background, which would be of the greatest value in defining their outline . . . The sides of the pedestal could be filled up with inscriptions . . . [sketch inserted] . . . I need hardly say that if the commission . . . is entrusted to me, I would try my utmost to do a fine and original work of art, and make it worthy not only of the great man whose life and work it is to commemorate, but of myself as well. PS. Thinking over the idea of the terrace, I feel it would not help the importance of the monument, as it would give a spreading effect, which would not add to the dignity of the whole. A monument to such a strong and powerful Viceroy as Lord Curzon proved himself to be, should try to express his striking characteristics; dignity, stateliness and simplicity, and with this in view, I should like to see the monument more compact . . . [a second sketch inserted, showing a tighter arrangement of main and subsidiary pedestals].[53]

Still Curzon prevaricated; still he pressed for more money, until in despair Playfair wrote again to the executive committee who replied that there was now absolutely 'no prospect of further subscriptions being forthcoming'. When a new plea to Curzon to select a sculptor proved fruitless the committee took matters into its own hands. 'Members have decided', wrote Playfair in October, 'to place the commission for your statue either with Mr Hamo Thornycroft RA or with Mr George Frampton RA. A majority is in favour of Mr Frampton . . . I think we should be quite safe in Frampton's hands and if you concur I propose to approach him at once and ask him to produce a sketch for the approval of yourself, myself and for the consideration and final approval of the members . . . I leave for Calcutta at the beginning of December . . . and I hope I may be able when there to obtain a decision without delay . . . on Frampton's sketch.[54] The letter evidently incurred Curzon's intense displeasure. Instantly he must have declared a conflicting preference for Mackennal, for Playfair hastily adopted a conciliatory tone. 'I am certain', he wrote, 'the members . . . would not think of doing anything not in harmony with your personal wishes . . . Personally I have for the last two years entertained a strong liking for Mackennal's work, although I had not previously to March last visited his studio . . . The Committee are anxious to avoid further delay. This I would impress upon you.[55] The unfortunate Mackennal, however, having been asked to submit a pencil sketch by mid-November, was discarded in his turn. During the last week of November 1908 Curzon made his final decision in favour of Thornycroft. Having outlined his revised scheme in detail once again and reassured his clients of its suitability for the grand site on the Maidan, the sculptor formally accepted the commission in the early spring of 1909, precisely three years after the first approach to him had been made.

Curzon gave sittings for the portrait figure later in 1909. By April 1911 the model was at Singer's foundry in Frome and work on the clay for the four allegorical groups was well in hand. Curzon watched Thornycroft's progress with a critical eye. He was far from satisfied with the bust, based on the colossal portrait, which was shown at the Academy in 1910. In 1911 the sculptor parried some undisclosed criticism of one of the

ideal groups with the wry comment, 'I fear that sculptors too often commit the crime to wh[ich] you allude – in my group – that M. Angelo should have done so is a poor excuse!'[56] By September 1912 most of the bronzework had been cast. One hundred and seventy tons of masonry were packed and ready for shipment. A temporary site pending the completion of the Victoria Memorial Hall was allocated on the Maiden and in February 1913, after the customary unforeseen delays at the foundry, Playfair informed Curzon that the whole of the work had been dispatched to India and that Thornycroft had been paid the balance of his fee. In the same month the sculptor sent his client a set of photographs of the bronze portrait. 'Though I have a fear', he wrote,

'that you are not satisfied with the head ... I have a hope that you may allow that the whole figure looks well and commanding – as I remember you desired it should at our first interview. "Commanding and head erect, not pensive and with no hand touching the sword". These I think were your words. The sword is in fact hidden beneath the robe.'[57] Curzon's answer must have been immediate and reassuring for three days later the sculptor wrote again: 'It would be difficult for me to express how pleased I am to receive your letter. I thank you most sincerely; and the thought that he who has inspired and is most concerned in the matter is gratified will qualify any criticism which later is sure to come – and what is more important to me, will qualify and be an asset

230. Thomas Brock, monument to Queen Victoria, 1901–11. Marble and bronze. Buckingham Palace. From photograph of unveiling ceremony in 1911, before addition of bronze figures on podium.

against the many "staircase thoughts" which so often afflict me (and probably most sculptors!). Yes! Heaven preserve us from works by sculptor amateurs in public places!'[58]

The Curzon Memorial was unveiled on 8 April 1913. After the completion of the Memorial Hall it was moved to a position on the public road due north of Frampton's *Queen Victoria*. It is now at the Flag Staff House, Barrackpore, the portrait figure replaced by an effigy of Sri Aurobindo.

Curzon's belief in the power of sculpture to enhance his image and his determination to outstrip the Gladstone monument in grandeur resulted in a structure oddly reminiscent of the Albert Memorial. The massive podium and pedestal supporting the portrait statue rise from a broad stepped platform, at the four corners of which, raised on a high parapet, are four weighty multi-figured groups in bronze. Thornycroft had to conform not only with a prescribed list of subjects (Famine Relief, Commerce, Agriculture and Peace) but also with Curzon's insistence that the allegories should consist of more than one principal figure. To this he seems to have agreed with considerable reluctance. 'I think', he had told Playfair in 1908, 'it would be a pity to overweight the monument with subsidiary work, so if groups are substituted for single figures I should make the said groups less in scale.'[59] Combining the ethnic with the ideal and narration with symbol in busy profusion, the groups read as bronze counterparts of the miscellaneous heaps of marble that surround Prince Albert in Hyde Park. The Curzon Memorial shows Thornycroft as the victim of the very demand that he and his contemporaries had done so much to create.

Not inappropriately, the pre-war development of the public monument was carried to its logical extreme by the great plagiarist of the New Sculpture, Thomas Brock. The Queen Victoria Memorial, commissioned after the competition of 1901 as part of Aston Webb's replanning of the approach to Buckingham Palace, is an astonishing assemblage of echoes of the monuments of others (plate 230). The huge gilded bronze Victory derives from Gilbert; the seated figures at her feet are borrowed from Stevens's model for the 1851 Exhibition Memorial. The marble Queen is based upon her counterpart at Winchester; the bronze figures accompanied by lions which stand on the podium point unmistakably to their origin in Dalou's political sculpture. It is as if Brock had hoped that by marshalling all the images he most admired in memorial sculpture and enlarging them as far as space and money would allow, he could achieve the perfect monument. By the time the central part was unveiled in 1911, however, those images had already been stretched to exhaustion over monument after allegorical monument commemorating the South African War. The tide of popular and informed opinion had begun to turn. 'What can be more idiotic', exclaimed a cynical newspaper reporter, 'than a human figure with a pair of huge wings sprouting from the shoulders? There is something of the sort perched on the top of the Queen Victoria memorial – a huge gilded person with wings stuck on her back . . . Why should artists always choose wings for such memorials? Birds have tails and beaks. Why not press these things also into the service of allegorical art?[60] Less explicit, less flippant, but no less damning was the verdict of the *Architectural Review*. It was time, warned the journal in 1910, to consider the possibility that 'though the piling together of tons of marble and bronze may . . . perpetuate the memory of a sovereign or statesman, it may also, in the eyes of posterity, be regarded as a mausoleum for the reputation of the sculptor'.[61]

9. *Retrenchment and Eclipse*

THE four years from 1898 to 1901 may be shown, with unnerving ease, to have contained not only the greatest achievements of the New Sculpture movement but the forces and events which contributed most insidiously to its decline. During that period Gilbert was preoccupied with the Clarence Tomb, the polychromed statuettes of which are among the purest and most completely symbolist figure sculptures ever devised. To those years also belong Bates's *Mors Janua Vitae*, Drury's *Prophetess of Fate* and Toft's *Spirit of Contemplation*, each saturated in the half-melancholy, half-ecstatic spirit of the *fin-de-siècle*. To 1900 belongs Frampton's *Lamia*, that bronze and ivory head of 'subtle, exquisite refinement', which, if Huysmans had known it, would surely have taken its place beside the paintings of Moreau in the night-world of Des Esseintes. What work of nineteenth-century sculpture could have better slaked that terrible thirst for 'erudite fancies, complicated nightmares, suave and sinister visions'?[1] Like Gilbert's ivory-faced saints conceived to stand, pinioned by their monstrous costumes, round the tomb at Windsor, *Lamia* is infected by the same sado-masochistic delight in flesh constrained and corsetted in metal and gems which is conveyed in *A Rebours* with such hypnotic and revolting clarity. Like Gilbert's *Virgin* and Bertram Mackennal's *For she sitteth . . .*, like Toorop's *Three Brides*, Klimt's *Pallas Athene* and Munch's *Madonna*, like Des Esseintes himself, *Lamia* is one of the most self-revealing statements ever made by its creator. Like them it is concerned with the conflict between the nature and fact of female sexuality and the myth of purity; with the relationship of conscious to unconscious mind. Beneath the immaculate disciplines imposed by art and ego lies an attempt to confront the terror and chaos of the id.

By 1901 most of the practical aims of the New Sculptors had also been realised, while those destined to fail were still the focus of hope and excitement. Architectural decoration had become an accepted, highly honoured part of the sculptor's role. Sparkes's carver–modeller apprentices from Lambeth had achieved national recognition, their extraordinary commitment to freedom in the practice and scope of their art symbolised as much in the facades and internal decoration of Lloyd's Registry as in the ideal work they continued to send to the Royal Academy. The Academy itself had lowered its defences against applied art, conceding the importance of schools such as South Kensington and their promotion of the idea of sculpture as three-dimensional decorative design. Frederick Schenck and Alfred Drury, both former South Kensington students, were beginning their phase of deepest involvement in collaborative schemes: Schenck with the architect Henry Hare, Drury with Belcher and Joass and Aston Webb. The cult of small-scale sculpture, fostered so carefully by

231

231. George Frampton, *Madonna of the Peach Blossoms* (1909–10). Bronze, 22½ in. National Museum of Wales, Cardiff.

Gilbert, Thornycroft and Onslow Ford, had not yet foundered on the problem of cost. It had led to a revolution in bronze-casting methods and given new significance to the delicate lyrical modelling of Pomeroy, William Reynolds-Stephens, Ellen Rope and the women of South Kensington.

The death of Harry Bates in 1899 was followed two years later by the death of Ford. In 1901 Gilbert retreated to Bruges. Thornycroft and Frampton, already preoccupied with official commissions and with their status as the most revered establishment sculptors in England, had little enthusiasm or insufficient time for developing new ideas. When they did turn to ideal work, they listlessly repeated well-tried earlier themes. The only self-motivated sculptures shown by Thornycroft at the Academy between 1899 and 1904 were four minor statuettes of sentimental genre subjects. The rest of his exhibits were related to prestige commissions for portrait busts and public monuments. Frampton produced a small number of pretty bronze idealised heads after 1900, but all were heavily dependent on the Lloyd's statuettes and increasingly vapid in quality, their smoothed-out modelling devoid of psychological tension (plate 231). If opportunities for architectural work arose after 1905 when he undertook to design the Victoria and Albert Museum spandrels he did not accept them, overwhelmed with portraits of dignitaries, monuments to Queen Victoria and her family and other public statuary.[2]

No sooner had the movement reached a critical turning-point about 1901, than the sense of national identity in Britain, already much sharpened during the war in South Africa, was abruptly intensified after the death of the Queen. An unattractive Kiplingesque obsession with patriotism, health and 'masculinity' is reflected in the increasing numbers of lusty, 'outward-bound' youths that appeared on the pedestals of public monuments, not all of them representative of Boer War heroes (plates 232–3). It was a development, nourished after 1905 by the rising popularity of Beaux-Arts ideals, which reached an inglorious climax in ideal sculpture in Bertram Mackennal's *Dawn of a New Age*, completed in 1924 (plate 234). The cumulative deadening effects on sculptural vitality were accurately recorded, if not entirely understood, by contemporary critics. The work shown at the Academy in the summer of 1907 'wears an air of restraint and reserve', wrote Rudolf Dircks, 'which has scarcely been its character of recent years, in which one has seen so much ability in the making. It contains nothing wild or particularly experimental . . . Imagination is held in hand by a scholarly feeling for the scholarly things that have gone before. And the scholarly feeling is largely French . . . It is an exhibition of conciliation and good manners; time, and possibly other influences, have tempered the zeal of the young bloods.'[3] Ten years later a memorial exhibition of the work of Hamo Thornycroft and Francis Derwent Wood was held at the Academy. 'Derwent Wood', wrote Herbert Furst,

> was by more than twenty years Sir Hamo Thornycroft's junior, yet the visitor . . . can be excused if he found himself traversing the three rooms without immediately noticing where Thornycroft begins and Derwent Wood ends. This . . . may be regarded by some as a triumph of Academicism, for if there be such a thing as objective beauty, and if this was discovered about four centuries B.C. in Greece, and rediscovered some fifteen hundred years after the Birth of Christ in Rome . . . then the art of the twentieth century sculptor consists in getting away at least four hundred . . . years from himself and his own vision.[4]

Sexual polarisation, curiously and mercifully in abeyance in England during the last decades of the nineteenth century, had by 1905 already begun the 'fatal' erosion of aesthetic values that Virginia Woolf was to describe and abominate during the 1920s.[5]

232

When Charles Hartwell carved his marble *Dawn* (plate 235) he no doubt had Drury's *Evening* (plate 94) in mind, but such delicate symbolism was now far beyond his grasp. The female nude in sculpture had become the victim once more of the crypto-pornographic silliness from which the New Sculptors had rescued it in the 1880s.

Perhaps no tendency that emerged after 1901 was more symptomatic of decline than the rejection, by many leading sculptors and most of their younger followers, of bronze in favour of marble for ideal work. The peculiarly expressive qualities of bronze as it was used by Gilbert in his *Study* of 1883 (plate 130) or by Bates in his Lord Roberts Memorial (plate 223) had little relevance in the context of bland, unremarkable images of idealised love and conventional beauty (those perennial recourses of the destitute imagination) which could be more effectively rendered in the bland, smooth substance of marble (plate 236). Even Reynolds-Stephens who clung doggedly to the ideal of alliance between modelling and decorative design resorted to such subjects as *A Royal Game* (plate 237). Here, in 1911, a manic precision and profusion of detail was thrown away in support of trivial historical anecdote as the sculptor fought desperately to inject a 'more inherently British feeling' into his work.[6]

Fragmented, not only by the physical loss of three leading figures, but by an ideological loss of identity, the movement thus turned back upon itself. The images first invented in the service of an intuitive symbolism lost their compelling quality as they were imposed over and over again on ideal sculpture and commemorative monuments. Never wholly understood by the public, they became, increasingly, objects of ridicule.

232. Albert Toft, group representing Education and Progress, detail of monument to King Edward VII, 1913. Bronze, Birmingham.

233. Paul R. Montford, lantern group, 1914–26. Bronze. Kelvin Way Bridge, Kelvingrove Park, Glasgow.

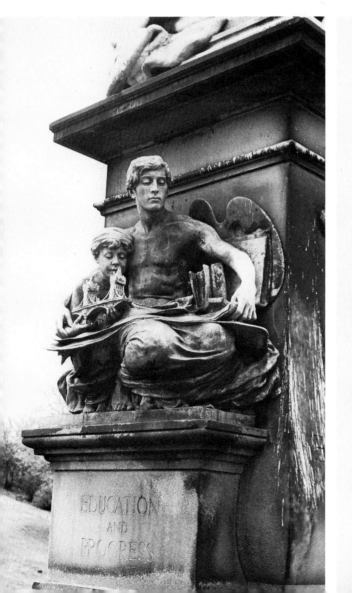

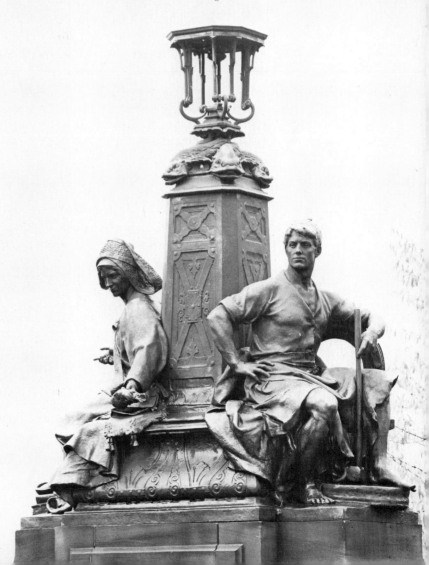

Such frivolous passing shots as that fired by the journalist who described Brock's Victoria Memorial in 1911 (see p. 230) rapidly developed into the kind of savage assault launched by Lord Redesdale in 1913 upon Reynolds-Stephens. The sculptor had produced two designs for a memorial to Edward VII, to be erected in the Memorial Park at Shadwell. Both models were rejected out-of-hand by Redesdale in the most contemptuous terms. The first design, he wrote in his report, 'consisted of a pedestal adorned by a medallion portrait of King Edward in relief, surmounted by one of those conventional winged ladies who do duty as representing Peace, Victory, Science, Art, or any other abstract idea which the poverty-stricken mind of man can suggest. This design appeared to me to be extremely commonplace.' The second, he sneered, was more ambitious: 'It represented a boat out of the bows of which the King was represented as about to jump, apparently in order to escape from the same winged lady-of-all-work, who this time was serving in the wings as coxswain. The boat was standing on a lofty pedestal – always an appropriate and natural position for a boat. The whole idea seemed undignified and grotesque.' Not surprisingly, the scheme progressed no further.[7]

It was in the context of the First World War and in the cruelly public setting of Hyde

234. Bertram Mackennal, *The Dawn of a New Age*, 1924. Bronze, 29½ in. Royal Academy of Arts.

235. C.L. Hartwell, *Dawn*, *c.*1909–14. Marble, 76 in. Tate Gallery.

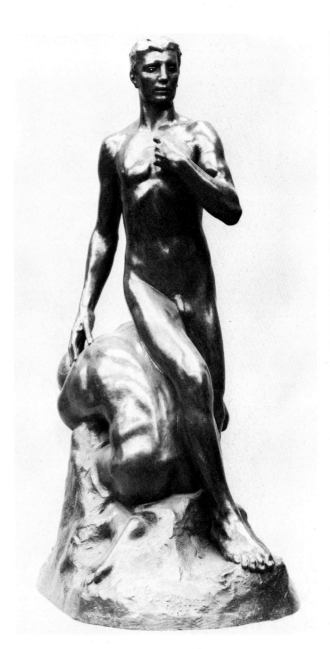

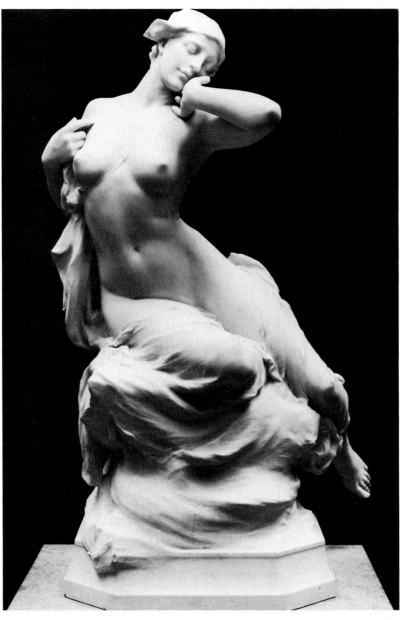

236. William Hamo Thornycroft,
The Kiss, 1916. Marble, 70 in. Tate
Gallery.

237. William Reynolds-Stephens, *A Royal Game* (Queen Elizabeth and Philip II playing chess), 1906–11. Various metals and inlays, 95 in. Tate Gallery.

Park Corner that the last remnants of credibility were torn from a weary and corrupted tradition. The searing realism of Sargeant Jagger's Monument of the Royal Artillery Regiment is more than an expression of the horror of war. It represents a violent gesture of revulsion against the aesthetic cliché embodied by its neighbour, the langorous nude *David* by Derwent Wood, which commemorates, with sickening irrelevance, the dead of the Machine Gun Corps.

One sculptor alone worked on after 1910 in total commitment to the old stylistic ideals. About 1909 Alfred Gilbert met in Bruges the patron for whom he was to execute his only work of true 'household' sculpture. The theme of the nightmare bronze chimneypiece completed for Sam Wilson of Leeds in 1911 was, Gilbert wrote, 'A Dream of Joy during a Sleep of Sorrow'.[8] Beneath the overmantel, like crusty mounds of decomposing matter, are piled two groups of figures, animals and birds (plate 238). The solid block of mouldings below them is supported by a series of attenuated pilaster-terms (plate 240), their terrible death's-heads in potent juxtaposition with the kissing faces extruded from the panel over the grate (plate 239). Intimations of death and ecstasy lie just beneath the surface of all symbolist imagery. But statements as extreme and as overt as this, precisely paralleled in painting by Gustav Klimt's contemporary *Death and Life*, are the mark of a dying age, the last convulsive fantasies of the symbolist movement in art.

236

238. Alfred Gilbert, detail of chimneypiece for Sam Wilson, c.1909–11. Bronze. Leeds City Art Gallery.

239. Alfred Gilbert, detail of chimneypiece for Sam Wilson.

240. (following page) Alfred Gilbert, detail of chimneypiece for Sam Wilson.

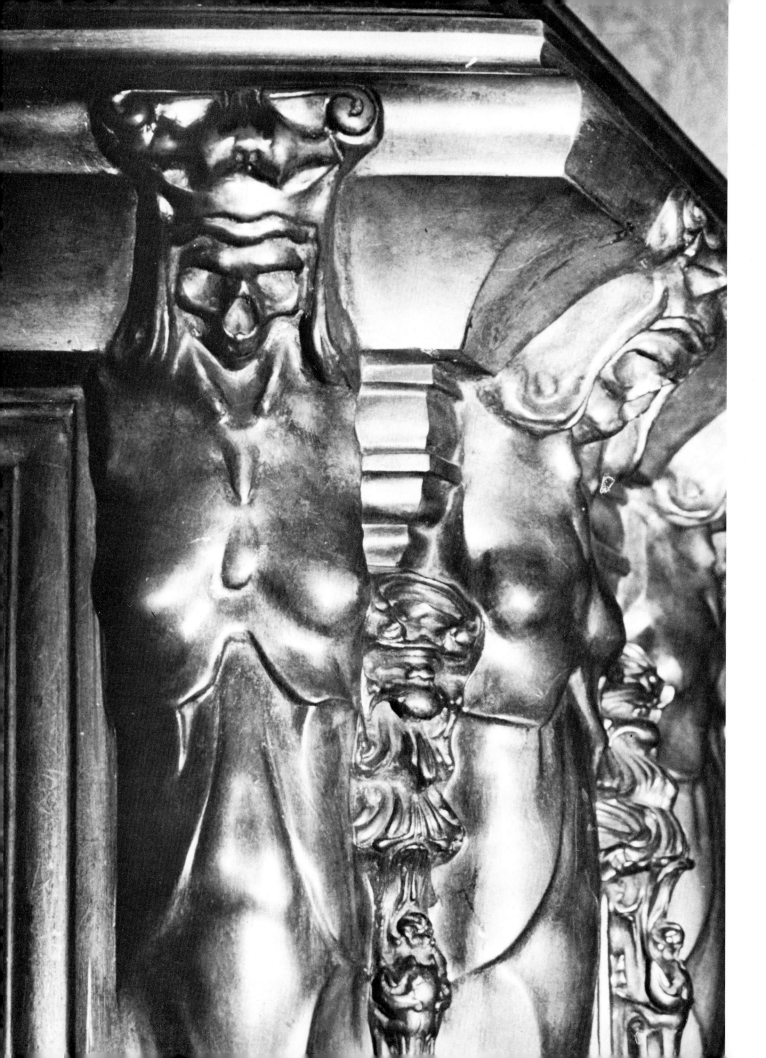

Biographical Notes

THE notes are confined to those sculptors who, in the author's opinion, made some significant contribution to the New Sculpture movement after 1880, or whose work shows the close and persistent influence of its leading protagonists; they are also limited to sculptors whose training took place or was based in Britain. Thus Stevens, Watts and Leighton, Dalou and Lanteri are all excluded, together with those artists who, like George Tinworth, remained outside the mainstream of the movement, while the Australian-born Mackennal, for example, and the relatively minor sculptor Gilbert Bayes, close follower of Frampton, are represented here. Minimal reference is made to work executed after 1910 and, unless of special interest, obituary notices are not included in the bibliographical lists. Location of buildings and monuments and place of publication is London unless otherwise indicated. Recurring names of institutions, etc., are abbreviated as follows:

Ashmolean	Ashmolean Museum, Oxford	Port Sunlight	Lady Lever Art Gallery, Port Sunlight, Cheshire
AWG	Art Workers Guild, 6 Queen Square, London	RA; ARA	Royal Academy of Arts, Royal Academician;
Birmingham	City Museum and Art Gallery, Birmingham		Associate of the Royal Academy. Date of entry
Cardiff	National Museum of Wales, Cardiff		to Schools indicates year of first acceptance as a
Chantrey/Tate	Purchased by the Trustees of the Chantrey Bequest and now in the Tate Gallery, London	RBS	probationer Royal Society of British Sculptors (founded 1904, designated 'Royal' 1911)
DNB	*Dictionary of National Biography*	SLTAS	South London Technical Art School, Kennington
Glasgow	Glasgow Art Gallery and Museum, Kelvingrove		Park Road, Lambeth (established 1879 as
Leeds	City Art Gallery, Leeds		extension to Lambeth
LS	Life-sized		School of Art)
Manchester	City Art Gallery, Manchester	Sydney	Art Gallery of New South Wales, Sydney, Australia
NATS	National Art Training School, South Kensington (renamed Royal College of Art 1896)	V & A	Victoria and Albert Museum, London
		WAG Liverpool	Walker Art Gallery, Liverpool, or extension
Preston	Harris Museum and Art Gallery, Preston		gallery at Sudley

ALLEN Charles John **1863–1956**

Born at Greenford, Middlesex. Apprenticed and employed as carver in wood and stone at Farmer & Brindley, as less costly alternative to architectural apprenticeship 1879–89. In 1882 entered W.S. Frith's modelling class at SLTAS and RA Schools in 1886. Became chief modelling assistant to Hamo Thornycroft 1890, working on *John Bright* statue for Rochdale and relief panels for frieze, Institute of Chartered Accountants. Took up post as instructor in sculpture at newly opened School of Architecture and Applied Art, University College, Liverpool 1895. Close friend of Robert Anning Bell and like him associated with the Della Robbia Pottery, Birkenhead. Won gold medal at Paris International Exhibition 1900 for bronze group *Love and the Mermaid* (RA 1895, WAG Liverpool) and LS plaster group *Rescued* (RA 1899, bronze version exhibited 1902 and purchased by Queen Alexandra; bronze reduction at Williamsons Art Gallery and Museum, Birkenhead). Notable for architectural sculpture (stone reliefs at St George's Hall, Liverpool; Royal Insurance Buildings, Liverpool), ideal groups and statuettes principally with nude and increasingly sentimentalised figures (*A Dream of Love*, 1895, bronze, Birmingham; *The Woman thou gavest . . . me*, 1913, marble, Glasgow). Also executed many portrait busts and medals. Principal monument is Queen Victoria Memorial, Liverpool, 1902–5.

AWG 1894.

E. Rimbault Dibdin, 'Our Rising Artists: Charles John Allen', *Magazine of Art* 1901, pp. 15–19.

BATES Harry **1850/1–1899**

Born at Stevenage, Herts. Began work as an architect's clerk. Apprenticed and employed as stone carver at Farmer & Brindley 1869–*c.*1882. Entered modelling class at SLTAS where he was taught by Dalou 1879. Admitted to RA Schools 1881 and in 1883 won gold medal and travelling studentship. Worked in Paris 1883–5, in contact with Dalou and Rodin. Much influenced by the latter in his view of sculpture as a means of expressing pure energy, whether physical as in *Hounds in Leash* (RA 1889, LS bronze purchased by Earl of Wemyss and March and still at Gosford House, East Lothian; bronze reduction at Birmingham) or emotional as in the deeply meditative head of *Rhodope* (portrait of his wife, exhibited in *cire perdue* bronze at the Grosvenor Gallery 1887 and also worked in marble; whereabouts of versions unknown). Ideal work, central to the development of the New Sculpture movement, included many relief panels (Aeneid triptych, RA 1885, bronze at Glasgow; *Homer*, RA 1886, plaster model and bronze at Glasgow; Cupid and Psyche triptych, RA 1887, silvered bronze at WAG Liverpool). Executed much vigorous architectural decoration in terracotta and stone (at

60 Buckingham Gate, Westminster, for Thomas Verity; at Victoria Law Courts, Birmingham, for Alfred Waterhouse; at Institute of Chartered Accountants, City, for John Belcher; at Holy Trinity, Sloane Street, Chelsea, for J.D. Sedding); the full extent of his collaboration with architects, which may include the reliefs in Doulton terracotta for Ernest George's 52 Cadogan Square, Chelsea, has yet to be investigated. Notable sculpture in the round includes *Pandora* (RA 1890, LS nude in marble with ivory and bronze casket, Chantrey/Tate), Lord Roberts Memorial (colossal bronze equestrian portrait and pedestal figures, 1896 for Calcutta, replica at Kelvingrove Park, Glasgow), Queen Victoria Memorial (1899 bronze, Dundee), *Mors Janua Vitae* (RA 1899, large statuette in bronze, ivory and mother-of-pearl, WAG Liverpool).

AWG 1886; ARA 1892.

Walter Armstrong, 'Mr Harry Bates', *Portfolio* 1888, pp. 170–4.
E.J. Winter Johnson, 'Mr Harry Bates, ARA', *Artist* December 1897, pp. 579–88.
Anonymous (obituary), *Magazine of Art* 1899, p. 240.
DNB entry by Ernest Rutherford.

BAYES Gilbert William **1872–1953**

Born in London. Studied at City and Guilds School, Finsbury. Entered RA Schools 1896, sponsored by George Frampton, by whom he was much influenced. Won gold medal and travelling studentship 1899 and went to France and Italy. Interested, like Gilbert and Frampton, in sculpture as applied decoration and in colour and mixed materials. Ideal work before 1910 falls into two principal categories: flat, formalised reliefs, usually of horses, and statuettes in bronze, sometimes with enamel detail, of knights on horseback, elaborately caparisoned and often accompanied by fairies, sprites, etc. (*Sirens of the Ford*, RA 1899, version at Preston; *Knight Errant*, 1900, St Cross College, Oxford). *Sigurd* (1910, Chantrey/Tate, versions at Ashmolean and WAG Liverpool) shows him moving towards an almost Futurist handling of planes. Also produced many bronze statuettes of female nudes, best known of which is the *Greek Dancer* (1905, version at Ferens Art Gallery, Kingston-upon-Hull; other examples at Sydney, and Port Sunlight). Executed monumental statuary and reliefs for Art Gallery of New South Wales 1903–16. Designed and modelled polychrome stoneware decorations for Doulton 1923–39, including ornamental clock for Selfridge's, Oxford Street, and many garden figures.

AWG 1896 (Master 1925).

Walter Shaw Sparrow, 'A Young English Sculptor: Gilbert Bayes', *Studio* March 1902, vol. 25, pp. 102–8.
Rudolf Dircks, 'Mr Gilbert Bayes', *Art Journal* 1908, pp. 193–9.

Charles Marriott, 'The Recent Works of Gilbert Bayes', *Studio* December 1917, vol. 72, pp. 100–13.

See also *The Doulton Story*, 1979, pp. 29–30 et passim (souvenir booklet produced for the exhibition at the V & A by Royal Doulton Tableware Ltd).

BROCK Thomas 1847–1922

Born in Worcester where he attended the Government School of Design. Entered studio of J.H. Foley in London 1866 and RA Schools the following year. Won gold medal for sculpture 1869. After Foley's death in 1874 completed many of his master's works and thereby rapidly achieved status as 'establishment' sculptor. Highly competent but seldom inspired, his work reveals the steadily accumulating influence of a wide range of superior artists, from Foley and Alfred Stevens to Dalou, Gilbert, Drury and Onslow Ford. Only occasionally, as in *Eve* (RA 1898, LS marble at Tate Gallery; reduced versions in bronze at Preston and RA), did he succeed in fully identifying with the new movement. A vast body of memorial and portrait sculpture includes *Sir Bartle Frere* (1888, Victoria Embankment Gardens), *Sir Frederic Leighton* (1893, bronze bust, RA Diploma work; numerous reduced versions exist), tomb of Lord Leighton (1900, St Paul's Cathedral; model at RA), equestrian *Black Prince* (1902, City Square, Leeds) and, crowning achievement of his career for which he was knighted, Queen Victoria Memorial in front of Buckingham Palace (1906–24; models on loan to V & A).

ARA 1883; RA 1891; founder member RBS; knighted 1911.

DNB entry by Tancred Borenius.

Elizabeth and Michael Darby, 'The Nation's Memorial to Victoria', *Country Life* 1978, vol. 164, pp. 1647–50.

COLTON William Robert 1867–1921

Born in Paris. Studied under W.S. Frith at SLTAS; entered RA Schools 1889. Continued training in Paris and remained heavily indebted to French romantic sculpture. Nude females, lovers and children dominate subject matter of ideal work, their titles such as *The Crown of Love*, *The Wavelet* and *Love's Bondage* underlining the fulsome sentiments they embody. Other examples, much acclaimed in their day, are *The Image-Finder* (RA 1897, LS bronze male nude, Nottingham Castle Museum), *The Girdle* (RA 1898, LS bronze female nude, Chantrey/Tate) and *The Springtide of Life* (RA 1903, LS marble, Chantrey/Tate; bronze versions at Glasgow and Preston). Monuments include Drinking Fountain in Hyde Park, 1896, and Royal Artillery Memorial, The Mall, unveiled 1910.

AWG 1894; ARA 1903; RA 1919; RA Professor of Sculpture 1907–10, 1911–12.

M.H. Spielmann, 'W.R. Colton, The New Associate of the Royal Academy', *Magazine of Art* 1903, pp. 300–4.

W.T. Whitley, 'W. Robert Colton ARA', *Art Journal* 1911, pp. 177–82.

A.L. Baldry, 'Modern British Sculptors: W. Robert Colton', *Studio* November 1915, vol. 66, pp. 93–9.

CRESWICK Benjamin 1853–1946

Born in Sheffield. Apprenticed as a knife-grinder. Met Ruskin and worked under his supervision at Coniston and Oxford. Joined A.H. Mackmurdo's Century Guild and was responsible, both under the aegis of the Guild until its disbandment in 1888 and independently, for much architectural relief decoration, principally in plaster and terracotta. Work included frieze for Cutlers' Hall, City of London (1887–8), panels for Bloomsbury Library, Birmingham (1893), and frieze for Heath's Hattery, Oxford Street (demolished). Appointed teacher of modelling at Birmingham School of Art 1888. Modelled the Memorial to the Men of Huddersfield, Greenhead Park, Huddersfield (1904–5, solitary LS soldier in bronze on granite pedestal). Largely self-taught and working, like George Tinworth, in the naive-realist manner admired by Ruskin, he shared few of the stylistic objectives of the New Sculptors though his lively and strongly individual reliefs were an important contribution to the revival of architectural sculpture.

T. Raffles Davison, 'An English Sculptor', *British Architect* 1887, vol. 27, p. 303.

DRESSLER Conrad 1856–1940

Born in London of German descent. Studied modelling under Lanteri at NATS during early 1880s and travelled in France. Encouraged by Ruskin and stayed with him at Coniston 1886, a determining factor in future stylistic development. Moved to Birkenhead from London in 1894 and joined Harold Rathbone in Della Robbia Pottery (examples of related work at WAG Liverpool and Williamson Art Gallery and Museum, Birkenhead). By 1897 joined Medmenham pottery at Marlow, responsible for 150 foot frieze in faience for Lever Bros. soap factory, Port Sunlight. Independent decorative sculpture includes figure of Mary Magdalen for Magdalen College, Oxford (c.1888), frieze of *Justice* for Common Room of Law Society in Chancery Lane, copper altar frontal for chapel at Welbeck Abbey (1898, in collaboration with Henry Wilson and F.W. Pomeroy) and two panels for St George's Hall, Liverpool (1895–9). Executed many portrait busts of notable contemporaries, including Ruskin (bronze, National Portrait Gallery; terracotta, Tate Gallery) and William Morris (bronzed plaster, AWG Hall). Though much concerned with sculpture's decorative possibilities and versatility, remained

241

committed, like Benjamin Creswick, to a somewhat coarse realism which impeded his identification with the aims of Gilbert, Frampton, etc. Spent much of later life in USA and in France, where he died.

AWG 1891.

Frederick Miller, 'A Sculptor-Potter: Mr Conrad Dressler', *Artist* 1900, pp. 169–76.
See also Jeremy Cooper Ltd, *The Birkenhead Della Robbia Pottery, 1893–1906*, 1980 (exhibition catalogue by Victoria Cecil and Jonathan Baddeley).

DRURY (Edward) Alfred (Briscoe) 1856–1944

Born in London. Studied at Oxford School of Art and then at NATS where as a National Scholar he was taught modelling by Dalou and his successor Lanteri; won gold medals in National Art Competitions in 1879, 1880 and 1881. Worked as assistant to Dalou in Paris 1881–5 and, for a short time after his return to London, to J.E. Boehm. Taught briefly c.1892–3 at Wimbledon School of Art. Overwhelming influence of Dalou shown in early terracotta figures and groups (*The First Lesson*, 1886, Birmingham) gave way during 1890s to gentle symbolism of *Circe* (RA 1893, LS bronze on hideous modern brick plinth in Park Square, Leeds), St Agnes (formerly Leeds) and *Griselda* (RA 1896, LS bronze bust, Chantrey/Tate; reduced versions at Glasgow, Ashmolean, York Art Gallery and Preston). Won gold medal at Paris International Exhibition 1900 for *Circe* and child-bust *The Age of Innocence* (RA 1897, bronze versions at Laing Art Gallery, Newcastle-upon-Tyne, Manchester and Preston; later reworked in marble, versions at Cartwright Hall, Bradford, Blackburn Museum and Art Gallery and, formerly, Luxembourg Museum, Paris). Impact of Gilbert, Bates and Frampton, together with keen interest in work of Alfred Stevens, is evident in many schemes for architectural and decorative sculpture after 1895. Notable surviving examples are eight bronze figures of *Morning* and *Evening* for Leeds City Square (1897), twelve busts of the months for Barrow Court near Bristol (c.1897), monumental groups in stone for the old War Office, Whitehall (1905), four colossal bronze figures for Vauxhall Bridge (1909) and reliefs and niche figures in stone for facade of V & A (1905–7). Produced numerous portrait busts, statuettes (original scale and reductions from large decorative figures; several at Ashmolean) and memorials, including Joseph Priestley for Leeds City Square (1898), Queen Victoria at Bradford (1902, with the architect J.W. Simpson), and Boer War Memorial at Clifton College, Bristol (1905, figure of St George).

AWG 1899; ARA 1900; RA 1913.

A.L. Baldry, 'The Art Movement: Decorative Sculpture by Mr Alfred Drury', *Magazine of Art* 1898, pp. 442–5; 'Our Rising Artists:

Alfred Drury, Sculptor', *Magazine of Art* 1900, pp. 211–17; 'A Notable Sculptor: Alfred Drury, ARA', *Studio* February 1906, vol. 37, pp. 3–18.
Anonymous, 'Some New Sculpture by Mr Alfred Drury, ARA', *Studio* March 1901, pp. 100–5.
DNB entry by James Laver.

FEHR Henry Charles 1867–1940

Born at Forest Hill. May have been apprenticed to Horace Montford who was his sponsor for entry to RA Schools 1885. Narrowly lost gold medal and travelling studentship to Goscombe John in 1889. Entered studio of Thomas Brock as assistant till c.1893, while there producing his first major work, monumental bronze group *Perseus rescuing Andromeda* (RA 1894, Chantrey/Tate). Other ideal work (present whereabouts of which is largely unrecorded) similarly reveals a histrionic style relating only marginally to New Sculpture movement. Chief link with movement was his activity as architectural decorator, notably for J.S. Gibson and partners (at West Ham Technical Institute; Technical School, Scarborough; Middlesex Guildhall, Parliament Square), Fitzroy Doll (at Hotels Russell and Imperial, Russell Square) and Lanchester, Stewart and Rickards (decorative sculpture in lead for domes of Methodist Central Hall, Westminster, and Cardiff City Hall). Portrait and memorial work includes bronze bust of William Morris (RA 1900, versions at William Morris Gallery, Walthamstow, and AWG Hall), marble busts of Ruskin and Robert Browning (South London Art Gallery) and statues of James Watt and John Harrison in City Square, Leeds.

AWG 1896.

FORD Edward Onslow 1852–1901

Born in Islington. Studied painting in Antwerp 1870 and Munich 1871–2, where he met and worked with Edwin Roscoe Mullins. Returned to London c.1874 with intention of working as portrait sculptor. In close contact with Gilbert after 1884 and highly responsive to new ideas, began series of ideal nudes and busts which, hailed then as daringly 'realist', are imbued with delicate, melancholy symbolism. They include *Folly* (RA 1886, large bronze statuette, Chantrey/Tate; original plaster model and bronze replica at National Gallery of Scotland, Edinburgh; reduced versions at Ashmolean and Port Sunlight), *Peace* (RA 1887, bronze statuette, LS version of 1890 at WAG Liverpool; reduction by Arthur Collie published 1890, examples at Cecil Higgins Art Gallery, Bedford, Leicester Art Gallery, private collections), *Bust of a Girl* (RA 1891, in marble and possibly 1886 in bronze; marble version at Pollok House, Glasgow; bronze at Aberdeen Art Gallery), *Still as a Bud whose Petals Close* (RA 1894, marble bust, version at Sydney), *Fate* (bronze statuette,

among his last works, versions at V & A and Port Sunlight) and *Snowdrift* (RA 1902, marble statuette completed posthumously by his son, Port Sunlight). Exhibited five works at Paris International Exhibition 1900 but was disqualified, as a British juror, from competing for awards. Portrait and memorial work includes bronze statue of Rowland Hill (1882, King Edward Street, City), series of busts for facade of E.R. Robson's Royal Society of Painters in Watercolours, Piccadilly (1881–2), *Henry Irving as Hamlet* (RA 1883, LS marble seated figure now at City of London Guildhall; produced also as a large bronze statuette), *General Gordon on a Camel* (1890, bronze, for Khartoum; original now at Gordon Boys' School, Woking; replica at Royal Engineers Institute, Chatham), Shelley Memorial for University College, Oxford (1892, marble and bronze), equestrian statue in bronze of Lord Strathnairn for Knightsbridge (1895, now at Foley Manor, Liphook, Hants) and Monument to Queen Victoria at Manchester (1901). Attempts to emulate his contemporaries, as in the Gilbert-inspired *St George and the Dragon* (RA 1902, silver, marble and ivory, now at Port Sunlight) sometimes failed disastrously. His best work, however, whether on a large or a small scale, has a daintiness and intensity that reflects his love for Flemish Renaissance paintings and places it among outstanding achievements of New Sculpture movement.

AWG 1884 (Master 1895); ARA 1888; RA 1895.

Walter Armstrong, 'E. Onslow Ford', *Portfolio* 1890, p. 67.
Marion Hepworth Dixon, 'Onslow Ford ARA', *Magazine of Art* 1892, pp. 325–30; 'Onslow Ford RA', *Art Journal* 1898, pp. 294–7; 'Onslow Ford RA: An Imaginative Sculptor', *Architectural Review* 1900, vol. 8, pp. 257–63.
M.H. Spielmann, 'E. Onslow Ford RA: In Memoriam', *Magazine of Art* 1902, pp. 181–4.
Frank Rinder, 'Edward Onslow Ford RA', *Art Journal* 1902, pp. 59–62.
Francis Haskell, 'The Shelley Memorial', *Oxford Art Journal* 1978, vol. 1, no. 1, pp. 3–6.
DNB entry by Walter Armstrong.

FRAMPTON George James 1860–1928
(during 1880s sometimes self-styled George Glanfield Frampton)

Born in London. First interest was architecture and like Harry Bates began work in an architect's office. Later apprenticed to firm of architectural stone carvers (possibly Farmer & Brindley) and maintained close involvement with architectural decoration for many years. Entered W.S. Frith's modelling class at SLTAS *c.*1880–1; admitted to RA Schools December 1881, won gold medal and travelling studentship 1887 and went to Paris

where he became a pupil of Antonin Mercié. Returned to London late in 1889 to develop highly personal symbolist style of *Mysteriarch* (RA 1893, polychromed plaster bust, WAG Liverpool) in which four crucial influences are apparent: contemporary French and early Italian Renaissance decorative sculpture, the work of Alfred Gilbert and the paintings of Edward Burne-Jones. From 1893 frequently exhibited with Arts and Crafts Exhibition Society and became renowned for experiments with non-figurative motifs in relief decoration, notably a stylised tree with flattened leaves. Appointed teacher of sculpture at Slade School and joint head with W.R. Lethaby of Central School of Arts and Crafts 1893–4. Wrote for the *Studio* in 1894 and 1897, where his work was frequently illustrated. Exhibited with Libre Esthétique, Brussels, first Vienna Secession 1898 and on numerous other occasions abroad. Gained Grand Prix for four works shown at Paris International Exhibition 1900. Preoccupied with numerous commissions for architectural work, medals, monuments and memorials, portrait busts and his own interest in designing household fittings and jewellery, he produced few independent ideal sculptures after 1893. Among notable exceptions is *Lamia*, a LS bust which develops the theme of *Mysteriarch* (RA 1900, bronze, ivory and opals, RA collection; painted plaster version at Birmingham). Principal surviving works relating to architecture are nine silver-gilt figure panels for door of Great Hall at Astor House (now headquarters of Smith & Nephew, 2 Temple Place, Westminster), sandstone reliefs for 177 Ingram Street, Glasgow (1896–1900), bronze group and stone spandrels for front of Glasgow Art Gallery (1897–1901), bronze figures and stone frieze for facades of Lloyd's Registry, Fenchurch Street, City (1899–1901), stone spandrel reliefs for Electra House, Moorgate (*c.*1902), and for front of V & A (1905). Principal monuments and memorials include bronze and marble statue of Dame Alice Owen for Owen Boys' School (1896, now at Potter's Bar), Charles Mitchell Memorial, St George's Church, Newcastle-upon-Tyne (1897, bronze with enamel, etc.), Queen Victoria for Calcutta (1897; later variants for Winnipeg, St Helens, Lancs., Leeds, etc.), portrait group of William and Mary Howitt for Nottingham Poets' Memorial (1900–2, Nottingham Castle Museum portico), Peter Pan, Kensington Gardens (1910; replica at Sefton Park, Liverpool; reductions of central figure at Preston, Sydney, private collections). Portrait busts, produced in vast numbers after 1900, include Marchioness of Granby (RA 1902, marble, Diploma work at RA), William Strang (bronze, 1902, AWG Hall and RA), G.F. Watts (1905, posthumous portrait in marble, South London Art Gallery). Intensity of early style gave way towards 1910 to insipid smoothed-out modelling and re-use, to exhaustion point, of themes developed during 1890s (see, for example, the ideal busts *Madonna of the Peach Blossoms*, 1909, at Cardiff and Cartwright

Hall Bradford, and *Enid the Fair*, 1908, Aberdeen Art Gallery, or the bronze statuette *La Belle Dame sans Merci*, 1909, Museum of Modern Art, Venice).

AWG 1887 (Master 1902); ARA 1894; RA 1902; founder member RBS; knighted 1908.

'E.B.S.', 'Afternoons in Studios: A Chat with Mr George Frampton, ARA', *Studio* January 1896, vol. 6, pp. 205–13.
Frederick Miller, 'George Frampton, ARA, Art Worker', *Art Journal* 1897, pp. 321–4.
Anonymous, 'Jewellery and other Enamel Work by George Frampton', *Studio* May 1899, vol. 16, pp. 249–54.
H.C. Marillier, 'Die Kunst George Framptons', *Dekorative Kunst* 1904, vol. 12, pp. 369–77.
W.K. West, 'Some Recent Monumental Sculpture by Sir George Frampton RA', *Studio* October 1911, vol. 54, pp. 35–43.
Jules Brunfaut, 'Les Oeuvres de jeunesse de Sir George Frampton', *Académie Royale de Belgique Bulletins de la Classe des Beaux-Arts* 1928, vol. 10, pp. 56–61.
Malcolm Haslam, 'George Frampton: Context and Contribution', *Courtauld Institute: Review and Opinion* March 1968, vol. 1, pp. 28–32.
Rosalind Barnett, 'Frampton's Monument to Queen Victoria', *Leeds Art Calendar* 1977, no. 81, pp. 19–26.
DNB entry by Tancred Borenius.

FRITH William Silver 1850–1924

Studied at Lambeth School of Art from late 1860s, then concurrently from 1872 at RA Schools. Instrumental, with John Sparkes, in transfer of Lambeth modelling class to SLTAS in 1879 where he assisted and succeeded Jules Dalou as modelling master in 1880. Henceforth till 1895 when he retired from most of his duties at the school he exerted profound influence as a teacher, steadfastly promoting idea of essential unity of all aspects of sculpture. Entered, unsuccessfully, competitions for Blackfriars Bridge sculpture (1880) and for St George's Hall relief panels (1882). Collaborated with F.W. Pomeroy and Doulton artists on Victoria Fountain 1886–7 (Doulton's entry for Glasgow International Exhibition, 1888, now on Glasgow Green), contributing monumental group representing Canada and crowning figure of Victoria. Practice as independent sculptor centred on work for architects, notably Aston Webb at St Mary, Burford, Shropshire (*c.*1890, bronze lectern), Clare Lawn, Sheen (*c.*1893, terracotta figures for conservatory and fountain, destroyed), Victoria Law Courts, Birmingham (ceilings, pediments and panels), 13–15 Moorgate, City (*c.*1893, stone niche figures and reliefs), Christ's Hospital School, Horsham, Sussex (1902–3, stone carving and fountain in quadrangle), and at Imperial College, South Kensington (*c.*1906, allegorical figures in stone). Collaborated with Stirling Lee, Pomeroy and A.G. Walker in

decoration of 1a Palace Gate, Kensington, for the architect C.J. Harold Cooper. Other works include bronze lamp standards for entrance steps of Astor House, 2 Temple Place, Westminster, stone spandrel reliefs for bridge over King Charles Street, Whitehall, King Edward VII Memorial opposite London Hospital, Whitechapel, portrait bust of Selwyn Image (bronze, AWG Hall).

AWG 1886; founder member RBS.

GILBERT Alfred 1854–1934

Born in London. Intended to become a surgeon but, enrolled temporarily at Thomas Heatherley's art school, remained there 1872–3 after failing examination for entrance to Middlesex Hospital. Entered RA Schools 1873. Apprenticed to J.E. Boehm 1874 and in 1876 on his advice went to Paris to study at École des Beaux-Arts under Pierre-Jules Cavelier. Spent 1878–84 working in Italy. Early bronzes exhibited in England (*Perseus Arming*, Grosvenor Gallery 1882; numerous versions in various sizes in private and public collections including Leeds, Glasgow, V & A, Ashmolean, Manchester, Birmingham, Ferens Art Gallery, Kingston-upon-Hull; *Icarus*, RA 1884, large statuette at Cardiff, half-sized casts at Tate Gallery, Birmingham, Ashmolean and elsewhere; *Study of a Head*, Cardiff) immediately acknowledged to carry new and exciting implications for sculpture and established him as most profoundly influential English sculptor of his generation. Among the first to reintroduce lost-wax casting to this country, a technique learnt during his years in Italy, and to express in sculpture the visual and emotional intensity of late Pre-Raphaelite symbolist painting. Among important commissions rapidly following on his return to England were the Queen Victoria Jubilee Memorial for Winchester (Great Hall, Winchester Castle) and Fawcett Memorial, Westminster Abbey, into which he introduced rich colour with gold and silver-plated bronze and semi-precious stones (1885–7). Worked during the same period as jeweller and silversmith, making Mayoral Chain for Preston and silver epergne with figures in ivory, bronze and mother-of-pearl presented by the Army to Queen Victoria on her Jubilee (at present at V & A). Obtained, through Boehm, commission for Shaftesbury Memorial, Piccadilly Circus, and in 1892 began design for tomb of Duke of Clarence at Windsor which, with its series of polychromed symbolist statuettes, became his chief concern during 1890s (completed 1926). Also to the 1890s belong the statuette *Comedy and Tragedy* (large casts at Nottingham Castle Museum, Leeds, Ashmolean, etc.; half-sized versions at Birmingham, Tate, Cardiff, Preston, etc.), memorial statues of Prescott Joule (1890–4, marble, Manchester Town Hall) and John Howard (1894, Bedford), memorial screen at Whippingham Parish Church (1896), reredos of St Alban's Cathedral (1890–1903) and memorial candelabrum of Lord Arthur Russell at Chenies (1899–1900). Appointed Professor of Sculpture at

RA 1900. Increasingly harrassed by financial crises and his own inability to complete commissions in a given time, he declared himself bankrupt in 1901 and left for Bruges where he was based in semi-exile for more than two decades. Among the few works originating and completed between 1909 and 1926 was bronze chimneypiece for Sam Wilson (Leeds). His break with the Royal Family over the Clarence Tomb was resolved in 1926 and he returned to England to finish it. Unique among New Sculptors in having consistently upheld symbolist values of 1890s, he completed his last work, the Queen Alexandra Memorial at Marlborough Gate, in 1932.

AWG 1888; ARA 1887; RA 1892; RA Professor of Sculpture 1900; knighted 1932.

W. Cosmo Monkhouse, 'Alfred Gilbert ARA', *Magazine of Art* 1889, pp. 1–5, 37–40.
Joseph Hatton, 'The Life and Work of Alfred Gilbert RA', *Easter Art Annual* 1903.
Alys Eyre Macklin, 'Alfred Gilbert at Bruges', *Studio* November 1909, vol. 48, pp. 98–118.
Lavinia Handley-Read, 'Alfred Gilbert and Art Nouveau', *Apollo* January 1967, vol. 85, pp. 17–24; 'Alfred Gilbert: A New Assessment', *Connoisseur* 1968, vol. 169: 'Part 1: The Small Sculptures', pp. 22–7; 'Part 2: The Clarence Tomb', pp. 85–91; 'Part 3: The Later Statuettes', pp. 144–51.
Mark Roskill, 'Alfred Gilbert's Monument to the Duke of Clarence: A Study in the Sources of Later Victorian Sculpture', *Burlington Magazine* December 1978, vol. 110, pp. 699–704.
DNB entry by James Laver.
See also main bibliography: Isabel McAllister 1929; H.F.W. Ganz 1934; Adrian Bury 1954; Minneapolis Institute of Arts 1978.

GILES Margaret exhibited 1884–1909
(married Bernard M. JENKIN c.1899)

One of notable group of women who trained in Lanteri's modelling class at NATS; won numerous prizes in National Art Competitions during period 1892–4. In 1895 won Art Union of London's competition for a statuette with her model for *Hero*, cast in bronze and distributed as a prize in the annual lottery (one cast recorded in a private collection). Exhibited at RA and Arts and Crafts Exhibition Society; interested in sculpture as applied decoration and is known to have executed a terracotta frieze for facade of a house in Newgate Street, City (no longer extant).

HODGE Albert Hemstock 1875–1918

Born in Glasgow; commenced training as architect. Attended Glasgow School of Art during 1890s and turned to architectural sculpture. Worked for Salmon, Son & Gillespie in Glasgow. Lived in London from 1900 and executed much decorative work in severe, dispassionate classical style, including figures on General Buildings, Aldwych, for J.J. Burnet, reliefs in pediment of Royal Academy of Music, Marylebone Road, and Royal Exchange Buildings, Cornhill, both for Ernest George and Yeates, sculpture for Hull Town Hall (Russell and Cooper), for Institute of Civil Engineers, Great George Street, Westminster (James Miller), and for Glamorgan County Offices, Cardiff (E. Vincent Harris and Moodie). Architectural decoration in Glasgow includes sandstone reliefs on Anderson Savings Bank, c.1900, and Clyde Trust Buildings, Clyde Street, c.1905.

JENKINS Frank Lynn (surname 1870–1927
later hyphenated as LYNN-JENKINS)

Born in Torquay. From c.1890 attended W.S. Frith's modelling class at SLTAS; admitted to RA Schools 1893, where friendship with the painter Gerald Moira led to their collaboration on numerous schemes for coloured plaster bas-relief decoration (Trocadero and Throgmorton Restaurants, Hotel Metropole, Folkestone, Passmore Edwardes Library, Shoreditch, etc.). Collaborated with Moira and the architect Thomas Collcutt at P & O Company's Pavilion for Paris International Exhibition 1900, winning medal for his frieze panels in low relief. Again for Collcutt executed frieze of electrotyped copper, ivory and mother-of-pearl for vestibule of Lloyd's Registry, City (c.1900). A sumptuous bronze and marble group, *The Spirit of Maritime Commerce*, which stands at head of vestibule stairs, reveals his debt to Frampton, his fellow-collaborator in the decoration of Lloyd's. In 1904 provided, for Collcutt's Savoy Hotel, momumental figure in bronze gilt of Count Peter of Savoy above entrance arcade and in 1911, for Collcutt and Hamp, monumental figures in stone for facade of Thames House, Southwark Bridge. Other work included two marble groups, *The Virgin* and *St George*, for Matthew's Church, Cockington, Devon (c.1899), metal frieze for Henry Hare's Ingram House, Strand (1907, demolished), and *The Triumph of Youth*, an ideal head in marble (1904, Preston). Moved to New York after 1917 and died there.

AWG 1900; founder member RBS.

M.H. Spielmann, 'F. Lynn Jenkins: His Decorative Sculpture, His Methods', *Magazine of Art* 1902, pp. 295–301.

JOHN William Goscombe 1860–1952

Born in Cardiff. Entered workshop 1874 of his father, woodcarver to third Marquess of Bute whose Cardiff Castle and Castell Coch were then being rebuilt under supervision of William Burges. Employed as pupil-assistant 1881–6 in Lambeth studio of Thomas Nicholls, Burges's architectural carver. Joined W.S. Frith's class at SLTAS and entered RA Schools December 1883. Won gold medal and travelling studentship 1889. Journeyed

extensively and finally took studio in Paris where he was in contact with Rodin, the influence of whom, and of other French sculptors, seems to have inhibited his development towards an individual style. Highly eclectic ideal work in bronze executed after return to London in 1891 includes *St John the Baptist* (RA 1894, Cardiff), *Boy at Play* (RA 1896, Chantrey/Tate; reductions at Manchester, Newport Art Gallery, Gwent, and private collections), *A Maid so Young* (bust of the sculptor's daughter Muriel, RA 1897, Cardiff, Port Sunlight, Preston), *The Elf* (RA 1898, Cardiff, RA collection; marble version of 1899 at Glasgow) and *Merlin and Arthur* (RA 1902, Cardiff; reduced version at Cartwright Hall, Bradford). Won gold medal at Paris International Exhibition 1900 for *The Elf* (in marble), study of a head (in bronze) and *Boy at Play* (in plaster). Monuments include colossal seated figure of seventh Duke of Devonshire for Eastbourne (1901, bronze; reduction at Fitzwilliam Museum, Cambridge), Memorial to King's Regiment at Liverpool (1905, statuette of *Drummer Boy* figure at WAG Liverpool; full-size replica at Cardiff), tomb of third Marquess of Salisbury, Westminster Abbey (1906), and equestrian figure of Viscount Wolseley, Horse Guards' Parade (1920). Numerous portrait busts and commemorative medals. Among his few sculptures in an architectural setting are relief panels in stone for Electra House, Moorgate, City (1902), stone figures of Edward VII and Queen Alexandra for V & A facade (1906) and marble *St David* for Cardiff City Hall (1916).

AWG 1891; ARA 1899; RA 1909; knighted 1911.

A.L. Baldry, 'A New Associate of the Royal Academy: W. Goscombe John', *Studio* March 1899, vol. 16, pp. 115–20, 127–30.
DNB entry by R.L. Charles.
See also main bibliography: National Museum of Wales 1979.

LEE Thomas Stirling 1857–1916

Born in London. Entered RA Schools 1875, sponsored by J.B. Philip; won gold medal 1877, then travelling studentship 1879. Spent three years studying at École des Beaux-Arts in Paris under J.P. Cavelier, and in Rome. On return to London, assisted Gilbert with lost-wax casting experiments. Won competition for marble reliefs for St George's Hall, Liverpool, 1882, and executed eight of twelve existing panels. Other architectural works include reliefs for W.D. Caroe at Adelphi Bank, Liverpool (1893, bronze gates), and for Edgar Wood at Lindley clock tower, Huddersfield (1902, stone). Examples of ideal work and portraiture are at Leeds (*The Music of the Wind*, 1907, silver), Bristol City Museum and Art Gallery (*Contemplation*, marble relief), Cartwright Hall, Bradford (two portrait heads in bronze, one in marble), WAG Liverpool (marble bust of Alderman Edward Samuelson, 1885; marble relief head of a woman, *c*.1890), AWG Hall (bronze bust of John Brett,

1902), and Tate Gallery (marble bust of Margaret Clausen).

AWG 1889 (Master 1898); founder member RBS.

LEVICK Ruby exhibited 1894–1921
Winifred (married Gervase BAILEY)

Studied at NATS under Lanteri *c*.1893–7; gold-medallist in 1897 for statuette *Boys Wrestling* (RA 1898). Specialised in bronze statuettes and garden sculptures (many cast by J.W. Singer & Sons) of figures in action, children at play, etc., and in architectural reliefs. Before 1905 executed decorative panels at Roman Catholic Chapel of St Edmund, Hunstanton, Norfolk, reredos and relief panels for St Brelades, Jersey, and decoration for a shop front in Sloane Street, Chelsea. Her bronze statuette *Boys Fishing* (RA 1900) is in Stirling Maxwell collection, Pollok House, Glasgow.

T. Martin Wood, 'A Decorative Sculptor: Miss Ruby Levick (Mrs Gervase Bailey)', *Studio* March 1905, vol. 34, pp. 100–7.

LUCCHESI Andrea Carlo 1860–1925

Born in London, son of an Italian sculptor. Attended West London School of Art. Worked as assistant to various sculptors, including H.H. Armstead and E. Onslow Ford, and also for commercial silversmiths. Entered RA Schools 1886. Specialised in ideal busts and female nudes, characteristically pert and mildly erotic but in symbolist guise with such titles as *A Flight of Fancy*. Reductions of bronze *The Myrtle's Altar* (RA 1899) are at Birmingham and Preston. Reduction of *Destiny* (RA 1895) also at Preston. Won gold medal for LS plaster models of *Destiny* and *A Vanishing Dream* at Paris International Exhibition, 1900.

AWG 1907.

C.C. Hutchinson, 'Our Rising Artists: A.C. Lucchesi', *Magazine of Art* 1899, pp. 24–9.

MACKENNAL (Edgar) Bertram 1863–1931

Born in Melbourne, Australia, of Scottish parents. Studied under his father, an architectural carver, and entered National Gallery Art School 1878. Arrived in London 1882, entered RA Schools the following year. Some three months later left for Paris where he received instruction from Rodin. Appointed head of modelling and design department at Coalport Potteries, Shropshire 1886. Returned to work in Australia 1888 and afterwards again in Paris. First major ideal work, *Circe*, much acclaimed at 1893 Salon and much influenced by voluptuous French manner, exhibited RA 1894 (LS bronze at National Gallery of Victoria, Melbourne; reductions at Sydney, Art Gallery of South Australia, Adelaide, and Birmingham). Settled in London 1894. Produced many small sculptures during 1890s, including household

fittings (doorplates, switches, etc., produced by Singer & Sons, Frome), busts with decorative bases, bronze reductions and original statuettes such as *Salome* (RA 1897, small cast at Preston); bust of Queen Victoria published by Arthur Collie 1897. Turned increasingly to marble for ideal work after 1900, as, for example, in *The Earth and the Elements* and *Diana Wounded*, both Chantrey/Tate, 1907 and 1908 (bronze reduction of *Diana* at Ashmolean). Executed several notable architectural sculptures between 1900 and 1910, including high reliefs in pediment of New Government Offices, Parliament Street, Whitehall, and putti for Belcher and Joass's Royal Insurance Buildings, St James's Street, Piccadilly. Among numerous prestigious commissions for monuments were Boer War Memorial, Highbury, Edward VII Memorial, St George's Chapel, Windsor (with Edwin Lutyens), and equestrian statue of Edward VII, Waterloo Place (1920).

AWG 1905; ARA 1909; RA 1922; knighted 1921.

R. Jope-Slade, 'An Australian Quartette', *Magazine of Art* 1895, pp. 389–92.
W.K. West, 'The Sculpture of Bertram Mackennal', *Studio* September 1908, vol. 44, pp. 262–7.
Noel Hutchinson, *Bertram Mackennal*, 1973 (Oxford University Press, Great Australians series).
DNB entry by Charles Marriott.
See also: Graeme Sturgeon, *The Development of Australian Sculpture, 1788–1975*, 1978 (chapter 5, 'Local Boys Make Good').

MACLEAN Thomas Nelson 1845–1894

Born at Deptford. Apprenticed to Carrier-Belleuse in Paris *c.*1860, studied at École des Beaux-Arts and became his studio assistant. Returned to London 1870; worked for H.H. Armstead and prepared terracotta figure for decoration of Horticultural Society's Garden, South Kensington (never executed). Became well-known for classically draped female figures and ideal busts including *Ione* (RA 1875, executed in terracotta, marble and bronze versions), *Sappho* (*c.*1885), *Meditation* (*c.*1882, ideal bust; marble version in private collection), in reticent, graceful style intermediate between late neo-classicism and New Sculpture. Sold four designs to Minton 1872, including *Fine Art* and *Science*, for production in tinted parian ware. Much influenced by High Victorian painters such as Albert Moore and Alma-Tadema and produced many of his works in Doulton terracotta, marble and bronze versions. Interested in lost-wax casting and mass-production of small bronzes; published work through Bellman & Ivey during 1880s. Executed memorial relief for Weeting Church, Norfolk. Settled in Italy after 1891. Present whereabouts of almost all his sculptures unknown.

J.A. Blaikie, 'An English Sculptor', *Magazine of Art* 1886, pp. 233–8.

MONTFORD Paul Raphael 1868–1938

Born in London, son of Horace Montford, sculptor and curator of RA School of Modelling. Learnt drawing at Lambeth School of Art and modelling in father's studio. Entered RA Schools 1887, winning many prizes including gold medal and travelling studentship 1891. Details of travel and further training unknown. Modelling master at Chelsea Polytechnic from 1898. Specialised in architectural decoration; worked with father on reliefs for facade of Battersea Town Hall (for E.W. Mountford, 1892) and for Mountford again at Northampton Institute, Clerkenwell (1897). Other notable decorative sculptures are groups and panels for Cardiff City Hall and Law Courts (including *River Severn* at springing of dome), parapet reliefs for bridge over King Charles Street, Whitehall, monumental figures and busts for facade of Royal College of Technology, South Kensington, and four groups of bronze figures for Kelvin Way Bridge, Kelvingrove Park, Glasgow (won in competition assessed by Frampton, 1914). Executed war memorial at Croydon and several in Melbourne, Australia, where he lived from 1922.

Geoffrey Giddings, 'Paul Raphael Montford', *Architects' Journal* 1922, vol. 56, pp. 789–92.

MOORE Esther Mary exhibited 1890–1911

Lived at Bedford Park, Chiswick. Worked as silversmith's designer until, aged about thirty-one, she won National Scholarship to NATS and studied modelling under Lanteri. Awarded silver medal in National Art Competition 1893. Showed numerous examples of her designs for metalwork at Arts and Crafts Exhibition Society 1896, including design for a cabinet in collaboration with the architect C. Harrison Townsend. Worked for Della Robbia Pottery, Birkenhead; produced much decorative sculpture in the form of light fittings and other household objects. Bronze statuettes include *The Charmed Circle of Youth* (version in John Lewis Collection) and exhibit a fluid, almost abstract treatment of form owing much to Gilbert.

Frederick Miller, 'Women Workers in the Art Crafts', *Art Journal* 1896, pp. 116–18 (cursory mention).

MULLINS Edwin Roscoe 1848–1907

Born in London. Studied at Lambeth School of Art; entered RA Schools 1867, sponsored by John Birnie Philip for whom he worked as assistant. Went to Munich and became pupil of Wagmüller, sharing studio with Onslow Ford. Returned to London *c.*1874. Frequent exhibitor at Grosvenor and New Galleries. Executed busts and ideal figures and groups in a somewhat archaic classical style showing little influence of symbolist ideas, as for example, '*Bless me, even me also, O my father*' and '*My punishment is greater than I can bear*' (RA 1884 and 1899; marble versions of both groups at Glasgow).

Much concerned with architectural sculpture, among which chief surviving examples are pediment figures for Harris Museum and Art Gallery, Preston (1886 for James Hibbert), and five decorative relief panels in stone for Braithwaite Hall, Croydon Municipal Buildings (1896 for Charles Henman). Executed circus-horse memorial to circus-owner Mr Ginnett in Brighton cemetery (1893), and other memorials. Appointed instructor in modelling as applied to architecture at Central School of Arts and Crafts 1897.

AWG 1884.

Walter Armstrong, 'E. Roscoe Mullins', *Portfolio* 1889, pp. 141–3.
DNB entry by S.E. Fryer.

PEGRAM Henry Alfred 1862–1937

Born in London. Attended West London School of Art, winning book prizes in National Art Competitions in 1881 and 1883. Entered RA Schools 1881, sponsored by Thomas Heatherley and took prizes there in 1882, 1884 and 1886. Worked as assistant to Hamo Thornycroft 1887–c.1891. Specialised in decorative and ideal work but never fulfilled early promise of *Ignis Fatuus* (RA 1889, small bronze relief, Chantrey/Tate; version at Cardiff) and *Sybilla Fatidica* (RA 1891, LS plaster group; marble version RA 1904, Chantrey/Tate), both of which show influence of Gilbert's symbolist sculpture. Work grew increasingly flamboyant in style and insensitive in execution, as shown, for example, in the deplorable bronze candelabra at St Paul's Cathedral (model exhibited at RA 1898). Architectural work includes reliefs at entrance to Imperial Institute, South Kensington (1891–2), and other decoration for Collcutt; frieze at 20 Buckingham Gate, Westminster (c.1895), and United University Club, Suffolk Street (c.1906), both for Reginald Blomfield; caryatid *Persians* at entrance to Drapers' Hall, Throgmorton Street, City (1898–9 for T.G. Jackson), and *Arts* and *Science* gable reliefs at St Paul's Girls' School, Brook Green, Hammersmith (c.1904 for Gerald Horsley).

AWG 1890; ARA 1904; RA 1922.

PIBWORTH Charles James 1878–1958

Born in Bristol. Studied at Bristol School of Art, winning book prize in National Art Competition 1894. Entered RA Schools 1899, winning prizes in 1899, 1900 and 1902. Chiefly notable as architectural sculptor in stone, working frequently for Charles Holden during first decade of twentieth century (relief panels for Bristol Library; figures in window recesses at Law Society extension building, Chancery Lane; relief of *Euterpe* for facade of Orchestral Association, Archer Street, Westminster).

AWG 1910.

POMEROY Frederick William 1856–1924

Born in London. Apprenticed to firm of architectural carvers (possibly Farmer & Brindley) and spent four years at SLTAS, taught by Dalou in 1880 and by W.S. Frith. Admitted to RA Schools December 1880 and won gold medal and travelling studentship 1885. Studied under Mercié in Paris and travelled in Italy. On returning to London carved *Athlete wrestling with a Python* group in marble for Frederic Leighton (now in Glyptothek, Copenhagen) and commmenced wide-ranging activity as independent sculptor in forefront of new movement. Collaborated 1887 with W.S. Frith and Doulton artists on Victoria Fountain (now on Glasgow Green), modelling monumental group *Australia*. Began to exhibit with Arts and Crafts Society in 1888. Notable early works include the bronze statuettes *So on a Delphic Reed* (RA 1888; version in private collection, Brighton), *Dionysus* (RA 1890, Tate Gallery and Cardiff) and *Love the Conqueror* (RA 1893, WAG Liverpool) and much decorative modelling and carving for architects including E.W. Mountford (at Paisley Town Hall 1890 and Sheffield Town Hall 1895), J.D. Sedding (at Holy Trinity, Sloane Street, Chelsea, 1890) and Henry Wilson (mantelpiece for Kensington Public Library, no longer extant; sculpture for west front of St Clement's Church, Boscombe, Hants; font, baptistery gates, lectern, alabaster mantelpiece, etc., for chapel and library, Welbeck Abbey; frieze, etc., for chapel at Douglas Castle, Lanarkshire). Later worked again for Mountford at Museum and Technical College, Liverpool, Booth's Distillery (Britten Street, City), Lancaster Town Hall, Central Criminal Court, Old Bailey, City. Executed four colossal bronze figures for Vauxhall Bridge (1905). Later ideal sculptures show increasing dependence on French precedents, and a gradual loss of gentle, contemplative mood of his early bronzes. They include *The Nymph of Loch Awe* (RA 1897, marble statuette, Chantrey/Tate), *Snake Charmer* (RA 1899, bronze statuette, Glasgow) and *Perseus* (RA 1898, LS bronze at Cardiff; numerous reductions of widely varying quality in private and public collections including V & A, Laing Art Gallery, Newcastle-upon-Tyne, Ashmolean and Stirling Maxwell Collection, Pollok House, Glasgow). Executed numerous monuments and portrait statues including Robert Burns for Paisley (1894), Dean Hook for Leeds City Square (1900), W.E. Gladstone, Central Lobby, Houses of Parliament (1900), Mons. Nugent, St George's Square, Liverpool, Lord Dufferin and Ava, Belfast and Boer War Memorial, Guildhall, London.

AWG 1887 (Master 1908); ARA 1906; RA 1917.

A.L. Baldry, 'The Work of F.W. Pomeroy', *Studio* November 1898, vol. 15, pp. 77–85.

POOLE Henry 1873–1928

Born in London, son of an architectural carver. Attended SLTAS under W.S. Frith 1888–91; admitted to RA Schools 1892. Worked for Harry

Bates and for G.F. Watts at Compton, Surrey. Notable chiefly as architectural sculptor with fluent but increasingly mannered style. Carved caryatids for Rotherhithe Town Hall (1897, demolished; caryatids survive on Heygate Estate, New Kent Road). Won competition for a group for Cardiff City Hall 1900 and thus began long friendship and working association with the architect A.E. Rickards and his partner H.V. Lanchester. Work for Rickards includes *Giraldus Cambrensis* and other figures for Cardiff City Hall, spandrel reliefs for Methodist Central Hall, Westminster, caryatids, etc., at Deptford Town Hall (showing influence of Harry Bates's similar figures at Institute of Chartered Accountants, City) and china figure *Painting* for facade of 144–146 New Bond Street. In collaboration with Rickards entered and won competition for London County Council staff war memorial (1916). Executed monumental stone figures for Henry Hare's Ingram House, Strand (1907, demolished; some fragments of his sculptures survive) and bronze low reliefs, etc., for Black Friar Public House, Queen Victoria Street (1906, for H. Fuller Clark).

AWG 1906; ARA 1920; RA 1927.

H.V. Lanchester, 'Henry Poole, RA 1873–1928', *Journal of the Royal Institute of British Architects* 1928, vol. 36, pp. 18–23.

REYNOLDS-STEPHENS 1862–1943
William Ernest

Born in Detroit of English parents; left America in early childhood. Began training as engineer. Attended RA Schools 1884–7, sponsored by J. (*sic*) Heatherley (? T.J. Heatherley, in whose School of Art he may therefore have begun his studies). Identified rapidly with ideals of Arts and Crafts movement, exhibiting with Arts and Crafts Exhibition Society and experimenting with polychromatic sculpture and electro-deposit process, working with architects and designing furniture and other objects of everyday use. Much influenced by Gilbert and Frampton in his choice of imagery as well as in technique, style and use of materials. Notable surviving architectural decoration includes bronze lunette over entrance to National Westminster Bank, Croydon (1889), and fittings for Church of St Mary, Great Warley, Essex (c.1903 for C. Harrison Townsend). Executed bronze bas-reliefs for Alma-Tadema's St John's Wood studio (1889), *Sleeping Beauty* overmantel for chimneypiece designed by Norman Shaw (c.1897) and many schemes for interior decoration now lost. Copper and bronze bas-relief on a stand, called *Youth* or *Happy in Beauty* . . . (RA 1896) awarded gold medal at Vienna in 1900 (version at Preston). Exhibited silver bon-bon dish at RA 1897 (bronze version in private collection, Brighton). Ideal work, frequently in form of statuettes, included *Sir Lancelot and the Nestling* and *Guinevere and the Nestling* in mixed materials (present whereabouts unknown), *Guinevere's Redeeming* (RA 1907, bronze

and ivory versions at Nottingham Castle Museum and Warrington Museum and Art Gallery; bronze variant at Preston) and *Castles in the Air* (RA 1901, Port Sunlight). Symbolism often sugary or nationalistic after 1900, as in *Love's Coronet* (RA 1902, coloured plaster group at Nottingham Castle Museum) and *A Royal Game* (RA 1906, Chantrey/ Tate 1911). Memorials include Archbishop Davidson, Lambeth Palace, and *The Scout in War*, bronze equestrian figure for East London, South Africa (1908). Dedicated campaigner for state patronage and better copyright and exhibition conditions for sculptors; awarded RBS gold medal for services to sculpture 1928.

AWG 1888; founder member RBS; knighted 1931.

M.H. Spielmann, 'Our Rising Artists: Mr W. Reynolds-Stephens', *Magazine of Art* 1897, pp. 71–5 (see series at V & A library, vol. 19; some bound series do not include this article).

A.L. Baldry, 'The Work of W. Reynolds-Stephens', *Studio* July 1899, vol. 17, pp. 75–85; 'A Worker in Metals', *Art Journal* 1901, pp. 9–11; 'A Notable Decorative Achievement by W. Reynolds-Stephens', *Studio* February 1905, vol. 34, pp. 3–15; 'Recent Decorative Work by Mr W. Reynolds-Stephens', *Studio* January 1911, vol. 51, pp. 260–74.

W.K. West, 'Recent Works by Mr W. Reynolds-Stephens', *Studio* January 1904, vol. 30, pp. 292–302.

Graham Seton Hutchinson, *The Sculptor Sir William Reynolds-Stephens, PRBS, 1862–1943: A Bibliographical Note*, Nottingham 1944 (Nottingham Castle Art Gallery and Museum publication).

ROLLINS John Wenlock 1862–1940

Studied at SLTAS under W.S. Frith, winning prizes in National Art Competitions 1885 and 1886. RA Schools 1885–9. Notable chiefly as efficient but unadventurous architectural sculptor; executed marble chimneypiece for Lord Windsor at Hewell Grange (1890) and was assistant to T. Stirling Lee on panels for St George's Hall, Liverpool, in 1892. Responsible for various decorative works at Croydon Municipal Buildings for Charles Henman, including pediment over Library entrance, interior friezes, capitals and pilasters. Also for Henman, caryatid figures and other decorations in Doulton terracotta for Birmingham General Hospital (1896, no longer extant). Executed bronze fountain and plaque at Horniman Museum for C. Harrison Townsend, bronze relief sculpture for facade of 14–16 Cockspur Street, Westminster (1907), and was among those who contributed subsidiary figures for niches on the principal front of the V & A.

ROPE Ellen Mary 1855–1934

Born at Blaxhall, Suffolk. Studied at Slade School under Alphonse Legros c.1878–84. Began produc-

ing low reliefs in plaster with delicate linear quality much influenced by Legros and by early Florentine Renaissance decorative sculpture. Exhibited frequently with Arts and Crafts Exhibition Society. Obtained commission for four figure spandrels for vestibule of Women's Building, Chicago Exhibition (1893). Worked for Della Robbia Pottery, Birkenhead, from c.1896 and became architectural sculptor of some note though much of her work is now lost or remains unidentified. Executed large relief in coloured plaster for Council Chamber of Rotherhithe Town Hall (1897, destroyed). Known to have been employed by the architects Arnold Mitchell and Horace Field. Responsible for carved capitals at Cricklewood Church, decorative panels for St Joseph's Church, Aldershot, and memorials in Salisbury Cathedral, Merton Church, Norfolk, Earl of Strafford's Chapel, Wrotham, Blaxhall Church and Michaelhouse School Chapel near Durban, South Africa. Few examples of her ideal sculpture, habitually in the form of bas-relief and depicting children at play or in a biblical context, appear to have entered public collections; a bronze panel dated 1907, *Boys with Palms*, is in Ipswich Museum.

B. Kendall, 'Miss Ellen Rope Sculptor', *Artist* December 1899, pp. 206–12.
'A.F.', 'The Art Movement; The Work of Miss Ellen M. Rope', *Magazine of Art* 1900, pp. 323–6.
F.J. Maclean, 'The Art of E.M. Rope', *The Expert* 13 July 1907, pp. 251–2.
See also: Jeremy Cooper Ltd, *The Birkenhead Della Robbia Pottery, 1893 to 1906*, 1980 (exhibition catalogue by Victoria Cecil and Jonathan Baddeley).

SCHENCK exhibited 1886–1907
Frederick E.E.

Specialist in low relief. Appears to have trained at both Edinburgh and Hanley Schools of Art; became a National Scholar at NATS 1873–5 and then appointed art master at Hanley. Worked during 1880s for several potteries, including George Jones, Wedgwood and Brown-Westhead Moore, Moved from Basford, Stoke-on-Trent, to London c.1888 and from 1889 showed numerous plaster models for architectural relief decoration at Arts and Crafts Exhibition Society. Worked almost exclusively for architects, most notably A. Beresford Pite at 37 Harley Street (facade reliefs in stone, 1898) and H.T. Hare (Stafford County Buildings, 1896; Oxford Town Hall, 1897; Shoreditch Public Library and Baths, 1899; Islington Public Library, Hammersmith Public Library and Ingram House, Strand, 1904–8). Carved in stone and modelled in plaster or terracotta with equal facility in a nervous, elegant style with interesting tendencies, observed, it seems, by Epstein, towards abstract handling of form.

SIMONDS George Blackall 1844–1929

Members of the Reading family of brewers and thus with private means; trained in Dresden and in Brussels under Louis Jehotte, from whom he acquired expertise in lost-wax casting method. Spent early years as independent sculptor in Rome and settled in London 1877. Though, as first Master (then President) of the Art Workers Guild and as firm advocate of 'autograph' bronzes, he has a place in the history of the New Sculpture, he was essentially a late neo-classicist, working in a dry academic style that continued to reflect his European background. Known principally for public monuments, notably the Reading Lion (1884) and Queen Victoria Memorial in the same town (lost-wax sketch exhibited at New Gallery 1888). Responsible for memorial to Frederick Tollemache, Grantham (1890), recumbent effigy of J.C. Bruce, Newcastle Cathedral (1892), and memorial to Sir Joseph Bazalgette, Victoria Embankment (1899). Ideal sculpture (present whereabouts unknown) included *Perseus* (RA 1884, bronze) and *Goddess Gerd: The Northern Aurora*. Executed bronze bust of Walter Crane for Hall of Art Workers Guild (RA 1889, *in situ*).

AWG 1884 (President 1884–5).

STEELE Florence H. exhibited 1896–1918

Lived in Hammersmith. Between 1892 and 1896 while in her mid-thirties trained as a designer and modeller at NATS, winning National Scholarship and working under Lanteri. Gold medallist 1894. Worked principally in low relief in silver, bronze or plaster, producing jewellery, mirror-backs, caskets and other decorated household objects, and exhibiting with Arts and Crafts Exhibition Society from 1896. Employed as designer by Elkington and Pilkington. One of the many women artists patronised by Art Union of London: reproductions of her ivory-tinted plaster bas-relief *Dawn Dispelling Sleep and Night*, showing marked influence of Harry Bates, were offered to subscribers in 1910 (a version of this plaque appeared at Sotheby Belgravia in December 1975).

SWAN John Macallan 1847–1910

Born at Brentford, Middlesex. Attended Lambeth School of Art. Entered RA Schools (as a painter) 1872. Continued training in Paris at École des Beaux-Arts and studied sculpture under Frémiet. Concerned primarily with depiction, in painting and bronze sculpture, of wild animals, though his sympathy with mainstream of New Sculpture movement is evident in series of ideal statuettes produced after 1894 which include *Orpheus* (RA 1895, silver; large bronze version at Manchester), *St John the Baptist* (1899, silver, Perth Art Gallery) and *Fata Morgana* (RA 1900, lost-wax bronze). Examples of *animalier* bronzes at Tate Gallery, Manchester, Glasgow, Cartwright Hall Bradford, National Gallery of Scotland, private collections.

AWG 1887 (described as a painter); ARA 1894; RA 1905.

R.A.M. Stevenson, 'J.M. Swan', *Art Journal* 1894, pp. 17–22.
Cosmo Monkhouse, 'John Macallan Swan', *Magazine of Art* 1894, pp. 171–6.
A.L. Baldry, 'The Work of J.M. Swan, ARA' (part II), *Studio* April 1901, vol. 22, pp. 151–61.
DNB entry by Walter Armstrong.

THOMAS James Havard 1854–1921

Born in Bristol of Welsh parents. Studied at Bristol School of Art, then as National Scholar at NATS 1872–5. From 1881 attended École des Beaux-Arts in Paris, working under J.P. Cavelier. Returned to London 1884. Lived in Italy 1889 to 1906. Executed ideal works, portraits, public monuments including marble *Boadicea* for Cardiff City Hall, two over-LS statues of Samuel Morley, one for Bristol and one for Nottingham, and a bronze statue of W.E. Forster for Bradford. Taught at Slade School from 1911 and appointed first Professor of Sculpture there in 1915. Worked in a bland academic style and, absent from England at a crucial period, took little part in development of New Sculpture movement. Received wide acclaim as a classicist after the First World War. Numerous ideal works in bronze and marble (which he carved directly) at Tate Gallery, Cardiff, Manchester, Bristol City Museum and Art Gallery.

Frank Gibson, 'The Sculpture of Professor James Havard Thomas', *Studio* April 1919, vol. 76, pp. 79–85.

THORNYCROFT William Hamo 1850–1925

Born in London, son of sculptors Mary and Thomas Thornycroft. Entered RA Schools 1869 while training and assisting in parents' studio; visited Italy 1871; 1875 won gold medal for *Warrior bearing a Wounded Youth from Battle* (reproduction rights bought by Art Union of London for reduced version; full-sized bronze cast at Leighton House, Kensington). Influenced by sculpture of G.F. Watts and Frederic Leighton and later by early work of Alfred Gilbert, produced series of grave, classical-realist figures, working first in marble (*Lot's Wife*, RA 1878, now at Leighton House; *Artemis*, RA 1880, now in grounds of Eaton Hall, Cheshire, original plaster cast at Macclesfield Town Hall) and then in bronze (*Teucer*, RA 1881, Chantrey/Tate, reductions in various sizes, at Preston and in numerous private collections; *Mower*, RA 1884, full-sized bronze at WAG Liverpool, reductions at Cardiff, Preston, Ashmolean, private collections; *Sower*, Kew Gardens). Much concerned during 1880s and early 1890s with issues central to New Sculpture and Arts and Crafts movement: collaboration in architecture (stone frieze for Institute of Chartered Accountants, City, for John Belcher, *c*.1890), statuette production, the revival of art-bronze

casting and the place of sculpture in society. Took active part in Arts and Crafts Exhibition Society. Increasingly preoccupied during later 1890s and after with commissions for public monuments and portrait busts. Principal monuments (all in bronze) are Gordon Memorial (1887, now Victoria Embankment; reductions by Arthur Collie), John Bright (1891, Rochdale; reductions by Arthur Collie), Oliver Cromwell (1899, Old Palace Yard, Westminster), John Colet for St Paul's School, Hammersmith (now resited in modern school's playing fields at Barnes), King Alfred for Winchester (1901), Gladstone Memorial, Strand (1905), and Curzon Memorial, Calcutta (1910). Awarded Grand Prix at Paris International Exhibition 1900 for plaster model of Oliver Cromwell Memorial and two ideal works in bronze, *Joy of Life* (RA 1895; reduced versions in private collections) and *Bather* (original statuette, RA 1898; versions at Sydney and in private collections). Towards 1910 ideal work, usually in marble, grew bland and trivialised, as in *The Kiss* (RA 1916, Chantrey/Tate). Numerous sketches in wax, plaster and plasticine, for major works, are at Reading Museum and Art Gallery.

AWG 1883; ARA 1881; RA 1888; knighted 1917.

Edmund Gosse, 'Our Living Artists: Hamo Thornycroft, ARA', *Magazine of Art* 1881, pp. 328–32.
Walter Armstrong, 'Hamo Thornycroft', *Portfolio* 1888, pp. 111–15.
DNB entry by Tancred Borenius.
See also main bibliography: Elfrida Manning 1982.

TOFT Albert 1862–1949

Born in Birmingham. Apprenticed as a modeller to Elkington & Co. and subsequently to Wedgwood. Attended art schools at Hanley and Newcastle-under-Lyme. National Scholar at NATS 1881–3, learning modelling under Lanteri. Set up studio in London as a portrait sculptor (terracotta bust of George Wallis, 1889, at V & A). Important ideal work includes LS *Fate-Led* (RA 1890, marble, WAG Liverpool) and *The Spirit of Contemplation* (RA 1901, bronze, Laing Art Gallery, Newcastle-upon-Tyne), both with soft, nervous modelling in the Dalou–Lanteri tradition and with rhythmic line and symbolist overtones showing marked influence of Alfred Gilbert. Produced numerous original bronze statuettes, including *Mother and Child* (1899, Preston and private collections) and the realist *Metal Pourer* (1913, Cardiff, Sydney, private collections). Work as decorative sculptor included a pulpit for Congregational Church, Palatine Road, Manchester, *c*.1908. Several monuments incorporate decorative-ideal sculpture of much interest, as, for example, Queen Victoria for Nottingham (1905), Edward VII for Highgate Park, Birmingham, South African War Memorial, Cannon Hill Park, Birmingham, and the Welsh National Memorial, Cathays Park, Cardiff (1909).

Participated in general decline towards bathos after 1910, as in LS marble *Bather* (1915, Chantrey/Tate; small version in marble at Glasgow).

AWG 1891.

John Hamer, 'Our Rising Artists: Mr Albert Toft', *Magazine of Art* 1901, pp. 392–7.
Arthur Reddie, 'Albert Toft', *Studio* October 1915, vol. 66, pp. 18–28.

TURNER Alfred 1874–1940

Born in London. Attended SLTAS under W.S. Frith; worked for a time as assistant to Harry Bates; entered RA Schools 1895, winning gold medal and travelling studentship 1897. Went to Paris. Carved two over-LS marble figures for staircase of Fishmongers' Hall, London Bridge (1898, now on river terrace). Executed stone frieze above main entrance to Central Criminal Court, Old Bailey, and *Owen Glyndŵr* for Cardiff City Hall. Most notable monument is that to Queen Victoria at Tynemouth (1902), showing influence of Alfred Gilbert's Jubilee statue at Winchester. Also executed Victoria memorials at Sheffield and Delhi. Late work includes war memorial in Vicarage Garden, All Saints' Church, Fulham (1920), and LS marble *Psyche* (1922, Chantrey/Tate).

ARA 1922; RA 1931.

WALKER Arthur George 1861–1939

Born in Hackney. Attended RA Schools 1883–8. A competent but minor artist only marginally relevant to New Sculpture movement. Executed some decorative sculpture, including evangelist emblems in bronze and stone for Church of the Ark of the Covenant, Stamford Hill, *c*.1895, various works for the architect Harold Cooper and two niche figures for front of V & A. Ideal work exemplified by *The Thorn*, a mildly erotic female nude first exhibited RA 1896 and in 1903 as a bronze statuette (version at Glyptothek Museum, Copenhagen). Monuments include Boer War Memorials at St Anne's Limehouse, Bury St Edmunds, and Hawarden Church, Cheshire, and statue of Florence Nightingale, Waterloo Place (1915). Executed bust of his friend T. Stirling Lee for Hall of AWG.

AWG 1892; ARA 1925; RA 1936.

WELLS Reginald Fairfax 1871–1951

Born in London. Among last immediate followers of New Sculptors to train under Lanteri at South Kensington. Between 1900 and 1910 produced numerous small terracottas and bronzes in Millet-like realist style with soft, fluid modelling. Established Coldrum Pottery near Wrotham, Kent, *c*.1904 and another at Chelsea in 1910. One-man show of statuettes held at Carfax Gallery 1908. Many examples of small bronzes in private collections; three at Birmingham; *Putting the Weight* at Cartwright Hall, Bradford; *Sower* at V & A.

Anonymous (probably Walter Shaw Sparrow), 'A Young Sculptor: Mr Reginald F. Wells and his Rustic Art', *Studio* February 1903, vol. 28, pp. 17–22.

WILLIAMS (Lucy) Gwendolen 1870–1955

Born at New Ferry, Cheshire, of Welsh parents. Attended Wimbledon School of Art 1892–3; taught there by Alfred Drury and advised by him to take up sculpture. Studied under Lanteri at NATS. Travelled in France and Holland. Specialised in bronze statuettes of lyrical female figures and in ideal busts, many of which show marked influence of Drury. Moved to Rome *c*.1910. Works at National Library of Wales, Aberystwyth, Cardiff, WAG Liverpool and private collections.

WOOD Francis Derwent 1871–1926

Born at Keswick. Studied art at Karlsruhe and returned to England 1889, working as modeller for Maw & Co. and for Coalbrookdale Iron Co. Attended NATS as National Scholar, working under Lanteri; *c*.1890–2 assisted Alphonse Legros at Slade School. Entered RA Schools 1894, sponsored by Lanteri. Worked as assistant to Thomas Brock. Won gold medal and travelling studentship 1895 with *Daedalus and Icarus*, much influenced by Gilbert (bronze at Bristol City Art Gallery, plaster at Russell-Cotes Art Gallery, Bournemouth) and went to Paris. Appointed modelling master at Glasgow School of Art *c*.1897; won competition (assessed by Frampton) for decorative sculpture at Glasgow Art Gallery 1899, and executed other architectural sculpture in the town, notably at Mercantile Chambers, Bothwell Street, and Caledonian Chambers, Union Street. Settled in London 1901. Produced numerous lively portrait busts (Charles Harrison Townsend, 1904, Hall of AWG; other subjects at Tate Gallery, Fitzwilliam Museum and Sydney) but ideal and memorial sculpture became increasingly eclectic and variable in quality. Contributed putto emblematic of Australia for gate post of Brock's Queen Victoria Memorial, The Mall; executed Machine Gun Corps Memorial, Hyde Park Corner (unveiled 1925, his best-known post-war work); statues of General Wolfe at Westerham, Lord Ripon at Ripon and several monuments in India. Widely represented in public collections including Tate Gallery, Birmingham, Manchester, Sydney and National Gallery of Victoria, Melbourne, Australia. Professor of Sculpture at Royal College of Art, 1918–23.

AWG 1901; ARA 1910; RA 1920; founder member RBS.

W.K. West, 'The Work of F. Derwent Wood', *Studio* January 1905, vol. 33, pp. 297–306.
DNB entry by Tancred Borenius.

Place of publication is London unless otherwise indicated.

NOTES TO CHAPTER 1

1. First published 1951.
2. 'Living English Sculptors', *Century Magazine* 1883, vol. 26, pp. 162–85.
3. For a summary of Stevens's life and work and a full bibliography, see Susan Beattie, *Catalogue of the Drawings Collection of the Royal Institute of British Architects: Alfred Stevens*, Farnborough 1975.
4. 'The New Sculpture', *Art Journal* 1894, p. 140.
5. Ibid., pp. 138–42, 199–203, 277–82, 306–11.

NOTES TO CHAPTER 2

1. See Quentin Bell, *Schools of Design*, 1963.
2. *Art Journal*, 1849, pp. 270–1.
3. James Cond, 'Municipal Schools of Art', *Art Student* [Birmingham] 1885, no. 1, p. 101.
4. *Report from the Select Committee on Schools of Art*, 1864, vol. 12, p. 224.
5. *Second Report from the Royal Commission on Technical Instruction*, 1884, vol. 3, p. 199 (evidence of Alphonse Legros).
6. From *Foreign Reports, 1864: Extracts . . .* (miscellaneous papers published by the Science and Art Department, South Kensington Museum and National Art Training Schools; Victoria and Albert Museum Library).
7. *Second Report from the Royal Commission on Technical Instruction*, 1884, vol. 3, pp. 96–111 (evidence of John Sparkes).
8. *Works sent from the various schools of ornamental art and exhibited at Marlborough House . . .*, 1852, preface (Department of Practical Art; Victoria and Albert Museum Library).
9. Op. cit. n.5.
10. 'Some Recollections of the National Art Training School and the Old Museum', *RCA Students Magazine* March 1912, vol. 1, pp. 61–3.
11. 'Recollections of the Old School', *RCA Students Magazine* June 1912, vol. 1, pp. 155–61.
12. F.W. Moody, *Lectures and Lessons on Art*, 1873, p. 47.
13. Op. cit. n. 11.
14. E.J. Poynter, *Ten Lectures on Art*, 1880 (2nd edition), p. 45.
15. As quoted by Michael Reynolds in 'The Slade: The Story of an Art School, 1871–1971', unpublished typescript deposited in University College Library London, 1974.

16. *Precis of the Board Minutes of Science and Art Department, 23 December 1869–31 December 1877*, 1880 (Library of the Department of Education and Science).
17. Op. cit. n. 5.
18. Maurice Dreyfous, *Dalou, sa vie et son oeuvre*, Paris 1903, pp. 69–70.
19. Op. cit. n. 16.
20. Reynolds, op. cit. n. 15.
21. *Magazine of Art* 1902, p. 377. See also *RCA Students Magazine* December 1911, vol. 1, pp. 9–12.
22. Op. cit. n. 16.
23. *Robert Gregory, 1879–1911: Being the Autobiography of Robert Gregory D.D., Dean of St Paul's*, 1912, p. 56 et seq.
24. Parish records of St Peter, Vauxhall: volume of minutes, notes and cuttings relating to the School of Art, 1859–1873.
25. Ibid.
26. Gregory, op. cit. n. 23.
27. Op. cit. n. 7.
28. *Second Report from the Royal Commission on Technical Instruction*, 1884, vol. 1, part 4, p. 520.
29. Op. cit. n. 24.
30. Gold medal to Mullins in 1868 for a model from the antique; bronze medal to Tinworth in 1869 for terracotta medallions; bronze medals in 1872 and 1873 to Frith for models of the figure from life; silver medal in 1875 and bronze medal in 1876 to Rogers for figures modelled from life, and a bronze in 1877 for a design in plaster for a decorative panel; bronze medals to Montalba in 1872 and 1875 and silver medals in 1874 and 1876, all for models of the figure from life. Schenck's award of a bronze was for a figure modelled from the antique. In 1873 he came to South Kensington for a two-year National Scholarship and in 1875 won a book prize for designs for cups and tankards. Three volumes of National Art Competition results between 1857 and 1895, extracted from the Reports of the Science and Art Department, are in the library of the Department of Education and Science. After 1895 only gold medal awards are recorded in the Reports.
31. The reports of the examiners on the National Art Competitions between 1874 and 1895 are collected in a single volume in the library of the Department of Education and Science.
32. 24th and 25th Reports of the Science and Art Department, pp. 476–88; pp. 414–26.
33. *Studio* February 1906, vol. 37, pp. 3–4.
34. The dates and general details of Drury's life given in the *Dictionary of National Biography* are substantiated by his son, Paul Drury, to whom I am indebted for much help.
35. Twelve of these scholarships had been established in

1863 'to enable advanced students, who have given evidence of special aptitude for design, to prosecute their studies in the Training School and Museum at South Kensington . . . When elected they receive free instruction and allowances for maintenance varying from 20s. to 40s. a week according to their merit, and they generally remain at South Kensington two years; the appointment may be renewed for a third year in cases of great proficiency.' J.C.L. Sparkes, *Schools of Art: Their Origin, History, Work and Influence*, 1884, p. 109 (handbook printed and published for the executive Council of the International Health Exhibition and for the Council of the Society of Arts).

36. *RCA Students Magazine* January 1912, vol. 1, pp. 37–8.

37. *A Short History of the City and Guilds of London Institute . . .*, 1896.

38. Op. cit. n. 7.

39. *Second Report from the Royal Commission on Technical Instruction*, 1884, vol. 3, p. 74 (evidence of Godfrey Wedgwood).

40. *Report of the Committee of Inquiry on the National Art Training School*, 1889 (found among various printed papers relating to the National Art Training School at the Public Record Office, Ed.24/56A).

41. Op. cit. n. 7.

42. City and Guilds of London Institute, *Minutes*, 5 August 1881.

43. Public Record Office, Ed.23/58: Treasury acknowledgment, dated 7 September 1881, of letter announcing the resignation of Mr Poynter

44. Op. cit. n. 40.

45. Public Record Office, Ed.24/56A: *Report by John Sparkes . . . December 1881.*

46. L.M. Lamont, *Thomas Armstrong C.B.: A Memoir*, 1914, p. 65.

47. Four students received silver medals – Drury, A.M. Singer, R.A. Ledward and Alfred Bowcher – and a bronze went to Conrad Dressler for a bust modelled from the antique. In 1883 Boehm was joined on the examining board by a second sculptor, William Hamo Thornycroft. Until 1889 when Boehm received his baronetcy, they shared with Henry Armstead the duty of judging sculpture in the Competitions. The increasing importance placed on clay modelling in art education was reflected by the gradual accumulation of sculptor Royal Academicians or Associates on the examining board, while the number of examiners for other sections remained stationary. By 1895 there were five: Armstead, Thomas Brock, Onslow Ford, George Frampton and Thornycroft.

48. Before Toft left South Kensington to take up his first appointment as a modeller with Wedgwood, he established a friendship with Domenico Tonelli, a gold, silver and bronze medal winner in 1884 and 1886, who later became his modelling assistant and worked for many other sculptors in a similar capacity without ever fulfilling the promise of his student years.

49. Medal awards to the group were as follows: Florence Steele – bronze 1892 and 1893, gold and bronze 1894, silver and bronze 1895; Margaret Giles – gold and bronze 1892, gold and silver 1893, bronze 1894; Ruby Levick – bronze 1893, gold 1897; Esther Moore – silver 1893; Gwendolen Williams – silver 1894.

50. A copy of the report, apparently the only one to have survived, is at the City and Guilds Art School which still occupies 124 Kennington Park Road. The main body of printed reports and minutes is preserved at the Institute's headquarters in Portland Place, Westminster.

51. *Second Report of the Royal Commissioners on Technical Instruction*, 1884, vol. 1, part 3, p. 409.

52. Op. cit. n. 16.

53. City and Guilds of London Institute, *Minutes*: Report of the Superintendent of the South London Technical Art School, 1898.

54. *Portfolio* 1888, p. 171

55. City and Guilds of London Institute, *Minutes*: Report of the Superintendent . . ., July 1895.

56. An appendix to the *Minutes* for 1888 lists names, occupations and other details of students in the modelling school between 1881 and 1888. However, several obvious omissions and inaccuracies cast doubt on the reliability of all this evidence.

57. Op. cit. n. 7.

58. *Portfolio* 1888, p. 170.

59. Victoria and Albert Museum Library, MS collection 86 PP 2: letters to A.L. Baldry.

60. Op. cit. n. 56.

61. *Studio* January 1896, vol. 6, p. 205.

62. Evidence of Allen's daughter, Mrs Margaret Gibbs, to whom I am indebted for much help. See also *Magazine of Art* 1901, pp. 15–19.

63. City and Guilds of London Institute, *Minutes*: Report of the Council, 13 March 1882.

64. Ibid.: Report of the Principal . . ., 26 July 1883.

65. Medals for modelling work were awarded in 1880 to Frith (silver) and Pomeroy (bronze); in 1881 to Mark Rogers (silver), Harry Bates (bronze) and Pomeroy (bronze); in 1882 to Mark Rogers (gold), Frampton (silver and bronze) and Pomeroy (bronze); in 1883 to Frampton and Charles Allen (bronze); in 1884 to Goscombe John (bronze); in 1885 to Allen (bronze); in 1886 to Allen and John Wenlock Rollins (silver); and in 1887 and 1888 to William Sadler (silver).

66. City and Guilds of London Institute, *Minutes*: Report of the Superintendent . . ., 16 July 1886. A two-monthly internal competition had been organised and was assessed by William Brindley, a 'Mr Webb', the architect J.P. Seddon, the sculptor Thomas Nelson MacLean, Hugh Stannus and Sparkes himself. In 1890 the visiting panel included Harry Bates, Thomas Stirling Lee, Frampton, Lanteri, the bronze caster F. Bulwer and Horace Montford of the Royal Academy Schools.

67. Ibid.: letter from W.S. Frith to J.C.L. Sparkes, 14 April 1890.

68. Ibid.: Report of the Superintendent . . ., July 1890.

69. Op. cit. n. 53.

70. Royal Academy of Arts, *Council Minutes*, 24 January 1851. An unpublished thesis by H. Cliff Morgan, 'A History of the Royal Academy Schools, 1837–1878' (University of Leeds, 1968), is a most useful source of information.

71. *Report of the Commissioners appointed to inquire into the Present Position of the Royal Academy in relation to the Fine Arts, together with the minutes of evidence*, 1863 (evidence of Morton Edwards, 4 May).

72. Ibid. (evidence of A.J. Beresford Hope, 8 May).

73. Ibid., p. xiii.

74. *Reports from Commissioners*, 1864, vol. 19, part 1, 'Observations of the Members of the Royal Academy of Arts upon the Reports . . .', p. 285.

75. *Lectures on Art*, 1880, p. 119.

76. Ibid., p. 134.

77. Mrs Russell Barrington, *The Life, Letters and Work of Frederic Baron Leighton of Stretton*, 1906, vol. 1, p. 69.

78. Ibid., pp. 5–6.

79. *Art Journal* 1884, p. 131.

80. Edmund Gosse, 'The New Sculpture', *Art Journal* 1894, p. 140.

81. Details of awards and other documentation are taken, except where otherwise stated, from the printed Annual Reports of the Council of the Royal Academy in the Royal Academy Library.
82. *Art Journal* 1894, p. 141.
83. Isabel McAllister, *Alfred Gilbert*, 1929, p. 149.
84. Ibid., p. 28.
85. Barrington, op. cit. n. 77, p. 7.
86. *Art Journal* 1891, p. 63 (obituary notice).
87. *Magazine of Art* 1880, p. 335.
88. Op. cit. n. 59.
89. Op. cit. n. 54.
90. The West London School in Great Titchfield Street, which specialised in the teaching of design and applied art, was founded in the 1860s by a committee whose chairman was Peter Graham of the furnishing firm, Jackson & Graham. It survived with increasing financial difficulty until 1889 when it was absorbed by the Polytechnic School of Art (later the Regent Street Polytechnic, now the Polytechnic of Central London).

NOTES TO CHAPTER 3

1. *Art Journal* 1856, p. 304.
2. Library of the Royal Institute of British Architects, Stannus Papers: letter dated 2 October 1890.
3. *Fraser's Magazine for Town and Country* 1861, vol. 63, pp. 493–505.
4. *British Architect* 1874, vol. 1, p. 241.
5. 'English Sculpture in 1880', *Cornhill Magazine* 1880, pp. 184–5.
6. *Magazine of Art* 1881, p. 282.
7. 'On Some of the "Sights" of London', *Magazine of Art* 1880, pp. 7–8, 133.
8. Corporation of London Record Office, Bridge House Estates Committee minutes, vol. 9, 8 October 1880.
9. Ibid., 8 July 1881.
10. Ibid., 9 September 1881.
11. Ibid., Journal of the Court of Common Council (no. 160), 15 December 1881.
12. Ibid., Bridge House Estates Committee minutes, vol. 9, Special Committee, 28 July 1882.
13. Ibid., vol. 10, Special Committee, 14 March 1884.
14. Ibid., 9 April 1884.
15. Ibid., *Statuary, Blackfriars Bridge*: printed report of the Bridge House Estates Committee, presented 15 July 1886.
16. Ibid., Bridge House Estates Committee minutes, vol. 11, 10 December 1886.
17. *Builder* 1881, vol. 41, p. 499.
18. *British Architect* 1886, vol. 26, p. 121.
19. *Builder* 1882, vol. 43, p. 97.
20. See Chapter 2, note 67.
21. *Royal Institute of British Architects: Transactions* 1892, vol. 8, p. 55.
22. *British Architect* 1888, vol. 30, pp. 429–30.
23. *Builder* 1889, vol. 57, p. 5.
24. *Builder* 1890, vol. 58, p. 179.
25. Ibid., p. 109.
26. Ibid., p. 200.
27. *British Architect* 1886, vol. 25, p. 107.
28. Peter Stansky, 'Art, Industry and the Aspirations of William Martin Conway', *Victorian Studies* 1976, vol. 19, no. 4, p. 465.
29. Ibid., pp. 471–2.
30. *Journal of the Royal Institute of British Architects* 1900, vol. 7, Congress Supplement, p. 21.
31. *British Architect* 1885, vol. 24, p. 210, illustrated.
32. *Journal of the Society of Arts* 1888, vol. 36, pp. 911–12.
33. *Builder* 1887, vol. 52, p. 116.
34. *Builder* 1888, vol. 54, p. 45.
35. *National Association for the Advancement of Art and its Application to Industry: Transactions* 1891, p. 53.
36. Ibid., p. 217.
37. *British Architect* 1888, vol. 29, p. 243.
38. *English Architecture since the Regency*, 1953, chapter 6.
39. *British Architect* 1887, vol. 28, p. 130.
40. *Portfolio* 1888, p. 170.
41. An article on Bates by E. Winter Johnson, published in the *Artist* December 1897, pp. 579–87, refers briefly to two bronze plaques, *Spring* and *Harvest*, that were 'placed on either side of the walls flanking Mr Hill's shop in the neighbourhood of Albert Gate'. Post Office Directories reveal the precise location of the shop, 29 Kensington High Street, now much altered. In 1973 the two plaques, unidentified, were sold at Sotheby Belgravia. Bronze casts of their close counterparts, *Peace* and *War*, are in Manchester City Art Gallery.
42. See, for example, *Magazine of Art* 1888, June 'Chronicle', p. xxxvi.
43. *British Architect* 1887, vol. 28, p. 76.
44. *National Association for the Advancement of Art and its Application to Industry: Transactions* 1890, p. 378.
45. *British Architect* 1888, vol. 30, p. 399.
46. *National Association for the Advancement of Art and its Application to Industry: Transactions* 1888, p. 100.
47. Ibid., pp. 133–7.
48. Ibid., pp. 375–80.
49. Ibid., p. 356.
50. City and Guilds of London Institute, *Minutes*: Report of the Superintendent . . ., 1894.
51. *Royal Institute of British Architects: Transactions* 1892, vol. 8, p. 55.
52. Greater London Record Office, LCC Technical Education Board Annual Report, 1896–7, p. 15, and Pocket Book, 1899–1900, which gives Mullins's date of appointment as November 1896.
53. *Catalogue of the First Exhibition*, 1888, pp. 60–4.
54. Reading Museum and Art Gallery, Tweed archive: Box 6, letter dated 6 July 1888.
55. National Westminster Bank archive, premises files. I am indebted to the archivist Mr Lovelock for providing me with this information.
56. The figure closely resembles the seated figure of a girl in low relief that decorates the copper photograph frame sold at Sotheby Belgravia on 19 April 1978 ('Decorative Arts, 1870–1940', p. 10, lot 39, illustrated), itself probably identical with that exhibited by the sculptor at the Arts and Crafts Society exhibition in 1889.
57. *Studio* July 1899, vol. 17, p. 75.
58. *Artist* 1900, vol. 28, pp. 169–76.
59. *Builder* 1891, vol. 60, p. 509.
60. Victoria and Albert Museum Library, MS Collection 86 PP 2: letters to A.L. Baldry.
61. Royal College of Art, Henry Wilson archive: vol. D.
62. Reported at length in the *Builder* 1891, vol. 60, pp. 86–7.
63. *British Architect* 1890, vol. 33, p. 468.
64. Op. cit. n. 62.
65. '"Couleur" in Sculpture', *Universal Review* 15 August 1888, p. 526.
66. As, for example, in the *British Architect* 1893, vol. 40, p. 346.
67. *British Architect* 1889, vol. 31, illustration following p. 6, pp. 25–6. *Builder* 1889, vol. 56, competition plans, elevations and sections following p. 30.

68. The building is described in detail in the following publications: *The Institute of Chartered Accountants in England and Wales Moorgate Place E.C. John Belcher, architect*, [Batsford] 1893; John Squire, *The Hall of the Institute of Chartered Accountants in England and Wales*, 1937; John H. Stern, *A History of the Hall of the Institute of Chartered Accountants in England and Wales*, 1953; more recently the Hall has been analysed in the context of Belcher's complete *oeuvre* by Alastair Service in 'Belcher and Joass', in *Edwardian Architecture and its Origins*, 1975, pp. 310–27.

69. 'Some Recent Architectural Sculpture, and the Institute of Chartered Accountants: John Belcher, Architect', *Magazine of Art* 1895, p. 189.

70. H.J.L.J. Massé, *The Art Workers Guild, 1884–1934*, 1935.

71. Institute of Chartered Accountants, Building Sub-Committee minute book B, p. 4.

72. Ibid., p. 6.

73. *Royal Institute of British Architects: Transactions* 1892, vol. 8, pp. 49–50.

74. *Accountant* 21 February 1891, p. 148.

75. *Realism*, 1971, p. 133.

76. City and Guilds of London Institute, *Minutes: Report of the Superintendent . . .*, 1892. One of Thornycroft's plaster models for the frieze still survives at 2A Melbury Road.

77. *Magazine of Art* 1891, p. 404.

78. *Builder* 1895, vol. 69, p. 30.

79. Institute of Chartered Accountants, Building Sub-Committee minute book B, meeting held 24 June 1892. A small maquette for the figure of Justice is at Reading Art Gallery.

80. The firm is listed among the contractors in *Builder* 1892, vol. 63, p. 168.

81. Institute of Chartered Accountants, Building Sub-Committee minute book B, meeting held 14 August 1889.

82. Ibid., meeting held 11 July 1892.

83. *Accountant* 15 October 1892, p. 769.

84. Service, op. cit. n. 68, pp. 312–13.

85. *Palast-Architektur von ober-Italien und Toscana vom XV bis XVII Jahrhundert: Genua* (ed. Robert Reinhardt), Berlin 1886, plates 51–2.

86. Op. cit. n. 73.

Notes to Chapter 4

1. Isabel McAllister, *Alfred Gilbert*, 1929, p. 55.

2. *A.A. Notes* 1889, vol. 4, p. 24.

3. *On the Recent Reaction of Taste in English Architecture*, 1874, p. 8 (paper read at the Royal Institute of British Architects to the General Conference of Architects, 18 June 1874).

4. *Studio* October 1896, vol. 9, p. 50.

5. Mosaic decoration was one of Townsend's special interests. He compiled a scrapbook of notes and cuttings on the subject, now in the library of the Victoria and Albert Museum, in which Burne-Jones's Rome mosaics are briefly mentioned.

6. *Studio* January 1896, vol. 6, p. 211.

7. Illustrated in *Art Journal* 1897, p. 326 (no. 6)

8. *Studio* October 1899, vol. 18, p. 52.

9. *Studio* January 1910, vol. 48, p. 304.

10. See *Artist* 1900, vol. 27, p. 339, which identifies the railings as among several 'new' designs by A. Harold Smith for the Falkirk Iron Company.

11. *Art Journal* 1897, pp. 322–3.

12. *Studio* October 1897, vol. 12, p. 46.

13. *Magazine of Art* 1904, pp. 210–11, 263–4.

14. Illustrated, respectively, in *Academy Architecture* 1895[1], p. 11; *British Architect* 1895, vol. 44, plate following p. 24; ibid., plate following p. 95; *Magazine of Art* 1896, p. 40.

15. Illustrated, respectively, in *British Architect* 1896, vol. 45, plate following p. 238; ibid., plate following p. 382; *Academy Architecture* 1896[1], p. 29.

16. Illustrated in *British Architect* 1897, vol. 48, plate following p. 458.

17. *British Architect* 1899, vol. 51, plate following p. 147.

18. *British Sculpture and Sculptors of To-Day*, 1901, p. 135.

19. *Journal of the Royal Institute of British Architects* 1897, vol. 4, p. 168.

20. Ibid., p. 173.

21. *British Architect* 1899, vol. 51, p. 93.

22. *Builder* 1899, vol. 76, p. 370.

23. *Studio* January 1896, vol. 6, p. 205.

24. A long list of early architectural work was given by Frampton to the interviewer from the *Studio* in 1896. References to these and to several others are to be found in contemporary journals, as, for example, the *British Architect* 1886, vol. 26, p. 102 (Fawcett Memorial); *Builder* 1888, vol. 54, p. 158 (New Zealand panels); *Architecture* 1897, vol. 2, p. 84 (2 Kensington Court). All the early works cited in the text survive, except the decorations for the Constitutional Club, destroyed with the building.

25. *Studio* June 1894, vol. 3, p. 79.

26. *Studio* December 1897, vol. 12, pp. 159–60.

27. *Architectural Review* 1897, vol. 1, pp. 104, 106.

28. Several bronze casts, dated 1889, are in private collections. The panel was first exhibited at the Academy in 1890 in coloured plaster. The following year it appeared there in bronze.

29. John Pope-Hennessy, *Donatello's Relief of the Ascension*, [Victoria and Albert Museum monograph no. 1] 1975, p. 11.

30. The panel illustrated in plate 69 appears above the mantelpiece in Frampton's drawing room as photographed for the *Art Journal* in 1897 (see note 7).

31. *Magazine of Art* 1893, 'Chronicle of Art' for October 1892, p.i.

32. *Studio* January 1896, vol. 6, p. 209.

33. *Studio* May 1899, vol. 16, p. 249.

34. Illustrated in the *Studio* January 1896, p. 212; *Magazine of Art* 1896, p. 32; and *Dekorative Kunst* [Munich] 1904, vol. 12, p. 375. Also for Miss Radcliffe, Frampton designed in 1898 a pair of electric light brackets with mother-of-pearl, enamel and crystal decoration (now in a private collection abroad; see *Studio* May 1899, vol. 16, p. 252; *Dekorative Kunst* 1904, vol. 12, p. 377).

35. 2 Temple Place on the Victoria Embankment was built in 1895 to the designs of J.L. Pearson as a residence and estate office for William Waldorf Astor. In 1928 the house became the premises of the Society of Incorporated Accountants and Auditors and is now the head office of Smith & Nephew. Frampton's door fittings and almost all the other original decorations remain intact.

36. *Magazine of Art* 1900, p. 88.

37. *Art Journal* 1897, p. 321.

38. *Magazine of Art* 1902, p. 282.

39. *British Architect* 1902, vol. 57, plate following p. 346. The monument survives in Hampstead Cemetery.

40. *British Architect* 1897, vol. 48, pp. 471–3.

41. Glasgow Corporation, *Minutes* 23.7.97, p. 643.

42. Op. cit. n. 40.

43. Glasgow Corporation, presented papers: 'Report by the Architect and Master Sculptor on the Sculpture and Carving'.
44. Op. cit. n. 40.
45. Glasgow Corporation, *Minutes* 10.11.97, p. 29.
46. Ibid., 29.4.98, p. 480.
47. Ibid., 26.5.98, p. 565. See also *British Architect* 1898, vol. 49, pp. 305–6.
48. *British Architect* 1898, vol. 50, p. 19.
49. Glasgow Corporation, presented papers. The other winning entrants were William Birnie Rhind of Edinburgh (Science), Johan Keller of Glasgow (Religion), E.G. Bramwell of London (Literature) and A. Fabrucci of London (Commerce). Specially commended models were submitted by Birnie Rhind, Keller, W.F. Woodington, Edith Maryon, John Wenlock Rollins, C. Rutland and Edwin Roscoe Mullins. The committee decided that all but the two already named in the winning group should receive an honorarium of ten guineas.
50. Glasgow Art Gallery and Museum, *Report*, 1902, p. 4.
51. *Studio* October 1897, vol. 12, p. 46. Frampton was referring here to the crozier held by the standing St Mungo in the niche above the entrance to J.J. Burnet's Savings Bank, Ingram Street, Glasgow, on which he was working when he began the Gallery commission.
52. *Studio* October 1911, vol. 54, p. 40.
53. *Studio* February 1901, vol. 22, pp. 14–18.
54. The titles of the spandrels are given, as quoted, by Sparrow in his *Studio* article of February 1901, but do not appear in documentary sources.
55. All primary source material relating to Lloyd's and its building sub-committee is contained in files kindly made accessible to me at the Registry by Mr F.O. Farwell.
56. *Lloyd's Register of British and Foreign Shipping: Description of the Society's New Premises at 71 Fenchurch Street, London E.C.*, n.d., pp. 4–6 (reprint from the *Shipping Gazette and Lloyd's List*, 16 December 1901). A copy of this booklet is among the Registry archives. The description of the bronze statuettes as 'in duplicate' is misleading: the figures are all treated individually, though paired in the sense that two hold models of sailing ships and two carry modern steamships.
57. *Magazine of Art* 1903, pp. 19–24, 60–7.
58. Vol. 12, pp. 369 ff.
59. Christian M. Nebehay, *Ver Sacrum, 1898–1903*, 1976, p. 302 (nos. 11–14; no titles specified). My written requests to Vienna for further information from the original 1898 catalogue produced no result.
60. Quoted by Peter Vergo, *Art in Vienna, 1898–1918*, 1975.
61. Frampton had not, however, abandoned the Arthurian imagery he loved so much. On several occasions in 1902 he exhibited two ideal busts entitled *Lyonors* and *The Lady of the Isle of Avelyon* (at the Royal Society of Arts and the Fine Art Society in red wax and at the Royal Academy in bronze), derived from two of the Lloyd's statuettes. A bronze version of *Lyonors*, dated 1902, is in the City Museum and Art Gallery, Stoke-on-Trent.

Notes to Chapter 5

1. Public Record Office, Works 30/3530. On the occasion in 1895 when Stirling Lee and Pomeroy addressed the Architectural Association on architec-tural decoration Young wrote to explain his absence from the meeting and to express his ardent enthusiasm for the collaborative ideal. Architects must, he declared, take care to choose 'not mere figure carvers in stone', but 'sculpture of the highest class'. See *Builders' Journal* 1895, vol. 1, p. 58.
2. Public Record Office, Works 30/3528.
3. Ibid., Works, 12, 91/12 (1–7).
4. *Magazine of Art* 1898, p. 68.
5. *Magazine of Art* 1900, p. 211.
6. *Studio* February 1906, vol. 37, p. 14.
7. London Borough of Hammersmith, Central Library archive department, 1896 Rate Book.
8. The firm, by the name of William Cole, is unknown to Mr Gordon Offord, a leading historian of the carriage-building industry in London.
9. The plaques were cast by Singer's of Frome and illustrated in the *Studio* April 1899, vol. 16, p. 195.
10. *Studio* February 1906, vol. 37, p. 14.
11. *Magazine of Art* 1898, pp. 444–5.
12. See Brian Lewis, 'The Black Prince in Leeds City Square', *Leeds Arts Calendar* 1979, no. 84, pp. 21–8. A drawing by Harding's architect, William Bakewell, showing the scheme as first conceived, is in Leeds City Reference Library.
13. A photograph of the square, 'just completed', appeared in the *Studio* November 1903, vol. 30, p. 165. Statues of Joseph Priestley by Drury, Dean Hook by Pomeroy and James Watt and John Harrison by H.C. Fehr originally occupied two triangular areas defined by an outer balustrade, and have also been resited.
14. *Studio* June 1899, vol. 17, p. 47.
15. Evidence of Paul Drury, the sculptor's son.
16. *Architectural Review* 1913, vol. 33, p. 60.
17. Illustrated in the *Studio* August 1909, vol. 47, p. 216.
18. Public Record Office, Works 12, 91/12 (1–7).
19. Ibid., Works 12, 91/20.
20. *Studio* February 1906, vol. 37, p. 14.
21. According to his son, Drury used blankets on his models instead of ordinary cloth, in order to achieve an effect of weight and mass in the carved draperies.
22. *Studio* February 1906, vol. 37, p. 18.
23. Greater London Record Office, L.C.C. Bridges Committee Papers, January–April 1904.
24. Ibid., May–July 1904.
25. Ibid., September–December 1904.
26. L.C.C. *Minutes of Proceedings*, November–December 1904.
27. Art Workers Guild Library, 'Masters of the Art Workers Guild from the beginning till 1934', unpublished typescript, 1938.
28. Ibid.
29. The building was erected in Cowcross Street, Finsbury, in 1901. During the 1970s it was demolished and the facade re-erected in nearby Britten Street, City.
30. *Royal Institute of British Architects: Transactions* 1892, vol. 8, pp. 52–3.
31. *Builder* 1891, vol. 60, p. 88.
32. Illustrated in the *British Architect* 1894, vol. 41, p. 326. The sculptures were destroyed with the house, c.1929.
33. Op. cit. n. 30.
34. Like many commercial firms at this period the Eastern and Associated Telegraph Companies published an impressive illustrated brochure to celebrate the completion of their new premises. A copy of the Electra House brochure, proudly describing the building and the allocation of its sculptural decorations, is among the records of the now re-named Cable and Wireless Group. No other

documents relating to the early history of the building appear to have survived, but some of Belcher's elevational drawings, showing suggestions for sculptured figure decoration, are held by the firm of Enthoven and Mock, architects to the City of London College, present occupant of Electra House.

35. Quoted from George Somers Clarke's introductory notes to the catalogue of the first exhibition held by the Arts and Crafts Exhibition Society (see Chapter 3, note 53).

36. Public Record Office, Works 17, 22/16.

37. Ibid., Works 17, 22/14.

38. The history of the Cromwell Road frontage is summarised by John Physick in *Decorative Sculpture*, [Victoria and Albert Museum leaflet] 1978.

39. *Studio* March 1909, vol. 46, pp. 104–5.

40. *Journal of the Royal Institute of British Architects* 1905, vol. 12, p. 504.

41. Ibid., p. 507.

42. *Builder* 1906, vol. 90, pp. 90–1.

43. One of Rickards's detailed sketches for the sculptural decoration on the facade is illustrated in *Architectural Review* 1912, vol. 32, p. 279.

44. *Journal of the Royal Institute of British Architects* 1909, vol. 16, p. 392.

45. *Architectural Review* 1916, vol. 40, p. 36.

46. Quoted by Alastair Service, *Edwardian Architecture*, 1977, p. 185.

47. Royal Society of British Sculptors, typescript volume of historical records.

48. Ibid. and *Annual Report of the Council for the Year Ending December 21st 1905*.

49. Ibid., Minutes of Council Meetings, 15 December 1913–12 January 1914.

50. Op. cit. n. 47.

Notes to Chapter 6

1. Art Workers Guild Library, 'Masters of the Art Workers Guild from the beginning till 1834', unpublished typescript, 1938.

2. See Gosse's article 'Living English Sculptors', *Century Magazine* 1883, vol. 26, pp. 162–85.

3. *Art Journal* 1894, p. 202.

4. Joseph Hatton, 'The Life and Work of Alfred Gilbert', *Easter Art Journal* 1903, p. 10.

5. Quoted by Richard Dorment in the exhibition catalogue *Victorian High Renaissance*, Manchester and Minneapolis [Institute of Arts] 1978, pp. 175–6, from a letter in the National Museum of Wales.

6. Hatton, op. cit. n. 4, p. 11.

7. Ibid.

8. Isabel McAllister, *Alfred Gilbert*, 1929, pp. 144–7.

9. Hatton, op. cit. n. 4.

10. *Saturday Review* 26 June 1886, p. 882.

11. *Spectator* 29 May 1886, p. 719.

12. *Art Journal* 1887, p. 180.

13. *Art Journal* 1894, p. 282.

14. *Universal Review* 15 August 1888, p. 525.

15. The memorial is dirty and dark and photographs extremely badly. It is illustrated in McAllister, op. cit. n. 8, facing p. 73.

16. *Magazine of Art* 1881, p. 330.

17. M.S. Watts, *George Frederick Watts: The Annals of an Artist's Life*, 1912, vol. 1, p. 237.

18. Ibid., vol. 3, p. 35.

19. Illustrated by Edmund Gosse in *Art Journal* 1894, p. 141.

20. Evan Charteris, *Life and Letters of Sir Edmund Gosse*, 1931, p. 115.

21. *Magazine of Art* 1881, p. 331. A cast of the *Stone Putter* is at Leighton House.

22. *Magazine of Art* 1883, p. 451.

23. McAllister, op. cit. n. 8, p. 94.

24. Ibid., p. 87.

25. *Magazine of Art* 1892, p. 328.

26. Ibid., pp. 325–6. The critic was describing the marble version of the bust illustrated in plate 146, exhibited at the Academy in 1891 and now at Pollok House, Glasgow. In 1886 Ford's Academy exhibits had included 'A Study; bust, bronze', described in an annotated catalogue in the Royal Academy Library as life-sized and for sale at £105. It seems likely that this was the original version of the 1891 marble and identical with plate 146. (See also Chapter 7, pp. 187–8.)

27. Hatton, op. cit. n. 4, pp. 9–10.

28. *Second Report from the Royal Commissioners on Technical Instruction*, 1884, vol. 3, p. 150.

29. *Builder* 1899, vol. 76, p. 390.

30. A photograph of Frampton at work on the *Angel of Death* was reproduced in *Art Journal* 1897, p. 321. Though the title of the *Christabel* bust strongly suggests that it was inspired by Frampton's future wife, the sculptor's son Meredith vigorously denies that it bears any resemblance to her as a young woman. Another possibility is that the subject derives from Coleridge's poem of the same title. Nothing is at present known of the whereabouts of either plaster: they may never have been cast in bronze.

31. The helmet and the upper part of the cuirass were made by the French goldsmith Lucien Falize. See catalogue of the Decorative Art section of the 1889 International Exhibition and *Magazine of Art* 1898, pp. 414–18, illustration p. 416.

32. Frampton's debt to *Gallia* was first noted by Lavinia Handley-Read in her introduction to the exhibition catalogue *British Sculpture, 1850–1914*, Fine Art Society 1968, pp. 12–13.

33. *The Vision* was first exhibited, in painted gesso, with the Arts and Crafts Society in 1893. A version in bronze, dated 1893, is in Birmingham City Art Gallery (formerly in the Handley-Read collection).

34. 'La Libre Esthétique', 1 November 1894, pp. 475–8.

35. *Magazine of Art* 1895, p. 69.

36. Meredith Frampton, persistently reluctant to speak of his father except in the most general terms, went so far as to admit to me, on one occasion, that his relationship with his father was 'cold'.

37. *Magazine of Art* 1895, p. 442.

38. *Studio* October 1899, vol. 18, p. 50.

39. *The Pilot* 1900, vol. 1, p. 450. This comment, by a writer identified as 'E.H.', was first noted by Lavinia Handley-Read and quoted in abbreviated form in the exhibition catalogue cited in note 32 above. The version described here must, I think, be identical with that illustrated in plate 155, colour plate I, now in the Royal Academy's permanent collection and once owned by William Vivian. Meredith Frampton and his mother, the sculptor's widow, bought the bust back from the Vivian family before the First World War and gave it to the Academy in 1938. Only one other version is known: a polychromed plaster inscribed 'To my old friend Walter Bell' (brother of Robert Anning Bell) now in Birmingham City Art Gallery (formerly Handley-Read collection).

40. Hatton, op. cit. n. 4, p. 11.

41. The best account of the tomb and the various versions of the statuettes that relate to it was written by

Richard Dorment for the exhibition catalogue *Victorian High Renaissance*, Minneapolis [Institute of Arts] 1978, pp. 192–202.

42. Whether Frampton knew them remains obscure. Gilbert exhibited an aluminium and ivory figure of St George for the tomb at the Academy in 1896, but was notoriously secretive about his sculpture while it was in the making. In 1899, however, versions of *St Elizabeth of Hungary* and the *Virgin* in bronze and ivory (probably identical with those owned by the Scottish Kirk and now in Kippen Parish Church, Stirling-shire) were purchased by William Vivian, the collector who knew Frampton and who subsequently bought *Lamia* from him (see note 39 above). There is a possibility, therefore, that through Vivian if not through Gilbert himself Frampton had the oppor-tunity to see both statuettes before or during his work on the *Lamia* bust.

43. Hatton, op. cit. n. 4, p. 31.

44. The companion works, *Launcelot and the Nestling* and *Guinevere and the Nestling*, exhibited at the Academy in 1899 and 1900 respectively, are illustrated in M.H. Spielmann, *British Sculpture and Sculptors of To-day*, 1901, pp. 107–8, and in *Modern British Sculpture*, n.d., pp. 108–9, where they are described as being in the possession of Percy Eccles. Their present location is unknown.

45. A photograph of *The First Reflection* is in the Royal Academy Library but the whereabouts of the statuette is unknown.

46. Illustrated in Spielmann, op. cit. n. 44, p. 109.

47. The *St Agnes* exhibited at the Academy in 1894 and purchased for Leeds City Art Gallery disappeared during the Second World War and still awaits rediscovery.

48. A figure entitled *Pensée*, identical with that in plate 173, was illustrated by A.L. Baldry in *Magazine of Art* 1897, p. 67, and described as having been exhibited at the New Gallery in 1897 as a bronze statuette. The same figure is illustrated in Spielmann, op. cit. n. 44, p. 117, over the title '*Pleasures are like poppies spread, you seize the flower, its bloom is sped*', the quotation from Burns used by Pomeroy for a statuette (probably in plaster) shown at the Academy in 1896. Until further evidence emerges it must be assumed that both titles refer to the same figure.

49. *Royal Academy Pictures* 1895, p.v.

50. Illustrated in *Magazine of Art* 1891, p. 402.

Notes to Chapter 7

1. *Magazine of Art* 1895, p. 329.

2. *Art Union of London: Transactions, 1842–1844*, vol. 2: report presented to the General Committee of Management, December 1841.

3. *Annual Report of the Council* 1842, p. 8.

4. *Annual Report of the Council* 1860, p. 4.

5. *Annual Report of the Council* 1861, p. 9.

6. *Annual Report of the Council* 1876, p. 12.

7. *Building News* 1875, vol. 28, pp. 710–12. Henry Young (1842–1929) was England's first major art-bronze founder of modern times. His foundry in Eccleston Street, Pimlico, was a social centre for the London art world in the 1860s and 1870s. Many sculptors, including Alfred Stevens, were his personal friends. Among the most fascinating interviews I was privileged to hold was with Miss Amy Young, his daughter, then in her 102nd year.

8. *Portfolio* 1889, p. 48.

9. *Annual Report of the Council* 1885, p. 6.

10. Evan Charteris, *Life and Letters of Sir Edmund Gosse*, 1931, p. 166.

11. *Universal Review* 15 August 1888, p. 525.

12. Royal Academy Library, Spielmann papers: letter dated 11 April 1885.

13. Isabel McAllister, *Alfred Gilbert*, 1929, p. 87.

14. *Journal of the Society of Arts* 1888, vol. 36, p. 277.

15. *Journal of the Society of Arts* 1886, vol. 34, p. 277.

16. The library of the Victoria and Albert Museum holds the only copy of this catalogue which has yet come to light.

17. The other exhibits to be mass-produced in bronze were no. 14, *A Sea Nymph*, the terracotta model of a statue for the centre of a fountain executed in marble for Stephen Winkworth, nos. 18 and 19, terracotta studies for two privately owned marble statuettes *Art* and *Science*, nos. 25 and 26, two studies for figures of Tragedy and Comedy, and no. 35, a group already cast in Paris from the original study for the marble *Spring Festival*, inspired by Alma-Tadema's painting of the same title, shown at the Academy in 1880.

18. At the 1886–7 winter exhibition of the Royal Society of British Artists (nos. 498 and 499, 'copyright reserved').

19. *Magazine of Art* 1886, p. 234.

20. *National Association for the Advancement of Art and its Application to Industry: Transactions, 1889*, 1890, pp. 117–21.

21. p. 672.

22. Fine Art Society Ltd, *British Sculpture, 1850–1914*, 1968, p. 33, no. 167.

23. See Elfrida Manning, *Marble & Bronze: The Art and Life of Hamo Thornycroft*, London and New Jersey 1982, p. 109. Mrs Manning reveals that her father sold the copyright of *General Gordon* to Arthur Collie in 1888 for £50 down and one-fifth of the net profits.

24. Fine Art Society Ltd, op. cit. n. 22, p. 27, no. 101.

25. p. 461.

26. Fine Art Society Ltd, op. cit. n. 22, p. 28, no. 107.

27. Evidence, from a note in Thornycroft's diary, provided by the sculptor's daughter Mrs Manning. See also Manning, op. cit. n. 23, p. 109.

28. A history of the firm, written by Duncan James in 1971, exists in typescript and a copy of it is held at the Morris-Singer Foundry in Basingstoke, Hants. I am much indebted to the foundry for help and hospitality.

29. pp. 121–4.

30. This appears, however, not to have been Thornycroft's first venture of the kind. See Manning, op. cit. n. 23, p. 157: '...as early as 1881 he had taken the unusual step of casting his original sketch model of *Teucer*, and in 1884 he published his sketch model of the *Mower* in an edition of 25 copies'.

31. The catalogues are held by J.W. Singer & Sons, now a subsidiary of the Delta Group in Frome, Somerset. The day-book is at the Morris Singer Foundry, Basingstoke, Hants.

32. *Magazine of Art* 1895, pp. 368–72.

33. The only primary source material relating to Collie yet discovered is a series of letters written by him between 1893 and 1896 to the sculptor John Tweed (Tweed Papers, Reading Art Gallery and Museum). These illuminate various interesting aspects of his career: his friendship and working relationship with Tweed and his first meeting with Bertram Mackennal in 1894, his impecunious circumstances and his commission from the architect Herbert Baker to decorate the interior of Cecil Rhodes's house at Groot

Schuur, South Africa. Containing no direct reference to the bronze publishing business, nor to any sculptor apart from Tweed and Mackennal, they do include one enigmatic comment which suggests an association with Frampton. Collie wrote on 20 February 1894: 'I saw Gleeson White of the *Studio* this morning. He kindly said I might have the plate of "St Christina". As a matter of fact – of course – the copyright being mine – it's mine already!' In February 1894 the *Studio* published a full-page illustration of Frampton's *St Christina* relief.

34. *Magazine of Art* 1899, pp. 2, 40.
35. Ibid., August 'Chronicle', p. xlii.
36. Ibid., p. 371.
37. *Portfolio* 1889, p. 48. The small plaster relief *Artemis* which was shown at the 1888 exhibition was illustrated here. It was adapted from the monumental marble figure of 1879–80 (plate 139).
38. Duncan James, 'The Statue Foundry at Thames Ditton', *Foundry Trade Journal* 7 September 1972, pp. 279–89.
39. *Builder* 1887, vol. 53, p. 89. Bellman & Ivey's catalogue of a large exhibition, *Bronzes, English, French, Italian and Russian*, held c.1889, is in the library of the Victoria and Albert Museum. It included thirteen works by Frémiet, two by Falguière and others by Delaplanche and Gustave Doré. The most notable British artists represented were T.N. MacLean and Leighton (with one work entitled *Wedded*).
40. Reviewed in the *Studio* October 1894, vol. 4, p. 68.
41. *Magazine of Art* 1894, pp. 385–6.
42. *Studio* November 1898, vol. 15, p. 80.
43. The panel was exhibited under the title *Youth* at the Fine Art Society's statuette exhibition 'Sculpture for the Home' in 1902 (see note 61 below, item 52). Its symbolism was described in the catalogue as follows: 'The mirror in the background typifies (by the sunrise scene) the unclouded brightness of youth's outlook into life. On the stand are emblems of spring, the narcissus, and a bird singing to his mate.'
44. *Studio* July 1899, vol. 17, p. 83.
45. Ibid., p. 80, illustrated p. 79.
46. *Annual Report of the Council* 1894, p. 4.
47. *Annual Report of the Council* 1895, pp. 5–6.
48. *Annual Report of the Council* 1897, p. 11.
49. *Studio* January 1896, vol. 6, p. 205.
50. University College, London, *Calendars* of Department of Fine Arts, for sessions 1877–8 and 1884–5.
51. The three panels formed a triptych and were described in the catalogue as *A Guardian Angel*, *Children bringing Lilies to the Holy Child* and *Mother and Child*. They were produced, at the same time, in glazed earthenware for the Della Robbia Pottery. The *Guardian Angel* panel was illustrated in the Pottery's 1896 catalogue (see Jeremy Cooper Ltd, *The Birkenhead Della Robbia Pottery, 1893 to 1906*, 1980, p. 62, no. 79 and cover plate).
52. *Studio* August 1897, vol. 11, p. 249. The precise size of the model is not known but is likely to have been similar to Levick's subsequent group *Boys Fishing*, 12¼ inches high, a bronze cast of which is at Pollok House, Glasgow.
53. Numerous small bronze versions of the life-sized group, varying from about 9 inches to about 3 feet in height, exist in private and public collections, including the Ashmolean Museum, Walker Art Gallery, Birmingham City Art Gallery, National Museum of Wales and Portsmouth Art Gallery. See Royal Academy of Arts, *Victorian and Edwardian*

Decorative Art: The Handley-Read Collection, 1972, nos. F37–9.
54. *Annual Report of the Council* 1896, p. 4.
55. *Studio* February 1903, vol. 28, pp. 19–22.
56. *Magazine of Art* 1895, p. 329.
57. Ibid., p. 372.
58. *Studio* May 1902, vol. 25, pp. 275–6.
59. There is evidence to suggest that he sold at least two of his copyrights when the publishing business failed. A 14½ inch cast of *General Gordon* which appeared at Sotheby Belgravia in 1977 was inscribed on the base '. . . published by S L Fane, 49 Glasshouse St, London W. June 1906'. One of the loose-leaf catalogues of the productions of J.W. Singer & Sons (see note 31 above), probably published shortly before the First World War, contains a photograph of the 20½ inch *Sluggard* statuette, captioned 'from the original signed Model, by the late Lord Leighton, of which we hold the copyright'.
60. A senior architect employed by the London County Council, for example, received an annual salary of about £400 during the 1890s.
61. Abstract of the catalogue (annotations including prices in guineas are quoted in full in italics):
Of a total of 114 catalogued items 18 have no prices marked or were not for sale, including:
 12. Hero. Bronze. (Lent by the Art Union of London.) Margaret M. Giles.
 54. Aeneas. Three panels. (Lent by the Earl of Wemyss and March.) The late Harry Bates, A.R.A.
27 works were priced at 25 guineas and under, and included:
 23. Teucer. Bronze (cire perdue). Hamo Thornycroft, R.A. *25. no. 20 of edition of 25*
 27. Griselda. A. Drury, A.R.A. *16*
 37. Salome. Bronze. Bertram Mackennal. *20 Edition of 25 (10 left)*
 39. An Offering to Hymen. Bronze. Alf. Gilbert, R.A. *20*
 42. The Sluggard. Bronze. The late Lord Leighton, P.R.A. *15*
 45. Burns. Bronze. F.W. Pomeroy. *22*
 49. Spring. Plaster (Tinted) Albt Toft *15 bronze all sold Plaster limited to 8 (3 sold)*
 71. Sea Chariot. Bas relief. Silvered Bronze. E.M. Rope *10 bronze 7 gs*
 81. Photo-frame. Copper. W. Reynolds-Stephens *5*
 83. Newly born Baby. Bronze. R.F. Wells *10*
 84. Woman and Child. Bronze. R.F. Wells *20*
 90. Innocence. A. Drury, A.R.A. *20*
 91. Needless Alarms. The late Lord Leighton, P.R.A. *15*
 105. Boys Fishing. Bronze. Ruby Levick. *Original not for sale Plaster 10 gs bronze 25 gs*
27 works ranged in price from 30 to 50 guineas and included:
 6. Perseus. Alf. Gilbert, R.A. *35*
 8. Comedy and Tragedy. Bronze. Alf. Gilbert, R.A. *35*
 31A. Door Knocker. Bronze. The late Harry Bates, A.R.A. *42*
 53. Folly. Bronze. The late Onslow Ford, R.A. *44*
 56. Spring. Plaster (Bronzed). Alfred Drury, A.R.A. *40 bronze limited to 20*
 97. Perseus. Bronze. F.W. Pomeroy *30*
 103. Mower. Bronze (sand). Hamo Thornycroft, R.A. *45*
Among the remaining 43 works costing more than 50 guineas were:

3. St George. Gilt and enamelled bronze. G. Frampton, A.R.A. *300*
26. Psyche. Panel (Plaster). The late Harry Bates, A.R.A. *300 marble bronze 180, plaster 65 gs*
28. Eve. Plaster (Bronzed). T. Brock, R.A. *175 in bronze, only 1 or 2 copies*
44. Bather. Bronze (cire perdue). Hamo Thornycroft, R.A. *150 no copies. 2 only in existence*
52. Youth. Bas-relief and Stand in metals, inlay, woods. W. Reynolds-Stephens *150 a limited number of others varying @ an increasing price of 5 gs each*
58. Drinking Lioness. John M. Swann, A.R.A. *150 2 copies only produced other in Luxembourg – limited to 6*
59. St Elizabeth of Hungary. Bronze Coloured. Alfred Gilbert, R.A. *300*
86. Boy at Play. Bronze. W. Goscombe John, A.R.A. *75*
93. Rhodope. Marble. The late Harry Bates, A.R.A. *250 original facsimile 130 gs*
62. *Studio* February 1903, vol. 28, pp. 19–22.

Notes to Chapter 8

1. City of London Guildhall Library, MS 192, Peabody Committee Minutes 1866. The minute book has unreliable page-numbering: the location of this and each subsequent reference to it is self-established by date.
2. William Wetmore Story (1819–1895) was born in Massachusetts and settled in Rome in 1856. His *Cleopatra* and *Libyan Sibyl* were widely acclaimed at the International Exhibition in London in 1862 and established his reputation as a leading Anglo-American sculptor. He moved in literary circles and was a close friend of the Brownings. A replica of the Peabody Memorial was erected in Baltimore. See *Dictionary of American Biography*.
3. City of London Guildhall Library, MS 192, Peabody Committee Minutes 1866: copy and original letter written from Royal Hotel, North Berwick, dated 2 August 1869.
4. Ibid.: copy and original letter dated 31 August 1869.
5. *Magazine of Art* 1880, p. 135.
6. *Magazine of Art* 1887, pp. 168–9.
7. *Magazine of Art* 1895, p. 408.
8. *Magazine of Art* 1880, p. 335.
9. Public Record Office, Works 20/50 (part 1): extract from a newspaper report.
10. Ibid.: draft letter dated 31 August 1885.
11. Ibid.: letter dated 29 June 1886.
12. Ibid.: letter dated 25 September 1886.
13. Ibid.: letter dated 31 January 1888 from Thornycroft to the First Commissioner, explaining the delay.
14. *Art Journal* 1888, p. 382.
15. *Graphic* 13 October 1888, p. 382, and many other detailed contemporary reports.
16. *Magazine of Art* 1889, p. 68.
17. *Dictionary of National Biography*, entry by Robert Hamilton Vetch.
18. *Magazine of Art* 1889, p. 68.
19. *Hampshire Observer* 18 May 1912, pp. 9–10. This report of the unveiling contains a usefully detailed description of the monument and its history.
20. Isabel McAllister, *Alfred Gilbert*, 1929, p. 126.
21. Ashmolean Museum, Oxford: letter to the Rev. J.W.R. Brocklebank, 1 January 1911.
22. India Office Records, Curzon Collection, volume of newspaper cuttings: speech by Sir Francis Maclean, Chairman of the executive committee of the Queen-Empress Commemoration Fund, reported in the *Englishman* 20 March 1902. Apart from the occupation and address listed in *Thacker's Directory* nothing is yet known of Charles Moore. On at least one other important occasion, however, he acted as go-between for a Calcutta memorial committee (see note 38 below) and was evidently in close touch with academic art circles in London.
23. The figure in the *Studio*'s photograph is winged and therefore unlikely to be St George, but more probably a Victory or Peace.
24. *Studio* July 1898, vol. 14, pp. 121–4.
25. India Office Records, MSS EUR F111/161, p. 93: letter from Viceroy to Secretary of State, dated 20 March 1902.
26. *Calcutta Old and New*, 1907, pp. 393–4.
27. A grant of £100 towards the statue was made by the school's Trustees, the Brewers' Company, on 11 June 1896 (City of London Guildhall Library, MS 5445, vol. 40). The work was unveiled in the entrance hall of the school, then recently built in Owen St., E.C.1., in October 1897, against a background of mural relief decoration also devised by Frampton. The figure now stands in the assembly hall of the modern school in Dugdale Hill Lane, Potter's Bar. I am much indebted to the staff of Owen's School for giving me free access to photograph it.
28. The plaque is still *in situ*, with the companion portrait of Leigh Hunt, also by Frampton, in the library's entrance lobby.
29. *Architectural Review* 1915, vol. 38, notes of the month (unnumbered end-pages).
30. As, for example, by Nikolaus Pevsner and Ian A. Richmond in *The Buildings of England: Northumberland*, 1970, p. 299.
31. The history of the commission, as tortured as that of the Wellington Monument and with comparably dire emotional and financial consequences for the sculptor, is told in detail in the *Survey of London, Parish of St James Westminster* (part II), 1963, pp. 101–10. An admirable summary with interpretive comments by Richard Dorment is included in the exhibition catalogue *Victorian High Renaissance*, Manchester and Mineapolis [Institute of Arts] 1978, pp. 185–8.
32. McAllister, op. cit. n. 20, p. 104.
33. Ibid.
34. Joseph Hatton, 'The Life and Work of Alfred Gilbert, RA', *Easter Art Annual* 1903, p. 15.
35. Ibid., p. 11.
36. Public Record Office, Works 20/76 (part I).
37. Ibid. (part II). See also Westminster Reference Library enquiry file 1139. The equestrian figure, re-erected on a plain pedestal, now (1981) stands in the grounds of Foley Manor, Liphook, Hants. I am much indebted to the present owners for giving me free access to photograph it.
38. India Office Library, Elgin Spring Tours photograph album, 1894–1898, p. 41: newspaper cutting of Sir Patrick Playfair's address to the Viceroy Lord Elgin inviting him to unveil the monument.
39. Ibid.
40. *Artist* December 1897, p. 586.
41. Op. cit. n. 38.
42. Public Record Office, Works 20/136: letter dated 17 November 1920.
43. Op. cit. n. 38.
44. Royal Academy of Arts Library, *Annual Report* 1899.
45. Public Record Office, Works 20/136: memo from Sir

Lionel Earle, Permanent Secretary, Office of Works, to First Commissioner, dated 20 December 1920.

46. A bronze cast of the *Courage* statuette is in Birmingham Museum and Art Gallery (formerly Handley-Read collection).

47. India Office Records, Curzon Collection, MSS EUR F111/461. Letters were entered in order of receipt by Curzon. Only those from which substantial quotations are made are referenced below.

48. Ibid.: letter dated 28 March 1906.

49. Ibid.: copy, dated 6 June 1906.

50. Ibid.: letter dated 28 June 1906.

51. Ibid.: copy, dated 21 June 1906.

52. Ibid.: undated letter entered between correspondence of 4 and 16 March 1908.

53. Ibid.: copy and original letter dated 21 March 1908.

54. Ibid.: letter dated 6 October 1908.

55. Ibid.: letter dated 26 October 1908.

56. Ibid.: letter dated 13 December 1911.

57. Ibid.: letter dated 25 February 1913.

58. Ibid.: letter dated 28 February 1913.

59. Ibid.: undated copy, entered between correspondence of 25 and 26 November 1908.

60. Public Record Office, Works 20/19: unidentified newspaper cutting dated 2 April 1911.

61. *Architectural Review* 1910, vol. 28, p. 152.

NOTES TO CHAPTER 9

1. J.-K. Huysmans, *A Rebours*, Paris, 1884 (translation by Robert Baldick, Penguin Modern Classics, 1959, p. 63).

2. Frampton remained, in principle at least, committed to his old ideals. He left his residuary estate to the President and Council of the Royal Academy upon trust to create a 'Fund for the encouragement of the highest form of the Art of Sculpture'. It would be the duty of a sub-committee to select works by sculptors of British birth 'including works of a decorative or architectural character or Sculpture applied to architecture which have been executed only in plaster or other material of a non-permanent character', to submit such works for the approval of the Council and to have them executed in permanent material for the Nation. The terms of the will do not come into effect until the death of Frampton's son.

3. *Art Journal* 1907, pp. 206–7.

4. *Apollo* 1927, vol. 6, p. 138. I am much indebted to Theo Cowdell for drawing my attention to this review.

5. 'And fatal is no figure of speech, for anything written with that conscious bias is doomed to death. It ceases to be fertilized. Brilliant and effective, powerful and masterly, as it may appear for a day or two, it must wither at nightfall; it cannot grow in the minds of others. Some collaboration has to take place in the mind between the woman and the man before the art of creation can be accomplished.' Virginia Woolf, *A Room of One's Own*, 1928 (Penguin Modern Classics, 1973, p. 103). This statement makes an interesting comparison with Walter Shaw Sparrow's comment on Frampton's Glasgow Art Gallery sculptures, quoted in Chapter 4.

6. W. Reynolds-Stephens, 'A Plea for the Nationalisation of our Sculpture', *The Nineteenth Century and After* 1911, vol. 69, p. 160.

7. Public Record Office, Works 20/63: letter, with memo enclosed, dated 4 April 1913. The Park was opened, sculptureless, in 1922.

8. Isabel McAllister, *Alfred Gilbert*, 1929, p. 192.

Select Bibliography

THE list below and the references to articles on individual artists (incorporated in the biographical notes) reflect the extraordinary dearth of published comment of any significance on the New Sculptors and their work. For an excellent general bibliography of British sculpture, 1830–1914, see Benedict Read, *Victorian Sculpture*, New Haven and London 1982. For comparative purposes the following two works are particularly useful: Harold Berman, *Bronzes, Sculptors and Founders, 1800–1930*, Chicago 1974–7 (three volumes of plates with notes, containing no reference to sculpture in Britain); Los Angeles County Museum, *The Romantics to Rodin: French Nineteenth Century Sculpture from North American Collections*, Los Angeles 1980 (exhibition catalogue, including extensive bibliography, edited by Peter Fusco and H.W. Janson). The place of publication is London unless otherwise indicated.

Edmund Gosse, 'Living English Sculptors', *Century Magazine* 1883, vol. 26, pp. 162–85.
 'The New Sculpture, 1879–1894', *Art Journal* 1894, pp. 138–42, 199–203, 277–82, 306–11.
 'The Place of Sculpture in Daily Life', *Magazine of Art* 1895, pp. 326–9, 368–72, 407–10. (The articles in this series were sub-headed, respectively, 'Certain Fallacies', 'Sculpture in the House' and 'Monuments'. A fourth article, 'Decoration', is missing from some bound series of the *Magazine of Art* but appears in the volume numbered 19 (1895–6), pp. 9–12, in the library of the Victoria and Albert Museum.)
M.H. Spielmann, *British Sculpture and Sculptors of To-Day*, 1901.
Hermann Muthesius, 'Kunst und Leben in England' (part II), *Zeitschrift für Bildende Kunst* [Leipzig] 1902–3, vol. 14, pp. 73–85.
M.H. Spielmann, 'British Sculpture of To-Day', *Journal of the Royal Institute of British Architects* 1909, vol. 16, pp. 373–94.
James Gildea, *For Remembrance and in honour of those who lost their lives in the South African War, 1899–1902*, 1911.
Kineton Parkes, *Sculpture of To-Day*, 1921 (vol. 1: America, Great Britain, Japan; vol. 2: Continent of Europe).
Modern British Sculpture: An official record of some of the works by members of the Royal Society of British Sculptors, n.d. (published *c.*1922 under the aegis of *Academy Architecture* with foreword by A.L. Baldry).
Tancred Borenius, *Forty London Statues and Public Monuments*, 1926.
Edward Gleichen, *London's Open-Air Statuary*, 1928.
Isabel McAllister, *Alfred Gilbert*, 1929.
H.F.W. Ganz, *Alfred Gilbert at his Work*, 1934.
Adrian Bury, *Shadow of Eros: A Bibliography and Critical Study of the Life and Works of Sir Alfred Gilbert, R.A.*, 1954.
Charles Handley-Read, 'Sculpture in High Victorian Architecture', in *The High Victorian Cultural Achievement*, 1967, pp. 26–35 (illustrated 2nd edition of the report of the 1964 conference of the Victorian Society).
Fine Art Society Ltd, *British Sculpture, 1850–1914*, 1968. (Lavinia Handley-Read's introduction to this exhibition catalogue was the first cogent account of the subject to appear in print. The exhibition was assembled in emulation of the 'First Exhibition of Statuettes by Sculptors of Today, British and French', held by the Fine Art Society in collaboration with M.H. Spielmann in 1902, and included versions of many of the same works.)
Renée Free, 'Late Victorian, Edwardian and French Sculptures', *Art Gallery of New South Wales Quarterly* January 1972, vol. 13, no. 2, pp. 646–63.
Royal Academy of Arts, *Victorian and Edwardian Decorative Art: The Handley-Read Collection*, 1972 (catalogue entries for section F, 'The New Sculpture', by Lavinia Handley-Read).

Arts Council, *Pioneers of Modern Sculpture*, 1973 (catalogue foreword by Albert E. Elsen).

Jeremy Cooper, *Nineteenth Century Romantic Bronzes, 1830–1915*, 1975.

Minneapolis Institute of Arts, *Victorian High Renaissance*, Manchester and Minneapolis 1978. (Catalogue of the exhibition shown at Manchester, Minneapolis and Brooklyn, which was confined to the work of four artists, G.F. Watts, Frederic Leighton, Albert Moore and Alfred Gilbert. The material relating to Gilbert, including introductory and biographical essays, bibliographical lists and the catalogue entries themselves, was compiled by Richard Dorment. A major contribution to work in this field, it laid the foundations for the book on the sculptor which Dorment is now writing.)

National Museum of Wales, *Goscombe John*, Cardiff 1979 (exhibition catalogue entries and introduction by Fiona Pearson).

Whitechapel Art Gallery, *British Sculpture in the Twentieth Century* (ed. Sandy Nairne and Nicholas Serota), 1981. (See part II, 'Classical and Decorative Sculpture', by Ben Read.)

Benedict Read, *Victorian Sculpture*, New Haven and London 1982. (The first comprehensive study of sculpture in the Victorian age, introducing, with splendid illustrations, the New Sculpture movement in part IV, 'The End of the Century'.)

Elfrida Manning, *Marble & Bronze: The Art and Life of Hamo Thornycroft*, London and New Jersey 1982. (The first full-scale monograph on a New Sculptor to appear since Isabel McAllister's biography of Alfred Stevens in 1934.)

ILLUSTRATIONS

Spielmann's *British Sculpture and Sculptors of To-Day*, 1901, and the Royal Society of British Sculptors' *Modern British Sculpture*, [*c*.1922], are the only books which purport to illustrate the subject in any depth within a single volume. Both, however, have serious limitations imposed by their scope or by their date of publication. The first, for example, is confined to the work of living artists and thus excludes Harry Bates. The second omits, without apology, any reference to either Gilbert (an honorary member of the Society) or Frampton (who resigned his membership in 1914) and devotes many of its plates to recent work by the Society's younger members. The best sources of illustrations are contemporary journals. Sculpture appearing in current exhibitions began to feature regularly in art and architectural periodicals during the 1880s. In 1888 the *Magazine of Art* began publication of its supplement *Royal Academy Pictures* in which sculpture exhibits were illustrated in steadily increasing numbers, though not until 1907 was its title changed to *Royal Academy Pictures and Sculpture*. A similarly useful and concentrated survey of new work was provided by *Academy Architecture* which appeared for the first time in 1889 and in 1891 began a special section of illustrations of ideal as well as architectural sculpture.

GENERAL REFERENCE

Algernon Graves, *The Royal Academy of Arts: A Complete Dictionary of Contributors and their Work from its Foundation in 1769 to 1904*, 1905 (eight volumes, reprinted in four volumes 1970; extension volumes for 1905–70 in course of production).

U. Thieme and F. Becker, *Allgemeines Lexikon der Bildenden Künstler von der Antike bis zür Gegenwart*, Leipzig 1907–50 (thirty-seven volumes).

James Mackay, *Dictionary of Western Sculptors in Bronze*, Woodbridge [Suffolk] 1977.

Index